BRITISH COLOUR CINEMA

BRITISH COLOUR CINEMA
PRACTICES AND THEORIES

Edited by Simon Brown, Sarah Street and Liz Watkins

A BFI book published by Palgrave Macmillan

First published in 2013 by
PALGRAVE MACMILLAN

on behalf of the

BRITISH FILM INSTITUTE
21 Stephen Street, London W1T 1LN
www.bfi.org.uk

There's more to discover about film and television through the BFI. Our world-renowned archive,
cinemas, festivals, films, publications and learning resources are here to inspire you.

Palgrave Macmillan in the UK is an imprint of Macmillan Publishers Limited, registered in
England, company number 785998, of Houndmills, Basingstoke, Hampshire RG21 6XS.
Palgrave Macmillan in the US is a division of St Martin's Press LLC, 175 Fifth Avenue, New York,
NY 10010. Palgrave Macmillan is the global academic imprint of the above companies and has
companies and representatives throughout the world. Palgrave® and Macmillan® are registered
trademarks in the United States, the United Kingdom, Europe and other countries.

Cover image: LEON NEAL/AFP/Getty Images
Designed by couch
Set by Cambrian Typesetters, Camberley, Surrey
Printed in China

This book is printed on paper suitable for recycling and made from fully managed and sustained
forest sources. Logging, pulping and manufacturing processes are expected to conform to the
environmental regulations of the country of origin.

British Library Cataloguing-in-Publication Data
A catalogue record for this book is available from the British Library
A catalog record for this book is available from the Library of Congress

ISBN 978–1–84457–413–1 (pb)
ISBN 978–1–84457–414–8 (hb)

CONTENTS

ACKNOWLEDGMENTS

We would like to thank the many people who shared their experiences of working with colour film. All were generous with their time and helped us to bring together this collection of memories and documents that we hope contributes towards a greater understanding of the collaborative nature of the filmmaking process, particularly regarding colour. The book was one of the outcomes of a project funded by the Arts and Humanities Research Council, which we would like to thank for its support. As well as the many people we interviewed who feature explicitly in this book, we would like in addition to acknowledge assistance at several key points from Sonia Genaitay, Luke McKernan, Steve Neale, Elaine Burrows, Frances Russell, Duncan Petrie and the late Les Ostinelli. We would like to thank Kieron Webb and Ulrich Rüdel for responding to some of our more technical questions and the British Film Institute Library staff for their support. Rebecca Barden at BFI Publishing has supported this project throughout, and we thank her for her input at crucial stages of its development. We are very grateful to Richard Chatten for additional proof-reading and for his enthusiasm for the project. We also thank Sophia Contento at BFI Publishing/Palgrave Macmillan, and Belinda Latchford for copy-editing/proof-reading. Every effort has been made to trace all copyright holders, but if any have been inadvertently overlooked, the publisher will be pleased to make the necessary arrangements at the earliest opportunity.

PERMISSIONS

The editors would like to thank the following interviewees for giving up their time and for their kind permission to print the transcripts of their interviews: Chris Challis, Ossie Morris, Duncan Petrie, Paul de Burgh, Kieron Webb, Sonia Genaitay, João S. de Oliveira, Paolo Cherchi Usai, Giovanna Fossati, Ulrich Rüdel and Daniela Currò.

BECTU interviews with Syd Wilson, Dave Davis, Bernard Happé, Frank Littlejohn and Les Ostinelli are presented here by kind permission of the BECTU History Project, <http://www.bectu.org.uk/advice-resources/history-project>.

BECTU interview with Pat Jackson was transcribed by the University of East Anglia (UEA) as part of the British Cinema History Project housed at UEA. The full text is available by contacting the British Cinema History Project via the UEA website. It is reprinted here by kind permission of UEA and the BECTU History Project.

Extracts from Jack Cardiff, 'Shooting *Western Approaches*', *Cine-Technician*, November–December 1944, pp. 112–16 and Ronald Neame, 'A Talk on Technicolor', *Cine-Technician*, May–June 1944, pp. 36–40 are reprinted courtesy of BECTU.

E. S. Tompkins, 'In Defence of "Glorious" Colour', *British Journal of Photography*, 3 March 1944, p. 74 and Robert M. Fanstone, 'Experiences with Dufaycolor Film', *British Journal of Photography*, 7 June 1935, pp. 358–9 were first published in the *British Journal of Photography* and are reprinted courtesy of Incisive Media.

'Preservation of Films', *Kinematograph Weekly*, 13 March 1952, p. 22 and 'Gasparcolour Explained to the R.P.S.', *Kinematograph Weekly*, 31 January 1935, p. 47 are reprinted courtesy of *Screen International*.

ABOUT THE EDITORS

SIMON BROWN is Director of Studies for Film and Television and New Broadcasting Media at Kingston University. Before joining Kingston, he worked for ten years in the BFI National Film and Television Archive, and so has a background in both archiving and academia. His main areas of research are early and silent cinema, British cinema, contemporary American television and colour. His recent work on colour includes 'Colouring the Nation: Spectacle, Reality and British Natural Colour in the Silent and Early Sound Era' (*Film History*, August 2009), and the chapter 'The Brighton School and the Quest for Natural Color – Redux' in the collection *Color and the Moving Image: History, Theory, Aesthetics, Archive* for Routledge, which he co-edited with Sarah Street and Liz Watkins. Outside of colour he is currently editing and writing a piece for a special issue of the *Journal of Science Fiction Film and Television* commemorating the twentieth anniversary of the first transmission of *The X-Files* in the US, and is also writing an article on 3DTV for *Critical Studies in Television*.

SARAH STREET is Professor of Film at the University of Bristol. She has published extensively, including *Cinema and State: The Film Industry and the British Government* (co-authored with Margaret Dickinson, 1985); *British National Cinema* (1997; 2nd edition 2009); *Costume and Cinema* (2001); *British Cinema in Documents* (2000); *European Cinema* (co-edited with Jill Forbes, 2000); *Moving Performance: British Stage and Screen* (co-edited with Linda Fitzsimmons, 2000); *Transatlantic Crossings: British Feature Films in the USA* (2002); *The Titanic in Myth and Memory* (co-edited with Tim Bergfelder, 2004); *Black Narcissus* (2005) and *Queer Screen: The Queer Reader* (co-edited with Jackie Stacey, 2007). *Film Architecture and the Transnational Imagination: Set Design in 1930s European Cinema* was co-authored with Tim Bergfelder and Sue Harris (2007), and was the result of a collaborative Arts and Humanities Research Council-funded project. She is also author of *Colour Films in Britain: The Negotiation of Innovation, 1900–55* (2012) and is a co-editor, with Simon Brown and Liz Watkins, of *Color and the Moving Image: History, Theory, Aesthetics, Archive* (2012), publications which, in addition to this volume, resulted from a research project funded by the AHRC.

Sarah Street is co-editor of two key journals in the field, *Screen* and the *Journal of British Cinema and Television*.

LIZ WATKINS is a Lecturer at the University of Leeds. Her research interests include the significance of colour for film theories of subjectivity, perception and sexual difference. Her research also engages with gesture as an insidious force of discontent in the interactions of body and language. She has published on feminism, film/philosophy and colour in *Parallax*, *Paragraph* and the *British Journal of Cinema and Television*. Liz Watkins's research also includes a focus on the materiality of film and archive. She contributed a case study of the BFI National Film Archive's 2010 colour restoration of *The Great White Silence* (Herbert G. Ponting, 1924) to a collection of essays *Color and the Moving Image: History, Theory, Aesthetics, Archive*, which she co-edited with Simon Brown and Sarah Street for Routledge.

INTRODUCTION

It is significant that a book on the theory and practice of colour should be completed in the year that the winner of the Academy Award for Best Picture, *The Artist* (2011), was black and white, only the second such film to win since *The Apartment* (1960), the other being *Schindler's List* (1993). When reviewing the 2012 ceremony film critic Mark Kermode noted that 'It's amazing how quickly everyone got used to, and then bored with, the idea that a black and white, near silent 4 x 3 film … was about to win the Oscar for best picture'.[1] In his view, despite the hype that made the awarding of the Oscar to *The Artist* unsurprising, it was precisely the fact that the film was in black and white which made the win remarkable. Colour in contemporary cinema is so taken for granted that it only becomes a topic of discussion when attention is drawn to it.

This, Tom Gunning argues, is part of the processes of modernity, in which the 'new' becomes familiar and the wonder which first greeted a new technology, such as colour, 'becomes subsumed in action, then in habitual action, and ultimately in the diametric opposite of wonder, automatism'.[2] However, Gunning argues that wonder does not disappear but 'crouches there beneath a rational cover, ready to spring out again … through aesthetic defamiliarization'.[3] In the same way we take an ordinary household object like a television set for granted until it breaks down and we are forced to reassess its significance in our lives, *The Artist*, at least temporarily, disrupted contemporary complacency with the use of colour in cinema (along with sound) before that same complacency reasserted itself through the predictability of the awards season.

What should not be forgotten is that black and white are themselves colours. While the contemporary concept of a film being in black and white connotes the absence or antithesis of colour, black-and-white films are, nevertheless, colour films. They just happen to use only two colours that do not approximate the world as we normally see it. This is noteworthy because colour in contemporary mainstream cinema is, for the most part, perceived to be used not for artistic purposes but purely to approximate the colour of the real world. Thus a blue sky represents what a blue sky looks like, and a red Transformer, even though computer-generated, nevertheless looks like a red Transformer would look like in the imagination of the director. While colour manipulation is now

relatively commonplace in post-production, especially for example in CGI blockbusters such as *Transformers* (2007) and *Avatar* (2009) where a large proportion of what is on screen does not actually exist outside an imagined virtual space, nevertheless there is a tacit understanding that the purpose of colour is to replicate the colours of the real ('reel' in the case of CGI) world and so part of the 'disruption' is the use of colour in ways that are not merely representative, such as the use of black and white in *The Artist*. But the fact that colour on film is seen to be replicating reality also hides the fact that colour on film is the result of a series of significant creative and technological decisions on the part of filmmakers, technicians and, in the case of restorations, archivists. Decisions about costume and lighting, about grading and the mixing of colour dyes, about photochemical or digital restorations of old negatives, all have impact on the colour which we see on the screen.

The focus of this book is the creative decision-making which goes into the life cycle of a colour film, from production to post-production, preservation and restoration, concentrating in particular upon the British contribution to colour. While Technicolor and Eastmancolor were American processes, British artists, craftsmen and technicians have over the years played a substantial role in the 'look' of colour, particularly Technicolor, in terms of how it was filmed, printed and, more recently, restored. A case in point is Michael Powell and Emeric Pressburger's two acclaimed post-war Technicolor masterpieces, *Black Narcissus* (1947) and *The Red Shoes* (1948). The vibrant colours on display in recent restored prints and DVD releases were filtered through the eyes of British craftsmen such as cinematographer Jack Cardiff, through lab technicians such as Syd Wilson and Jack Houshold, and through restoration experts like Paul de Burgh. This book aims to illuminate the wealth of work, thought and attention to detail which hides behind the seemingly known concept of colour. Colour in film is created, not re-created; interpreted, not represented. This book 'disrupts' assumptions about the process of putting colour on the screen, and encourages the reader to wonder anew.

To fulfil this aim the book presents case studies in three key areas of production, post-production and archiving/restoration. Rather than academic analysis, these chapters are comprised of interviews with key personnel in these areas, some of which are new interviews conducted by the authors, while others were undertaken as part of the BECTU History Project organised by the trade union which represents those working in film and other entertainment industries. These interviews are contextualised by introductions and by documents contemporary to the production and restoration of each film.

Part I highlights the contributions of cinematographers, many of them credited with filming some of the most significant colour films ever made. Their accounts of working with various processes, and of witnessing the arrival of colour in commercial cinema, reveal their pioneering achievements in rising to the demanding challenge of creating colour in the camera. While colour innovation is often credited solely to cinematographers, the interviews and documents show that they were part of a highly collaborative system devising ingenious methods to overcome exacting technical problems. Whether they were grappling with the structures imposed by the Technicolor Color Advisory Service, with bulky cameras or demanding directors, these technicians highlight the significant contribution of British labour to the story of colour film, as well as their mutual respect for each other

as professionals engaged in technical discovery during a key period in the history of cinema and technology.

Part II focuses upon the post-production process, with a series of interviews which illuminate the work of the Technicolor Film Laboratories at Denham. The labs were opened in 1937, just as Technicolor was becoming the industry standard, specifically for the purpose of undertaking the complicated post-production process required to produce Technicolor prints. The labs were subsequently forced to adapt in the 1950s, when the advent of Eastmancolor signalled a shift in colour film production and post-production. The interviews included in this chapter highlight not only the complexity of the post-production process, but also the input of these highly skilled technicians to the final product.

Part III draws together interviews with film archivists, curators and laboratory personnel specialising in restoration to offer an overview of some of the challenges encountered in archival work. Restoration projects tend to be international as well as national and so perspectives from the BFI National Film Archive and PresTech Film Laboratory (London), the EYE Film Institute and Haghefilm Conservation B.V. Amsterdam are offered.[4] The assembled interviews and documents from British and international archives indicate the significance of the provenance of the film materials for histories and theories of film.

Together these chapters demonstrate that colour is a technical, mechanical and interpretive process involving creative decisions at all levels of its development. It is precisely the creativity involved in the production of colour that allows it to be considered not just as professional practice but also through the intellectual rigour of theory. The theory of cinematic colour was discussed as it emerged, particularly with the rise to prominence of colour in the 1930s through to the 1950s.

Part IV reprints some key contemporary documents that reveal the range of opinion surrounding colour films in the 1930s to early 1950s. These documents serve to establish a broader context for thinking about film, and for imagining what it must have been like to encounter colour films for the first time. Their appearance was a puzzle to many industry professionals, as well as to artists, technicians and audiences. What is striking is how so many attitudes towards colour persisted over the decades, and how to a certain extent these are influenced by consistent, fundamental and verisimilar questions regarding the way we expect the world to be depicted on screen.

NOTES

1. Mark Kermode, 'Oscars Over', Kermode Uncut Blog, <http://www.bbc.co.uk/blogs/markkermode/2012/02/oscars_over.html>, accessed May 2012.
2. Tom Gunning, 'Renewing Old Technologies: Astonishment, Second Nature, and the Uncanny in Technology from the Previous Turn-of-the-Century', in David Thorburn and Henry Jenkins (eds), *Rethinking Media Change* (Cambridge, MA: MIT Press, 2003), p. 42.
3. Gunning, 'Renewing Old Technologies', p. 46.
4. Clyde Jeavons, 'The Archive and around the World', *BFI News* no. 49, 1981, p. 4.

PART I

COLOUR AND THE CAMERA:
CINEMATOGRAPHERS

INTRODUCTION

One cannot over-estimate the tremendous task of creating a satisfactory colour film system.[1]

(John Huntley, 1949)

I marveled as the first Technicolor camera emerged from its packing case with an air of proud, sleek beauty. It was painted bright blue and its shining chrome fittings reminded me of a brand new Rolls Royce.[2]

(Jack Cardiff, 1996)

When writer and film historian John Huntley wrote these words colour films were not the norm. After half a century of experimentation, three-strip Technicolor had however emerged as the most commercial process and Huntley's book was a celebration of how British filmmakers had responded to the challenge of creating colour in the camera. With perhaps the exception of Jack Cardiff, who wrote a foreword to the book, most British cinematographers were trained to work with cameras that filmed in black and white. Mastering the exacting technical specifications of three-strip cameras, and acquiring detailed knowledge about how best to deploy colour in short and feature films, were problems technicians grappled with for many years. Yet most found working with colour highly rewarding and British cinematographers made ingenious and creative contributions to some of the most celebrated films. Through select interviews and documents this chapter recounts some of the trials and tribulations experienced by a number of key technicians who share their varied histories of and encounters with colour. Details of their careers and key films are included before each interview, and documents have been reproduced to support and illustrate some of the issues, films and points raised in the interviews.

The chapter begins with an interview with Chris Challis undertaken in 2008, supported by insertions from an earlier interview conducted as part of the BECTU History Project in 1988. Challis recalls the early years of Technicolor and of working with the Color Advisory Service established by the company in order to regulate use of its technology and its application. As in many of the other interviews, Natalie Kalmus, head of

Technicolor's Color Advisory Service, features as a figure who, in the opinion of Challis and many other technicians, imposed restrictions on the creative deployment of colour. The interview contains a considerable amount of technical detail about cameras, lighting and printing, and Challis tells of the challenges of working in locations across the world. He shot a great number of films over the years, and worked with filmmakers associated with colour, most notably with Powell and Pressburger on *The Tales of Hoffmann* (1951). Since many of the cinematographers interviewed grew up with Technicolor, they subsequently witnessed the ascendancy of Eastmancolor from about the mid-1950s. While films continued to be processed with Technicolor, the single-strip Eastmancolor stock meant that the Rolls Royce camera so admired by Jack Cardiff and other technicians was no longer needed.

The interview with Pat Jackson, conducted as part of the BECTU History Project in 1991, affords a case study of the logistical and other difficulties of filming *Western Approaches* (1944). Although Jackson directed the film, information on Jack Cardiff's colour cinematography and experiments with monopack, are recounted in detail. The interview is supported by Cardiff's first-hand account of this film, published in 1944. Jack Cardiff is mentioned many times by the interviewees. We were not able to interview him for this project because of his ill health towards the end of his life, but readers are referred to his autobiography, *Magic Hour* (1996), as well as to Justin Bowyer's book of interviews with Jack Cardiff which cover the production circumstances of the many films he shot, including those in Technicolor.[3] Ossie Morris, the third interviewee in this chapter, furnishes an extensive account of a long career as a cinematographer. It ranges from early experiences, learning his craft, working with celebrated directors and, in particular, the details of his distinguished experiments with colour on *Moulin Rouge* (1952) and *Moby Dick* (1956). At the end he discusses a question we asked several interviewees as to whether a 'British School of Technicolor' existed, and he comments on the impact of the different qualities of light in California and Britain. Yet again there is a fairly dismissive reaction to Natalie Kalmus, whereas her British counterpart Joan Bridge is generally admired. The interview extracts in the last part of the chapter come from interviews conducted by Duncan Petrie in the 1990s which he kindly allowed us to reproduce. They are particularly interesting because they include lesser-known figures who were nevertheless important in the history of British colour cinematography. Finally, some documents provide additional contemporary contexts for the chapter.

NOTES

1. John Huntley, *British Technicolor Films* (London: Skelton Robinson, 1949), p. 15.
2. Jack Cardiff, *Magic Hour* (London: Faber and Faber, 1996), p. 46.
3. Justin Bowyer, *Conversations with Jack Cardiff* (London: Batsford, 2003).

INTERVIEW
CHRISTOPHER CHALLIS, BSC, FRPS

Chris Challis was born on 18 March 1919 in Kensington, London and attended school in Wimbledon. He entered the film industry, working as a camera assistant on Gaumont-British newsreels before working at Denham Studios when three-strip Technicolor was introduced to Britain. Challis was an assistant on the *World Windows* travelogues shot by Jack Cardiff in the late 1930s and on other productions, including location work in India for *The Drum* (1938). He worked as a cameraman for the RAF Film Production Unit during World War II. In the post-war years he was camera operator on Powell and Pressburger's *Black Narcissus* and *The Red Shoes* before photographing *The Tales of Hoffmann*, *Gone to Earth* (1950), *The Elusive Pimpernel* (1950), *Oh … Rosalinda!!* (1955) and *The Battle of the River Plate* (1956). During his long career he photographed many popular British films including *Genevieve* (1953) and *Footsteps in the Fog* (1955), and worked with British and American directors, most notably Stanley Donen, Billy Wilder, Joseph Losey, J. Lee Thompson and Ken Annakin. He became known for his ingenuity, reliability and expertise and is credited as cinematographer on major box-office successes including *Those Magnificent Men in Their Flying Machines* (1965), *Chitty Chitty Bang Bang* (1968) and *Evil under the Sun* (1981). He won a BAFTA for Best Cinematography for *Arabesque* (1966). He retired in 1985 after working on *Steaming* (1984), Joseph Losey's last film. He died in May 2012.

FILMOGRAPHY

Films as Director of Photography unless other role stated. Colour process indicated where information is available; film director listed and country of production

1984 *Top Secret!* (Jim Abrahams, David Zucker, Jerry Zucker, USA/GB: Metrocolor); *Steaming* (Joseph Losey, GB: colour)

1983 *Secrets: First Love* (Gavin Millar, TV transmission, GB: colour)

1981 *The Nightingale* (Christine Edzard and Richard Goodwin, GB: colour); *Evil under the Sun* (Guy Hamilton, GB: Eastmancolor)

1980 *The Mirror Crack'd* (Guy Hamilton, GB: Technicolor)

1979 *S.O.S. Titanic* (William Hale, USA/GB: Technicolor)

1978 *Force 10 from Navarone* (Guy Hamilton, GB: Technicolor); *The Riddle of the Sands* (Tony Maylam, GB: Eastmancolor)

1977 *The Deep* (Peter Yates, USA/GB: Metrocolor) Challis nominated for BAFTA for Best Cinematography

1976 *White Rock* (Tony Maylam, GB/USA: Fujicolor) Cameraman; *The Incredible Sarah* (Richard Fleischer, USA: Technicolor)

1975 *In This House of Brede* (George Schaefer, USA: colour); *Mister Quilp* (Michael Tuchner, GB: Technicolor)

1974 *The Little Prince* (Stanley Donen, USA: Technicolor)

1972 *Follow Me!* (Carol Reed, GB: Technicolor); *The Boy Who Turned Yellow* (Michael Powell, GB: Eastmancolor)

1971 *Villain* (Michael Tuchner, GB: Technicolor); *Mary, Queen of Scots* (Charles Jarrott, GB/USA: Technicolor); *Catch Me a Spy* (Dick Clement, GB/France/USA: Technicolor)

1970 *The Private Life of Sherlock Holmes* (Billy Wilder, GB/USA: Deluxe)

1969 *Staircase* (Stanley Donen, USA: Deluxe)

1968 *Chitty Chitty Bang Bang* (Ken Hughes, GB: Technicolor) Joan Bridge: colour/costumes; *A Dandy in Aspic* (Anthony Mann, GB: Technicolor)

1966 *Arabesque* (Stanley Donen, USA/GB: Technicolor) Challis won BAFTA for Best British Cinematography; *Two for the Road* (Stanley Donen, GB: Deluxe); *Kaleidoscope* (Jack Smight, GB: Technicolor)

1965 *Those Magnificent Men in Their Flying Machines or How I Flew from London to Paris in 25 Hours and 11 Minutes* (Ken Annakin, GB: Deluxe), Challis nominated for BAFTA for Best British Cinematography (Colour); *Return from the Ashes* (J. Lee Thompson, GB: black and white)

1964 *A Shot in the Dark* (Blake Edwards, GB: Deluxe); *The Americanization of Emily* (Arthur Hiller, USA: black and white) Additional photography

1963 *The Victors* (Carol Foreman, GB/USA: black and white), Challis nominated for BAFTA for Best British Cinematography (B/W); *The Long Ships* (Jack Cardiff, GB/Yugoslavia: Technicolor); *An Evening with the Royal Ballet* (Anthony Havelock-Allen and Anthony Asquith, GB: Technicolor)

1962 *H.M.S. Defiant* (Lewis Gilbert, GB: Technicolor)

1961 *Flame in the Streets* (Roy Ward Baker, GB: Eastmancolor); *Five Golden Hours* (Mario Zampi, GB/Italy: black and white)

1960 *The Grass Is Greener* (Stanley Donen, GB: Technicolor); *Surprise Package* (Stanley Donen, GB: black and white); *Sink the Bismarck!* (Lewis Gilbert, USA/ GB: black and white); *Never Let Go* (John Guillermin, GB: black and white)

1959 *Blind Date* (Joseph Losey, GB: black and white)

1958 *Rooney* (George Pollock, GB: black and white); *Floods of Fear* (Charles Crichton, GB: black and white); *The Captain's Table* (Jack Lee, GB: Eastmancolor)

1957 *Miracle in Soho* (Julian Amyes, GB: Eastmancolor); *Windom's Way* (Ronald Neame, GB: Eastmancolor); *Ill Met by Moonlight* (Michael Powell and Emeric Pressburger, GB: black and white)

1956 *The Spanish Gardener* (Philip Leacock, GB: Technicolor); *The Battle of the River Plate* (Michael Powell and Emeric Pressburger, GB: Technicolor)

1955 *Footsteps in the Fog* (Arthur Lubin, GB: Technicolor); *Raising a Riot* (Wendy Toye, GB: Technicolor); *The Adventures of Quentin Durward* (Richard Thorpe, USA: Eastmancolor); *Oh … Rosalinda!!* (Michael Powell and Emeric Pressburger, GB: Technicolor); *The Sorcerer's Apprentice* (Michael Powell, USA/German Federal Republic: Technicolor)

1954 *Malaga* (Richard Sale, GB: Technicolor); *The Flame and the Flesh* (Richard Brooks, USA: Technicolor)

1953 *Twice upon a Time* (Emeric Pressburger, GB: black and white); *The Story of Gilbert and Sullivan* (Sidney Gilliat, GB: Technicolor); *Saadia* (Albert Lewin, USA: Technicolor); *Genevieve* (Henry Cornelius, GB: Technicolor)

1952	*Angels One Five* (George More O'Ferrall, GB: black and white); *24 Hours of a Woman's Life* (Victor Saville, GB: Technicolor)
1951	*The Tales of Hoffmann* (Michael Powell and Emeric Pressburger, GB: Technicolor)
1950	*The Elusive Pimpernel* (Michael Powell and Emeric Pressburger, GB: Technicolor); *Gone to Earth* (Michael Powell and Emeric Pressburger, GB/USA: Technicolor) Photography and location footage
1949	*The Small Back Room* (Michael Powell and Emeric Pressburger, GB: black and white)
1948	*The Red Shoes* (Michael Powell and Emeric Pressburger, GB: Technicolor) Camera operator
1947	*Black Narcissus* (Michael Powell and Emeric Pressburger, GB: Technicolor) Camera operator; *The End of the River* (Derek Twist, GB: black and white)
1946	*A Matter of Life and Death* (Michael Powell and Emeric Pressburger, GB: colour and black and white) 2nd Camera operator; *Theirs Is the Glory (Men of Arnhem)* (Brian Desmond and Terence Young for the Army Film Unit, GB: black and white) Photography
1937–40	*World Windows* series of travelogues (Technicolor) Assistant
1938	*The Drum* (Zoltan Korda, GB: Technicolor) Focus puller

SELECT BIBLIOGRAPHY

Anon, 'A Feature Cinematographer Photographs the Olympics', *American Cinematographer* vol. 57 no. 4, April 1976, pp. 406–7, 458–9.

Brett, Anwar, interview with Chris Challis, 'Reflections on a Golden Age', *Exposure*, October 1998, pp. 16–17.

Challis, Christopher, '*Hoffmann* sets new pattern in film making technique', *American Cinematographer* vol. 32 no. 5, May 1951, pp. 176–7, 194–6.

Challis, Christopher, *Are They Really So Awful? A Cameraman's Chronicles* (London: Janus Publishing, 1995).

Film Dope entry on Challis, no. 6, November 1974, pp. 41–3.

Petrie, Duncan, *The British Cinematographer* (London: BFI, 1996), pp. 80–2.

INTERVIEW TRANSCRIPT

DATE OF INTERVIEW: 17 OCTOBER 2008
INTERVIEWERS: SARAH STREET AND LIZ WATKINS

SARAH STREET: To start off broadly, we thought we'd ask you how would you define the role of Director of Photography?

CHRIS CHALLIS: I think it's different on every film. It depends on the film, the style of the photography and very much on your relationship with the director. Some directors have

a great visual sense, they know exactly how they want their picture to look and it's an integral part of the way they're going to direct it. That's the ideal situation because it gives you a lead into what you want to do. Others who don't have a visual sense, and they're in the vast majority I think, then you're in a bit of a vacuum because you don't know which way to go with it. Now I think it's [DOP] a very important part of the film and I admit that I've always felt that you are the director's sort of paintbrush. He's the artist, although you're sort of carrying it out and doing the artist's part of it, and it does differ from working in the initial stages and pre-production with the art director, the costumes and looking for locations. Of course it's all changed now because of digital – it's incredibly easy I think. You can photograph anywhere really – you could come in here and cover us talking to one another with these [domestic] lights. For Technicolor it's different because it's all arc lights and building a set, and the equipment was impressive, I mean physically impressive.

SS: When did you first become aware of Technicolor as someone who was keen to get into film and cinematography? Can you remember when you first heard of it?

CC: I started in the film industry with Gaumont British News. My father knew the managing director of Gaumont British News and Castleton Knight,[1] and they were just starting to use live sound for doing interviews and things. They didn't use sound normally and newsreel cameramen were like photographers. The cameras were quite small and they didn't have assistants or anything like that. With the advent of sound they needed help to lug the gear around and everything like that and so I think I was one of the first people ever to get that job and I had a year or just over a year of covering all the sort of things that the newsreel seems to ply.[2] They were a major part of cinemagoing; there were cinemas that just showed newsreels and there was great competition between the films. I happened to see or read that Technicolor were coming to England and doing the first colour film in Europe which was *Wings of the Morning* [1937]. It was made at Denham but Technicolor brought their own technicians. They took over a couple of machines in Humphries Laboratory in London, processed the negatives and made a black-and-white rush print, and then the negatives were shipped out to the States and the colour didn't come back for four weeks and then it was only a pilot, it wasn't a whole scene. It was a scientific process at that stage. I took myself down to Denham and the head of the camera department, George Kay, gave me a job. It was only loading magazines in the darkroom but I thought it was a step toward realising my ambitions. I suppose it was in a way but I spent most of my time loading these enormous magazines. At the end of the film the demand for colour was growing so rapidly that Technicolor decided to build a laboratory in Europe and they chose England in Harmondsworth on the Bath Road. So at the end of *Wings of the Morning* the laboratory was almost built – just the building because it didn't have any of the equipment in it – because all the processing machines had to come from the States. They kept me on and so I was the first actual employee and I was very lucky because it was like going on a sort of university course.[3] I went through every department as they were installing the equipment which came over without lenses. The lenses and the prism, which was the heart of the process, were made by Taylor and Hobson in England; I went through all of that and so I knew exactly how the process worked.

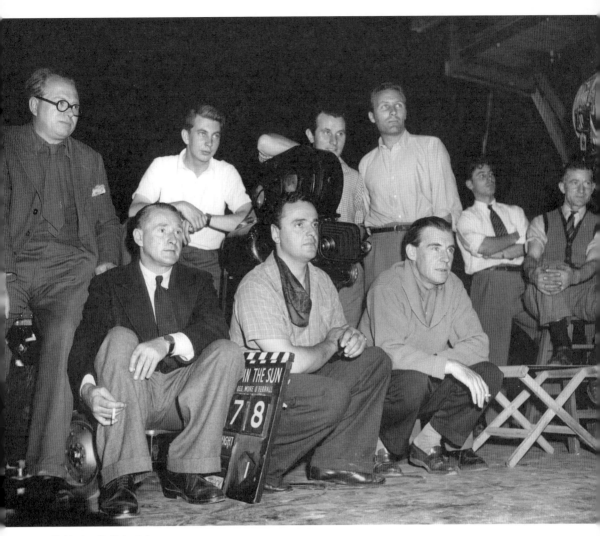

Christopher Challis (centre)
on the set of *Angels One Five*
(1952)

SS: Did they screen *Wings of the Morning* and have discussions about it because it was the first feature film? Do you remember anything of the reaction to that particular film?

CC: Do you mean during the making of it?

SS: Yes, during the process. I imagine everyone was intrigued to see this first British feature?

CC: Yes, of course they did, but it didn't involve me, I was too busy loading the camera!

SS: Have you seen it since?

CC: I have, yes.

SS: Do you like it?

CC: Yes, and they were terribly impressed with it because Technicolor was a scientific process originated in California, where colours appear harsher and that's the way they expected colour to be rather than how it was, particularly in the Irish locations that were a bit misty and hazy.

SS: It was quite soft, wasn't it?

CC: There's less contrast and everyone thought it was beautiful. The advent of colour had an enormous impact because people thought in terms of black and white.

SS: Yes, people seem to judge colour very harshly if it was seen to be not quite right.

CC: Technicolor retained a very strict control over what people did with it. Natalie Kalmus[4] especially was in charge of colour control and she interfered with everything that our directors wanted to do, or the cameramen. They [the Color Advisory Service] didn't like things like contrast and it was only later when it got into the hands of Jimmy Wong Howe[5] and people like that that they started to experiment.

SS: Did you feel that the Color Advisory Service was something that took part in the production process? In reality, how did it impinge on people's work?

CC: In the early stages it took a very big part because they vetted everything. There was no such thing as white and they dipped all the whites to a one- two- or three-grade dye because of the contrast which was a great problem. It was very difficult to get a good result because of the light levels. Dark colours went black and light colours [went] blue. There's no such thing as having a pale blue or a pink because it would photograph white under certain conditions and you couldn't see dark colours because they went black. So they tried to keep all the clothes the same, toward the middle range.

SS: So was that quite useful to some extent to prepare the production side?

CC: Yes, I think it was, so as far as the look of the picture was concerned it was very difficult to do anything unusual. They didn't like low key lighting or anything like that.

SS: I've read about Natalie Kalmus developing charts for films. Is that true? Were you aware of a chart that was devised in these terms, because they don't seem to be in the archives anywhere?

CC: Well if you were to see Natalie Kalmus you'd think she was the last person in the world to have anything to do with it because of course she dressed, well, she looked like an explosion in a paint shop.[6]

SS: Did you work with Joan Bridge because I get the impression that she was somebody who really knew about colour and was very helpful?

CC: Yes, she was very much better, much less aggressive than Natalie Kalmus, and she got along better with the artists. Joan Bridge was much more diplomatic. She only worked on the English films and became a colour consultant when they [Technicolor] opened up here. She had most of the contacts and during shooting she would come down once a week and maybe she would see the rushes and things.[7]

SS: We're very interested in *The Drum* which was one of the early Technicolor British films.

CC: Oh yes, that was the first feature film made from the Technicolor laboratory in Harmondsworth.[8]

SS: Was Technicolor very helpful with advice about humidity controls and temperature or did you pioneer filming in a difficult location?

CC: They'd never done a location like that ever, and of course we didn't shoot sound at all so the camera wasn't quite as heavy.[9] I was a trainee assistant [listed on Film Index International and IMDb as 'focus puller'] and we had a unit if you could believe it; it was a major film. We didn't take artistes [to India] but the unit consisted of a cameraman who was Osmond Borradaile[10] and Geoff Boothby was the director. Henry Imus was the American Technicolor technician and I was his trainee assistant.[11] I flew to India and yes, Technicolor did a lot of research on conventional film under extreme conditions such as heat leads to a build up of latent exposure; it's like a fogging over which eventually ruins it. Also you can get static if the film gets very brittle and looks like lightening, and humidity affects it. So they did a lot of research in California and produced a whole series of recommendations about temperatures. Their thinking was that where we were going we would have the facilities that they had in California; in actual fact we hadn't anything, there was no such thing as refrigeration. They had this idea of packing the film stock in drums, which was rather strange considering the film's name! Each drum took what we termed two 'groups', and a group contained 1,000 foot screen footage but 3,000 foot linear footage of separate cans [because of the three records needed for three-strip Technicolor].[12] The film was put in the drums with a silica gel which acted as a dehumidifier, and then tightly sealed and then soldered the metal drums. But of course when they [Technicolor] gave me a list of the film's useful life at various temperatures, they were so unrealistic. I'd arrived in Karachi and had to go by train to Delhi across the Sinai desert and the temperature was well over 100 in the shade. I thought I might as well go home because I wasn't even going to get to Delhi with the film let alone the rest of it, but thought we could try various ways of keeping it cool. The train didn't have corridors so you had half a carriage with a shower and everything else but there was no air conditioning. They had galvanised tin baths in which they put eighty-pound blocks of ice. I had all the film stock in my compartment surrounded with these and covered with a tarpaulin sheet to try and keep it cool, and by the time we arrived in Delhi we had to renew the ice because it had gradually melted. The dust was colossal crossing the Sinai desert and so with all this water melting and everything I was in sort of two inches of mud. But finally the only check that I could develop was hand tests: I could break off a foot of film of each of the unexposed negatives, develop it and then see whether the fog level was building up.[13]

SS: But you wouldn't be aware of how the colour might be affected?

CC: No, because we were dealing with three black-and-white images. The other interesting thing was that they had these camera report sheets which the assistant was responsible for and they were very, very extensive in their coverage; you had to record everything and they had this thing called a 'lilly'. There's three white cards, one at right angles, and two at forty-five degrees on either side, and you took a reading either side with a photometer so it would be whatever setting, 1,500 foot candles this way and 2,000 that way, 4,500 this, and all this had to be noted for each single shot and then you also had to give a brief description of the scene. If it was a close-up of you then I would have to describe the colour of your clothes and the settee behind you and the colour of your hair, and so they had all this data and they were really quite ridiculous about it. All this built up but for four months we'd had no contact; we couldn't send any film back so we had it with us all the time.

SS: I wonder what happened to that kind of documentation because it strikes me that those kinds of records would be wonderful for researchers because British studios weren't very good at keeping records.

CC: They went to Technicolor. They took the Technicolor cameras apart and I'm told that when we came back from India with what was the first film George Kay sat up all night reading all of my reports and he congratulated me. I got a rise and was made a qualified technician.

SS: So your notes would be very useful for other films, other texts?

CC: They would give a good lead, yes. When they printed the rushes they didn't print in colour, they printed these pilots. Every shot you did a ten-foot or a fifteen-foot take with the 'lilly' in front and the colour chart and a greyscale, and that's what they printed up. So we'd got the rushes in black and white and the colour pilot so we could see what it was like. They needed all these notes for the people who were to do the grading. When I became the Director of Photography I certainly sat in on all the grading and added my comments to everybody else's. It was such a laborious process because once the negative had been cut – the final cut – they had a black-and-white print of it. The negative was handed over to Technicolor for negative cutting and they cut the negatives into this master, then they started printing in colour. Well of course when you saw it side by side cut together it was sometimes wildly different from how you thought it looked during shooting. This is when grading started. They would make a print based on the grading of the colour pilot, which they'd made originally, and then you would screen that and they might say 'it's too dark or it's too blue and it was minus point this', and they would make those corrections and make another print which took another two or three days and you'd see that and if that still wasn't right, then you'd have to make more corrections. If you think you had to do this for every shot in the film then you can imagine how long it took. But Technicolor was a wonderful process because as a cameraman one had enormous control, not in the shooting but in the printing of contrast because the final colour print consisted of a black-and-white key which was printed from the blue record which was the sharpest of the three films. What defeated Technicolor in the end was definition, and they put this black-and-white key on to improve definition, contrast or reduce colour saturation. They used this idea in *A Matter of Life and Death* (1946).

SS: In the transition shots?

CC: Yes, they were all done that way, by increasing the black-and-white density and losing the colour. You could slowly do away with the colour and bring it back vice versa. I think, I believe Ossie Morris used it quite a lot to do some effects.

SS: Can you say more about blue being the particularly dominant register in the Technicolor process?

CC: Of course. The basis of the process was a prism and it reflected a third of the light and transmitted two-thirds approximately and you had two gates at right angles; in one of them ran the green record which was by itself because it had filters on the back. So the green record only recorded the subtractive colour, and on the bi-pack the two films ran emulsion to emulsion. The red record, which was the back one of the two, was photographed through the blue record so the definition on the red record was very, very poor. The blue record was a different type of emulsion so it was much sharper and that's why they used that to make a black-and-white picture. If you hadn't the least idea of how it worked you'd say of course that it can't be done.

IN CHALLIS'S BECTU INTERVIEW WITH KEVIN GOUGH-YATES ON 11 OCTOBER 1988, HE GIVES SOME INTERESTING DETAIL ON TECHNICOLOR CAMERAS AND TECHNOLOGY WHICH IS INCLUDED HERE:

KEVIN GOUGH-YATES: Can you say something about the Technicolor cameras of this time?

CHRIS CHALLIS: There was only the one camera which was three-strip, it had three films running in it so it was large as you can imagine. It hadn't got a turret – it had single interchangeable lenses in its mount and magazines had 3,000 foot and so were jolly heavy to cart around. It was a difficult camera to take on location because obviously the heart of the Technicolor process, which is still an engineering miracle to me, was that, it had two gates in the camera which were at right angles to each other and one was a single film and the other was a bi-pack. Two films running together, emulsion to emulsion, and the image coming through the lens was split, intensity-wise, allowing approximately a third of light through to the single film and two-thirds to the double. This was done by the means of a prism which had a spotted surface across the middle which allowed part transmission and part reflection of the image. The location of this prism was unbelievably critical. The images had to exactly coincide in the registers so when finally the thing was printed you could enlarge it up on a cinema screen and you could get reasonable definition. There was a degree of adjustment in the printing, but nevertheless it had to be as right as one could have it in the camera and it was adjustable by means of moving the prism, but it was a jolly difficult thing to do on location. I mean the reading of the register was done in the cameras when you were working in England – the camera came back to the laboratory every night and they went into the mechanical department and they were serviced and the register was checked and then you did a photographic check of the register every morning on the floor before you began to shoot. You photographed a chart which was read that evening under a toolmaker's microscope so they could check the image size and the spread and [that] everything was within the tolerance to get the sort

of definition they wanted in the final print. Well when you were away from home, a long, long way, you obviously couldn't have a microscope check because there was nobody to do that, so you had to do it visually. And of course you were into all sorts of problems if you were out in hot countries because you had a jig in which you put two pieces of film and you drilled this with this special jig of five holes; one in the middle and one in each corner of the actual aperture and these I think were twelve-thousandths of an inch in diameter. Then you put the film into the camera, the strip of film that you'd drilled, and you put it down into the register so that you actually used the claws to pull it into the right position and the register pins would hold it just as the film would actually come down when the camera was being used. You took the pressure plates out of the gates and you put lamps so you were shining light through the back of the film and then you put the prism in and you looked through the lens with a telescope and then you could see these five holes one at a time. If they coincided as you were looking through the filters on the prism they were white, but if they didn't you had a magenta or green fringe around it and you had to then adjust this prism on a rocker as it was on a sort of knife edge until you got the best distribution of error over the whole area. I mean it was never absolutely perfect but you had to get it as right as you could get it. It was an awful business doing this; we had to do it every night when you were away from home.

KGY: How did the equipment change over the years?

CC: Very little. It was incredibly advanced compared to any other camera when it came out. The lens mounts were just magnificent. They were on roller-bearings and they had a motor focus so the assistant could stand away with a slave motor and follow focus on it. It had a parallax corrector at a time when many other cameras, you know, the old Mitchells had the image upside down and no parallax corrector. It was a very advanced camera for its time and never really changed. The blimp was enormous; it had to be housed in all this to make it quiet. It had wonderful geared heads which have now become universal although they had them when nobody else had them. The geared heads were by Moy of England which is rather interesting [the geared head, which was operated with handles, fixed on to the studio dolly and made the camera easy to operate despite its weight]. To give you an idea of light levels, in the studio on *Wings of the Morning* and around that time you had to use 700 foot candles, wide open on the lens; you had to shoot wide open. It had to be an arc, basically because the process was balanced to white light or daylight. So there was no incandescent, no other coating of film that was compatible; it was all balanced to daylight, to white light. So anything that you used you had to balance, so of course arc was all right, it was slightly blue and you used a very pale straw-coloured filter. [CC notes that internal filters and effects were problematic in this system because of the high lighting levels required; CC gives an example of an internal filter in the camera which would cut the light by 35 per cent as problematic because with '700 foot candles you could just about light a head and shoulders'].

[REVERT TO 2008 INTERVIEW TRANSCRIPT]

SS: Were you aware of other processes like Dufaycolor and Gasparcolor?

CC: Yes. Of course colour was available to amateurs long before it was professionally. They raked up a lot of that early film for this BBC series [*The Thirties in Colour*, BBC4, 2008].

CC: Technicolor had other processes before the final one. They had a bi-pack process where they stuck the two films together for the final print.

LIZ WATKINS: The colour on some of the *World Windows* films[14] seems quite distinctive from what's found in feature films and I was wondering if they were definitely filmed using the three-strip process?

CC: Oh yes, they were made fairly shortly after *The Drum*. Jack Cardiff photographed them. He was a camera operator on *Wings of the Morning* and he worked for Denham Studios. He was a very unusual sort of chap who wanted to be a Director of Photography (they didn't call them that then, they called them cameramen), but this was a break for him and his contribution to the *World Windows* films was enormous. They came into being in a very strange way because Kay Harrison met Count von Keller and his wife socially.[15] Count von Keller was German and he had escaped from Germany. He was a *bon viveur*, an extraordinary man, and he had this American heiress wife who had a lot of money. His great love was fast cars and I suspect fast women, but they'd also travel and Kay Harrison said to him, 'Well, if you're going to do all this travelling and go to all these places, why don't you make films?' To which he apparently said, 'I don't know anything about film.' Kay replied 'I can put you in touch with people who do', and that's how it all started. The first three were all made in Italy and an Italian named John Hanau who worked in the film industry was a partner with von Keller. We did one of the Rome Hunt [*Fox Hunting in the Roman Campagna*] which is the only fox hunt in Italy. The hounds were imported from Yorkshire. It's quite unique because it's very pictorial. You've absolutely got a conventional hunt that could be in England. Then we did one of Rome itself [*Rome Symphony*] and we did one of Vesuvius [*The Eternal Fire*]. They were so impressed with them because they were much better than any other travel films, different from the Fitzpatrick travelogues.[16] Jack's contribution was great I think visually and they became much more than simple travelogues. United Artists distributed the films and was very impressed and wanted more. So we went to the Middle East and it became more complicated because we wanted to be able to track the camera. We wanted a dolly, tracks and reflectors so we needed a camera car. We built a special Bedford truck which we took out to Palestine, drove it across the desert to Damascus and then down to the Persian Gulf. Then we made a whole series of them and the final lot were made in India. I went back to India and we made a whole series of films there. They would have gone on had it not been for the war.

LW: We were wondering if you could tell us about the lighting levels for exterior filming for Technicolor?

CC: We didn't take any lighting equipment; it was all exterior shooting. We didn't have electricians or anything like that with us.

LW: So that was sufficient light?

CC: Yes. We had this truck and we had a camera car which was Count Keller's. He loved motor cars and he had a Packard shooting break camera car and two open Buicks for transporting people or anything like that. So it was quite a little convoy and we drove enormous distances. It was very exciting and they were lucky that they had Jack, who was very imaginative. He had ideas such as in the one about Petra [*Petra*], a rose-red city which is half as old as time; he had lovely shots of these steps that had been cut into the rock,

going up them with the camera. Petra was a strange, enormous building. I think now there's a Hilton you can go and stay in but when we went we had to stay in chaos in camps, and you went in through this gorge where you could either walk or ride on a donkey and you can really touch both sides and that's the only way in.

SS: Had the films been scripted?

CC: They were scripted, yes. It wasn't a tight script but the two directors who directed them [Hans Nieter and John Hanau], leap-frogged so while one director directed one, the other chap was preparing the second; he went there and got an outline to the script. *The Arabian Bazaar* was one of the second batch. We also did *Jerusalem*, *Wanderers of the Desert*, that's the one with the Bedouins, and we did the one in Petra; that was quite a handful.

LW: In *Wanderers of the Desert* there's a sequence that looks as though it's shot at night. It has very intense blues, but the lighting levels would have been problematic?

CC: Well, that's called 'day for night' photography. It was very phoney really but you couldn't do it any other way than with a special heavy blue filter and neutral densities. It may look like night, I don't know.

LW: [laughs] It was very blue.

SS: So because there were no lights you were using filters on the lens?

CC: No, no filters. I don't think we did much in the early stages but later on I used to if one had a very bright sky. On a fixed, or static shot, I'd put a neutral density one on; I'd cut it more or less to fit so it would cut down on the exposure on the sky without affecting anything else. You didn't use colour filters unless you wanted to for an effect. We cameramen, Jack certainly, and to an extent myself, had filters made for us by a couple of ladies who used to make them by hand; graduated colour filters and things like that for special effects.

SS: I suppose with the camera being different it wouldn't be the kind of filter that would be current?

CC: It wouldn't be used for anything else, that's right.

SS: Would you perhaps be putting filters on lights sometimes instead?

CC: Yes, but of course you couldn't for something like *World Windows*, you'd just cut the exposure down for the night [scene]. To give you an idea of the light levels, the Technicolor process was colour-balanced to daylight, to the colour temperature of the daylight. The only light source that matched daylight was arc, so it was all arc lighting. Well the arcs were enormous and they gave off a lot of fumes so if you had a big set with a lot of arcs you very quickly built up a haze in the studios and you started to see the beams of all the lights. Of the conventional incandescent lights, the biggest one listed in those days was five kilowatts and you could direct it to the colour temperature of daylight with a blue filter. If you had that largest incandescent light available with the blue filter on you could just about light a seated figure in a domestic interior and daylight from a window, two or three metres away. But that's all it would give enough light for. So you could imagine what it was like lighting a big set. On *The Tales of Hoffmann*, which was shot on a silent stage, it was the old shape of things to come because we recorded at Worton Hall studios, Isleworth, for all the model work. They moved to Shepperton and it was known as the

'silent stage', the biggest in Europe but it was not soundproofed. We shot the whole film on that stage because it was shot to playback. Sound didn't bother us and so we had the space and light.

SS: Shall we talk about *The Tales of Hoffmann* because we've read that one of your favourite memories is working with Powell and Pressburger?

CC: The art director was Hein Heckroth. Hein came from the background of opera; he was art director of the state opera in Hamburg and also a very good painter. But when they made the 'Red Shoes ballet' which was a film which was within a film [*The Red Shoes*], it was such a success Micky said, 'Well we'd better do a complete opera and that's the way we're going to do it and we're not going to do many special effects in the laboratory. We'll have to do everything in the camera', so we did most of the effects theatrically as you would do them on the stage; we did a lot of work with gauzes. As you probably know if you have a black gauze, paint something on it and light it from the front, it becomes more or less solid so you can paint a backdrop. If you take the light off the front and light from behind it disappears and you can do a tremendous change. Now that's the theatrical side of the thing but of course light levels in the theatre are nothing and the human eye adapts so well, whereas we were doing the same thing with enormous light levels and changing had to be done with dimmer shutters because you can't fade an arc light like you can with a resistor electric light. If you've got a lot of them then they have to be mechanised so they all worked electrically, then they all stuck and jammed and it was an absolute nightmare. My favourite sequence was the Venice sequence.

SS: Did you feel able to have ideas accepted and that you were very much part of the collaborative team?

CC: Oh yes, terrifically so. In fact we had one wonderful thing where the silent stage was built quite a little way off from the main studio buildings at Shepperton and Micky had the idea that after we'd seen the rushes we'd want to discuss them and talk about what we were doing. So he had a marquee put up by the silent stage and we used to have lunch brought out to us there so we didn't have to go to the studio restaurant. It was a lovely idea really and it worked jolly well. Micky's films were exciting because he was a great, efficient director and he had enormous energy. They were the most extraordinary unconventional couple; I mean, you would never have thought that they would ever work together. They had really nothing in common. Emeric was a mid-European Jew; Micky was a 100 per cent English. Emeric spoke with a heavy Hungarian accent, and they were a wonderful team. I knew them both very well as friends as well and I worked for them for years and I never, never heard either of them run the other one down which is pretty unique in the world of entertainment. They were great, great friends and welded together as a wonderful team. Either Micky or Emeric told me that they had been in America for the premiere of *I Know Where I'm Going!* (1945). They came back on the Queen Mary and Micky said that on the first night at dinner they were just talking about things and Emeric said to him, and I can't do his accent, 'Michael, would it not be a good idea if we made a film in heaven and on earth and earth was in colour and heaven was in black and white?' and Micky said straight away that it was a great idea. Now Emeric didn't know whether it was technically possible, and Micky said that when they got off the boat five

days later they had an outline of the working script of the film which they took to Rank and they got the go-ahead. It was a brilliant piece of filmmaking.

SS: Oh yes, so imaginative with the colour composition.

CC: It was pure cinema, as much as Disney.

SS: Am I right in thinking that the black-and-white sequences were actually, in the transition scenes leading up to when the film flips from black and white to colour, filmed with the Technicolor cameras but then not processed for the Technicolor printing?

CC: Yes that's right because they needed the three negatives.

SS: I've read that that was supposed to be less jarring than if it had been filmed with a conventional black-and-white camera?

CC: Yes with all the transition scenes.

LW: So you could print a black-and-white film from the three-strips of Technicolor negatives without any problem?

CC: Yes, it would come out in black and white.

LW: So the printing process introduces the problem with contrast and colour?

CC: The definition was fine, as good as straight black and white really, but then colour had an enormous impact as much as sound. They were the people that I liked to work with. My favourite directors were Micky and Stanley Donen, who was very, very similar. He grasped suggestions that I had and Joe Losey was good to work with.

SS: Did you have much contact with what went on in the lab?

CC: Yes, not initially but in the final printing.

SS: It can seem like a somewhat mysterious process of what actually went on in the lab, and maybe Technicolor sought to impose colour control at that stage? We're fascinated by the whole process but with the lab stage being so important, we wondered how much intervention you were able to have?

CC: Well you had it at the end in the final printing but not during the actual shooting because the rushes were processed at night, you got them the next day and it was a *fait accompli* with Technicolor in the early stages. They were very conscious of anything they thought was a technical defect because the process hadn't made the grade. There was one wonderful thing on *Black Narcissus* when it all fails and the nuns come back and there's a shot of Sister Clodagh [Deborah Kerr] in her office in Bombay or something like that.

SS: Calcutta?

CC: Yes, Calcutta. There's a big window and it's pouring with rain. Jack did this close-up of her and lit her through a bit of glass but he had water running down it and so it had the effect of rain. Well this shot didn't come back from Technicolor with the rushes; we got the rushes but minus this shot and everyone said, 'What's happening?' They said, 'It's a problem with the printer. It's not a very good print and we're re-printing'. This went on for about four days and we never got it back. Eventually Frank Bush, who was the whipping boy of the mechanic department, came over and he told Micky and Jack that they'd had a problem in the lab and they hadn't got it tied down and it looked as though we'd have to retake this shot. He said, 'You know we've got this effect on it' and Jack said 'It's supposed to be there!'. So they were trying to get rid of it desperately; that's a true story.[17]

LW: That's interesting the way an effect can be perceived differently. I was wondering if you could tell us more about *The Tales of Hoffmann*? Were you using blue gels which you would deliberately fade before using them?

CC: There were no really big incandescent lights in that period. Technicolor made a blue glass filter which was fitted into the lamp which we used rather than gels. Technicolor then made stock which was colour balanced to incandescent light so you didn't need filters and it made the process faster. You didn't need so much light and that changed everything enormously. You then had to put filters on the arcs because they were too blue. So basically you'd use arcs outside and as they made the bigger incandescent lights ten kilowatts you'd use those inside and they'd make lighting a bit easier. But it was a great process and good in the camera.

LW: We wanted to ask you about *Footsteps in the Fog*. Joan Bridge was colour consultant on that film as well and there's a preponderance of browns and greys in the colour. Is that part of the design or something which occurs in filming?

CC: That was done in printing. You didn't have to use filters if you wanted to have an overall warm tone on something that's candlelit. I wanted it to be dark and murky and it worked quite well in the fog scenes.

SS: Could I ask you about *The Battle of the River Plate*?

CC: The picture was going to be in CinemaScope and I was actually working on another film while everything was being got ready. At the last minute John Davis fell out with CinemaScope and then we were landed with this awful VistaVision camera.[18]

SS: I think it looks wonderful.

CC: Yes?

SS: I was struck very much by that wonderful mobility and in the scenes in Uruguay, almost travelogue types of scenery.

CC: Well it looks all right on DVD and when it's projected the same way it was shot. It's not too bad when you see a reduction print but colour, well in black and white it doesn't work well I don't think. Then Technicolor converted their cameras to do the same thing and called it Technirama and they put an anamorphic lens on the front of it so it became enormous. We shot *The Grass Is Greener* (1960) that way.

LW: Were there any problems with colour resolution using the widescreen processes and those different lenses when they first came in?

CC: No, not really when we went over to Kodak.

LW: Eastmancolor?

CC: Although it was a multilayer emulsion the definition on that was pretty well as good as black and white and of course the best Eastmancolor was printed by Technicolor. Instead of having a contact print they printed up and made separation negatives and then they printed on the imbibition system, so they'd got that under control you see? With Eastmancolor you have no control in the printing other than how dense you make it and you can only do corrections with colour filters. So it's pretty crude, whereas if they printed with Technicolor they could reduce it all to the Technicolor and it was very good. Eastmancolor got better and better.

LW: So did it improve or change Eastmancolor?

CC: They improved the emulsion – it got faster and less contrasty and it became very, very good.

LW: Were there problems with colour fading with Eastmancolor at this time? At what point did this occur? I wonder because there's a lot that has been written on colour preservation – at what point did that become an issue? Were people immediately aware of that?

CC: I don't obviously know the answer to that but I would think it's fairly long term. Technicolor negatives were black and white anyway so you could go on *ad infinitum*. I don't think they faded all that quickly; it's like ordinary colour photography. Some Kodacolor prints fade and others don't. It's extraordinary. If they're in direct sunlight they do. That's why I think they can do so much with remastering; it's absolutely uncanny. I had a wonderful experience of that because in quite early days of CinemaScope I made a film with Micky and Emeric called *Oh … Rosalinda!!*, which did all sorts of things with CinemaScope. You know that CinemaScope was an additional lens, was put on the front of the conventional camera. We had a duff one and definition was not terribly good. Also, it was in the very early days of Eastmancolor and the colour rushes were just dreadful. I could never get anything right and I was getting more and more depressed about it and I don't think I ever saw it on release – I absolutely hated it! Many years later I was living in Scotland and I got involved with the Edinburgh Film Festival. I did some things for them and as a 'thank you' on about the second or third year they held a party for me and got all sorts of people who had worked with me. It was a great surprise and they got Micky's widow, Thelma [Schoonmaker] and one or two other people and they said 'Well, we've got another surprise for you.' After we'd finished our drinks they screened *Oh … Rosalinda!!* It had been remastered and looked wonderful – much better than it ever did when we made it.

SS: Are you often consulted when this remastering takes place? What you've just told us sounds like a happy occasion but presumably it's possible that there are other instances when a remastered film can look different, even untrue to the original idea?

CC: Yes, but I never have been consulted, although I must say most of them have been pretty good. I mean, they have just made a DVD in America of *The Small Back Room* (1949), which was my second picture as a Director of Photography and my first film with Michael Powell. They interviewed me, which was included in the DVD and it looks absolutely great; so does *Gone to Earth*.

SS: Yes, it does. It's a very fascinating film. Your work often seems to involve quite a lot of location work. The landscapes are very striking.

CC: *Gone to Earth* was shot again entirely with Micky. I loved making it and it did look quite nice with all the shots in the countryside and beautiful landscape. [David] Selznick was the co-producer and he'd just married Jennifer [Jones] and at the end he had the right to alter the production for the American market if he so wished. He wanted to do all sorts of things, have an extra scene. Micky wouldn't do it so Rouben Mamoulian directed. They wanted me to photograph it and I said to Micky, 'What am I going to do?' and he said, 'Well, you should go, you know, keep our end up a bit'. So I went and it was the funniest thing because Selznick was extraordinary. He used to be up all night writing scripts, changing the scripts and it went on and on and on and it was three weeks before we did anything. Eventually we shot it and we had an all-American camera crew who

were very anti having this young limey coming over, which I think didn't make any sense really. They got lots of work out of it but anyway there I was and Mamoulian had a pact with Selznick that he'd only do it if Selznick didn't come on the floor when he was directing Jennifer. Selznick used to come on the floor and I'd hear this sort of 'psst, psst', and he'd be hiding behind a flat and he'd call me over. He said, 'Suggest to Rouben that …' [CC would reply]: 'I can't do that'. It was ridiculous and the American crew filled me with grim stories of Selznick, that no cameraman had ever completed a picture with Selznick and that he interfered on everything which he did and I was going to have a hard time. We had one new scene with Jennifer going to her room. I suggested candlelight with a candle and David talked to me about it and said he wanted it low key and that was fine. In the middle of lighting it he came on the floor and looked around and said, 'You've got too much light! I want it dark.' So I said, 'I know you do, David, that's why I'm doing it but we need more light than one candle'. [Selznick replied]: 'Turn some of the lights off!' It was ridiculous. So I said,

> Look, David, let me do it. If you don't like it tomorrow I'll go home and I'm very happy to go home, I would like to go home. I'm fed up with being here – I would really be delighted to go back.

So he turned on his heel, walked off the floor and all the crew had backed away. They slowly came back and we shot it. And the next day at rushes it looked fine and at the end Selznick got up, turned around and he said 'Chris, you're quite right, I apologize.' Arthur Fellows, who was his assistant, said, 'He's never done that before in his life'. He liked you to argue with him, and they all were terrified of him.

SS: So would he override people at Technicolor?

CC: Oh he'd have a go. He'd have a go at overriding everybody. But if you made your point as I think I did and it didn't really bother me if I was going to get the sack. I wasn't employed by him anyway; I was employed by Micky and Emeric and I was quite happy. He liked people to be like that. Micky was like that and could be absolute poison.

SS: Yes, his autobiography gives a little sense of that.

CC: I mean there's a side to him which isn't in the autobiography of extreme loyalty and kindness. I know many instances of that and I liked him a lot. I thought he was a great director and they were great movies. Now they're all coming back including *Peeping Tom* (1960), which I didn't like.

SS: We'd like to ask you what it was like to be in your profession as a cinematographer for so many years. You worked primarily as a freelance is that right?

CC: Except for one ghastly period when I was under contract to Rank and only because John Bryan who was an art director became one of the Rank producers. I made *The Spanish Gardener* (1956) with John.

SS: Did you feel you would just literally have to be doing whatever was thrown at you rather than have any choice?

CC: Well, apart from John, they were a pretty dead outfit. They had all second-rate pictures, dreadful things because I had to make a couple while I was under this contract. I actually got the sack in the end. They wouldn't release me and there was some terrible

hiatus where they had a huge programme and suddenly they hadn't got anything. They had redundancies and everything else. The unions asked for a meeting with John Davis and I got co-opted onto the ACT.[19]

LW: Something we've read and would like to know more about is when the Technicolor lab was set up in the UK and American technicians came over to run training and to establish a working practice. Did that cause any problems you can recall? Was it possible eventually for British cinematographers to go and work in America?

CC: It wasn't possible, really. When I went to do the extra scenes for Gone to Earth they had to employ an American cameraman who never came; he didn't have to come and he was paid more than I was. The unions were very strong – they wouldn't let you train at all. Technicolor had all their own people for a long time. The three-strip cameras belonged to Technicolor. You couldn't hire any other camera from any other process and the cameras went back to the lab every night and they were serviced. They had a big camera department and a service department and then the normal crew on a picture. On a Technicolor picture not only did they supply the camera but the equivalent of the first assistant who was known as a 'Technicolor technician' because on location he did very much more than a normal camera assistant inasmuch as he did the servicing of the camera.

SS: Can you tell us about Genevieve, a successful colour British film you worked on?

CC: The story behind Genevieve was quite annoying really. I was on holiday and I had a phone call from George Gunn who was in charge of the Technicolor camera department. He said,

> Well, I've got somebody who is going to make a picture called Genevieve about the London to Brighton run and I think it's a very good script and I'm trying to persuade him to make it in colour and he says no way, he can't afford it, there just isn't the money in the budget.

I half persuaded him that it was going to be a tough assignment whoever shoots it because you've got to shoot in any conditions really; literally any conditions. He said, 'Would it interest you?' And I said, 'Yes, but I'll have to check with Henry [Cornelius]'. Henry said, 'It'll be nearly all on location because we can't afford the studio rental.' We were starting very late in the year – it was September or October when we shot it. Nothing matches anything else but strangely enough colour looks better in that dull light and if you can get the minimal exposure and you can sort of enhance it slightly with a bit of arc light to get a shine or something like that so when it comes to it, it doesn't look bad really. Funnily enough I got some of the best reviews for photography I've had on Genevieve, so the rest of them must be awful!

SS: Do you think there were any particularly British conditions that made British Technicolor films made in the UK look a little different from those made elsewhere, experimentation aside?

CC: Yes, I do I think there is a different quality of light. I mean the soft sunlight that you get here a lot of the year where there's a lot of moisture in the atmosphere is quite different from anywhere else. It's different certainly from California which makes the

colours hard, and Africa is hard and brash and even the South of France. I also think that we had some exceptionally good art directors and some good cameramen. You can almost thank Korda for that really because he brought Georges Périnal who was a wonderful cameraman from France and Harry Stradling from America. We learned from them quite rapidly and we had Freddie Young, who was marvellous and a great champion of our cause and a great cameraman. We built up a pretty good school of cameramen I think. There was Geoff Unsworth of course; Geoff was a fabulous technician at Technicolor and Douglas Slocombe was wonderful. Arthur Ibbetson was jolly good. Ossie Morris of course was excellent. And so I think that there maybe was a British school of cinematography which was slightly different. We went for softer light conditions and out of necessity we very often had to shoot without direct sunlight and we realised that it could look very good.

SS: Did you tend to discuss amongst yourselves? I'm imagining a group of fellow professionals who knew each other when they were working on a particular film who'd discuss the latest developments?

CC: Yes, yes.

SS: So you saw their latest film when it came out and there was a sort of community of cinematographers?

CC: Yes, very much so.

LW: Were there any particular colour effects at this time that you couldn't get with Technicolor that you could with Eastmancolor or vice versa?

CC: Yes, colour reproduction was very far from being perfect for any process, Technicolor, Eastmancolor, Agfacolor or anything else. The areas of absolutely correct exposure are crucial. That's why you have the theory about Technicolor not liking experimental colour because in dark areas, which are necessarily underexposed areas or bright areas which are overexposed, the colour rendition goes to pot a bit and that's true of all colour processes. I don't think there's any way round that unless you accept having absolutely flat light, which is what Technicolor wanted, but it's not suited chromatically for a lot of subjects. I mean I'm told that when Jimmy Wong Howe did *The Adventures of Tom Sawyer* (1938) all the sequences that were in the cave and in Technicolor were terribly low key. He had a terrible row with Natalie Kalmus; they wanted that all flat lit and he wouldn't do it. Of course it was a wonderful sequence. The colour was probably quite wrong but it didn't matter because dramatically it was terrific. So I think the answer is you know you can't reproduce every colour perfectly but the compromise is fine, depending on how it's used and that's true of all processes.

NOTES

1. L. Castleton Knight was the overall 'producer' of the Gaumont British News from 1934 to 1958.
2. Kevin Gough-Yates's BECTU interview with Challis (11 October 1988), tape no. 59, includes reference to Challis showing Castleton Knight some 16mm footage he'd shot for a school project.

3. In his BECTU interview Challis also praises the grounding he gained from Technicolor, commenting that: 'They didn't let anyone out to be the equivalent of a first assistant until they'd done a lot of work in the laboratory and knew a bit about it.'

4. Natalie Kalmus (1992–1965) was head of Technicolor's Color Advisory Service, in the 1930s and 1940s. She is credited as advisor on all Technicolor productions until 1949.

5. James Wong Howe (1899–1976) was a celebrated Chinese-born Hollywood cinematographer. He worked at Denham on three black-and-white films in 1937.

6. It was common for cinematographers to claim that Natalie Kalmus knew little about colour on the basis of their dislike for her wardrobe.

7. Joan Bridge (1909–2009) worked with Natalie Kalmus when she was in the UK. She is credited on many British films as colour consultant. She had studied Dufaycolor, and had useful contacts for Technicolor when operations began in the UK.

8. Challis only worked on the Indian location shoot.

9. The blimp needed for filming with sound made Technicolor cameras extra cumbersome, so greater mobility could be obtained if sound was added in post-production.

10. Borradaile was responsible for location shooting in India; the rest of the film was shot by Georges Périnal.

11. Henry Imus (1908–81) was an uncredited camera operator on *Wings of the Morning*.

12. This detail also features in Challis's BECTU interview. For greater clarity the following sentences are an amalgam of the detail provided in both interviews.

13. In the BECTU interview Challis recalls that during shooting the drums were kept in pits dug in the ground that were packed with blocks of ice.

14. The *World Windows* short travelogue films were shot in Technicolor during 1937–40 by Jack Cardiff in a number of locations, including India, Italy and Israel.

15. Kay Harrison (1895–1962) was managing director of Technicolor Ltd.

16. The 'Fitzpatrick Travel Talks' were an American series of Technicolor films made by James Fitzpatrick and distributed by MGM.

17. There is no such shot in *Black Narcissus*. This 'missing' scene is discussed in Sarah Street, *Black Narcissus* (London: I. B. Tauris, 2005), pp. 59–60.

18. Challis also discusses widescreen techniques in the BECTU interview, confirming problems with VistaVision.

19. John Davis (1906–93) was managing director of Rank, and the ACT was the trade union, the Association of Cine-Technicians.

INTERVIEW
PAT JACKSON

Pat Jackson (1916–2011) worked for the Crown Film Unit. His most celebrated colour drama-documentary experiment was writing and directing *Western Approaches*, which he discusses below.

EXTRACTS PERTAINING TO COLOUR FROM BECTU INTERVIEW NO. 185

DATE OF INTERVIEW: 22 MARCH 1991
INTERVIEWER: JOHN LEGARD

PAT JACKSON: To answer your question, John, about *Western Approaches*, I mean, I could talk for three hours on that without difficulty, but I don't think you want three hours of it! [Chuckles] Well, you see … in the first place, I went in and Dal [Ian Dalrymple] called me and sort of looked at me and said, 'I've just had Owen Rutter who is a very famous naval historian […] he's just come in here and wants us to make a film on the Battle of the Atlantic'. And this has come from the Admiral in command of the Battle of the Atlantic, Admiral Sir Percy Noble, who, so Owen Rutter says, is a little bit piqued that the RAF, after *Target for Tonight* (1941) is getting all the glamour, all the acclaim!

JOHN LEGARD: Interesting, yes.

PJ: And he thinks, now it's time for the Silent Service to speak up for itself a bit. So he said, 'Would you like to tackle it?' I said, 'Well yes, it sounds marvellous. Have we got any storyline?' He said, 'No, we haven't, Owen Rutter's left a sort of treatment here, twelve pages, so take it away and read it.' So I read it, and it was just an outline, it had no, sort of, storyline. So anyway, I phoned up Owen, who was a charming man, and he said, 'Well, we must go and see the Admiral, how quickly can we go?' So we went up the next day. And Admirable Sir Percy Noble was really a delightful, charming man. And I had my one and only Burton pin-striped suit, which was very worn, it shone at the backside and elbows practically and I hadn't got the coupons to buy another. Anyway, he was absolutely charming, and … what was I now? Twenty-five, I suppose. So he said, 'Well now, Jackson, I understand you're going to make this film for us?' And I said, 'Well, I'm going to have a jolly good try, sir, yes I certainly am.' So he said, 'Well, what can we do for you? What do you want to do?' So I said, 'Well, sir, I must obviously go to sea as soon as possible.' So he looked at me with a wry smile and said, 'Well you've come to the right place for that haven't you? Where do you want to go? Malta or Cape Town, or where?' So, Owen then spoke up and said,

> Well, sir, I think, if I might suggest … I think it's quite simple for Jackson, isn't it, to go up on the East Coast Convoy and come down, perhaps on a Destroyer? Because then he'll see how a Convoy works. If he goes to Malta, it'll take him a month to get there and back, and, oh … what a waste of time.

'It's a very good idea, Owen, very good, yes. We'll arrange that for you.' So I went up with the East Coast Convoy … I joined it at Southend, I think, and went through what was

Pat Jackson

called 'The Graveyard' down the Thames estuary. This is just after the magnetic mine had been discovered and made innocuous by degaussing, but the acoustic mine had just then appeared too. So, the trawler ahead of us was flying the red sign that it was sweeping the channel. And anyway, we went, without any event at all, we got up to Methil. And … the depressing thing about it was that it was so desperately monotonous … desperately monotonous! Nothing happened! And if it did happen, you wouldn't be able to film it. So, one was left with a subject that seemed hardly to move, because 400 or forty ships lolling around the ocean, when you set the camera up, they're moving at six knots, they hardly seem to be moving. And the same thing happened … I came down on a Destroyer and the routine … the routine of running a ship is deadly dull. I mean, it produces wonderful characters and men of staunch iron and character, but it is the least filmic thing, you know. And by the time you've run through all the clichés there are on board ship, and we know what they are, don't we? The wash, the seagulls, the steward emptying the tit-bits and er … the bow-wave with a light bit of spray coming over, the wheel and all the rest of it! But what else is there, you see? And very early on I realised this was going to be a brute of a subject to dramatise, to make it cinematic. And there was absolutely no point in my pretending that I was going to get a capital ship to come and perform for me, or an enormous gun battle like the River Plate which was done later by Micky Powell, you know, and that was all going to be artificial with spray being thrown by stuntmen and effects men … that was not going to be any damn good at all! How the hell to dramatise it? So I came back down to Southend again, with a Destroyer, and went back home. Saw Dal for a moment, and he said, 'Any good, old boy?' I said, 'Well, for a moment, Dal, no. My mind is a total disastrous blank, I haven't got an idea in my head how to tackle this.' So he said, 'Well, you better just go and sit on the nest, old boy.'

JL: Sorry, just to interrupt, just for the tape … this is Ian Dalrymple you're talking to?

PJ: Oh, Ian Dalrymple, yes, who joined us, I think … '41. So, all right, I went home, I was living behind Pinewood at the time, and 'sat on the nest' as it were, and faced that terrible blank page. This went on for three weeks, with all sorts of false starts and absolutely nothing … I wasn't getting anywhere at all! I really wasn't getting anywhere, I was in a state of total despair, and I regretted waking up every morning, knowing that I'd have to face that blank page, and not an idea was going to come. And I'd juxtaposed every possible combination of what a convoy was and what the Destroyers were doing and this, that and the other and I could not make a story hang together that was filmable! It's all right having, you know, say the Prince of Wales comes up, and HMS … useless! We'd never get them! So, there were no facilities that one could rely on.

JL: Hmm … nightmare.

PJ: Absolute nightmare! So I thought, 'Well, it's no good. I'm wasting time, this is now a month, I haven't produced a thing, I must resign. Because, he must get somebody …'

JL: You really got to that … ?

PJ: Oh yes, I went through … I left Mandeville Cottage where I was and I walked through the woods towards Pinewood, and the birds had the impertinence to be singing! It was February still! No … just about March, a very cold, bitter, blasted day, and the mud was thick, and I thought, 'Oh God! This is absolute hell!' So, I got halfway there and then, for

some extraordinary reason, this idea popped into my head … somebody put it there, I don't know who the hell it was, but I'm most grateful to him or her, whoever it was! And this simple question, and it was this: it said,

> What would happen if a lifeboat sent out an SOS from its portable radio, giving its position and a U-boat, peering at it through its periscope, picked the message up through the aerial in the periscope and the U-boat commander decided to keep station on that lifeboat, use it as a decoy, knowing that sooner or later a Merchantman would pick up that message and probably come to the help of the lifeboat?

JL: Hmm.

PJ: He would have a sitting duck. And, once that equation was formed, we would have an inevitable suspense situation, which would build and build as those three elements started to interact, and we couldn't miss it! And, what were our facilities? I only had to have shots of the convoy, I had to have a lifeboat and its members in the lifeboat, (a story of survivors in a lifeboat) and a mock-up U-boat in the studio, so that I could get shots of the lifeboat through the periscope. That's all I wanted! God! I'd got it! Marvellous!!

JL: Who was it, do you think … where did this idea come from?

PJ: No idea!

JL: Did somebody suggest it to you, or did … ?

PJ: No, no, no!

JL: Oh, it was something you came to …

PJ: No, it was the result of worrying you see. The egg, eventually, was hatched. Because after three weeks, although one is in this total state of despair, there is, I suppose, sub-consciously, a gestation period. I mean that's what I suppose creative effort is, isn't it?

JL: Yeah.

PJ: You know, it's the old famous Stravinsky story. His wife was a famous artist and came in to him one morning, she'd been struggling in the morning and had produced nothing, and she came in and said, 'I am no good, I haven't got an idea, I'm finished for today.' So Stravinsky sent her straight back and said, 'You haven't worked! Go back and work and get an idea!' And so I suppose it is the result of application, and this applies to anybody or anything, you know. If you can pinpoint your concentration, however despairing the effort, something comes.

JL: Something eventually …

PJ: I don't know, nobody, not even Bernard Shaw could define the source of inspiration and ideas, we don't know where they come from. But it is the result, obviously, of sweat, tears and agony.

JL: Yeah.

PJ: I suppose. Anyway, thank God it came! Because, I was in a desperate state.

JL: Didn't you say in your book, 'that you were walking back from the "Crooked Billet" [pub] to Pinewood and the …'

PJ: Oh no, no, that was when I had written the script.

JL: Oh, that was later, wasn't it? Yes.

PJ: And then I had the treatment out – I think it took a fortnight – the treatment, then was done. A pretty detailed dialogue treatment, it wasn't in … . And then I had put it up to Dal, but then, he was busy seeing rushes – I left it on his desk. And I then went up to the 'Crooked Billet' and had two or three pints and, um … . And then Dal and old John Monck was there. He said, 'We like it' and he said, 'If we were a commercial firm, we'd still like it and we'd do it.' So then we wrote the shooting script, and it was fine. Well then, this is a great triumph for Dal, because, again, a very good public relations act on his part, because my story had very little to do with the Navy, as such. I mean, I was dealing with a U-boat, the survivors in a lifeboat and one Merchantman that comes to pick them up. Where the hell does the Navy come into it? Hardly at all. And this was supposed to be a film about Her Majesty's Navy and the ships and all that, and it hardly appeared. And, er … Sir Percy Noble, I think, saw the value of the story and was quite prepared for the Navy to play second fiddle, realised that the facilities that were asked of the Senior Service were very few and far between, and let it go. Because he liked the story, he thought it was a good story and thought, 'Yes, that's all right.' The next thing, once having got the finance, which was quite considerable, I think they put up £50,000 …

JL: Really?

PJ: Which was a lot of money in those days. And it was to be, you see, the first feature documentary in Technicolor. Well, that was fine! Now then, we had to cast it. How were we going to cast it? I needed about eighteen chaps in the lifeboat, of whom there were at least fourteen talking parts. So I went up to Liverpool and I hung around the pubs, and I had a great chum in the Shipping Federation, which was the place where the seamen came on a register, and so on, for their next job or claimed damages for having lost their possessions, if they'd been torpedoed and so on. A nice man, Hobbs. And so he said,

> Well you'd better sit in here, old boy, and just see faces, and if you like faces and want to talk to them, go up to the grill and tell the clerk behind that you'd like to …

So in this way we found one or two, but nobody really came from the Shipping Federation. The Shipping Federation then sent me to the 'Angel' pub, further down the road, and the 'Angel' pub was run by a marvellous old publican called Anderson. And Anderson was a great football fan of Liverpool and I think he was one of the directors of it. And he said, 'Yes, Pat. Use my pub as much as you want. There's a little private bar there, give me a wink if you like anybody and I'll tell them to come around to you.' So, I was up there with … awfully nice … my assistant, who was called Peter Bolton, charming boy.

JL: Oh, Peter Bolton! Yes, I knew him very well …

PJ: Yes, awfully nice, lovely sense of humour. We had a great giggle, he'd been invalided out of the RAF. And we sat for three or four days. And, you know, John, again a moment of despair, because three or four days had gone by and one hadn't seen a face or even anybody that looked likely. And here was the war in its worst phase, and here were we, bumming around in pubs, trying to make a dramatic story, you know. You might say, 'What on earth are we doing here?' you know. It was very difficult to relate this to being any sort of contribution in any way, shape or form. However, that was the job we had to

do and we carried on, discouraged and sometimes the morale was absolutely on the canvas. And then, one morning this character appeared, I see him now, with his funny little cap on the side of his head and a clay pipe … buccaneer, Wallace Beery kind of type. And he got to the bar and ordered his pint and chaser, and I heard that voice ring out … marvellous voice! And the barman said something, and he had a wonderful laugh that intrigued me. And he had piercing, funny little brown eyes that shone and a face that lit up every time he talked … fascinating little man! So I gave old Anderson a wink … so I heard him say, 'There are a couple of blokes round there want to have a chat with you … just go and see 'em round the corner there.' He said, 'What?' He said, 'Go on, it won't do you any harm, go and have a talk with them.' So this figure went out and we waited for him to come in our little door, and he sauntered in and looked at us, 'You chaps wanted to have a talk to me … are you the chaps?' I said, 'Yes, that's right, yes. My name's Pat and this is Peter here. What's your name?' And he said, 'My name's Bob, Bob Banner.' And he had a lovely Liverpool accent. He said, 'What's all this about then?' So I endeavoured to explain, you see. I said, 'Well, we're making a film and we think you might be very good in it.' 'What do you mean, very good in it?' 'Well, you might play a part in it, act in it.' 'Oh don't be fucking daft! What are you talking about? Act? I've never acted in me life!' I said, 'Well I don't want you to act in your life, I just want you to be yourself,' you see. So, [chuckles] after a long argument I told him roughly what the story was and he was going to play a very big part in it. I said,

> Look, Bob, you've got absolutely nothing to lose. We shall test you shortly at Pinewood, meantime you'll be on full pay, you won't have to go back to sea for a moment, until we decide whether you can do this or not. Will you do it? Will you have a try?

He said, 'Well, I've got nothing to lose, as you say. Oh, all right, yes I'll try. Here's me address.' And so we gave him a drink. He said, 'I'm living at this place' and he gave us his address. And in that way, we slowly built up eighteen or so people we found who we thought would be good for the lifeboat, you see. So then a fortnight later we brought these people down to Pinewood. Old Teddy Carrick was the art director, marvellous man! So, he put a half lifeboat section of the lifeboat in the lot at Pinewood, and we waited for the bus to arrive with these seamen. Pennington Richards was lighting for us. And slowly they appeared, the captain came first, who was very shy … and I was forced to take the captain because he was the only one available from the Blue Funnel Line …

JL: Hmm.

PJ: And he was on long-leave, because his ship Deucalion had been very badly damaged in the Malta Convoy. He was … he was just all right, just all right. But I knew he was the only one I was gonna get, so I had to make do with him. And then Bob Banner came next, and he was absolutely electrifying, straight away.

JL: Yeah.

PJ: Took command and was marvellous. And so that's how we found the cast, you see … slowly found them. He carried the film, you know, Bob Banner. He carried the film, in the lifeboat. I mean, he was a natural actor, you see! Absolute natural actor! And he was Wallace Beery to the 'T'. Marvellous performance, that man gave!

JL: Yes.

PJ: Absolutely … when he … I don't know if you remember it well, but there was a scene where he sings this extraordinary mock ballad … you know!

JL: Yes.

PJ: I mean, just unbelievably good!

JL: Yes, in fact, they were all … I mean a lot of them were good, weren't they? I mean, he was brilliant, I quite agree, but a lot of your cast were outstandingly good, weren't they?

PJ: Just themselves.

JL: They were just themselves. I mean you had devoted so much time to this casting, which was well worth it. It was the only way you could do it really, wasn't it?

PJ: The only way. Oh yes …

JL: I can't think of a … of a character in that film who didn't come off, I mean, they were all good.

PJ: Well, one would have liked … the captain of the lifeboat was … I mean he looked the part …

JL: Oh, he was all right, actually.

PJ: He looked all right. It was hard work, it was rather like pumping up a punctured tyre, but we got it out of him in the end.

JL: He was … sort of … I mean, you remember the circumstances, but for me as a member of the audience, I thought he was outstandingly good.

PJ: He looked marvellously patriarchal, didn't he?

JL: That's it, yeah.

PJ: Yes, he was fine … yes, he did very well.

JL: I think he was carrying that responsibility …

PJ: But, you see … that went on, I won't bore people any more with it but … it was a very difficult film.

JL: It's terribly interesting …

PJ: But you see, I think the real hero …

JL: … Because it's unique, that film.

PJ: … was Jack Cardiff. And it was his first feature film and my first feature film …

JL: Right.

PJ: And the one thing I did learn …

JL: Oh, I didn't realise it was Jack Cardiff's first film.

PJ: First film, yeah. One thing I did learn from the East Coast Convoy was that I had the stomach of a horse. That it didn't matter what the sea was or what it did to the ship …

JL: Not everybody did! [Chuckles]

PJ: … it didn't make me seasick. Because the combination of trying to make a film and direct people in the lifeboat, and being seasick, would have been impossible. You just couldn't have done it.

JL: And I seem to remember Jack Cardiff wasn't a very good sailor.

PJ: Oh poor, poor chap suffered real agonies. And when you think of the problems in exposure that poor man had with a three-strip camera, with the light varying every single moment of the day … a reflection … you see it was awfully difficult for him, because if

we were looking with the sun the sea became blue and green, if you look into the sun it became green (or the other way round, I can't remember which) but there were two. So starboard was one colour and port was another colour. Well, there was nothing you could do about that, because it was just impossible. But the problems of balancing exposure against the sky, with the light in the lifeboat was almost impossible for him. I mean, we had to give up for a while and get a generator and put arc lights in the lifeboat, if you please!

JL: Yes. I remember that comes across rather well in your book, because, obviously, if you'd had time, you'd have experimented with all this before you got your cast on location as it were. I mean, you needed … there were so many unknown factors which you didn't realise …

PJ: Oh, we needed six weeks preparation at sea before the cast was down. But I had to find the cast! I mean, as soon as I found the cast I was almost …

JL: Because you had to … you'd committed yourself to shoot …

PJ: But also you see, the other thing that held us up was the fact that there were only three cameras in the country, and one was being used on *Henry V* [1944], the other was *[This] Happy Breed* [1944], all three were involved, and so we couldn't get the equipment. It was Technicolor that held us up those vital months. I mean, my script was ready in July, we didn't start until September, which was beginning winter.

JL: I expect there were certain times where you thought, 'Oh, pity we aren't shooting this in black and white.' But what a disaster that would have been! [Chuckles]

PJ: Well, there were times when we thought we would never get through it.

JL: Oh really? Yes.

PJ: Oh yes. There were times when we thought, 'Well honestly, the conditions are really beyond the capacity of film to record.' Because it wasn't only Jack's problem, but you see, if you imagine you have a microphone cable going through the water, you have the power cable going through the water, the towing cable going through the water, the induction problems that poor old Kay Ash who was the sound recordist, was getting. So the electrical problems alone! Quite apart from the photographic problems! You know, posed an appalling amount of problems for the poor technicians. I mean, my job was just jolly simple, I mean, you just had to wait until the weather conditions improved and hope to God the cast wasn't seasick … and of course they very often were, just when we were about to turn, over the gunwale they'd go!

JL: Yes.

PJ: And here were hardened seamen you see, who'd been at sea all their working lives, but who weren't used to the rhythm of the lifeboat, bouncing about.

JL: How long in fact did you spend filming the lifeboat scenes?

PJ: The lifeboat was … six months.

JL: Six months?

PJ: Six months. And then we were held up, you see, so often by the Navy, and the original craft they gave me just wasn't seaworthy. I wasted six weeks before I had to go and see Sir Percy Noble and say, 'Unless I get a trawler from you, Sir, I can't continue.' And of course I'd known the importance of trawlers, because they were all minesweeping and

most of the available ones, you see, were following the convoys to pick up survivors. And so a trawler was really like asking for gold dust. Certainly they were all on the East Coast Convoys and they were mostly now being used more and more in the Atlantic, because the Battle of the Atlantic had reached a very, very crucial stage. Casualties were enormous, and therefore the number of survivors was enormous, so every available trawler was used. And I hesitated for weeks to ask him this because I knew that however important I thought the film was, it wasn't as important as saving life at sea! So this inhibited my approaching him earlier. However, I knew the film was going down the spout unless I got this trawler, so I went to see him, and he was absolutely charming, he said, 'Well, you must have it, of course you must have it.' And he sent me one and I had it within two or three days. And then we started … but that vital two months was wasted.

JL: Hmm. But fortunately you didn't have a deadline for completion, as they do nowadays … no way could you have …

PJ: No, we could never have. No, we were in the hands of the Navy you see. It was the Merchant Ship that eventually picks up the lifeboat, it was the hero of the film. Could we get an English Merchantman to take us? They wouldn't take us! Not one English Merchant Ship would take us aboard, because we were a crew of six, seven … and they wouldn't take us. Said, 'We haven't got the accommodation and we don't want to!' Fortunately I found a Norwegian ship and the captain was a charming man, and when I told him that his ship was really going to – it was a lovely, a white ship – that was going to be the sort of star of the film, his face beamed and he agreed to take us. Marvellous! But there, you see, we came up against other appalling problems, because Technicolor would not allow us to use one of their three-strip cameras, there were only three in the country and they weren't going to risk it – it didn't matter about us but the camera was important! [Chuckles] So, we then had to use a Vinten with a very, very new untried stock. Thorold Dickinson has always thought that he was the first to use Monopack but in point of fact …

JL: That, I suppose, was an early version of Kodachrome … of um Eastmancolor really, wasn't it?

PJ: Yeah, yes it was, and it was very untried. So, anyway, that's all we could use, so there we went. And then …

JL: I seem to remember you had certain matching problems with the Monopack and the real thing …

PJ: Oh, we did.

JL: I mean … it was OK actually, wasn't it? It worked, but if you knew about it you could recognise which was the Monopack and which was …

PJ: Oh yes. That was … honestly, John! When one thinks back it was a bloody miracle the thing ever got onto the screen, because … Monopack was a very critical stock in terms of temperature. It had to get to the labs at a certain temperature. Well, we could only send what we'd exposed from New York. Well, so that meant that the aircraft taking it to Los Angeles was going to at least stop at two aerodromes, in the tempera-ture which would probably rise to 100 in the sun, and they weren't going to look after this very carefully, however refrigerated it was. In point of fact, we lost about 30 per cent of the Monopack.

JL: Did you? Because of the temperature?

PJ: Because of the temperature problems …

JL: Oh! Dear! Dear!

PJ: And a lot of the most wonderful convoy stuff that we were shooting never came back …

JL: Really?

PJ: Lost, completely lost.

JL: What sort of effect did it have on the stock?

PJ: Oh … it went … magenta streaks.

JL: Oh did it? Nasty.

PJ: Hmm … apparently. And then, that was only one problem, which was tragic … where we weren't to know we were going to lose the stock until we got back. But when we came back from New York and the convoy started out, we had the very difficult scenes to do, which was the battle between guns, the rear gun on the Merchantman and the U-boat, you see. And this was the climax of the film, we had to shoot this coming back. And going out, we had eleven days of continuous thick fog, in which we couldn't shoot a foot!

JL: Oh bloody thing!

PJ: You couldn't see the ship's bows. So there we were, the unit, eating like fighting cocks, because the rations on this Norwegian ship were absolutely … smorgasbord every damn meal we had, I mean we were getting liver attacks and we were becoming very petulant, no exercise … and the frustration of eleven days at sea, crawling at about eight knots in thick fog was absolutely diabolical. So, coming back we now had to do half of what we were supposed to do, shooting out. So we were under enormous pressure. And we started the first day – it was beautiful for three or four days – onto the gun platform and the convoy made special movements so that we could fire it and gave us space and so on, and we got the Commodore's permission. And then what did we discover? That the Monopack had shrunk! An infinitesimal fraction, so that the sprockets … I suppose there was a hundredth of a millimetre out every ten feet … it was enough to jam the camera every hundred feet!

JL: Oh God!

PJ: So, imagine, here we came to the climax scenes with a lot of dialogue and all that we could hope for was a hundred feet. And poor Denny Densham who was the operator for Jack had to go down, load, reload, preserve the 900 ft left, because it had to be used again, can it up, tape it up. Up they go onto the gun platform again, get another 100 ft in, jam, unload, reload with a new magazine, hoping … sometimes the magazine would run perhaps two minutes. And in that way we limped through. I mean it was an unending nightmare from the moment we started to shoot. I was getting bald at the time I started, I was bloody near bald at the end of it! [Laughs]

JL: [Laughs] Yeah …

PJ: But there it was and … in the end we limped through it and er …

JL: So, yes … so you spent six months with the lifeboat, but how long did it take altogether?

PJ: From the time I did the research on the East Coast Convoy to the time it was shown at Warners, it was a two-year job.

JL: Two years? Yes …

PJ: Including the writing, the script, the casting, editing … because I edited it as well.

JL: If they'd known that it was going to take two years when they first suggested it, Sir Percy Noble … would they have … do you think …?

PJ: Oh dear, old boy … that's ….

JL: I mean, it's a hypothetical question, but it would have been tragic if you'd said something like 'It's going to take a long time …'

PJ: I suppose, yes, I suppose in hindsight, you see … it is the, sort of, official record isn't it – of the Battle of the Atlantic? And I see it's now on tape and, you know people buy it and so on. I think, what is fascinating about it, and I come back to my old plea of the use and the method of the non-actor … it won't date any more than *Nanook of the North* [1922] will date. It dates if you've got Larry Olivier in it or Cary Grant, because you can tell … 'Oh yes, he must have made that … oh yes, he's quite a young man there …'. As you've never seen these people before or will never see them again, it doesn't matter whether you see them in 2001, it is dateless for that reason, and it is a record for all time.

JL: Hmm. But obviously when you started, you assumed probably that it would be out in the cinemas a year later or something?

PJ: Oh yes. I mean we were innocents going to the slaughter. We hadn't the faintest idea what we were embarking upon. We would never be attempting … well, now of course you can do it with tapes so much more easily. But you see, to put a three-strip camera, don't forget it was damn nearly as big as the average refrigerator, and it wasn't until we'd worked out methods of moving it around the lifeboat that we could hope to do more than about one shot every time we were towed out of the harbour, you couldn't move the damn thing! You fixed it for one set-up and that was it! You had no means of fixing it, it was too heavy! And there weren't clamps, and this was a lifeboat, bouncing around, the damn thing would fall over! And then we developed, fortunately we developed, an idea of having portable rails built in the lifeboat, which screwed onto the thwarts. So that we could then, you see, put this on a tray along these rails that we'd bolted onto the thwarts so that it then became a portable camera, and you could move it port and starboard, fore and aft.

JL: That's where you really needed the pre-shooting time, wasn't it?

PJ: Oh! Of course it was! But the unit wasn't big enough, you see, we were tiny. All the available people were out making their own films, there wasn't … it needed a scratch unit with Jack Cardiff down there. Jack was on some other film, I mean we just had to cope with it as it came along. I mean the inventiveness of my chippy, Harry Tupper – wonderful, wonderful man. One owes the making of a film as much to the head carpenter, Harry Tupper, the master carpenter …

JL: It comes over very well in your book.

PJ: Oh, wonderful, wonderful man. All of them … and the prop man … they were a wonderful …

JL: Harry Tupper, yes he was outstanding.

PJ: Harry Tupper was the master carpenter and, dear old Charlie Squires the greatest prop man ever. Wonderful crew! God! One was lucky to have those men. I find very little glamour in showbusiness, but if there be glamour, I think it comes from the fact that, as I was

saying, you know, there are forty or fifty different people, different crafts, different walks of life, all concentrating on the one goal which is to get the film made somehow or other. And the unity, not only amongst the film unit, the unity of purpose and the deep relationships that last throughout that, which carries through all, or surmounts all the problems that beset this united fraternity, is magnificent. I mean it's a wonderful thing to experience that, because if ever there were difficulties and a unit coping with them, by God that unit had them on *Western Approaches*, and the way they coped with it and just would not allow themselves to get discouraged was wonderful. And that was quite an unforgettable experience of course, and no other film has measured up to it, and though working in Hollywood and going on the floor in Hollywood at Culver City was a totally different experience of a different kind, it was nothing like the magic of a unit coping with this sort of problem … and in the end, triumphing. And when I look back you see, John, and I realize the contributions of the master carpenter and the contribution of Gerry Bryant and Charlie Squires the prop men, getting us something that would just shelter, so that we weren't just standing around the dock wall … these sort of contributions that make the whole thing, in the end work. That was extraordinary.

JL: **Can you just stop just for a second, just for a moment … I've got to turn off …**

PJ: I can't remember what we …

JL: **Well, you'd finished on that last bit, hadn't you … about the aspect of the performances and the whole thing … and you were going to get onto the post production now, on *Western Approaches*?**

PJ: Oh the cutting, yes. Well … my dear old sister Joss [Jocelyn Jackson] …

JL: **Yes, I was going to say, of course, Joss was deeply involved in that wasn't she? Right from the beginning …**

PJ: Yes she was, she was assistant to the appointed editor … no point in mentioning … it doesn't matter … . And er, when I came back … I came back from New York and I had a look at this assembly, I practically burst into tears!

JL: **Oh really?**

PJ: It was absolutely appalling, and I can remember coming out of Theatre One …

JL: **At Pinewood.**

PJ: … and saying to Joss, 'My God! There isn't a film here! It doesn't make any sense, it's awful! I thought we had some quite good stuff, but this is terrible!' And old Joss, you know, she was a real old pistol shoot and we used to call her Margery Mayer not for nothing! I mean she …

JL: **Yes, she was splendid …**

PJ: She shot from the hip didn't she?

JL: **Hmm.**

PJ: She said, 'Don't talk such a lot of balls!' [Laughs] 'It's all there, it's all in the can somewhere, the silly bugger didn't know what he was doing. We'll have to start again, we'll have to start again.' And so I said, 'Right,' and so on. She said, 'Yeah, we'll have to print it up.' So, in short, we got the whole rushes printed up again.

JL: **Did you print up the whole lot again?**

PJ: The whole lot, in black and white.

JL: **In black and white, of course, yes, hmm.**

PJ: And there were eight reels of it, and we tore the whole lot up and started all over again.

JL: Hmm.

PJ: And old Joss and I re-edited that film from top to bottom. And then… and then all right and then … Muir Mathieson saw the final cut … . Who was going to compose the music? 'Very important …' and he thought for a moment and he said,

> You know, I think the chap we want has just had a nervous breakdown, but he's over it now. I think he's got this quality that I think this film needs, it's a sort of curious ethereal quality he can get, and his name's Clifton Parker. I'll get in touch, get him to come down and have a look.

So Clifton Parker came down and I met him, charming, delightful, sensitive face and a charming man. He had a look at the film, didn't say much. And we went out on the lot and we walked around, and he didn't say anything very much. Then he stopped and he looked at me and he said, 'Pat, I think I've got it, I think I've got it. If only I had a piano, I could tell you what I want to do.' … So I said, 'I've got a piano, it so happens by the grace of God I've got a piano, I've got a little Broadwood in my office – come along.' Well you won't believe this, he sat down and he played the theme of *Western Approaches* straight off, that was ten minutes after he'd seen the film.

JL: That's amazing.

PJ: That's quite astonishing, isn't it? And, I gather that …

JL: Was he able to explain that …

PJ: No. Just like, my getting the idea! You see? It's exactly the same, except that he didn't quite sweat … he sweated on it for ten minutes and he got it! [Chuckles] And Dennis, I saw Dennis Swann the other day … he told me that EMI have just put the tape of his score out, and which I must get … EMI have recorded it …

JL: Oh really?

PJ: Yep, the original score. So this must be got!

JL: Good news.

PJ: And then when he came to the recording, I mean that … barely a tune, that wonderful … I think almost as great, the title music of *Western Approaches* as Vaughan Williams' for Micky [Powell]'s *49th Parallel* [1941].

JL: Indeed, yeah.

PJ: They're both marvellous melodies, and that … when that melody comes back at the end, when the survivors of the lifeboat are climbing aboard …

JL: It's a very simple tune, isn't it?

PJ: It was his music that …

JL: A very simple tune, it's sort of modal, isn't it? Minor key …

PJ: And it was that tune over the final shots that produced the tears in the audience, not the story, it was the music of Cliff, and Cliff's contribution was enormous to that film.

JL: Well, it was inspired by having seen it with you.

PJ: Well, then, of course, a very strange thing happened, because then we dubbed it and showed double-headed to the Ministry of Information Films Distribution, and they didn't

quite know what to make of it. They weren't at all sure whether they'd got, by this time £70,000 worth of value on the screen … and, um, they said, 'Well I think we must get some advice on this.' And it so happened that the honorary film advisor to the Ministry of Information Films Division at that time was Sir Alexander Korda.

JL: **Oh was he? Yes … I didn't … hmm … interesting.**

PJ: Ah hmm. So, er … he was duly appointed to come down the following Wednesday to have a look at this film. So dear old Joss and I went through the cutting copy … it was still a cutting copy, you hadn't got a married print, you see.

JL: **Those old-fashioned cement joins, and build-up and all the rest?**

PJ: That's right! And awful every, every joint you went through, we had to … twenty-four hours …

JL: **Absolute nightmare! You didn't even have Sellotape to stick them down in those days!**

PJ: No! Just old … you know … the old cement stuff, the acetone. So I suppose there must have been, God knows, 3–4,000 joins, I suppose, in these reels.

JL: **I'm sure!**

PJ: And then, we really reached. We sweated that night, whether … God, the bloody cutting copy would stand up? There we were, at Theatre Two, Pinewood …

JL: **Oh, you showed it at Pinewood? Yes …**

PJ: Pinewood, yes … Theatre Two.

JL: **At least you'd got Dougie Smith to keep an eye on it for you.**

PJ: Well exactly, dear old Dougie Smith. And … there we were, and this funny character appeared, wearing a rather battered trilby hat and a rather dirty mackintosh! And I was on the front row looking up at old Dougie and old Dougie, you know, that lovely smile and he was putting his thumb up.

JL: **Yes …**

PJ: And then I heard [PJ imitates Korda's accent], 'My name is Korda, I have come to see a film called *Western Approaches*. I am ready when you are please. I will sit here, just leave me alone.' So … Joss and I sat in the back row and old …

JL: **So he came on his own, did he?**

PJ: He came on his own. And old Stewart McAllister joined us at the back, for some reason, I don't think he'd heard he was coming, and old Stewie was in there. And the lights dimmed, the curtains parted, and the first reel came up. And Joss and I sat at the back there, hearing these joins going through the projector like a train going over rather maladjusted points, thinking, 'My God, there's going to be a crash in a minute!'

JL: **[Chuckling] Yes …**

PJ: But by the grace of God, the cutting copy stood up to it and, er … the lights came up and the curtains closed, and this figure grew out of the front row, looked round for somebody there, so then I stood up. He very accusingly said, 'Who made this?' So I thought, 'My God, I'm for it now!' So I said, 'I did, Sir Alex.' And then er …

JL: **What did he say? Go on, tell us!**

PJ: Well no … he was very flattering. He said, 'You are coming with me, I am putting you under contract.'

JL: **Just like that?**

PJ: Just like that. And er, that was the beginning of something rather unfortunate … however, that's another story.

JL: So how long after that screening was the film shown? I mean that was presumably, then it was …

PJ: I think it was '44, the Warners somewhere …

JL: Yes, it did come out at the end of '44, hmm … I seem to remember it started about, just before … just about the same time as *Henry V*, because I remember the film critics were showing … describing, or doing their reviews of both films in the same week … I think I've got Dilys Powell's review somewhere of *Western Approaches*.

PJ: But the thing, John, that is interesting, you see, which supports my permanent plea for that type of filmmaking, because – and I say this, not simply because I had something to do with the film – it was nominated for an Oscar, as the 'best film from any source', which speaks highly for the non-actor. Now, if non-actors can suddenly appear and be nominated for an Academy Award, there is something in that system of filmmaking, and we can't do it now … because of the union trouble. So that it means that a vital form, a powerful form of expression on the screen, is denied it, which is tragic. And not only that, the way in which a nation expresses itself, by its people, directly to the screen is lost. Because these people spoke, don't forget, not as I thought they would speak, but as they spoke themselves. Our scriptwriters do not always know how our people speak. And so that, that vital, direct link of expression has gone, and it's tragic.

JL: Cinema vérité did sort of attempt that, didn't it? You know, Ricky Leacock and his company, Pennebaker, and they did all this handheld stuff and they went in on people being themselves. But the trouble with that system was that they ended up with an enormous amount of material and the problem was in the editing and they eventually got more or less drowned by it. The best of that stuff was brilliant.

PJ: You see, it's being done all the time, of course it's being done! The direct interview, you see it all the time on the 'box', of course you do. But … this is the constant intercutting of one piece of an interview, then you get the end of the interview stuck in after about four different intercuts … this is nothing whatever to do with drama, this is journalism! This is screen journalism!

DOCUMENT

JACK CARDIFF, 'SHOOTING "WESTERN APPROACHES"', *CINE-TECHNICIAN*, NOVEMBER–DECEMBER 1944

Shooting "Western Approaches"

by

Cameraman Jack Cardiff

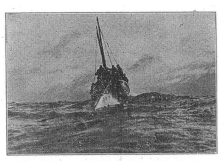

The Crown Film Unit, as everybody knows, adhere staunchly to realism in their films. Such studio requisites as make-up, model shots, back projection, etc., are anathema to them; so I was not surprised to learn that on "Western Approaches" we had to shoot many lifeboat scenes in a real sea and not in a studio, but my stomach rumbled nervously, for I am probably the worst sailor. in the world. When, however, I was told that these scenes were to be shot with *sound,* physical apprehension turned to dismayed incredulity, for this foretold many problems. The bare idea of using our Technicolor blimp in a lifeboat is uproariously funny to those who are acquainted with it; but to those who have not seen this Technicolor Titan I need only compare it in size and weight to a four-foot square steel safe, for them to see the joke. In its place we had to use an auxiliary lightweight blimp which is generally used for crane shots, or exterior scenes where the regular heavy but efficient studio blimp is impracticable. This emergency blimp is the *bête noire* of any cameraman who has ever used it, as, being light and abbreviated for soaring on a crane or being carried up rocky mountains, it is fitted in one piece, like a hat, over the camera, and laboriously strapped together. For the most trifling operation like changing a view finder matt, it all has to come off again. This is fidgety enough on land, but at *sea* in a rolling lifeboat

Chuckling in retrospect, I suppose, my assistant, Eric Asbury, was, on the whole, lucky to fall in the Irish Channel only once !

This turned out to be only a minor headache on a film which was the most despairing struggle a film unit ever had.

For the lifeboat scenes our headquarters was at Holyhead, Wales, which proved to be the mecca of film-struck gremlins. The plan was, to tow our lifeboat twenty miles or so out to sea by a drifter. Originally, we were to have two lifeboats : one fitted with a steel braced platform outside the aft end of the boat for our camera, and the other fitted likewise at the front end — sorry, for'ard. It

was confidently assumed that from these platforms we could cover everything, doing long shots and close-ups looking for-ard one day, and reverse shots looking to the stern in the other boat. It was thought that the weight of the twenty-two merchant seamen would counterbalance the weight on the outside platform, but on our first trials the boat ploughed along with the bows in the air like a speed boat and the platform, and our ankles, under water.

This was easy to adjust, we thought. Just a couple of heavyweights for-ard to balance things, and off we go.

The next trip was rather like a submarine patrol, with half-an-inch freeboard and only the camera visible, just out of the water like a periscope !

The next day the steel platforms were taken off and a much better idea of Pat Jackson's, the director, was employed. This was a grooved track running along the inside of the boat, with a platform on which was a second grooved track running across the beam of the boat, and by sliding the platforms down and across laterally, we could get any angle desired. Of course the long track was in sections, which could be unbolted if seen in picture.

It took many days for us to overcome literally hundreds of minor problems, but at last we went out to work. In our lifeboat was crammed, every day for six months, the director, myself and assistant, sound man, continuity girl, Western Electric sound gear, Technicolor camera with its many boxes of equipment, reflectors, props for the boat, such as a portable wireless transmitter, water barrels, and boxes of sandwiches for the day, and a flapping sail which swung murderously around when one least expected it. Oh, I forgot one other small item : *twenty-two merchant seamen!* All this in a 28-foot lifeboat.

I am relieved that this article is confined to photographic problems only. Anyone recording the problems of all departments would rival Tolstoy !

My first major problem was one of skies and

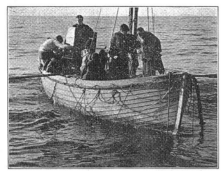

exposure. Winter had been rightly chosen to give the best dramatic environment typical of so many frozen merchant seamen in this war. Now a person seen up against a summer's blue sky, bathed in radiant sunlight, is, to use a technical term, a pushover; but take away the radiant sun and blue sky, and an unrecognisable silhouette is smudged against the grey horizon. On groups of seamen this was just right for atmosphere; but on a close-up I could not get enough exposure to see who it was, unless I shot with the lens wide open—but then that over-exposed the sky behind. For instance, the sky alone usually needed an exposure of five at least, but the face was usually under-exposed even with the lens wide open. Consequently, the laboratory could have printed on printer point 1 for the face, but that made the sky flare from over-exposure, so the scene should be printed at printer-point 20. I could not use a sky filter, as in black and white, for obvious reasons, and for a few worrying days "Western Approaches" looked like being the mystery film of all time, until we managed, after many difficulties, to get a couple of lamps in our boat—yes, there was only just room !—which were run from a small generator on the drifter towing us. This enabled me to put enough light on the faces until I could give an exposure of 5, and we were able to carry on.

The next problem was continuity of weather. Having started to shoot the scenes of the seamen's first day in the lifeboat—a matter of several days' work—in dull, rainy weather, we had to continue that way. But the next day would be like blazing June, with blue skies and that radiant sun again, so we decided that the second sequence would be shot in fine weather. So, if dull, first sequence; if sunny, second sequence; but after the first few days we ran into a much bigger headache—the continuity of the seamen's beards. After shooting in four days' fine weather on the second sequence, the seamen would show four days' growth of beard. Then rain and dull weather

would come for a week, but in order to return to the first sequence the seamen should be clean-shaven !

As the weeks went by and we had got to the sequence where the men had been adrift for twenty days, with beards over an inch long, we would be horrified to see that one or two of the seamen had gone to a dance the night before and were clean-shaven !

I made an interesting experiment at this stage, which enabled us to shoot sunny scenes in dull weather. The lamps I used were incandescent, and for normal use had to have a blue filter to correct the yellow light to white. By taking the blue glass off, the face was much too yellow for ordinary purposes, but by over-exposing to clean the dirty grey sky to a white one, and allowing for the laboratory to print on the blue side to correct the complementary yellow, so making the white sky blue, I was able to save waiting so long for sunshine.

When a rare sunny day did arrive in the months of October onwards, the sun was wan and orange, and always at such a low arc that the usual ground reflection was practically nil — but there wasn't any ground, only dark blue sea, which was in complementary opposition and accentuated the jaundiced effect. Reflectors in the shadow side were impossible with the boat rocking so much that the angle of reflection swung off far too much for the most adroit counter manipulation, and the inky gloom on one side of the face would be intermittently flared like a morse signal !

Winter sunlight is very yellow, much more than is usually realised, and when yellow faces are corrected by yellow's complementary, blue, the seas, which are already blue, look fantastically unreal.

At the start of the film I was dismayed to see many faces over-sunburnt, for a tomato face in Technicolor is not very charming; but by the time winter had been wearily passed there was very little tan to be seen, and the difference was

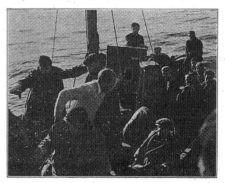

another headache for the cutter as well as myself.

Although our camera equipment was covered with water-proof canvas, salt water and salt atmosphere permeated everywhere, corroding viciously. Nearly every day the pungent smell of our cables and plugs shorting, with smoke issuing from our electrical gear told us that our salt water gremlins were having fun again, and we must dry the connections either by heating them with matches or lighters, or clean them under a waterproof while spray splashed in derisively.

The Technicolor camera is the swanky apotheosis of movie machines, bred in million dollar Hollywood, delicately coloured, with superb high-precision machinery and a prism which is set to a fraction of an inch and diligently watched for the most microscopic speck of dust, which would show as a large coloured blob on the screen. This prism is always placed, with tense caution and bated breath, into the camera, keeping a perfect balance while doing so. This meticulous operation was a sight to be remembered in a lifeboat on stormy seas. Reloading the camera with fresh film was always a nightmare, with the ubiquitous gremlins having glorious fun, making the boat heave right over and throwing gallons of water over us as we staggered drunkenly about, lifting the blimp off and threading up the film somehow under a flapping tarpaulin.

Seas, of course, were never the same, either in character or in colour. On one day the waves would tower monstrously in the true Atlantic manner; then on the next day the sea would be as flat as the Serpentine, and the colour changed every few hours, from deep blue to grey-green. One day fleecy, cumulus clouds; next day a completely cloudless sky. All these changes were typical of the ever-changing conditions at sea, but the difference can be glaringly seen when assembled together in the final cut film, with the whole sequence only supposed to be of five minutes' duration.

Our sail also had to be right for continuity on a starboard tack—that is, with the wind coming from our left side—but the wind changed many times in a day and we had to jib around so much that either the sun was in our lens or land came in the picture.

One day everything went off perfectly from the start. The weather was right; so was the sea, the wind, and all the rest of our ever-changing conditions. It was quite quiet, and so perfect for us that it was all rather uncanny. Our nautical gremlins must have taken the day off—so we imagined. I checked the light reading from my photometer twice to make sure; the focus was also double-checked. I set my exposure smugly: the light was perfect. One rehearsal and the actor-seamen were magnificent. Pat Jackson and I looked at each other a little nervously and warily.

Drawing a deep breath, Pat said: "It's too good to be true; let's put the sail up."

We both grasped the halliard and pulled exuberantly until the sail billowed gustily in the breeze, and hung on until it was made fast by a seaman. Suddenly, the mast snapped loose at the base, the sail and mast were blown over into the sea, with Pat and me clinging in dazed bewilderment to it over the side.

We went back for the day in silence, with set faces.

The most deadly burden of all was seasickness. Even some of the veteran seamen themselves were often horribly sick, so it was not surprising that most of the unit went through the ghastly misery of nausea nearly every day for many months. Sometimes our lifeboat looked as though a machine-gun had raked the whole crew down. Every wretched victim—except the few who were never sick—would lie inertly all over the boat or hang limply over the side heaving spasmodically like captured fish in a bucket. Our director was one of the heaven-blessed; he was not seasick once, but imagine how difficult it was for him to direct a scene when nearly all his crew were pathetically *hors de combat*.

With a sympathetic look around, he would say: "All right, let's try and get this scene before the sun goes in." Someone points feebly to Roland, the sound man, over the side, only his rear and twitching legs to be seen. "Well, I'll take the mike," says Pat. "Ready everybody?"

But my assistant hasn't taken the focus, only his tape measure is left swing dramatically from the side, and a horrible choking vomit peculiar to Eric, explains his absence.

"All right, I'll take the tape out," says Pat desperately. "Five feet two inches, is that right, Jack?"

I have just returned from the side, and my head is sunk down on my chest like a dead man; my blurred vision tries to envisage Pat as I say something like, "Egggmmmph."

"Right," says Pat grimly, "turn 'em over."

But now the actor-seaman himself suddenly rises with a stifled gurgle and falls purposefully over the side. We wait listlessly. He comes back.

Eric returns, looking very white and battered. Roland, the sound man, crawls painfully back in position and buzzers are pressed weakly for the recordist on the drifter to set the machinery in motion; but after a dreary, burping delay, it is learned that Charlie, the American recordist, who works down an evil-smelling hold on the drifter, is busily vomiting into a bucket which he brings down with him every day.

In answer to feverish enquiries over the 'phone, Charlie pants indignantly, between heaving: "Can't a guy have time to puke once in a while?"

Our staggering setbacks would have strained

the most brightly ingenious person with a clear head and resourceful energy, but having to deal with almost insoluble problems whilst feeling almost eager to die rather than vomit once more, was a little trying — to use a British under-statement. For instance, when shooting a close-up in rough seas, the seaman would roll and stagger about so much that the focus must be smartly changed to each lurch. Easy enough in a studio, but with our Selson focus motor shorting from salt water and giving hefty electric shocks to the sea-sick focus-puller, small wonder that he almost loses interest !

I also was a punctual sufferer, passing every day at sea with my soul in limbo and my stomach in the shades below, while looking through my camera to see that nothing except sea and sky were ever in the picture, for we were supposed to be on the Atlantic three thousand miles from anywhere. This was always difficult in the Irish Channel in wartime, with ceaseless convoys silhouetted against the horizon, and the Irish mail boat passing us four times daily heralded for miles with voluminous black smoke and thousands of sea-gulls; also aeroplanes humming around all day machine-gunning flying targets or mock-battling. There were many buoys to watch out for, and lighthouses, wrecks, mine-sweepers, and, most ridiculous of all on one occasion, thousands of oranges floating by from a nearby wreck !

The most hated object that most often appeared in my camera view-finder was the stern of the drifter when we did reverse shots. We couldn't make the bow look like the stern, because the passing sea would show, of course, that we were going backwards !

Apart from the thick rope used to tow us, there was also a heavy electric cable, and other cables for the microphone, etc., which, as they ploughed through the seas, gave us endless induction troubles — one of the million headaches that Kay Ash, the chief sound man, had to deal with. The only way of getting the drifter out of the picture was to let the drifter steam ahead fast for a few minutes, then slow right down and, if the wind was strong enough, our lifeboat would sail up level with it, the cables stretched awkwardly at right angles and threatening to capsize our boat at any moment. We did this on one occasion in a malevolent storm and our lifeboat was swept savagely the wrong way round, crashing into the side of the rearing drifter and nearly getting underneath it. I can say that by this time I was yearning to do the rest of the film in the studio !

For six weary months we struggled through the lifeboat sequence, and when at last our location came to an end, we thought that the worst was over and the rest of the film would be easy; but I should have known better.

Our next location was the real Atlantic, this time on a cargo ship to New York. As there are only four Technicolor cameras in this country, I was not allowed to take my camera over 3,000 miles of sea with many U-boats lurking around, so Monopack was used on a black and white camera.

Although it was midsummer, bad luck still pursued us, for the weather was very bad going out and coming back from America, and fog nearly all the time made us scramble many weeks' work into a few days.

One evening, about 9.30, the ship in front of us was torpedoed. It was carrying high octane petrol and was soon a blazing hulk — a terrible sight which I shall never forget. Many men were killed that night, and I realised then, more than at any other time, why Pat Jackson was so sincere about making this film.

When we reached England again, after some exciting incidents dodging U-boats, I heaved a sigh of relief and realised that I was definitely not a hero; but I also realised that every man in the merchant navy is a hero, for where I was relieved to be still alive after only one return trip, the merchant navy have made hundreds of dangerous crossings during the war. I hope that this film will impress the fact on the public as it did upon me.

After the voyage to America we made several trips out to sea in destroyers, corvettes, and other escort vessels, getting authentic shots of convoy escort patrols.

By this time, having been over a year on the film, I had given up the idea of seas and skies matching, and fervently hoped that the laboratories would match the scenes up as near as possible.

One of the last remaining thrills was on a submarine which has to be sunk in the film. My camera was tied on the stern end, and the commander was asked, on a pre-arranged signal, to

make a steep dive downwards, making sure that the end my camera was on was still above water. I started the camera on the signal, and the submarine accordingly dived so steeply that it disappeared rapidly, to my increasing concern, until just my camera and the top half of me were visible ! Of course the submarine was under perfect control, but I needn't say how relieved I was to see it surface again.

So ended a film which I regard as the most difficult film of my career so far. Don't misinterpret me ; I am not making us out to be heroes. It would be fatuous to compare our hardships on this picture with those of so many soldiers and civilians in this shuddering war; but as films go, although I have taken my camera all over the world : on live volcanoes, in fever-ridden jungles, scorched deserts, and on the perishing heights of the Himalayas, I have never had a job that was so onerous and nerve-breaking. I think I agree with one of our seamen who has been torpedoed already in this war. He said, quite seriously, that he would rather be torpedoed again and really cast adrift in a lifeboat, than have that film experience again.

OBITUARY Olaf Bloch

News of the death of Olaf Bloch on 19th October at the age of 72 will have been heard with regret by all those who crowded into his lectures at the Royal in Russell Square and by those who for many years came to rely on his guidance and help in all their problems of photographic technique. Olaf Bloch received his earliest scientific training at the Finsbury Technical College and followed this by wide experience at the Royal Institution in hospital work and in chemical manufacture. In 1910 he joined F. R. Renwick and B. V. Storr at Ilford Limited, and the remainder of his working life was spent in service to photography.

At Ilford, Bloch plunged straight into all the complexities of photographic manufacture. His first work concerned the production of panchromatic plates, then only a recent development, and from this beginning he retained throughout a keen interest in the application of sensitising dyes and valued always his collaboration with the organic chemists who conceived and produced them. Research in emulsions became his main activity and from his laboratory came a stream of new emulsions to maintain the position of Ilford materials in the photographic world; to mention only one, the Soft Gradation Panchromatic Plate, still, in its modernised form, a firm favourite.

Bloch took a keen interest in the affairs of the Royal Photographic Society, and he was elected President in 1931, a few months after becoming Chief Chemist of Ilford Limited. He was ever enthusiastic to apply new principles to production methods and he left no one in his company in ignorance of the value of his laboratory.

At the Royal he was always a popular lecturer, combining a great deal of instruction with even more of his unique brand of humour. The discovery and application of a new sensitiser, giving infra-red plates more sensitive than any known until then, led to the series of lectures and demonstrations for which Olaf Bloch will be best remembered by most photographers. A remarkable range of applications for infra-red photography was developed under his forceful guidance. The Royal Society, the Royal Institution, the Royal Society of Arts, the Institute of Chemistry, the Institute of Metals, the British Association and the Physical Society, were among the distinguished bodies which sought and obtained his services as a lecturer. It was fitting that he was chosen to preside at the commemoration of the Centenary of Photography at the Royal Society of Arts on May 17th, 1939.

Through close collaboration with Dr. F. W. Aston, F.R.S., he produced the " Q " plate, particularly designed for the recording of charged atomic particles of low penetration, and used in Dr. Aston's famous investigations of the isotopes. Consulted by astronomers throughout the world, Bloch produced many plates having special qualities, for the photography of the moon, the spectographic examination of meteors, observations at an eclipse of the sun and many other purposes. Most useful of all, perhaps, and certainly most widely used, are the special emulsions, evolved under his direction, for the recording of atomic particles derived from cosmic rays, or produced through radio-activity, or by the breakdown of atoms under bombardment from the cyclotron.

For these services to science, Bloch was made an Honorary LL.D. of Aberdeen University. He also received the Progress Medal and the Honorary Fellowship of the Royal Photographic Society, and was a Fellow of the Royal Institute of Chemistry and of the Institute of British Photographers.

Away from his work, Olaf Bloch was a keen gardener at his cottage in Surrey. At the age of 51 he took up mountaineering and attained the high honour of membership of the Alpine Club.

In 1937 deteriorating health sadly curtailed all these activities, and after his retirement from active participation in laboratory work in 1939 his wisdom and humour were greatly missed by all his colleagues.

G.P.

INTERVIEW
OSWALD MORRIS, OBE, BSC

Oswald Morris (known as 'Ossie') was born on 22 November 1915 in Ruislip, west London. He was first employed in the film industry as an assistant at Associated Sound Film Industries, Wembley, before moving to Elstree when the studios at Wembley closed. At Elstree he worked with cinematographer Otto Kanturek and director Karl Grune and was introduced to new camera techniques. When Wembley reopened he was employed as a camera assistant, eventually becoming an operator for Ronald Neame. During World War II Morris was conscripted to the Royal Air Force as a pilot and was decorated with the DFC (Distinguished Flying Cross) and the AFC (Air Force Cross). After the war he decided to return to the film industry and worked at Pinewood as a camera operator on films including *Blanche Fury* (1948) in Technicolor. Collaborating again with Ronald Neame on *Golden Salamander* (1950), Morris was selected by John Huston as colour cinematographer on *Moulin Rouge* and *Moby Dick*. His innovative experiments with filters, fog on the set and processing secured his place as one of the most notable cinematographers to experiment with colour. He won an Academy Award for his colour work on *Fiddler on the Roof* (1971). Morris worked with many British and American directors, and throughout his career he also worked extensively in black-and-white cinematography, winning British Academy Awards (BAFTAS) for his work on *The Pumpkin Eater* (1964), *The Hill* (1965) and *The Spy Who Came in from the Cold* (1965). He retired in 1982 and published an autobiography, *Huston, We Have a Problem* in 2006.

FILMOGRAPHY

Films as Director of Photography unless other role stated. Colour process indicated where information is available; film director listed and country of production

1988 *John Huston* (Frank Martin, GB: colour)
1982 *The Dark Crystal* (Jim Henson and Frank Oz, GB and USA: Technicolor)
1981 *The Great Muppet Caper* (Jim Henson, USA: Technicolor)
1980 *Just Tell Me What You Want* (Sidney Lumet, USA: Technicolor)
1978 *The Wiz* (Sidney Lumet, USA: Technicolor)
1977 *Equus* (Sidney Lumet, GB: Deluxe); *The Empire Blend* (National Film School, GB: colour) Morris thanked for assistance
1976 *The Seven Per Cent Solution* (Herbert Ross, USA: Technicolor)
1975 *The Man Who Would Be King* (John Huston, USA: Technicolor)
1974 *The Odessa File* (Sidney Lumet, GB and German Federal Republic and Netherlands: Eastmancolor); *The Man with the Golden Gun* (Guy Hamilton, GB: Eastmancolor)
1973 *The Mackintosh Man* (John Huston, USA: Technicolor); *Dracula* (Dan Curtis, GB and USA: Eastmancolor)
1972 *Sleuth* (Joseph L. Mankiewicz, USA: Deluxe); *Lady Caroline Lamb* (Robert Bolt, GB and Italy: Eastmancolor)

1971 *Isabel de España* (Ronald Neame, GB and Italy); *Fiddler on the Roof* (Norman Jewison, USA: Technicolor)

1970 *Fragment of Fear* (Richard C. Sarafian, GB: Technicolor); *Scrooge* (Ronald Neame, GB: Technicolor)

1969 *Goodbye, Mr Chips* (Herbert Ross, GB: Metrocolor)

1968 *Oliver!* (Carol Reed, GB: Technicolor); *The Winter's Tale* (Frank Dunlop, GB: Eastmancolor); *Great Catherine* (Gordon Flemyng, GB: Technicolor)

1967 *Reflections in a Golden Eye* (John Huston, GB and USA: Technicolor);

1966 *The Taming of the Shrew* (Franco Zeffirelli, USA and Italy: Technicolor); *Stop the World I Want to Get Off* (Philip Saville, GB: Technicolor)

1965 *Mister Moses* (Ronald Neame, GB: Technicolor); *The Spy Who Came in from the Cold* (Martin Ritt, GB and USA: black and white); *Life at the Top* (Ted Kotcheff, GB: black and white); *The Hill* (Sidney Lumet, GB: black and white); *The Battle of the Villa Fiorita* (Delmer Daves, USA and GB: Technicolor)

1964 *The Pumpkin Eater* (Jack Clayton, GB: black and white); *Of Human Bondage* (Ken Hughes, GB: black and white)

1963 *The Ceremony* (Laurence Harvey, USA and Spain: black and white)

1962 *Lolita* (Stanley Kubrick, GB and USA: black and white); *Term of Trial* (Peter Glenville, GB: black and white); *Satan Never Sleeps* (Leo McCarey, USA and GB: Deluxe) *Come Fly with Me* (Henry Levin, GB and USA: Metrocolor)

1961 *The Guns of Navarone* (J. Lee Thompson, GB and USA: Technicolor)

1960 *Our Man in Havana* (Carol Reed, GB and USA: black and white); *The Entertainer* (Tony Richardson, GB: black and white)

1959 *Look Back in Anger* (Tony Richardson, GB: black and white)

1958 *The Roots of Heaven* (John Huston, USA: Eastmancolor); *The Key* (Carol Reed, GB and USA: black and white)

1957 *Heaven Knows, Mr. Allison* (John Huston, GB and USA: Deluxe); *A Farewell to Arms* (Charles Vidor, USA: colour)

1956 *Moby Dick* (John Huston, USA and GB: filmed in Eastmancolor, processed in Technicolor) Colour style creation: Morris and Huston

1955 *The Man Who Never Was* (Ronald Neame, GB: Eastmancolor)

1954 *Monsieur Ripois* (René Clément, GB: black and white); *Beau Brummell* (Curtis Bernhardt, GB: Eastmancolor)

1953 *Beat the Devil* (John Huston, GB and USA and Italy: black and white); *Stazione Termini* (Vittorio de Sica, Italy and USA: black and white) Co-director of Photography Morris and G. R. Aldo

1952 *Moulin Rouge* (John Huston, GB: Technicolor) *South of Algiers* (Jack Lee, GB: Technicolor); *Saturday Island* (Stuart Heisler, GB: Technicolor); *The Card* (Ronald Neame, GB: black and white); *So Little Time* (Compton Bennett, GB: black and white)

1951 *The Magic Box* (John Boulting, GB: Technicolor) second unit; Cardiff: Photography; Neame: Producer

1950 *Cairo Road* (David MacDonald, GB: black and white); *Golden Salamander* (Ronald Neame, GB: black and white) Lighting cameraman; *The Adventurers* (David

MacDonald, GB: black and white); *Circle of Danger* (Jacques Tourneur, GB: black and white)

1949 *Fools Rush In* (John Paddy Carstairs, GB: black and white) Camera operator

1948 *Blanche Fury* (Marc Allégret, GB: Technicolor) Camera operator; *Oliver Twist* (David Lean, GB: black and white) Camera operator; *The Passionate Friends* (David Lean, GB: black and white) Camera operator

1947 *Captain Boycott* (Frank Launder, GB: black and white) Cameraman

1946 *Green for Danger* (Sidney Gilliat, GB: black and white) Cameraman

1930s Black-and-white films, all British:

1939 *I Met a Murderer* (Roy Kellino) Camera operator

1938 *Londonderry Air* (Alex Bryce) Assistant camera; *Who Goes Next?* (Maurice Elvey) Camera operator: Morris; Photography: Ronald Neame; *Second Thoughts* (Albert Parker) Assistant camera: Morris; Photography: Ronald Neame; *Murder in the Family* (Albert Parker) Assistant camera

1937 *The Black Tulip* (Alex Bryce) Assistant camera; *Strange Experiment* (Albert Parker) Assistant camera; *The £5 Man* (Albert Parker) Assistant camera; *Concerning Mr Martin* (Roy Kellino) Assistant camera; *Catch as Catch Can* (Roy Kellino) Assistant camera; *Calling All Ma's* (Redd Davis) Assistant camera; *Against the Tide* (Alex Bryce) Assistant camera; *Variety Hour* (Redd Davis) Assistant camera

1936 *The Big Noise* (Alex Bryce) Assistant camera; *Wedding Group* (Campbell Gullan and Alex Bryce) Assistant camera; *Troubled Waters* (Albert Parker) Assistant camera; *Highland Fling* (Manning Haynes) Assistant camera; *The End of the Road* (Alex Bryce) Assistant camera; *Cafe Mascot* (Lawrence Huntington) Assistant camera; *Blind Man's Bluff* (Albert Parker) Assistant camera

1935 *Sexton Blake and the Mademoiselle* (Alex Bryce) Assistant camera; *Old Roses* (Bernard Mainwaring) Assistant camera; *Abdul the Damned* (Karl Grune) Clapper boy; *White Lilac* (Albert Parker) Assistant camera; *Smith's Wives* (Manning Haynes) Clapper boy; *Late Extra* (Albert Parker) Assistant camera; *All at Sea* (Anthony Kimmins) Assistant camera; *Blue Smoke* (Ralph Ince) Assistant camera

1934 *The Third Clue* (Albert Parker) Clapper boy; *Rolling in Money* (Albert Parker) Clapper boy; *Mr. Cinders* (Friedrich Zelnik) Clapper boy; *Josser on the Farm* (T. Hayes Hunter) Clapper boy; *His Majesty and Co.* (Anthony Kimmins) Clapper boy; *Blossom Time: A Romance to the Music of Franz Schubert* (Paul L. Stein) Clapper boy

1933 *Money for Speed* (Bernhard Vorhaus, GB) Clapper boy; *Two Wives for Henry* (Adrian Brunel, GB) Clapper; *Follow the Lady* (Adrian Brunel, GB) Clapper boy

1932 *After Dark* (Albert Parker) Clapper boy; *Born Lucky* (Michael Powell) Clapper boy

SELECT BIBLIOGRAPHY

Calhoun, John, 'Wrap Shot', *American Cinematographer* vol. 84 no. 11, November 2003, p. 120: on the filming of *Moby Dick*.

Films and Filming vol. 23 no. 7, April 1977, pp. 10–16: interview with Oswald Morris.

Hill, Derek, '*Moby Dick* Sets New Style in Color Photography', *American Cinematographer* vol. 37 no. 9, September 1956, pp. 534–5, 555–6.

Morris, Oswald with Geoffrey Bull, *Huston, We Have a Problem: A Kaleidoscope of Filmmaking Memories* (Oxford: Scarecrow Press, 2006).

Petrie, Duncan, 'A Man for All Seasons', *American Cinematographer* vol. 81 no. 3, March 2000, pp. 38–49.

INTERVIEW TRANSCRIPT

DATE OF INTERVIEW: 6 AUGUST 2008
INTERVIEWERS: SARAH STREET AND LIZ WATKINS

SARAH STREET: How would you define the role of Director of Photography?
OSSIE MORRIS: The Director of Photography's responsible for the total visuals of the picture under the guidance of the director. The director is the captain of the ship always. Forget the producer, he's back in the office and all he does is promote the film; he gets the money and then grumbles because he has to spend it. So we're not very friendly to the producer, but the cinematographer, the first thing he does is go and see the director when he's assigned to the film, or at least I used to, and say, 'How do you see the film looking?' You have to do that. You have to get to know that and usually he'll give you a lead and some directors know more about the visuals than others. The directors that have come through the script department, who were screenwriters at some time, are usually very weak on the visuals and they need help. A director that's come through, like some cinematographers have become directors, well, you don't need to tell them the style, they'll tell you the style they want and they'll get all the set-ups. Some directors don't even know which end of a viewfinder to look through because they were writers. Martin Ritt who directed *The Spy Who Came in from the Cold* was a wonderfully talented director but he didn't know much about set-ups and composition. That was only black and white but the same thing applies in colour. Whereas Joe Mankiewicz – a wonderful writer – I did a film with him and I gave him the viewfinder one day to look through and he looked at the wrong end. All the unit were watching, and I just gently got hold of it and turned it around.

SS: What about David Lean, would he want to control everything?
OM: David Lean was perfection personified, he really was. He was a wonderful editor, he was a wonderful director, he knew scripts. I mean you can't fault David, you really can't. It was a great honour to be able to meet with him, it really was. You don't waffle, either it's right or it's wrong and that's it, that's the end of the conversation and if it's wrong, we'll do it again. He quizzes everybody at the end of a take. First of all he goes to the actors, asks if they're happy, do they feel comfortable? Then he says to the cinematographer, which was Guy Green in my day, because I was operating for David.[1] Guy says, 'Fine, David' and then he says to the sound man, 'How was it for you?' and then he'd say to me, 'Os, how was it for you?' Now this is when I first started to work with him. I said, 'Fine, David.' He said, 'Are you absolutely sure?' [OM would reply] 'Yes, David' [Lean

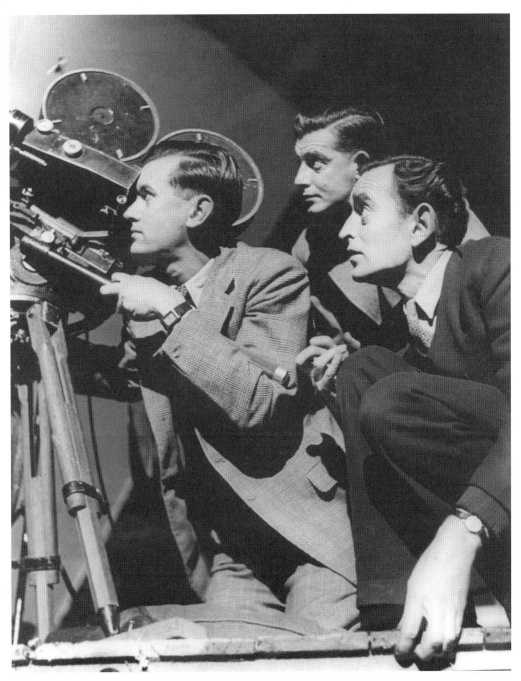

Filming *Oliver Twist* in 1948:
Ossie Morris, Guy Green and
David Lean

would ask] 'Did I see a jump in the track as we tracked forward? Did it jump?' [OM replies] 'No, David.' [Lean asks] 'And were we late coming on to Alec Guinness for that first line?' [OM replies] 'No, David' [Lean asks] 'Are you sure you got it in frame?' [OM replies] 'Yes, David.' I went through all of that for the first three or four weeks. He was testing me out you see and later on of course he'd just leave you be.

SS: Yes, that's very interesting. So when you were starting out when did you first become aware of Technicolor as something that was available as a cinematographer?

OM: Well, I started in the industry before Technicolor came into circulation. But it came in 1936 with *Wings of the Morning* as the first one. It was photographed by Ray Rennahan[2] and there were only six cameras originally and I can explain the reason for that in a moment.[3] When I first started nobody ever thought they'd be able to work in colour because there just weren't enough cameras and they sent a lot of crew over from America at first. In 1936 all the key people came from America and the laboratories were only built in 1936 on the Bath Road. So it wasn't until after the war, because I was in the forces for five, six, years unfortunately and didn't see a camera. Thereby hangs an interesting tale. The cameras I operated on before the war were the French Debrie cameras. After the war there were no Debrie cameras, they'd all been damaged or destroyed during the war and we had the American cameras – the Mitchell – and the Newall, which was the English version of the Mitchell camera. I had to learn to operate on those cameras that had a separate viewfinder,[4] whereas with the French cameras you would actually look through the film as it was going through the gate and operators used to go along all day with a velvet patch over their right eye because suddenly, particularly when you're working on a 'quickie' picture, they'd say, 'Right, let's shoot', and if you hadn't got the iris of that eye open you'd look through the camera and you couldn't see anything.[5] When the shutter goes you only see 50 per cent of it because the shutter takes 50 per cent away. So colour in my early days was just something I couldn't think about because it was a totally different ball game, it was awesome. You'd go on a colour set and it was absolutely awesome to see how much light there was on there; it was unbelievable.

SS: Because you were an operator at that time, weren't you, for Ronald Neame, so how did that happen?

OM: Yes that's right, well, this is extraordinary. At the end of the war four operators who were in the forces and under the release scheme getting us going in civilian life, were taken under contract by Pinewood Studios. One was Ernie Steward, one was Skeets Kelly, one was Chris Challis and I was the fourth. And we all got the same money – £20 a week – which was a lot of money in those days. I remember when I was leaving the Air Force I was an officer then, only a flight lieutenant, and they said they didn't want me to leave because I'd got so much experience in flying and could get a wonderful job in the airlines. I said I didn't want to do that but wanted to go back to a film studio. They said, 'Are you getting good money?' and I replied, '£20 a week', and they fell on the floor in the officers' mess, you know, about getting that much money. So that's how we started in 1946 and I did two black-and-white films and Ernie Steward was allocated to a colour picture called *Blanche Fury* directed by Marc Allégret, and starring Stewart Granger and Valerie Hobson. They had a terrible accident on it.[6] A Technicolor camera in the blimp was huge

and the blimp alone took four men to lift it. They had hooks on the corners and they got four men to lift it, to move it. The camera itself took two men because it had three rolls of film in it, everything was heavy and cumbersome. They were working on the set and Marc Allégret wanted to do a scene outside a window of a room and he wanted the camera to track through the open window into the room and with dialogue so they had to use the blimp. Cranes were in very short supply then and there was the most antiquated crane at Pinewood made of tubular steel. It was lethal, it wasn't counter-balanced properly, there was no safety thing on it at all, but they had to go on this crane to get this camera through the window.[7] Now this camera wouldn't go through the window with the blimp so they redesigned the set. When the sides of the window were out of the frame he [Allégret] gave a cue and men pulled two halves of the wall away, slid them away so the camera could get through. Now thinking about it, it was absolutely crazy, but the area of error between acceptance and it being wrong was so tiny. The camera was almost hitting the window before he gave the OK to pull it out. They were doing one take and the timing got wrong and they were going in fairly fast and the blimp caught the frame of the window while they were pulling it out and it snapped. The whole blimp on its mounting came off the crane and it fell to the floor. Now that in itself is horrendous, it really was. But now the crane is totally out of bal-ance, all the weights are on the back but there's nothing on the front and it went up like that you see? There's no safety brake on it or anything. Ernie Steward was operat-ing [so he was on the crane], he went over in circles and landed, God knows, away from the set and injured himself quite badly and luckily it was confined to his hand. He broke some fingers and this was during the morning and so they abandoned shooting for the day. I wasn't working on a film because we were all under contract and we had to wait in the camera room to be assigned to something. I was told that next morning I was to take over. Now it's what we called a geared head which I'd never used before, because you can't have a free head with this blimp because you can't hold it, you know. So there are handles underneath [that you rotate and which turn the camera] you see, I still remember how the handles go. I'm plunged onto the set and I'd had no training at all. Nor did I have training when I became a Director of Photography and I did the colour film. All they do is to give you a key, which was a light level. I'll have to quote foot can-dles to you on that; whereas on black and white you'd use 200 ft candles at T4, on colour we had to use 800 ft candles at a stop of T1.3, which is the widest open you could get.

SS: So you'd need as much light as possible on each take?

OM: Yes, and for colour it had to be white light or daylight because the prism was designed for daylight not incandescent light and that was a horrendous job.

SS: So what with the camera being so big and the equipment that you were just describing, do you think that generally the style of the colour picture was possi-bly more static because of the anticipated immovability?

OM: Oh yes, most certainly. You might be able to shoot a rider going along a road, but you had to have a very heavy and well-equipped vehicle, and you couldn't do it with a blimp. You'd have to do it wild and if there's any dialogue you'd have to post-synch it afterwards, but usually the camera movements were very limited.

SS: So it was quite brave of him to think of designing a shot like that.

OM: Well, I know, yes. The designer was John Bryan who was a brilliant designer. I worked with John a lot and he gave us wonderful sets. He believed in verticals, but not horizontals. You could break the horizontals and it gave a better composition. He was absolutely right. I remember working for John on these sets and they were absolutely wonderful.[8]

LW: With Technicolor was there a great deal of input from the company themselves? I was thinking of colour consultants. What were your experiences of working with Technicolor as a company?

OM: Well, this is an interesting point. I guessed you were going to ask this question and I think I can sum it up in two ways. Technicolor's aim in life was to sell colour, end of conversation. Eastmancolor was designed for you to *use* colour and that's basically the difference. If you went on a Technicolor picture and met the notorious Natalie Kalmus, as we all did. All she cared about was colour; she didn't care about performance, she didn't care about anything else, just colour and design. She was a pretty powerful woman because as you know she was divorced from Dr Kalmus and part of the divorce settlement was that she had the running of the European side. She would come on the set and she had the right to change the sets and the colours; the colours of the curtains, the colours of the walls. She might object to these and they would be changed, and silver was the kiss of death. If you put silver on the set she immediately came out with a spray and sprayed it matte because in the Technicolor system if there was a reflection, it split the colours of the spectrum. All the Technicolor camera assistants were armed with these sprays and when I first photographed colour films I used to see them going out and doing this. I mean there'd be a lot of silver on the photograph frames and they'd just go out and spray them because they would break the light up into colours. I said, 'What the hell are you doing?' and they said, 'We have to do that; it breaks the light up into colours and the plant don't like it.' I said 'I don't give a damn what the plant think, you're not going to do that.' [They would reply] 'Oh Natalie will be after you, you'd better watch out.' Then she'd come on the set and say, 'I hear you've not been spraying the picture frames?' And I'd say, 'Yes.' [Natalie would respond] 'You know, it's in our contract that we have the right to do this, to do that and to do the other.' Well, I was a bit flummoxed by that; there was a limit to what I could say. When you get a powerful director as [John] Huston was, she got her comeuppance. Well, we'll go through all what I did on *Moulin Rouge* in a bit, but we broke every rule in the book and I didn't care because it was my first big break in colour and I was determined that I'd either get it right or I'd be fired and it wouldn't be much of a problem if I was fired because I wasn't very well known. But he [Huston] backed me up to the hilt. She tried to throw her weight around and got the full force of his feelings, and she never came on the set again after that. God, if she'd seen what we did! As you know, Technicolor tried to get me fired on the film. Somewhere or other I had a copy and I unfortunately can't find it now, but I had a three-page letter which was sent.

SS: I'm quite curious about what Joan Bridge did in relation to operating in colour. According to other people she actually did more than Natalie Kalmus and she'd worked for Dufaycolor.

OM: Joan Bridge was the colour consultant and she got a credit [on the film] as colour consultant and her job was to do what I've been telling you, but she did it with great

dignity and she was sensible about it. If there was something very extreme she would come up to me and say, 'You don't mind me saying, do you, but we…' – meaning – 'Technicolor are a bit worried about the colours of those cushions. Do you mind if I ask if we can get them changed?' Things like that she'd do, she'd go to the designer. She did it in a very diplomatic way but Natalie wouldn't. Joan knew that this idea of refracted light on silver was really a joke and she never intervened on that and I stopped the assistants from spraying at all.

SS: So it wouldn't actually have the effect that they thought?

OM: No. She [Natalie Kalmus] was a showman and she could be a very difficult lady. She used to have the most ghastly collection of hats; they were designed to promote colour. I remember she came on one day with a hat on which had fruit, all grapes and bananas and so on all around the band of the hat she had on, and it's just selling colour. But she had no taste, she really didn't. Joan Bridge did have taste and was very diplomatic and was a lovely woman.

SS: So she was in some respect maybe a more significant figure?

OM: Yes, yes, she'd be very welcome on the stage but in the end you know we were trying to keep Natalie off the stage and thank God she wasn't with us all the time. I've read a lot about her now and she wasn't liked anywhere. I thought maybe it was just me. They [Technicolor] had the right to withdraw as they were a franchise. As you know you hire the whole system. They had the right to withdraw from a film, but I've never known them do that – I don't think she would have dared. So Joan was lovely and when she left them she teamed up with Liz Haffenden, didn't she? I think she did *Moby Dick*, didn't she? So she [Joan Bridge] was first with Technicolor and then with Liz Haffenden.[9] Now you may know their contribution was tremendous. They aged all the costumes [on *Moby Dick*]; they worked very carefully ageing them down around the cuffs and the collars and putting the grease on and that and they made a wonderful job of it.

LIZ WATKINS: So if someone came on set and asked you to make changes, that was part of the performance of marketing Technicolor, drawing attention to colour and marketing the process?

OM: That's all she [Natalie Kalmus] cared about. She didn't care about the performance or the picture or anything. All she cared about was colour.

SS: It's interesting because all that time there wasn't really a rival to Technicolor.

OM: Oh, there was no rival at that time.

SS: So it wasn't that she was trying to make it look different from other colour systems? Dufaycolor was used for a Coronation film in 1937 and there were several versions shot, one in Dufaycolor, one in Technicolor and one was in a system called British Realita.

OM: Now tell me, when did Dufaycolor cease? What year?

SS: I think it was late 1930s or early war period.

OM: So there was no post-war? The reason I ask, and I digress slightly, I was doing a black-and-white film at Elstree and we'd just finished and they asked me if I'd do a colour test for a new colour system at Elstree. Was there any colour system based in Elstree, over in the Rock Studios, somewhere there? All I remember is they wanted the 800 key [lighting]. They brought some film on and I did the test and we never heard another word

about it, so I can only assume it was a total disaster. Whether it was me that had done it wrong or not, I don't know, but nobody ever came and said, 'Well, you made a mess of it.' I was lighting then, and I started lighting in 1949 so this might have been 1950 or 1951.[10]

LW: I was wondering as Eastmancolor came in as an alternative colour process whether cost was a factor in choosing which colour process to use?

OM: Oh yes, most definitely costs came in to it. I mean the costs on a Technicolor film rocketed up – I mean the electrical bill.

LW: Of course, the lighting.

OM: The electrical bill would be 800 [ft candles] instead of 200, that's four times what was normal and it all has to be arc light and you have to have more electricians because they have to trim the arcs and put new carbons in because the carbons burn. You need more manual labour for moving everything; you need more standbys because everything is so much heavier. The whole thing is like comparing a lawnmower to a steamroller in bulk. It cost much, much more money. That's why so few were made. Did you know while we're talking about this they had six cameras and the six were deployed? You have to have a back up on each camera on each film, so there were two allocated to each production so they could only have two colour productions going at the one time. That takes four cameras although they only used two; you must have a back up for insurance purposes. The fifth one did the shorts, the *World Windows*.[11] There was a wonderful Technicolor series called *World Windows* which Jack Cardiff photographed; that was camera number five. Camera number six was kept at the plant to do titles and all special effects work, did you know all that?

SS: I think not so much about the specific uses.

OM: Well, it's an important point that there were only ever six cameras.

SS: So with the *World Windows* series we were talking earlier about how unwieldy for that sort of filming it must have been?

OM: Yes, I think most of it was shot with a silent camera. I've an idea there was a commentary put on it afterwards, I can't remember but they were very impressive, they really were. I mean this is Technicolor selling colour, it really was but that's the allocation. If you went abroad on location then you had to take the second camera, but you only took the camera, you didn't take another blimp. I mean, God, it's heavy enough taking the one.

LW: The second part of the question would be whether Eastmancolor had any comparable code of practice for using their process?

OM: Were they worried about how we did it? No, they knew they were on to a winner because they destroyed Technicolor overnight. The three-strip processing went on for a long time afterwards, but the shooting in Technicolor virtually stopped overnight. But there were terrible problems with Eastmancolor at the beginning. They were so keen to knock Technicolor off the block that I think they brought Eastmancolor on before they were really ready because we had horrendous problems at the outset. I did the first Eastmancolor film in this country which was *Moby Dick*. On the initial front end there wasn't a problem too much – there were irregularities in the batches of stock. In black and white there were irregularities so you'd get a whole batch number of stock allocated to your film (100,000 feet of film). You know they make it in a big roll and then they slice

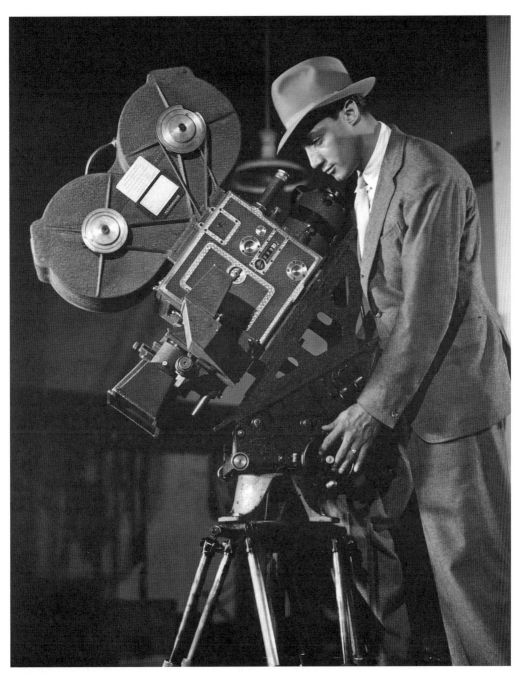

Jack Cardiff

it up into small rolls and they call that a batch; in other words it's that one chemical emulsion. Now with Eastmancolor they started the same way and that was fine, although we had our teething troubles, but it was wonderful using those light cameras and shooting colour and getting it the next day. I mean with Technicolor we didn't see any colour for a fortnight. When you're on a Technicolor film your rushes are in black and white and the drill was that at the end of a roll they issued a pilot. Say we'd been filming in this set – at the end of the roll before we reload – they would either just get the actors to stand there or they'd just have the set and they'd allow us ten feet of film. That's thirty feet of film really because it's three times ten feet running through the camera and that's called a pilot. You would see those a fortnight later. Now if there was anything wrong on this set, there was no chance of doing a retake once you'd seen the pilot because the sets were destroyed or were somewhere else, and if you're on location, you could be fifty miles away when you saw the pilots a fortnight later. Now I must emphasise this was the terrible thing about the Technicolor system, but it was the only system.

SS: Although perhaps because of that, even though Technicolor might object, it wasn't practical to reshoot anything. I suppose they might have thought, 'Oh, we'll live with it' because of the cost?

OM: Yes, but I must underline this business that you really photographed the film blind almost. The whole film; because the pilots came on and really you're two weeks ahead and you think, 'What did we do there?' and you can't remember. And you just see a flash of it and then you see a flash of something else and it's only ten seconds, and after that they pruned it down to five to save money, and that was a problem. It's like making a film when you're blind really. And the black-and-white [rushes] were taken off of one of the records and they were the world's worst black-and-white prints. I mean how directors could ever visualise what we'd been doing when they saw the next day a washed-out black-and-white print I don't know. And what a shock it is when you see it all in colour because it suddenly becomes much more powerful. The colours sort of leap out at you because Technicolor were the greatest ones in the world for piling on the colour. The thing was to tell them to cut the colour down and they didn't like that. They really were …

LW: Colourful?

OM: They were out to sell colour. They had the franchise and nobody was going to stop them. The whole system was like a Sherman tank and then there's this big delay before you see the thing in colour and then when you see it in the end you can't alter anything because they've got it locked in. They've got their matrices, they're not going to change what they've got because it's cost them a lot of money. You say, 'Well, can you reprint that reel a little bit lighter or a little bit darker?' Well, they'll do that but you say, 'That's a bit green. Can you do anything about that?' They'd say, 'Oh yes, we do that' and they might do you another reel of it just as a gesture but it's just the same really, they haven't altered anything. It means they've got to alter all their matrices and everything and they're not about to do that because that's their cost.

SS: The negatives would have to go to the lab where the process was by imbibition to make it a single strip? That was an elaborate process, but that was their big breakthrough wasn't it?

OM: That's right, that and the prism in the camera. That was the secret. Do you know nobody was allowed in that part of the laboratory where they did the imbibition prints? That was absolutely forbidden and only certain employees were allowed to go in there. I was never allowed to go in there; no cinematographer was allowed to go in there. Les Ostinelli, who's a famous contact man between the studio and the laboratory, even he wasn't allowed to go in. He'd go round in the mornings when they were delivered and get the comments from the cinematographer and the director.

SS: So Eastmancolor must have seemed like a dream?

OM: Well, it was like a dream. Anyway I've digressed slightly. I was telling you about Eastmancolor and about the problems we had. The problems were, now how can I put it? Not only was it difficult for them to get the prints right. When films reach what they call the answer-print stage – that's the one where it's delivered to the distributor or producer and he approves it and then they do the prints – up to that stage a print has come off the original negative. When that's approved, the first thing they do is make dupe negatives and they make say, six or twelve. Now if the film's made in England, six of those dupe negatives will go to America and the others will be distributed around Europe [to the Technicolor plants]. The prints are made not from the original because the insurance companies insist on the original being locked away in a vault. And that's the same for black and white. Well it was in my day. I think it's a bit different now with DVDs and things like that with the new digital process, but even on black-and-white film the answer print was made from the original and then the dupes were made from the original and the originals put in the vault. Now why am I telling you all this? Well, when Eastmancolor came in, not only were there problems with the original printing, but there were terrible problems with making a dupe. All the colours went in the shadows. The shadows were going green and they were having terrible problems with the contrast and often what you saw on a dupe was so depressing compared with the original that they had great, great problems. We went through the wringer as you'd say in the early stages of Eastmancolor because of this duping problem and this went on for several years, particularly with what we call under-exposure. Now underexposure is the detail in the shadows in a print, but on a grander scale, when we shoot what we call day for night – that's where we turn the sunlight into moonlight – we go outside and we put filters on cameras and graduated filters on the sky and we turn, say, a scene in the landscape which is shot in daylight, and try and turn it into moonlight. It's a bit difficult to do that but that's part of the job we have to do because producers want to go out and shoot at night, but they're not prepared to take the lights out there as it's costing too much money. Now that was also a great problem, because what you're really doing is underexposing the negative so they can get it darker; print it heavier. If you give it to them as a day negative they can't put enough light through it to darken it. So we have to underexpose the negative and we used to underexpose it by about two stops. Then it goes to the laboratory and they can do a heavy print with under-exposed negative and get it dark enough, but you can see everything still. Now, to develop that, what we used to do and this may confuse you, we'd get the sun round as a back-light and turn it into moonlight. It's easier to do that than to have a frontlight sun and try and turn that into moonlight. It didn't seem to work but sometimes we could do things like that. There were terrible problems with that [practice] and duping that which is already

underexposed was horrendous. We used to use black-and-white filters – there was a series of filters we could use in black and white to get night effects – and we were using those on colour film to try [and achieve this look]. Technicolor didn't know anything about this but we were trying to get this wretched colour thing sorted out. It really was a horrendous problem. We had this on *Moby Dick* all the time because of it being the first film. I'm absolutely amazed it looks as good as it does today.

SS: Can I just ask you something about filters as it seems to come up naturally before we talk more about *Moby Dick*? My understanding is, and perhaps you'll know, that with Technicolor films it was fairly unusual for people to use filters on the camera, not necessarily on lights, but on the camera it would be seen as a bit experimental?

OM: Well, between you and me, I don't think there were any filters made because the lenses were much bigger and the black-and-white filters were made for a black-and-white camera which was smaller. The only thing we might have used is that we put a graduated filter on to darken the sky a little bit to make it a little more moody, but I'm not sure whether we were able to do that with the three-strip camera. I don't think we were because you'd need a special matte box on the front and Technicolor made the matte boxes. They wouldn't make matte boxes you see, they'd say, 'Sorry, chum, we haven't got a matte box and we haven't got a filter big enough', because they needed bigger filters because the lenses were bigger.

SS: I suppose with Eastmancolor, then, that was a considerable advantage and the experiments and what you were able to achieve were only possible because of that?

OM: Yes, that's absolutely right.

LW: Perhaps this links with Eastmancolor as well; could we ask about *The Man Who Never Was* (1955)?

OM: Oh, yes.

LW: Was there anything in particular that you would take into consideration with colour using CinemaScope lenses?

OM: Well, no – CinemaScope with colour – it didn't make much difference. The problems with CinemaScope in the original applied both to black and white and to colour, but that wasn't the fault of Technicolor. That was the Bausch and Lomb [adapter lens] that they were using, trying to get them so that they didn't distort on the edges, but that was nothing to do with Technicolor. That applied to black and white as well really. The main problem when Eastmancolor came in was the duping process. Somebody you ought to interview about this is a man called Les Ostinelli.[12] I know he'd love to talk to you about it because he'll tell you all about the lab end of it. He was the one. I know they've got a three-strip camera at the club house at Pinewood Studios and Les was instrumental in getting that there and looks after it. He would show you the camera. Now what do you want to ask about *Moby Dick*? *Moby Dick* was in a class of its own really; it's definitely a one-off. It received very good notices photographically and Huston was over the moon about it and you'll see it in the book that he sent me [Morris's autobiography], the way it was received in Los Angeles was wonderful. So I was now in his good books, you know, I had passed my exam with *Moulin Rouge*. We haven't talked

about the fog and the mist and everything in *Moby Dick*. I don't know whether you want to talk about that?

SS: Oh, yes, absolutely.

OM: We can go back to that. I said to him, 'How do you see the film?' He said he'd love if it were possible to have an edging, a black-and-white image around the outline of the characters as though it was a pen drawing with colour wash in it. Well, oh good, I thought, this is something, how do we do it? But by now I had Technicolor eating out of my hand. Having done their best to fire me and not succeeded and having heard that Technicolor got wonderful rave reviews in America [for *Moulin Rouge*], and Dr Kalmus had sent a message to London congratulating them on what a wonderful job they'd made of the colour system on *Moulin Rouge* (no mention of me, of course, but he thanked the plant for what they'd done), they'd do anything. So I thought, 'Now, how do we do it?' So a stills man went down from *Life Magazine* to a harbour that's similar to New Bedford in the book and the nearest town we could think of was New Haven. We wanted to try and get a colour wash with an outline with a pencil outline. I said,

> From my point of view, I wonder if we could get the pencil outline and if we get a negative and a positive together and we printed it with the light going not there, but the light going round the edge?

This is all pie-in-the-sky talk really but we were desperate to find something and he said, 'Well, I'll go and do some tests.' So off he goes down to New Haven and he comes back and he's working on the negative. He got some sort of effect and we were going to put a colour wash on it as well you see. So I showed this to George Gunn, who was running the plant for Technicolor by then, and I said, 'Do you think you could have a go and see if you can do something about this?' Well, they're desperate now to get in Huston's good books so they'd do anything. So they stripped a printer down and they somehow got a revolving light round it. I don't know how they did it but they did that and we shot some tests in colour. The colour wash wasn't a problem, they can do that easily with what we called wide-cut filters on the printers and that softens the colours. So that wasn't going to be a problem, but the problem was getting the outline. Well, I must give them full credit, they tried time and time again to get it and we were getting a form of outline, but the grain of the positive wasn't fine enough for what we were trying to do. We were expecting too much of it and the grain particles were breaking up and instead of having a clean black line like this print, it was blurred and it was moving as every frame was slightly different and it really wasn't acceptable. Now, we were due to start the film and Huston would come up to me and say, 'Os, how's my boy? How's my boy?' You see, I'm well in by now. I said, 'Fine, John.' [Huston]: 'How's the colour system going, kid?' [Morris replied]: 'John, we've got problems.' [Huston]: 'Oh well, come and see me when you've got them sorted out.' [Morris]: 'Yes, John, we will.' In the meantime, I'm thinking, 'I don't think we're going to be able to get the colour system before we start this film and I'd better go and tell him.' We tried and we tried and in the end it just wouldn't work, we were on the wrong track and about the week before we were going to Ireland to start on the film with no colour system. I went to the plant at West Drayton and I happened to go

into the theatre and I saw them running a very washed-out print of *Richard III* (1955). It was very pastel and washed out and it looked very interesting, nothing like I'd ever seen in colour before. I said to them, 'What are you doing this for?' And they said, 'It's for television.' I said, 'Why do television want it?' and they said, 'Well, they have to have pastel washed-out prints because the system can't take the normal contrast of a print.' I thought that was interesting; it looked like a very washed-out print. So I went into George Gunn's office and I said,

> I've just seen something in the theatre and you're probably going to curse me for this because I think we're on to something that might be an idea for *Moby Dick* – washed-out colour – is that a problem for when you print your answer prints?

He said, 'No, we do it all the time to print for television. We do it using what they call wide-cut filter.' I said, 'Now, how can we get the contrast back into it – could you add a black and white to that? A washed-out black and white and bring the contrast back?' He said they could do it – it would mean going through the process four times instead of three. For the colour system [Technicolor] they have three matrices and they've got three films in the camera and three matrices. In the camera it's red, blue and green. In the matrices they call them yellow, cyan and magenta; don't ask me why, but they're not the actual complementary colours but that's something to do with the system. So I said,

> Look, the tests that we shot and you tried the other way, we've still got the negative. Will you have a go and see what you can do because I've got to go to Ireland? We've got to start the film there, I don't know what to do.

So I went to John Huston and said,

> We're going to have to start in Ireland without the colour process, but I've got something – I think it's going to work. I said it won't affect you if you don't mind, you just shoot normally and let me look after it. All I'm going to ask is if sometimes we've got a very bright blue sea could you do something else because you get the blue seas with sun but it appears pastel with overcast, because, as you know, seas are really a reflection of the sky.

So he said, 'Fine, kid, fine.' And that's what we did. We started and they did this test and they brought it out to Ireland for us to see. We'd been shooting about two weeks and it seemed to be right and that's the system we used. It's the only film that's ever used the four matrix colour system.[13]

SS: Is that like four strips?

OM: Every print had to go through four processes. Now, I never knew if they were all on one machine. My guess is they were because it would start with the first process, go on to the second, go on to the third and they had to be absolutely [in alignment] – registration was a terrible problem. It's only got to be a thousandth of an inch out, you see, and a colour comes on the side. By the outline there'd be a colour leak out. Now they've got four to deal with and I don't know to this day whether the machines could take a fourth.

But they often said they had to do a special run but I don't think that would work because you might not get the fourth one exactly over the other three, but that's the way it was done.

SS: And the stock was Eastmancolor? That was the Eastman contribution, but the technical process was Technicolor?

OM: Yes, the stock was Eastman, but even the Technicolor print positive was made by Kodak, always has been. I go through the wringer every time I talk about this – I don't know how the hell we did it.

SS: Yes, it's amazing. We were watching bits of it again yesterday.

OM: Yes? I watched a clip of it the other day and it's the concept that Huston had. By modern standards you'd probably say, well they can do that now easily, and they can, but they couldn't in those days. You put it up against a Technicolor print and it's totally different.

SS: Technicolor's an exceptional colour process and I was wondering to what extent you'd work with set designers on a film such as *Moby Dick*?

OM: No, not really. A designer can work in black and white, or work in colour. I mean we obviously worked together. I spent a lot of time in their offices when they're building or designing the sets, but it doesn't make any difference whether it's black and white or colour. If a designer wants to use an unusual colour they'll come to me and say, 'Do you think we're sticking our necks out with this?' I'd say, 'Well, show me where you want to use it' and I'd say, 'No, that's all right, I think we'll get away with it.' Or if I see something going up and I see a ghastly colour wallpaper I'd say, 'Are you serious about this wallpaper?' And he'd say, 'Well, why, what's the matter with it?' I'd say, 'Well, we're supposed to look at the actor's faces but not with that wallpaper. Do you want me to keep all the lights off the wall a bit or do you think there's a chance you could change it?' And he said, 'Yes, if you feel strongly' and so they'll change it, you know? But if not, I'll say, 'No? Well, we'll get you out of trouble, I'll keep the light off of that.' We'd do things like that. Wonderful, top designers are very flexible, but they're brilliant. It's such a pleasure to work with them. The sets are so beautifully designed, they're composed and you can get a [cinematographic] composition anywhere. A bad designer, you can see it as soon as you walk on the set and you think, 'God, what have I let myself in for?' I must say that the latter half of my career I always checked who the designer was before I did the film. I've worked with some wonderful ones.

LW: If you're working with colour from the composition of the set how would you address that in a moving image composition that keeps shifting?

OM: Composition is decided by the director more than me. I'm his servant really. He has the right to compose any way he wants to and he composes to the action. Let's take *Moby Dick*, where you see a print of a whaling boat. If you choose the right locations, it does it for you. The secret is to choose the right location. When the Pequod leaves New Bedford, there's a big scene on the dock before it goes and there are a lot of whaling prints showing these boats. We went to a place called Youghal, west of Cork and it was an old harbour, but it was absolutely right. The only problem was it was silted up and we couldn't get the Pequod in there. So Huston said we'd dredge it out. They made the company pay for getting a dredger in and they dredged out the harbour along the jetty so at

least the Pequod could get in and get out. The other half of the harbour we couldn't use because it was silted up, so we just did the bit along the berth. Now that's the sort of thing, you see, it's taken from the whaling print. The Pequod was designed from the whaling prints, so you've got that, and the harbour is as in the whaling print. So you've got it all there. You mustn't inhibit the director from doing what he wants, because that's the most important thing. You'd get the actors dressed the same way as they are in the whaling prints. Like in the New Bedford scene, the two men, including the wonderful man with the beard and the big round black hat, who engage the crew for the boat are taken from a print. If I remember rightly, the actors are almost exact replicas. So you do all that and that's the way you get it, but you mustn't stop the director doing something he wants to do just because there isn't a print showing that they did that, you know?

LW: And visual characteristics like a colour wash or the lighting in a painting?

OM: Well, most of the whaling prints are pencil sketches so that's why we were knocking the colour down as much as we could.

SS: Did you use storyboards at all?

OM: Never, no! That's a point of interest. The industry's changed totally since I retired. No director that I know of would ever use a storyboard. He would take it as an insult to his intelligence, but I must say that there was one exception. That was the whaling sequence, the white whale sequence in *Moby Dick*. That had to be storyboarded, not because of Huston, but because we had to have three sizes of whale. We had to have the full-size pieces, the head, the midriff and the tail section. We had to have a one-tenth scale or size for working and then we had to have a real miniature size for the action when the whale goes into the Pequod. So you had to storyboard the picture because three units are working at one time. Huston would be with me working with the principals. Now we may be working on the jaw section, or we may be working on the midsection. We didn't do anything much on the tail section. So while we're doing that we had other units working on the middle and the tail section to save money. You have to do that otherwise it costs a fortune, but really that's the way we did it.

SS: So would a shooting script contain fairly detailed instructions because your films often have wonderful low and high angles in them and I wondered if those were your ideas and how you'd communicate with the director?

OM: For the fin section, the description is in the Melville novel and you'd take that because John doted on the book. He always thought it was absolutely wonderful and we went by that really, but you had to have those storyboards but an absolute minimum because if you did too much he'd take it as a personal insult, you know, like he didn't know what he was doing or something so you had to be a bit careful. But nowadays because of the digital age so much is done green screen. We used to call it blue screen but having said that I did a musical picture with Norman Jewison, *Fiddler on the Roof*. A DVD has come out which has got a promotional hour-long documentary about it. I'm interviewed as well as Norman and he lets the cat out of the bag that he did have some sketches made for some of the dance numbers. Well, I never knew that, none of it came on the set certainly, but I don't count those as being storyboards as far as I'm concerned. But nowadays everything's storyboarded and they're locked in and that's what you've got to use. Norman had them, I think, as a guide but never brought them on the set, but

that's the end of it, no other director. You wouldn't get David Lean, Carol Reed with a storyboard. Stanley Kubrick with a storyboard? Forget it. Dear, oh dear, they'd take it as an insult. None of them had storyboards.

LW: Is there anything particular that you look for in the composition of a shot that would lend itself to a certain edit, such as a dissolve?

OM: Well, obviously you don't just do them. The first or second part of the dissolve – doesn't matter which you do – and then when you do the other part you keep in mind what you've done in the first part. In other words, if the picture fades out or dissolves on a long shot, you often dissolve into a big head to make it more interesting on the next shot you know? There's a deliberate visual tension there. You don't often dissolve from a long shot to another long shot; it seems pointless to do that. You want to do something totally different really and that's usually partly in the writing, but if it's not then we make a point, you know, we discuss it with the director when we're shooting it. If we're doing the first part I'll ask, 'What are you going to dissolve to at the end of this shot?', and he might say, 'Well, it'll probably be a long shot of so and so.' So I'd say, 'And are you going to pan or are we going to finish on this one?' He said, 'Well, I thought we'd finish on the long shot here.' And I might say, 'A long shot to a long shot? That's not very interesting, is it?' and he said, 'Well, what do you suggest?' I said, 'Well can't we go out on a big head or something?' A classic one is to dissolve on a movement going left to right to a movement going right to left, so they're opposite ways so that when it dissolves it does something interesting. It doesn't usually work if you dissolve right to left into right to left; it looks as though you haven't thought it through. You design a dissolve. There's no law about it, you just kind of make it interesting. They just put 'dissolve to' in the script; they don't say what, the scriptwriters don't.

SS: So you would know it was coming up, yes?

OM: Most stage directors hate stage direction in the script; they think that's an insult.

SS: So they would just tell you as they were going along, say, that it might be a good idea to try this or that to see how it looks?

OM: Yes. A classic thing that a director doesn't like in a script is, say, when a man and woman are sitting at a table. Say she gets up, goes to the sideboard and gets a drink and then comes back and sits in the chair. They just hate that and they just won't do it. I mean it's an insult, telling them how to direct the film; they direct the film. They would use the dialogue, but they must do the stage directions. Now in more modern scripts you don't get stage direction now. I don't know what they do now with the digital age – it's all storyboarding, I think – but you wouldn't dare storyboard any of the directors I worked with; they'd throw the thing back at you.

LW: Shall we talk about *Moulin Rouge* a bit more? [This section of the interview includes commentary when SS and LW viewed a DVD copy of the film with OM.]

OM: Yes, of course. Can I just tell you one thing about that? It's very subtle in the film and I'm not sure it gets picked up. The fill light – that's the soft light that goes in with the key light – the key light is the bright light – well for the side light we have a different colour fill light for three characters. The ballet dancer Colette Marchand [plays Marie Charlet] she had a violet fill light; every time she appeared she had a fill light. Suzanne Flon [Myriamme

Hayem], who played the serious one who he falls in love with, she had a pink fill light and José Ferrer had a green fill light. Now that was something totally new that had never been done before and Huston was very keen on that. I mean I suggested that to him and he jumped at it; anything new he'd use.

SS: So the idea behind that was to differentiate the characters? For them to each have a different hue?

OM: Yes. When Colette Marchand, she gets very drunk in one of the bar scenes, we intensified the strength of the fill light so she went more purple and I think she had a purple dress on. When José Ferrer gets very drunk in one of the bars towards the end, just before he dies, we accentuated the green fill light and I don't know if it shows up on all the copies but on the main copies that we showed on film it did show up how we used colour to help character. Now I don't think that had ever been done in a film before and God, it was a pain, we had so much equipment going and so many filters and were having to change them in the arc lights because keep in mind that it was all arc light and we still had to change these filters.

SS: Now we love this quote from you where you say, 'Filters, diffusion, colour. It's the name of the game.'[14]

OM: Yes, yes.

SS: It does seem that that film was experimental in that some of the images look like paintings.

OM: Yes, well if you had come on the set and seen, you'd have thought I was mad, absolutely stark raving mad. And the problems we had, well, it's all documented in there I think [indicates autobiography on the table] with electricians going on strike because they couldn't breathe because of the amount of fog I was using all day. Six days a week we were doing this and I was trying to keep the doors closed to keep it in at lunchtime, but the electricians were going on strike and they were threatening to leave the film. The doctor was called and it was recommended to give them more milk, so we sent them churns of milk up and that didn't work. The idea was they could drink it and it would counter the mist and stuff we were using and I really wasn't very popular because Technicolor can cut through mist. That's another thing that's not known. If we were doing a fog scene you'd use much more fog in colour than you did in black and white. Colour cuts through fog unbelievably; it's quite uncanny. The camera can often see better than we can almost. In black and white it's different, you have to be very careful and go very easy, it's very sensitive to fog. If you ask me how you do it, well it's only by experience and I'm the only one that can judge it, you know? You get to know with black and white whether it needs a bit of fog or mist in and often we used it in interior scenes. In *Moulin Rouge*, of course, we used it a lot, in some of the bar scenes in particular. The whole picture was shot with a filter on the camera.

SS: So what does that do exactly? Can you tell us a bit more about it?

OM: It was to make it look more like the paintings.[15]

SS: So it's colourless, but has a sort of opaqueness?

OM: Yes, yes. In the industry we use what we call diffusers on ladies' close-ups to make them look nice. It also takes the harshness away from the set. We used a fog filter on the

camera and I used fog in the studio and I went round all day with a machine spraying this fog and particularly around the camera because nobody else was interested in it. Everyone wanted to get rid of it except me. And I must say John Huston thought it was great what I was doing and he was wonderful with it, but a lot of people complained; I wasn't exactly flavour of the month on that film.

SS: In the scene where he's walking down the lane and he's alone it's almost like a black-and-white effect?

OM: Yes, yes, after he's been in the Moulin Rouge and he's going home, where he meets the prostitute.

SS: Yes, that's right. Was that less heavily filtered?

OM: No, we couldn't use fog in France because of the wind and we were having terrible problems with the wind because we had so much light and to light those [shots] at night it was a monumental thing, but I used a very heavy fog filter on the camera.

SS: So there was a fog filter on that? It just seems slightly clearer than from inside the Moulin Rouge, but then when you fade up that works, because it isn't quite so …

OM: Yes, that's it, I couldn't use fog so …

SS: So that wasn't the studio? That was on location?

OM: That was Montmartre and the printing office where he prints the posters, that's an actual printer in Paris. There's a scene in Maxim's which was really done in Maxim's the restaurant. I can't tell you how embarrassed I was with what we were doing in there. It was a lovely restaurant and having to take in these arc lights with carbons and carbon dust coming out of the top of the lights.

SS: The opening sequence is amazing.

LW: The camera movement through the dance and around across …

OM: Yes, that was a very strict technical operation. Mind you, that opening movement of course is a silent camera, in other words, just the camera on the crane because they're dancing to a playback so you don't have to blimp the playback. It's up on the band and then it comes down the stairs and over the heads of the dancers and it comes down and the dancers are doing the kicking in the foreground.

OM: One question I often ask people who have see the film is, 'Can you remember the colours of the costumes of the dancers in the can-can in the first part?' Very few of them can remember the colours and then I say to them, 'Can you remember the colours of their underskirts and their underpants?' and they all remember they were white. Now that isn't by accident; that is because of the way it's shot. We had to get the camera right in amongst the dancers so that you see the flurry of their skirts; its almost like they're birds flying around and you see their faces when they do the splits and crash down onto the floor and that's all quite deliberately done. If that had been filmed a long way back, it wouldn't have been nearly as effective. Nobody notices this but it's right, we've made the audience look at those sort of things. Freddie Francis, who was operating for me then, had a huge crane with a camera hanging underneath it and he was walking along the floor. It was quite dangerous because they were going quite close. If those girls had kicked the camera they could've gashed their legs. It's not as though it was a light one like you get now.

LW: The whiteness and diffusion in that film is quite remarkable, because it works so effectively in the story; it reflects from the tablecloth when Lautrec's drawing on it.

OM: Yes, oh yes. Well you see now, that's another story which reminds me. One of the tricks with Technicolor was that you couldn't have white tablecloths, they had to be dipped and they called it 'Dipped Tech 1, Dipped Tech 2 or Dipped Tech 3' and that meant taking the whiteness down towards a grey. They had the power to do this although of course they weren't allowed to do it on *Moulin Rouge* because the girls' skirts were pure white.

SS: Is that because they didn't want them to be too distracting? What was the idea behind that?

OM: Well, it's like the silver around there with the sun on it [indicates a silver picture frame standing on the table]. It's the same rubbishy thing [they said] that they would be *too* white and they'd burn out. At 800 ft candles I should think they would on a white table-cloth and so you used to have to dip them all. In the end we found out that a cheaper way of doing it was to dip them in tea, but when you saw them in Technicolor three-strip they looked white.

LW: The placing of the mirrors and windows as well seemed to have quite a specific effect?

OM: Yes, the sketching that José Ferrer does on the tablecloth. That was Marcel Vertès' [décor and costumes] hand doing it.

SS: Yes, because the drawings are wonderful and often in films there's an attempt made, but ...

OM: Yes, I know he was hired because he was an artist and knew of Lautrec. We put the camera over his shoulder and he did the sketching on the tablecloth.

[...]

[In relation to the first can-can sequence of *Moulin Rouge*] If you were to see this in straight Technicolor it would look ghastly. All of this is done by what's called a silent camera because they were dancing to a playback and the music's already recorded. We tried to get the angles the same as the posters so we had all the references. There's a mass of smoke in that set, you see, and it's shot through a fog filter.

LW: Zsa Zsa Gabor – her shots seem so clear.

OM: Did you think so?

LW: Was that to make the colours associated with her more vibrant?

OM: I don't remember her interfering with my side of it. It's difficult to get the smoke there. If she had complained I wouldn't have taken any notice of her. It's difficult to keep it even all the time with everyone grumbling all day and choking.

LW: Any movement would disturb the smoke?

OM: Yes.

SS: It had to be done as a combination of fog and filter together, did it?

OM: A combination of the two, yes. I couldn't afford to take one off; I wasn't experienced enough to dare to do that.

LW: Did the fog filter have an effect on the clarity of the close-ups?

OM: It's difficult to get the depth with fog as you see people less and less clearly into the distance, but if you put a fog filter on it's the same for all of them ... but it helped counter bad gaps [in the even distribution of the fog] if we had a fog filter on.

[…]

OM: [regarding Lautrec's studio interior] The colours were knocked down quite a lot. The real Technicolor could not do this so we had to knock it down.

SS: The lighting's wonderful with the sources in the room and through the window.

OM: And when he starts to gas himself, that's when the blue-green comes in.

LW: That colour seems to be associated with the night scenes too?

OM: Yes, it's associated with him, you see. The light on his face, I'm glad you're seeing this scene because there are all sorts of bogus things on the wall because he's about to gas himself ... you know he's not going to enjoy himself with that colour on the wall. Actually, it's totally bogus, that colour, but we put it in and nobody ever queries it.

LW: It's maybe something that's not immediately obvious because it's part of a colour system and integral to the film.

OM: You can see the blue-green colour and the pink at the edge of the screen, which means to say it's happier out there to emphasise his [Lautrec's] problems that he's having. I mean in the original film it's more pronounced than this, but it's not bad in this [DVD]. I think it just about comes across what we were doing.

LW: Another thing we liked was the way that a light source will often be in the frame and within the story and quite prominent or sometimes it will be turned down. So those effects are really quite striking.

OM: I was particularly pleased with the end of the can-can when Joe gets up to go out and the cleaners come into the hall and the lights go down gradually.

SS: Yes, that's wonderful.

OM: You can't dim arc lights so we have to put what we call shutters on the front. You know, like a Venetian blind. Well, imagine a Venetian blind where every other one went the opposite way. With a Venetian blind they all go down or up together don't they? If you put that over an arc light you see lines. Well, this was designed so that every other one is the opposite way and then for some unknown reason it doesn't show lines. So we had special metal dimmers on all the arcs with little motors on them that were remotely controlled by me down by the camera. If you let electricians do it, they don't all do it in time. We had about forty or fifty of these to be dimmed down slowly as he walked out of the door. It looks simple on the film but ...

SS: Yes, you see those things in films ...

LW: That's interesting because we picked up on a sense of the lighting and the lights that are visible in the film being part of the story, where as often they [films] conceal the sources.

OM: Yes. We had terrible trouble getting the dancer in the top hat, the one with the chin. I always think the chin looks as though it was stuck on, which it really was, and we had

terrible problems with that, getting it right. It never stayed the same colour for some reason, whether it's because he was sweating and perspiring or not, I don't know, but it's a good copy. He had the extra bridge on his nose and he had that stuck on every day and I'm very conscious of that as well, but nobody seems to notice or comment on it.

LW: I guess he picked up a shape or silhouette from one of the posters?

OM: Yes, that's right.

LW: Something that I also thought was quite distinctive in the film was at the start when you see that long tracking shot over the bar.

OM: Oh yes, I remember. I thought that was just part of the design, but you see reflections in it, don't you?

LW: It added to that sense of theatre.

LW: You mentioned filters and lighting. I was wondering if you could say a little more about close-ups?

OM: Yes, the rules apply for black and white, colour, Eastman or Technicolor; what you do for one you do with the other and if you want diffusion you can use it in colour or you can use it in black and white. I'm only talking about the effect I was making on the picture; I was fogging it up all the way through you know, but the ordinary rules are you do what you think is right and you can forget that one's colour and one is black and white. You just do what it is that you want to do; it's as simple as that really.

SS: Would you have to develop a slightly different style for a film like *Moby Dick* because it's mainly male characters and so was slightly unusual? I'm sure there are quite a few close-ups of the actors?

OM: I wouldn't use something like diffusion for shooting men, particularly on a film like *Moby Dick*. There's really no women except at the widows' wall when the Pequod puts to sea. Otherwise it's an all-male cast, so it really wasn't a problem, no filters. The problem there was trying to get the colour system we'd agreed we'd use and I think generally we did it apart from one or two scenes in the end where we were really running out of time. In fact, we were doing it down in the Canaries. We ran out of warm water. We started in the summer on July 4th I think. I remember that was the day my son was born. We had the men in the water off Fishguard for a lot of the summer. Then it got too cold to keep the men in the water a lot so we came in and did all the studio work and then at the end we went down to Las Palmas Christmas week, because we had to spend Christmas down there. I can remember that I wasn't very popular with my family. We did the rest of the water stuff there. Now there the sea was very blue and that was a problem, but luckily it's the stuff where he's fighting the whale, full of action and it's the end sequence where the coffin pops up and if you look the water is blue. But if we hadn't got the colour system working at that point we would have failed, but the audience accepted it. If the audience have accepted it in the first half, you'll get away with it not being so good in the second half.

SS: And because the coffin miraculously appears and it's expressive?

OM: Yes, that's true, yes. And getting the gulls there, yes, 'Watch the birds, watch the birds.' We were throwing fish over trying to get the gulls. 'Don't throw the fish in the camera', I can think of some little stories to tell you! You see taking a ship like the Pequod to sea isn't a piece of cake. We had a tug with us all of the time towing it, but we had to

get the tug away when we were filming it, you see? Now, it's a sailing ship. You're in the tropics in bright hot sunshine and they're all exhausted because of the heat and there'll be calm there and Huston lines up a shot and they're in bright sunshine. Fine, because it's no good them being in the heat if they're in shadow, because it looks dark, you see? Right, so he does another one and they're in the shadow, so what were we going to do? He doesn't care, that's my job. So I've got to get this boat turned around at sea so the sun's on the men on the other side as well. Otherwise it's dark and they're saying, 'Oh, the heat, the heat.' I don't know about heat, but they're saying it and it doesn't look hot, you see? So you've got to turn this thing around – he (Huston) doesn't care, he just sits and reads his book until we're ready? So I've got to get the tug to tow this thing round and also with the wind sometimes we'd do sailing stuff with the Pequod in the wind. You'd get the wind in the sail so say the wind's in the sail on the starboard side of the boat and then we'd do another shot and the wind changes so the sail's on the port side. So the continuity girl comes up to me and says, 'Well, you're not going to shoot this are, you?' and I'd say, 'We've got to.' She'd say, 'Well, you can't – the sail's not in the right place, it should be over that side', and I replied, 'Well, what do you expect me to do about it?' and she'd say, 'You've got to get it right.' So I've the problem with the sun, the problem with the sail. It's her job you see to make sure, because people pick up on this sort of thing, and that would go on and in the meantime the director's just sunning himself at the back just waiting for it to get sorted out and I've got the blue sea to think about.

LW: That must have been very inconsistent with the skies and the sea?

OM: Yes, with the sky, you can't match everything. You have to learn what you can get away with and you've got to be ahead of the thing and think – well, if he wants to do so and so then were going to get the land in the picture – now, what are we going to do about that? Sometimes you never go right out to sea because it takes you four or five hours to get out there and you've got two or three hours' work and you've got to get them back home at night because the crew by then are all on double time. So what you do is you go just off land and you try and work there, manoeuvring the boat round without showing the land. That's another problem you get just right and you say, 'Turn over' and the wretched thing swings and the land comes in and they're supposed to be miles out in the Pacific Ocean.

LW: Another question about *Moby Dick*, there's a sequence with green light …

OM: Oh, St Elmo's Fire? That was put on afterwards – I didn't do that. It's a form of lightning apparently that used to happen out there and that was put on later. They've got a problem there because if it's on a moving thing, it's very difficult for them to match it, whereas if it's absolutely still, they can do it quite easily with a double exposure, but when the thing's moving it's quite a different matter. I don't know how they do it quite; that's something that they keep a secret, but that was put on afterwards.

SS: Would you say that you have kind of a style that developed over the years with your cinematography?

OM: No, the picture dictates the style. For my ninetieth birthday the British Academy of Film and Television interviewed me and unknown to me they compiled clips which they put on and they stopped between each group of clips and I just had to talk about them. It's amazing, you see the different styles and the different colours. My job and the job of

any cinematographer is to try and get something fresh and different. If you just treat it as another film you're not doing the industry any good. I tried to approach every film differently and I've been accused of retiring at the peak of my career. I probably did but I couldn't be like dear old Jack Cardiff. He did wonderful work as a cinematographer, then he started to direct and it all went sideways with his direction. It didn't do very well and then he came back to photograph in films and he was but a shadow of what he was before. I didn't want that to happen to me. So much to a lot of people's disappointment, including my crew and a few of the camera houses and the people at production houses, I decided to retire for that reason. I didn't want to go downhill, I always wanted a challenge, something different.

SS: And the decision to go freelance when you'd had the opportunity to work in the security of the studios really shows your commitment.

OM: Well, yes, I can augment that. The first film I did was *Golden Salamander*. I was a camera operator as you know. There were four of us and they gave me my break. I wanted to do this one film for Ronnie Neame that was prepared to take me. I did the film and we were under contract as operators, but they'd just put down money to the minimum rate that they could do for a cinematographer. At the end of the film the studio said to me, 'Now look, we've not got another film for you as a cinematographer, but you can if willing come back to operate on films as you've done before', which would mean reducing my salary again. I talked to my wife and she was wonderful, she said, 'I'll back you whatever you do.' I decided to take a chance and I went freelance. It was a bit dodgy for the first two or three films, but then as you get known and really to get the Huston film, you've read the book, well I …

SS: Yes, it's an extraordinary story of how you were called and then you …

OM: I know, I just don't know how!

SS: Brilliant!

OM: But having said that, and now I'm thinking back, I'm very proud that I did stick my neck out on that film. I had everything to gain and nothing to lose. I couldn't very well lose anything as I was pretty well at the lowest end anyway of cinematographers. He [Huston] admired me for that – I didn't realise at the time but we took terrible chances. He backed me up to the hilt, I couldn't have done it without him. Technicolor would've crucified me, they really would.

SS: One of the areas we're interested in is whether there was a so-called 'British School of Technicolor'? I wondered what's your impression?

OM: A British School of Technicolor? There are two different interpretations: a British interpretation of colour and an American, typically Californian, which are totally different.

SS: What reminds me is talking about the light and I thought maybe the light quality?

OM: The light quality, yes, it's much more garish in Los Angeles. In the Westerns the cowboys are very heavily tanned and look rough and rugged; the sea is an ultramarine blue colour and the sand is bright golden. In England the colours are much more pastel and our outlook in colour even though it's the same system was much softer, more pastel colours. Now a lot of Americans liked our colour system. It's due to our light. In California it's a very harsh vicious sunlight and you go on the beaches and it's all over the top, glaring and

almost a sort of a vulgar light. Here it's much softer. I mean look out of that window now and you'll see that there's a soft sunlight coming out now and in America it would be harsher. So there's a total difference, total. There always has been and they also said that the processing of the three-strip over here was more conducive to the light that we used than in California, where they couldn't get the same quality of processing because of their light.

NOTES

1. Guy Green was a well-known British cinematographer who worked on many films and won an Academy Award for cinematography on *Great Expectations* (1946). Known mainly for black-and-white cinematography, he shot *Blanche Fury* in Technicolor, and went on to direct films.
2. Ray Rennahan (1896–1980) was a veteran American Technicolor cinematographer who pioneered early three-strip colour cinematography in the 1930s.
3. Accounts differ as to the number of available cameras in the 1930s. Duncan Petrie notes that there were four cameras in *The British Cinematographer* (London: BFI, 1996), p. 41. This same number is quoted by Frank Littlejohn and Bernard Happé in their interviews in this volume.
4. The viewfinder was a foot away from the lens.
5. 'Quickies' were lower-budget films made largely to satisfy nationality regulations in respect of the Cinematograph Films Acts of 1927 and 1938.
6. Morris also recalls this incident in his BECTU interview, 21 July 1987, Tape 9, with Alan Lawson.
7. Without a locking system the crane tipped up and the operator was thrown to the ground.
8. John Bryan (1911–69) was a celebrated British set designer who worked on films including *Pygmalion* (1938), *Great Expectations* and *Caesar and Cleopatra* (1945).
9. Liz Haffenden (1906–76) was a British film costume designer. She worked on many Gainsborough melodramas, for MGM-British and from 1959 as a freelance designer working with her partner Joan Bridge.
10. The process was most likely Dufaychrome, a process developed by Dufay-Chromex after World War II to rival Technicolor. Work on this was carried out at Elstree in the late 1940s, but the process never took off commercially.
11. The *World Windows* short travelogue films were shot in Technicolor during 1937–40 by Jack Cardiff in a number of locations, including India, Italy and Israel. Jack Cardiff describes filming the series in Justin Bowyer, *Conversations with Jack Cardiff* (London: Batsford, 2003), pp. 45–9.
12. Les Ostinelli (31 August 1918–14 October 2008) was a film laboratory technician who started his career as a camera and labs trainee at Denham Studios in 1935. Ostinelli later worked as a technician at Technicolor, going on to take consultancy roles at Olympic Labs, Humphries Labs and Rank Films Labs before serving as technical director at Technicolor, 1974–84. We met Les Ostinelli shortly before he died but he was not

well enough to give an interview. He was, however, interviewed as part of the BECTU project on 5 November 1992, Tape 266, a section of which is included in this volume.

13. John Calhoun describes the technique thus:

> Morris devised a complicated process; he shot the film on Eastmancolor but printed in Technicolor, adding a black-and-white pass to the three color dyes. This achieved a remarkable degree of saturation at that time, and it created a palette that was primarily gray, brown and black – and of course, white.
>
> (*American Cinematographer* vol. 84 no.11, November 2003, p. 120)

This process is also referred to as 'a black and white register being incorporated in the final printing' in Duncan Petrie, 'A Man for All Seasons', *American Cinematographer* vol. 81 no. 3, 2000, p. 42.

14. Morris used this phrase in a lighting seminar at Laguna Beach, California, 1985 that was reported by Robert Kray in *American Cinematographer* vol. 66 no. 4, April 1985, p. 109.

15. Morris went to the museum at Albi in the south of France to study Lautrec's paintings. See *Films and Filming* vol. 23 no. 7, April 1977, p. 11.

INTERVIEW
GUY GREEN [EXTRACT]

Guy Green (1913–2005) was born in Somerset. He first entered the film industry in 1929. He worked as a camera assistant at Sound City Studios before moving to Denham. He trained and then worked with many celebrated cinematographers and directors, including Gunther Krampf, Mutz Greenbaum, Ronald Neame, Michael Powell and Emeric Pressburger, David Lean and Carol Reed. His black-and-white cinematography was celebrated in particular for *Great Expectations* (Green won an Academy Award for cinematography) and *Oliver Twist* (1948). Well established at Cineguild, the production company formed by David Lean, Ronald Neame and Anthony Havelock-Allan in 1944, Green was camera operator on *This Happy Breed* before shooting *Blanche Fury*, his first Technicolor film. He shot other colour films including *The Story of Robin Hood* (1952) and *Decameron Nights* (1952). From the mid-1950s he gravitated towards film direction.

SELECT FILMOGRAPHY

1955 *I Am a Camera* (Henry Cornelius, GB: black and white) Cinematographer; *The Dark Avenger* (Henry Levin, USA: Technicolor) Cinematographer

1954 *Souls in Conflict* (Leonard Reeve and Dick Ross, GB: Eastmancolor) Cinematographer; *For Better, for Worse* (J. Lee Thompson, GB: Eastmancolor) Cinematographer

1953 *Rob Roy the Highland Rogue* (Harold French, GB/USA: Technicolor); *The Beggar's Opera* (Peter Brook, GB: Technicolor) Cinematographer

1952 *Decameron Nights* (Hugo Fregonese GB/Spain: Technicolor) Cinematographer; *The Hour of 13* (Harold French, GB: black and white) Cinematographer; *The Story of Robin Hood and His Merrie Men* (Ken Annakin, USA/GB: Technicolor) Cinematographer

1951 *Night without Stars* (Anthony Pelissier, GB: black and white) Cinematographer

1950 *Captain Horatio Hornblower R.N.* (Raoul Walsh, GB/USA: Technicolor) Cinematographer; *Madeleine* (David Lean, GB: black and white) Cinematographer

1949 *Adam and Evelyne* (Harold French, GB: black and white) Cinematographer

1948 *The Passionate Friends* (David Lean, GB: black and white) Cinematographer; *Oliver Twist* (David Lean, GB: black and white) Cinematographer

1947 *Blanche Fury* (Marc Allégret, GB: Technicolor) Cinematographer; *Take My Life* (Ronald Neame, GB: black and white) Cinematographer

1946 *Great Expectations* (David Lean, GB: black and white) Cinematographer; *Carnival* (Stanley Haynes, GB: black and white) Cinematographer

1944 *The Way Ahead* (Carol Reed, GB: black and white) Cinematographer; *This Happy Breed* (David Lean, GB: Technicolor) Camera operator

1943 *Escape to Danger* (Lance Comfort and Victor Hanbury, GB: black and white) Cinematographer

1942 *In Which We Serve* (Noel Coward and David Lean, GB: black and white) Camera operator

1935 *The Immortal Swan* (Edward Nakhimoff, GB: black and white) Co-cinematographer

INTERVIEW EXTRACT TRANSCRIPT

DATE OF INTERVIEW: 1 OCTOBER 1991
INTERVIEWER: DUNCAN PETRIE

DUNCAN PETRIE: Did you find yourself restricted in terms of movement with the Technicolor camera?

GUY GREEN: Of course it was difficult but somehow one overcame it. It took time, that's all. We did all sorts of things with Technicolor cameras that we used to do with black-and-white ones, much more than they did when sound came in.

DP: When you moved into shooting film in colour how did you find that process – you had made your name as a black-and-white cinematographer?

GG: The first film I did was *Blanche Fury* that was also for Cineguild. I approach the colour thing very much as I approached black and white and it came out; they told me it wouldn't but it did. And then of course *Hornblower* [*Captain Horatio Hornblower R.N.*, 1950], we had a ship on stage down at Denham and I had three-strip – a lot of light; a whole row of arcs burning down on the shoot. George Bush from Technicolor came down after the first day's rushes and said, 'How does it look? It's pretty good. Can't you give us a little more light?' I was already burning 1,000 ft candles on the set, that's the way it went.

DP: I find that interesting reading about early colour films because it seemed to me that Technicolor had made up their mind that you would shoot it at this kind of level of illumination. I was interested to read that James Wong Howe, the Chinese-American cinematographer, apparently his first colour film was shot at almost half the level of illumination that Technicolor technicians recommended. It came out fine but he then found it very difficult to work on another colour picture for a very long time because he had gone against the grain.

GG: They didn't like it because he did it that way. I suppose I did the same thing with *Blanche Fury* but they didn't seem to mind as long as it came out. They really didn't complain and I liked what happened to that – I liked the way it looked.

DP: This was in the very early period in the mid-1930s that he (James Wong Howe) had done this. That's something Jack Cardiff managed to do as well – much more modelling and much more light and shade.

GG: The Technicolor organisation had a great deal of control in the beginning. They would tell you what to do and what you couldn't do. Obviously we all try to suit our own methods.

DP: Was it harder to get things like depth into a colour image?

GG: Yes, particularly if you were working with a wide aperture.

DP: Did you shoot any films in colour once the three-strip process had finished? Did you use Eastmancolor?

GG: Oh we all moved over fairly swiftly from the three-strip to the single film.

DP: How did you find it at the time? You were saying how these images have deteriorated. What different qualities did this other colour stock have?

GG: It looked pretty good at the time and it is only lately that some film that I shot twenty years ago has gone pink.

DP: Must be really annoying.

GG: I actually directed a film, *Light in the Piazza* (1962) in Metrocolor and it was photo-graphed by Otto Heller and he did a great job, it looked beautiful. I ran it about a year ago in California and I was bitterly disappointed – it was all pink.

DP: Do they know why this has happened?

GG: I'm not sure whether it's just the print that has gone pink or if they struck a new print from whatever there was – I don't know – I haven't found the answer to that.

INTERVIEW
ERWIN HILLIER [EXTRACT]

Erwin Hillier (1911–2005) was born in Berlin and trained at the Ufa Studios before moving to Britain in the early 1930s and finding employment with Gaumont British. In the 1930s he worked at Elstree, gaining experience working with celebrated directors including Hitchcock, but he did not work as a cinematographer until the war on Ministry of Information documentaries and on Powell and Pressburger's *A Canterbury Tale* (1944) and *I Know Where I'm Going!*. In the postwar years he gained experience with colour but, as he described in an interview in 1991, this was not a happy experience with *London Town* (1946). Much of his subsequent work was in collaboration with director Michael Anderson on films including *The Dam Busters* (1955) and *Will Any Gentleman?* (1953, Technicolor).

INTERVIEW EXTRACT TRANSCRIPT

DATE OF INTERVIEW: 28 OCTOBER 1991
INTERVIEWER: DUNCAN PETRIE

DUNCAN PETRIE: What about when you first came to work with colour? The first one I've got noted down is *London Town* – was that your first colour picture?
ERWIN HILLIER: Yes. That was a tragedy from my first point of view. Micky wanted me to work with him on *Black Narcissus*. At that time I had only signed up for *London Town* because my agent was a great friend of the director who was also a producer, Wesley Ruggles. To my dismay I discovered he was colour blind; we used to have many arguments about things. Wesley was a very difficult man. Then he admitted to me later on that he was colour blind. From my point of view it was a tragedy having been involved with this man because he was a man who used to be in Hollywood, a very big producer/director. But he was played out, he didn't contribute, he lowered the whole stature of the film. I had a very miserable time with him. I mean he treated me well, was very nice and so on, except in having no artistic appreciation. It was terrible, you have to be able to bounce ideas.
DP: And I guess it must have been difficult as well with it being your first colour picture. What is it like for someone who had worked for many years in black and white?
EH: It couldn't have been a worse start. It upset me enormously. Then again Michael Powell always wanted to get me back again you see and he said, 'I know you had a rough time with him, let's join forces again.' But somehow we didn't get back again because we overlapped each other. I was on another film for Ford by the time it finished. He had to have someone with him, which was very sad but there you are.

INTERVIEW
DOUGLAS SLOCOMBE [EXTRACT]

Douglas Slocombe was born on 10 February 1913, and entered the cinemato-graphy profession after working in photojournalism. His early work was with American documentarist Herbert Kline, then with the Ministry of Information and Ealing Studios. *Saraband for Dead Lovers* (1948) was the first film he shot in Technicolor. This was a very distinguished first experiment with colour, and Slocombe went on to shoot *The Titfield Thunderbolt* (1953) which was generally less adventurous in deploying Technicolor. He also shot the first German feature film in Technicolor, Helmut Kautner's *Ludwig II* (1955). In the post-Ealing years of his career Slocombe worked for American studios and with many celebrated directors including Joseph Losey, Roman Polanski, Ken Russell, Jack Clayton, Fred Zinneman and Steven Spielberg.

INTERVIEW EXTRACT TRANSCRIPT

DATE OF INTERVIEW: 22 JANUARY 1992
INTERVIEWER: DUNCAN PETRIE

DUNCAN PETRIE: What was it like using Technicolor for the first time on *Saraband for Dead Lovers*?

DOUGLAS SLOCOMBE: After years of black and white one's confronted with colour and the first thing to bear in mind is the difference in size of the equipment. The Technicolor camera was enormous in its blimp – it was more like a huge refrigerator. Then there was the mumbo jumbo – of course you had the three magazines, the prism and a couple of technicians to put all the bits and pieces together. Then of course the requirement was you had to use an enormous amount of light – nearly about six times the amount of light as one did for black and white. So whereas one had used little arcs and 2ks, now you had to use 150 amp arcs. And there was a political requirement from the Technicolor front office that one should light with a very low contrast – they didn't like high contrast, you mustn't leave shadows to go black. And I don't like that idea entirely so I decided to still go with the full contrast of black and white, but of course multiplied by the extra light requirements in terms of intensity. But I'd still keep my contrast, especially for this film which I thought needed a lot of shadows and so forth. And I discovered on the very first day – and it was very exciting – that of all the colours on the set, the black shadows sud-denly became something wonderfully rich and intense, and I carried on with these con-trasts. And at the time it was a great breakthrough – everybody thought I'd get an Oscar for it, but I didn't.

DP: The amount of shadow and darkness certainly stands out.

DS: I found it very exciting. That was the only Technicolor film that I was given that trans-lated to that type of thing. Otherwise they were mostly comedies that I did at Ealing. *The Titfield Thunderbolt* was in three-strip and was great fun to do but it had different require-ments. Then I did a film with Harry Secombe called *Davy* (1957) which was also in three-strip. But Technicolor at that time was moving into high screen and wide screen called Technirama. It was a short-lived process. The screen was wide and high and was fun in a

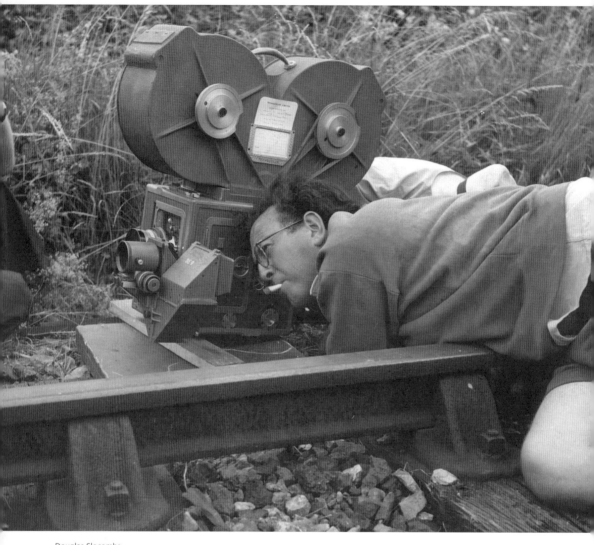

Douglas Slocombe

way because the film had a lot of backstage corridors and was rather a huge portmanteau. I don't think it's hardly ever shown.

DP: Going back to *Saraband*, I was interested to hear you talk about the pressure from the front office because every single cameraman I have talked to who worked with Technicolor felt that pressure, even people like Jack Cardiff who was trained by the company.

DS: There was a woman called Natalie Kalmus who was the ex-wife of Dr Kalmus, the inventor of the process. He sent his wife off to Europe for reasons he knew best. She went round the studios like a little dragon and it started with Jack (Cardiff) of course, who kept as far away from her as he could and when it came down to me she was exactly the same thing. Then she had an assistant called Joan Bridge. Joan had to try and keep the Technicolor principles going, but like Jack I ignored these things.

DP: The classic story was Ossie Morris and *Moulin Rouge*.

DS: I was sorry Ossie didn't get an Oscar for that, he deserved it.

DP: I noticed that *Lease of Life* (1954) was shot in Eastmancolor.

DS: That was Eastmancolor and was very early days. That was also a bit of a tragedy because the rushes looked very nice, they had a lovely clear, clean quality, very unlike the sort of saturated colours of Technicolor and I used to like it. The film was cut together. Then it was sent off to get prints for release and, in those days, you had an experiment with the grading systems. To grade the shots together, they had a ghastly system where they would print with the negative a sandwich between the negative and relief positive an awful strip of celluloid, which had strips of colour and different densities of colour on a standard piece of celluloid, which may have sounded fine in theory but in fact it gave a horrible dirty quality to the final dissolves and all the clear quality was gone. And one was left with this awful messy colour which I found heartbreaking. Since then of course, colour grading techniques have improved, they are now superb.

DP: You get the feeling that the Eastmancolor system was rather rushed in too quickly?

DS: It was in a way. I think in this country they were slower in developing a printing process than they were in the States.

INTERVIEW
PAUL BEESON [EXTRACT]

Paul Beeson (1921–2001) trained at Ealing Studios. His earliest Technicolor experience was as an operator working with Jack Cardiff on *Scott of the Antarctic* (1948) and on Hitchcock's *Under Capricorn* (1949). Subsequent colour work was as cinematographer on films including *Where No Vultures Fly* (1951), *West of Zanzibar* (1954) and *The Feminine Touch* (1956), all late three-strip Technicolor films.

INTERVIEW EXTRACT TRANSCRIPT

DATE OF INTERVIEW: EARLY 1990s
INTERVIEWER: DUNCAN PETRIE

DUNCAN PETRIE: Operating for Jack Cardiff – when did you first work with Technicolor three-strip?
PAUL BEESON: First time I saw it was when it was brought in a week before we started work on the interiors of *Scott of the Antarctic*. When I say interiors, I mean exterior interiors – snowscapes on stages. Prior to that I'd seen it but I hadn't touched it much on *Saraband* when Douggie and Jeff Seaholme were using it. So I had about a week on artist and costume tests.
DP: How did it handle, when you were used to Mitchells?
PB: It didn't take long, but it was such a big beast. It was heavy. It didn't restrict mobility – there was always ways of doing shots. I remember having a three-strip camera in its blimp and we were doing virtually hand-held shots, because we strung the thing from the studio room on bungee rubber and we had a couple of grips. We pushed it around as if it was a hand-held camera. It took assistants longer to re-load but there again you weren't often held up because they used to plan their re-loads in between shots. The ordinary black and white camera was quite big with its blimp – which was an awkward shape with no proper lines to it at all. At least the Technicolor camera in its blimp was a huge box.
DP: You operated on *Scott* and *Pandora and the Flying Dutchman* (1951) for Jack. Were there any others?
PB: *The Black Rose* (1950), *Under Capricorn*, with ten-minute takes, we used to take about a day to line up a ten-minute take. Then we'd probably rehearse for a day then shoot on the third day. Hitchcock was trying to find a new way of shooting films for television.
DP: Did you learn much from Jack in terms of lighting?
PB: *West of Zanzibar* was shot in monopack, which is rather like Kodachrome. In those days they would still make black-and-white separation films and print as normal. We used three-strip cameras for the interiors back in England. To take the huge camera to Africa – there weren't proper roads or anything. Also in those days Technicolor would dictate as to what films should be made in colour, bearing in mind they only had a limited amount of equipment. They could have turned round and said, 'We don't want this equipment to go on this particular job and you can use monopack.' On *Pandora* we took three-strip on location to Spain. On *Black Rose* we took it to North Africa. Actually we had four cameras

on that, we had two three-strip cameras and two Mitchells with monopack. By then we had about sixteen three-strip cameras in Britain. But I never worked for Technicolor, unlike people like Jack and Chris Challis. I only used their equipment as an operator, because you didn't have focus pullers, you used the Technicolor technician. He always came with the camera. One or two higher-budget pictures they used to employ a focus puller as well because they had probably used the fellow before. But you still had to have the Technicolor technician. You had Technicolor consultants as well assigned to the picture. It was to do with different types of materials, colours reacted differently on different fabrics and if you wanted a particular type of red, the consultant could help you get the result you were after. Most fabrics went before the cameras before they were made up into costumes so you could see how it was going to look. But this was always in the contract because Dr Kalmus had his wife Natalie as colour consultant. I think they worked more with dress designers than they did with cameramen.

DP: Some cameramen had great rows with Technicolor.

PB: The main reason being that on big screen the definition wasn't that good.

DP: You started lighting around the time Eastmancolor came in. How did you find working with that?

PB: It wasn't a great deal of difference from three-strip. We could use probably less light. The basic principles were the same. But the big problem with early Eastmancolor was that you still got the best results by letting Technicolor handle it with the IB [imbibition] process, because Kodak hadn't come up with a decent duplicating material. So it meant that most of the release prints came from a dupe negative and they were grainy and the colour wasn't very good in the early days. A lot of companies used Eastmancolor as a filming process – then it went to the Technicolor labs for release printing.

INTERVIEW
STAN SAYER [EXTRACT]

Stan Sayer (1917–2000), after studying science and photography at the London Polytechnic, made some 16mm home movies with his father, including one in colour. He was soon employed at the Rock Studios at Elstree where he eventually worked as a focus puller. He was interested in early Technicolor and was a focus puller/general technician on *The Thief of Bagdad* (1940). In the war he joined the RAF Film Unit and worked alongside Chris Challis and Denys Coop. Sayer and Coop were sent to West Africa. After the war Technicolor applied for Sayer to have an early release from the Forces.

INTERVIEW EXTRACT TRANSCRIPT

DATE OF INTERVIEW: EARLY 1990s
INTERVIEW: DUNCAN PETRIE

STAN SAYER: Technicolor cameras were like the crown jewels. There wasn't a great aura surrounding the equipment [before the war] as far as the English technicians were concerned because they were dead keen to learn. But I must say the American technicians put on a terrific act and as far as the ceremony of the prism for instance – that was something sacred, like something that would happen in a church, when this prism was put into place, resting on its knife-edge and they were good showmen as well, good technicians mind you. Henry Imus was the fellow I learned most from, and Sid Sidser. Stu Brown was another American but he was more to do with the running of the plant itself. George Cave was the boss and we would have lectures and I found it a lot of fun.

DUNCAN PETRIE: How did the British cameramen get on with the Americans?

SS: Bill Skall was an American with a fair amount of experience of Technicolor in the States but he had developed almost a flat light technique which our cameramen – who had a lot of experience in black and white and worked to a contrast ratio far higher than ever Technicolor thought was possible, whereas in the three-strip days we were told not to increase the contrast ratio more than one to three. I forget how much light we had to use but it was an enormous amount. And we used white light which meant using arc lights and we had white flame carbons and usually a straw filter called a 101 which brought it back to a truer daylight colour temperature which suited the process very well. I think possibly Jack Cardiff was the first cameraman to use three-strip Technicolor in England but he didn't do very much studio work – it was mostly on the *World Windows* series, foreign locations and that. I remember Harry Stradling, an American cameraman, was over here. I worked with him on *The Divorce of Lady X* (1938) as a technician. I used to measure the light on the photometer which basically is a photo-electric cell connected to a volt-meter which is calibrated in foot candles and basically you would put the paddle facing the camera at what you were actually exposing for and then tilt it forty-five degrees towards the main key light. There was then a formula which gave you the camera stop. Technicolor had their own stop system which was really basically the first T-stop system. Technicolor-4 was the nearest thing to F-4 in the old days. But as lenses developed – that's when T-stops came into being. At Technicolor we used to scale our lenses by the transmission, not by

any mathematical formula. In order to do that, we used to put a collar on the lens which was graduated in degrees, which we would fish for the actual stop to give the density on the negative which was required.

DP: By 1939 Technicolor film stock in America was faster. Do you know what was the first British production to use the faster stock?

SS: I remember when I went back to Technicolor after the war the first feature I worked on was *Black Narcissus*. We had the faster stock then but during the war years they probably didn't have it in Britain. By then they had also developed a prism with suitable filters with which incandescent light could be used. But even so, the stock was so slow that, using incandescent light, it was very difficult getting the key right so what we would do, of course, we would use brutes, big arc lights and put the CTO [colour temperature orange] on them which brought them back to incandescent colour temperature. Then of course it was more convenient to have your fill-in lights incandescent and this cut down the number of electricians required because, if you have a lot of arc lights, not only do you have a lot of electricians but you have a lot of smoke too, which sometimes you need extractor fans on and even the doors open. Later on the prism was changed, then you could use incandescent light in the studio and the stock was actually fast enough to use incandescent light on its own. Although if you wanted a sunshine effect or something, you would use brutes, with the suitable colour-correction filter.

DP: Using a mixture of arcs and incandescents, did this allow you to be more subtle in modelling?

SS: Yes. In the early days we used to have … scoops which were merely arc floodlights and there was usually one each side of the camera anyway and quite a few of them above the camera on a gantry. But directional lighting and higher contrast was projected by bigger lamps – by the brutes of 150s. But as you got more experienced we were able to set up the contrast and throw away the book.

DP: Was it difficult to do?

SS: No, because it meant going back more to the black-and-white technique.

DP: What did the Technicolor front office think of this?

SS: Well, they were all a little bit scared about it, of course. I remember Natalie Kalmus, although her main job by contract was to have a credit on every picture as colour controller, she didn't like high contrast. She liked everything flat so every colour that was there could be seen, whereas if you want some sort of stereoscopic result, you've got to have contrast. We couldn't care less many times if the shadows did go coal-black, because that's the way we wanted it. She used to have assistants she would train, and she did a good job – although from time to time I thought she must have been colour blind. We didn't use whites in those days, we used tech-whites, a little book with round holes cut in the middle of a four-inch square piece of material and the first one was pure white, then it would go into slightly different shades of grey. So if we wanted something snow-white we would go to Technicolor-2 or Technicolor-3 or something, rather than have it flaring. But this depended not only on the colour but also the texture in material. For instance, in *Black Narcissus* some of the nice results we got there were due to the roughness of the material, it wasn't shiny material, it was a rough material which cast shadows on the bumps of the material. Jack Cardiff did a wonderful job on that – it's still a classic.

DP: On *Wings of the Morning,* Annabella's white dress is very bright. In *The Four Feathers* [1939] the shirts of the men were light grey.

SS: When Eastmancolor came in, it was faster than Technicolor. This did mean that any camera was suitable, could use it, so Technicolor was phased out as a three-strip process. So to make use of our cameras we turned them into VistaVision cameras. The film goes through sideways and takes a picture which is eight perforations wide, as against the four normally. We went from VistaVision to Technirama which is a squeeze process – a 1.5 squeeze on the lens – and that would either be projected with the eight perforation projectors with a de-squeeze or the squeeze was taken out of it and put onto a 70mm. So the cameras were used right to the bitter end.

DP: Were there still only the four or had more come over?

SS: We got fed up being the poor relation of Hollywood and so they could supply us with the camera movements themselves – the two gates which are at right angles to each other – the light went straight through to the green record and was diverted into the bi-pack for the red and the blue. And we got Newalls to copy exactly, from the blueprints from Hollywood, and at one time we had eighteen three-strip Technicolor cameras, which meant that other producers could use them other than the two tied up with Korda and Rank. The 1948 era we still only had the four cameras; that's why we went over to the other two-colour process for the Games (*XIV Olympiad: The Glory of Sport,* 1948). But soon after that we began to build more. Agfacolor and Eastmancolor were coming up at that time. At Technicolor, the process itself – the imbibition printing – was very controllable and when it came to release printing, once everything was set up it was a case of catching the cans as they came off and we could release the films all over the world in a very short period of time, which you could never do with Eastmancolor positive. But the film business has shrunk so much now that we don't have such enormous releases and so we flogged all our IB materials to the Russians and Peking.

DP: What about the difficulty of experimenting in Technicolor – Cardiff's battle on *Black Narcissus*?

SS: Jack Cardiff is more of an artist than a technician and he won't stand for some of those technical arguments. He would experiment. And he's been very successful at it. And in many cases he has thrown the book away completely and it's worked. You've got to have courage to get away from some of the technical limitations and Jack couldn't care less if it was difficult for the laboratory, as long as he got on the screen what he wanted.

DP: Technicolor opened up a whole new set of possibilities but there is also a sense of tension between technical arguments against experimentation, a classic case being Ossie Morris and *Moulin Rouge.*

SS: The boffins at Technicolor were quite conscious of the fact that the three-strip had never excelled at definition. It stood up to normal magnification but when it went onto a very large screen, there was a lack of definition there so when Ossie Morris on *Moulin Rouge* wanted to have this nightclub atmosphere which was very soft by using smoke and diffusion, Technicolor got a bit scared that the final result would be lost in the mist – you couldn't see what was going on. But Ossie was quite determined to get that effect on it. He'd done several experiments and he'd found the right amount of diffusion and the fog filters and the smoke to use and the result was extremely good and

Technicolor enjoyed that breakaway from the normal technique because the final result was so good.

DP: Was the company secretive? In America there was great criticism.

SS: You find that sort of secrecy in optical houses as well. My main job now is travelling matte work – when optical houses talk to each other they hold their cards very close to their chests.

DP: The effects on *Black Narcissus* are stunning.

SS: They were mostly matte shots. Hein Heckroth did the paintings. In the early days it was Poppa Day. There are very few artists who can paint photographically. They like to bring in their own style. But when it has to match in with photography, it has to be photographic style and photographic accuracy. In those days we had some real experts who did that work. I always remember working with Poppa Day. We would go to his studio, I would take a developing kit with me and we would do tests. He was such an expert looking at the three negatives to know that that's got to have a little bit more blue in it, that should have a little more green, that more red – he could read the negatives relative to what he had to do in colour on the painting which we were photographing. And they were married together at Technicolor. Doug Haig was wonderful in that respect at Technicolor.

DP: Can you tell me some of the other films you worked on after the war?

SS: *Blanche Fury*, shot by Guy Green. I was connected with the location work. I was operator. I also used to do quite a number of short films. One I did in three-strip was a film about the life and work of Rembrandt, financed by the Dutch government. I did a sequence with several of his portraits and I lined up the eyes in the same position so when the montage was made the eyes stayed in the same place as the face aged. If Rembrandt had been alive today, he would have probably been a leading cameraman because he used light the way we use light in photography and his work is so magnificent. I learned so much about lighting from his pictures.

DP: Did you use Technicolor monopack?

SS: Technicolor monopack was the forerunner of Eastmancolor and, although it was slower and the grain was not as fine, it did mean it could be used in normal cameras. The first time I used it was in that picture we started to make about the work of the RAF in the very early days of the war. It could only be processed [at Eastman Kodak] in Rochester at that particular time so we couldn't see our rushes. As far as I know, no features were made in Britain entirely in Technicolor monopack. We also had TechniScope which divided the normal frame into two, which gave it CinemaScope proportions. That was used for sporting events, for instance. Agfacolor, Eastmancolor and Fujicolor all have their own characteristics. The Fujicolor is for softer, more pastel shades and the Agfacolor has more of a tinge of sepia about it, which some people like very much.

DOCUMENT

RONALD NEAME, 'A TALK ON TECHNICOLOR', *CINE-TECHNICIAN*, MAY–JUNE 1944

A TALK ON TECHNICOLOR

By Ronald Neame

LET'S face it, colour has come to stay. There are some of us that like it and some of us that don't but, whether we do or we don't, it's not going to make the slightest difference. East year for the past five years the percentage of Technicolor production has increased, and it's my guess than in five years' time Black and White will be on the way out for good. Of course colour will be vastly different from what it is today. I am convinced that before long we shall be able to dispense with three negatives and when Monopack or its equivalent is in general use, the present Technicolor camera will go the same way as the " camera booth " of the early talkies went. Mind you there's nothing wrong with the camera, some of its features are first-class, and should be adapted at once to all Black and White cameras.

Ronald Neame

Remote control focus, what a joy that is, and how much superior the viewfinder with its minimum of parallax. But size is against it, and although Technicolor will support it up to the hilt and maintain that it really is quite mobile, there is no doubt that it considerably slows up production and is a poor substitute for the comparatively light and up-to-date Mitchell. Soon too faster film will enable us to get rid of some of the oversize lighting equipment which at the moment makes colour a heavy-handed business.

Lighting for Technicolor is rather like drawing with a piece of charcoal after having got used to a very fine pencil, but it is surprising how quickly you get used to working with a " key " light of 800 foot candles instead of the 100 foot candles that you have probably been working with in the past. Yes, 800 foot candles. Just eight times as much light as you work with in Black and White at F.2. This will enable you to work at stop 1.5 in Technicolor. Technicolor stops are different from Black and White. The following chart will be a useful guide to cameramen new to colour :—

Black and White		Colour		Black and White		Colour
F 2	=	Stop 1		F 4.5	=	Stop 5
F 2.8	=	,, 2		F 5	=	,, 6
F 3.2	=	,, 2.5		F 5.6	=	,, 8
F 3.5	=	,, 3		F 6.5	=	,, 10
F 4	=	,, 4		F 8	=	,, 16

It is not advisable to work at Stop 1, because although this is possible with the 50 mm and 70 mm lenses, the wide angle lenses are full open at Stop 1.5, therefore it is obviously better for practical purposes to treat this stop as being the widest aperture.

Colour lighting in this country at the moment is practically all arc, incandescent light being far too red to be of any use. It can, however, be used to great effect when creating firelight scenes. The average interior set should be rigged with a mixture of Mole Richardson 150 amp, H.I arcs, and 120 amp, H.I arcs, and in view of the poor state of some of the lighting equipment in this country at the moment, the 150's should predominate. Nothing smaller is of very much use on the rail.

The following might be of some help when working on colour for the first time :—

Where in Black and White you would use a Mole 5 kilowatt, use a Mole 150 amp. H.I.

Where in Black and White you would use a Mole 2 kilowatt use a Mole 120 amp. H.I.

Where in Black and White you would use a Mole 500 watt use a Mole 65 amp. H.I.

Where in Black and White you would use a Can (floodlight) use a Twin arc, Broad or Scoop.

The usual Mole incandescent lamps can be converted for colour by incorporating a blue condenser ; these lights have little strength but are very useful for shadow or filler light.

For all straightforward lighting use white flame carbons and cover all arc spots with a Y.1 gelatine filter. Without this filter the light is too blue and cold to give a natural daylight effect. For night exterior shots in the studio, work without the Y.1.

When even experienced technicians go on to a Technicolor set for the first time they get the impression that a great mass of light is turned on to set and artists from every direction, without any apparent system, and this has led to the quite wrong impression in some circles that lighting for Technicolor is a haphazard affair. In actual fact, lighting for colour is almost in all respects the same as lighting for Black and White, with the exception of contrast.

Contrast is one of the great problems of Technicolor today. In Black and White, if negative contrast is increased the blacks look more black and the whites look more white, shadows go heavier and highlights stronger. In colour, something else happens as well—the reds look more red, blues look more blue, pink faces look more pink — sometimes "lobster" — and before you know where you are you are faced with **very** glorious Technicolor. As in Black and White, the higher the contrast the better the definition. Hollywood has realised this and that is the reason why all colour pictures from America are extremely colourful. With them, definition and visibility are of paramount importance, they are prepared to sacrifice more subtle tones of colour for clarity of vision. In England this becomes somewhat of a problem for the lighting cameraman, producers and directors not for the most part being technicians want the best of both worlds, they quite naturally want good definition but are determined not to put up with "Red White and Hot Technicolor" as served up by America, and it is very difficult to make them realise to what a large extent these two things are bound up together.

Out of this arises another problem—"colour separation." This again plays a large part in deciding the quality of results. If a face is photographed up against a bright blue, no matter how flatly it is lit, it will stand well away from the background. If, on the other hand, the background is pink, only the most carefully modelled lighting will give reasonable results. Here again you can see how Hollywood technicians work! In all their big musicals (*The Girls They Left Behind* is a perfect example) sets and costumes are all designed to give the greatest possible "colour separation," thus even the flattest flood lighting will give good bright results on the screen.

However, let's get back to straight forward lighting. Start off by using a three-quarter front key light of 800 foot candles, and having got that

fixed, carry on as though you are working in Black and White and then just throw in a little more shadow light for luck. In my opinion the use of a photometer is essential, but whatever happens don't let it destroy originality—it can so easily do so—read your key light to make sure that you are exposing correctly, then put the meter away and do the rest with your eyes. How often cameramen ruin good effects by refusing to disobey the photometer.

As in Black and White, a key light should be strengthened according to how far round to the side of the artist it is taken, and therefore weakened if it is brought further front than three-quarters. The reading of 800 foot candles is just a guide, it does not have to be strictly adhered to; for special effects very little light indeed can be used, and as little as 40 f.c. will register on the screen.

There is no doubt that seeing your first test in colour is a great thrill. Technicolor **always** " do you proud " on your first test—two, or at the most three, days after you shoot, it will arrive back from West Drayton, its quality good and true in every detail. I'm sure your first reaction will be—" But this is easy "—and so it is in theory, and when everything goes right. But making a test is one thing, shooting on the floor—perhaps in confined spaces—another, and there are still plenty of hurdles to get over before Technicolor becomes easy. Some of these hurdles are going to remain until after the war.

One of your first major problems will be getting enough foot candles out of a light while still having it sufficiently near full flood to cover a reasonable area of subject matter. Most of the lighting equipment in this country is getting pretty old and worn. Naturally the studios stick up for it, and claim that lighting cameramen are fussy and unreasonable people, but it is undeniably a fact that we are not getting nearly as much light from our lamps as we used to, and it has become necessary to have your 150 amp. key arc not more than 25 feet from your actors in order to get a good even light of 800 foot candles. This means that if your set is on the large size, you cannot light your artists from the rail, it being too far off. Therefore the best thing to do is to put your lamps on stands on the floor, or on rostrums. In Black and White there is no problem here : it is only a two-minute job to bring in a Mole " Junior," but in colour the increase in lighting time is extensive ; carrying a 150 amp. H.I arc around is not a very quick business. I became convinced that Hollywood must have found a way round this problem, and sent a cable to Mole Richardson of America asking for photometer readings from one of their 150 amp. arcs. When I receiped the reply I took the same readings from one of our own lamps—

the result, printed below, makes rather a sad story :—

Readings with 150 amp. H.I arc with Y.1 Filter, 25ft. from Weston Meter—

	Hollywood Studio		Home Studio	
Full Flood	385 foot candles		160 foot candles	
10 turns spot	610	,,	230	,, ,,
20 ,, ,,	1,410	,,	460	,, ,,
30 ,, ,,	4,220	,,	1,360	,, ,,

There would appear to be two main reasons for this pitiful discrepancy. The first, " Pool " carbons, and the second that the Americans are putting 150 amps through their lamps, whereas up to now we have only been using 136 amps. I am glad to say that recent experiments with higher amperage have already proved a great success and I hope before long all studios will convert their grids in this way. In addition to the light being brighter it is also much cleaner and whiter, and this is indeed important.

It is essential when lighting for colour to make sure that your arcs are burning correctly. If the gap between the positive and negative carbons is too large, in addition to loss of light the colour of the light will change to pink instead of white, and our old pal " lobster " will crop up again.

While writing about the colour of light, it would be as well to mention another problem, the problem of " practical " lamps on sets : wall brackets, table and standard lamps, etc. The ordinary 60 watt or 100 watt bulb is far too yellow to look natural, therefore it is necessary to dip these in a blue cellulose before using them on colour sets.

So far I have discussed only straight forward lighting, and before passing from this to night, and effect stuff, I would like to sum up by stressing the importance of getting fully exposed negatives with plenty of detail in the shadows. There is no doubt that sometimes excellent results can be obtained by breaking this rule, but generally speaking a well-exposed negative will give the most consistent and most pleasant effect. I think it is right to say that Technicolor exteriors are lovely, and not a little of this loveliness is due to good bright daylight and its accompanying strong and healthy negative. The amount of " control " that Technicolor have to exercise in order to give you a good result on the screen is something to be marvelled at, and it is not fair to make their problems greater by giving them a negative that because of thinness, or contrast, has little or no latitude. Don't forget that a negative printing correctly on light 12 will look reasonably good printed on light 14 or light 10, thus allowing for a margin of error—but a negative that is so thin that its correct printing light is light 4 will look quite impossible on light 6 or light 2.

Here is a still of a shot taken from *This Happy Breed* with particulars of lighting used. (At the time *This Happy Breed* was in production, Tech-

nicolor negative stock was faster than it is at present, but I have adjusted photometer readings to suit the stock we are using today).

I have picked this still for its simplicity of lighting.

Lighting plan — Still No. 2:—

1 120 amp H.I arc three quarters back, on John Mills, reading 800 foot candles, kept from burning up Kay Walsh by two thicknesses of net in kidney frame.

1 120 amp H.I arc three quarter back on Kay Walsh, reading 800 foot candles, kept from burning up John Mills by two thicknesses of net in kidney frame.

2 twin arc Broads, one either side of camera, each with one silk, giving together a front light meter reading of 400 foot candles.

1 three-quarter front 150 amp H.I arc from rail of set striking wall behind artists, with two twin arc Broads, with two silks each, one either side of settee on which figures are seated, giving total meter reading for set lighting of 400 foot candles.

Now to pass on to effect lighting. This is so much a matter for the individual that I do not intend to deal with it at length. " Night Exterior " in the studio is, perhaps, the most generally used effect. I have already mentioned the necessity of dropping the Y.1 filter, which will result in a colder more realistic night light. Hollywood obtain their romantic moonlight shots with the aid of light blue gelatine filters placed over their lamps, and these in conjunction with Y.1 filters covering lamps lighting the interior of windows, etc., can be very effective indeed. As a rough guide a key light reading of about 300 foot candles to 350 foot candles will give a good rendering of moonlight strength, but this is naturally dependent on the amount of shadow light which accompanies it.

Firelight effects, as I have already mentioned, are best obtained with the use of incandescent

light, or by putting panchromatic carbons in arcs. When shooting the seance scenes for *Blithe Spirit* in flickering firelight, I used a key light from the floor of about 500 foot candles, but the effective light was reduced to about 400 foot candles by the use of paraffin torches held in front of the lamp to create flicker.

Before dropping this photometer reading business I must once again repeat that there is no cut and dried ruling on the matter. Conditions vary all the time, so does Technicolor film stock. Colour film deteriorates very quickly, and in six months time, if we are still using the present batch of negative, we may well be using 33% more light. On the other hand, if new supplies arrive from America we may find that 500 foot candles will give us a good strong high light. Let us hope that the latter is the case.

Technicolor is great fun, but it is spoilt for me at the moment by one great handicap, the fact that all rushes are viewed in black and white, printed from the blue record. The result is hardly pleasant to the eye and one never enjoys seeing them, they give little or no indication as to what the colour will be like and are as often as not misleading. The short sections of colour that one **does** see (very often many days after the scenes are shot) are on and off the screen so quickly, and are so very often out of balance from the colour point view, that they are only just worth while. These short sections are known as "pilots," and after viewing a few one begins to understand very quickly just what problems Technicolor technicians have to cope with. A "pilot" can be too red, too blue, too green or too yellow, too flat, too contrasty, too light or too dark and at least half a dozen other things besides, small wonder that Mr. Kay Harrison is putting up a strong fight to prevent all his experts from going to the Forces, and experts they truly are.

Yes, of course, colour has its handicaps, but

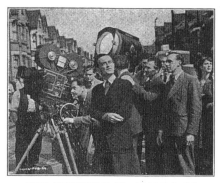

THE TECHNICOLOR CAMERA ON LOCATION (Still No. 3)

Director David Lean, with Ronald Neame and Camera Operator Bunny Francke shooting a scene for "This Happy Breed"

Shot in average three-quarter front sun, medium dark subject matter, with 150 amp booster arc. Technicolor Stop 4

colour has been born, and this healthy and sometimes unruly child is growing rapidly every day. I think it is true to say that at the moment it is suited best to costume and colourful subjects, but as each new production is added to the now long Technicolor list the colours will improve and become more subtle, until one day colour won't be a child any more. It will become, just as "Sound" has, an integral part of every film, and the hackneyed phrase "Glorious Technicolor" will die a natural death in the same way as "100% All Talking, Singing and Dancing" did ten years ago.

PART II

POST-PRODUCTION

INTRODUCTION

There's a huge amount of knowledge which people who go to the cinema don't even
begin to suspect which goes to make a Technicolor print.

(Dave Davis, production controller, Technicolor Laboratories)

Technicolor may have been created on the set, but it was made in the lab. While cine-
matographers like Chris Challis and Jack Cardiff used their skill to paint light pictures in
Technicolor, behind them lay a vast number of technicians whose job it was to turn pic-
tures into prints through an extremely complex chemical process. These highly specialised
technicians provided not only the basics required for print production, but also innova-
tions which streamlined that process for greater speed and cost efficiency. This chapter
presents sections from interviews with technicians who between them worked for British
Technicolor Labs from its inception in 1936 to the late 1980s. These interviews were
recorded as part of the BECTU History Project and are now housed in the BFI Reuben
Library.

The Technicolor Labs were built in 1936 by Alexander Korda as an adjunct to
Denham Studios, at the time the largest production facility in the UK. They opened in
1937 primarily for printing three-strip Technicolor. The process used a bulky camera
which split the light from the source into three and recorded it through filters onto three
black-and-white negatives to give a record of the red, green and blue portions of the
scene. From these negatives the lab produced matrices. The negatives were optically
printed onto a special stock and the prints were processed in such a way as to form relief
images. These were then dyed complementary colours and the dyes were transferred, one
after the other, onto a blank film coated with gelatine which absorbed the dye. The
advantages of the system were that no additional equipment was required in projection,
plus the matrices could be redyed at any point to make new prints, and the original black-
and-white negatives were not prone to fading. This was painstaking, labour-intensive
work and, at its height in the late 1960s and early 1970s, according to the interviewees
in this chapter, the lab employed around 1,400 people and was processing 310 million
feet of film per year.

Towards the end of World War II Technicolor production in Britain increased, with stock being imported from America to assist in processing key British feature films, including *The Life and Death of Colonel Blimp* (1943) and *Henry V*. In 1950 the launch of Eastmancolor's negative film, which captured all three colours in layers on a single strip, almost immediately rendered the three-strip camera obsolete. The dye imbibition process developed for Technicolor was still the best method for producing positive prints, so the labs continued to produce matrices throughout the 1950s and 1960s using Eastmancolor negatives, although they were also facing new challenges thanks to the introduction of numerous widescreen processes in the 1950s, including CinemaScope and VistaVision.

The five men whose interviews make up this chapter worked in the labs in a variety of roles, each ultimately achieving a position of seniority. But while their pathways through the labs were different, nevertheless a number of key threads emerge. The first is a focus on the process of producing Technicolor, which at times is discussed in highly technical detail. Another strand that occurs in multiple interviews is the relationship between the Hollywood and British labs. The British lab was given the responsibility for making prints for more or less the entire world outside North America, which was the exclusive provenance of the Technicolor lab in Hollywood. Given that both labs were processing the same films, a close relationship between them was vital to ensure that the prints were identical, especially given that the way in which the print was graded could affect the colour balance. Optical printing, in particular the use of opticals for special effects, is another recurring topic, as is the making of 16mm reduction prints for non-theatrical distribution. Such 16mm reductions were difficult because the machinery supplied by Technicolor was very hard to adapt. The 16mm was however a significant part of their work and of the film industry in the post-war period, so the labs developed a process for making 16mm reductions by printing the image onto part of a 35mm film and then slicing and reperforating the film to produce 16mm. Two final themes that emerge are the introduction of Eastmancolor and the various widescreen processes in the 1950s and the technical difficulties which this posed, and finally the colour consultants, the group of Technicolor experts under Natalie Kalmus who came with the process and worked with the productions, often engendering considerable friction with the filmmakers.

The interviews begin with Syd Wilson, who worked in the labs in various roles, including foreman from 1949 to 1971. Wilson's interview includes a useful section outlining the technical processes involved in Technicolor printing and the working practices of the labs. The second interview with production controller Dave Davis similarly highlights the organisational complexities involved in running the labs. Senior staff members Bernard Happé and Frank Littlejohn each then add their own memories and understanding of life in the labs, while Les Ostinelli discusses his role as a 'contact man', a liaison between the producers and the technicians.

INTERVIEW
SYD WILSON

Syd Wilson was born in Uxbridge in 1920. He left school at fourteen and served in World War II. After the war ended he saw an advert for Technicolor in the local paper and joined the company as a track printer in 1946. A rather basic job, which involved changing the exposure during processing, Wilson learned it in only two days and quickly became bored. He applied for a number of different jobs and eventually moved into matrix printing. Wilson was constantly suggesting ways of improving the efficiency of the plant, and in 1949 he was promoted to foreman and invited to join the Technical Development Committee, an internal committee responsible for discussing and developing new methods and ideas. Wilson left Technicolor in 1971.

EXTRACTS PERTAINING TO COLOUR FROM BECTU INTERVIEW NO. 69

DATE OF INTERVIEW: 18 JUNE 1991
INTERVIEWERS: ALAN LAWSON, JACK HOUSHOLD AND ALF COOPER

SYD WILSON: Matrix printing is optical printing … I went into matrix printing and I knew that the rate in there was two and sixpence so I put myself out and really learned matrix printing. Also, when I started at Technicolor I took up photography as a hobby, because I didn't know the back from the front of a Brownie Box camera and I realised I'd got to do it.

So we're now in 1948 and this was the time when I can see all sorts of things that were rather silly going on; that you had to do something but someone had to check you to make sure that it was right and then someone had to check the checker. There were all sorts of things that I could see that would enhance the machines and the way of doing things. There was a suggestion box there and you'd put a suggestion in and, if anyone thought it was worth taking up and did something about it, then you'd get a reward, and I was putting various suggestions in and getting £1 for this and £2 for that. Then we started doing the Pearl & Dean [cinema advertisements] and I designed a loop system. We had to produce ten matrices you see of every one and there were three records and thirty times you were having to print things; only short things, thirty-second things, one-minute things. Put it on a loop and run it through and it was a damn sight quicker than threading and unthreading thirty times. I put that one in and I got £5 for that one. This was magic! It was nearly a week's wages.

We'd started doing travelling mattes and *Black Narcissus* was on the go and the operator went out one night on his motorbike and had a crash and he was killed. There was no one in that place that knew how to run that printer and there was all this work to do. There was *Black Narcissus* and following that there was *The Red Shoes*. So the foreman said to me, 'Do you think you might do anything?' So I had to go on to this printer and work the thing out because there were all sorts of things on it that weren't on any other colour printers. It had the most peculiar fade-dissolve system. I taught myself how to do this and I did the travelling mattes on *Black Narcissus*. In those days you were quite

involved because you were talking about size, your developer, temperatures, speed and all sorts of things. Anyway, no sooner had we got through those travelling mattes and up came the trailers for *The Red Shoes* which was an eighteen printing job; eighteen printings for each of the three records.

JACK HOUSHOLD: That was the first picture where they wanted to put coloured letter titles.

SW: That's right.

JH: And Pressburger wanted the same colour in the titles as in her red shoes. So how do you do that? That is my *pièce de resistance*. I suddenly thought,

> If I can find a large shot of her red shoes in that picture I can read up the density gradients of the red and blue records. Therefore if I could make a red, green and blue dupe negative on this printer with the same density on the dupe negative RGB as they were on the original camera negative then I'd get the red.

And that's exactly what I did.

SW: We're getting to the 1950s where you were getting various new formats like CinemaScope and VistaVision and all these required different sorts of printers. We already had four of the new type of printer. They were designed in such a manner that you couldn't really modify them to do anything else. Technicolor designed and manufactured all of its own equipment. You couldn't buy anything outside because no one made it so we had a wonderful drawings office and a machine shop and they used to work hand in glove all the time. I knew what I wanted, so we'd put it on paper and they'd go away and do the detailed drawings and make the things. So we kept coming up with all sorts of bits to enable us to do more and more on these printers.

A remake of *The Four Feathers* (1939) was scheduled called *Storm over the Nile* (1955) and they wanted original negative quality. They didn't want to go into dupes and you couldn't really cut the negative because it was still required in that format. So, using the system I developed, one was able to interprint if you like from the original negative and with newly shot negative you could transpose scenes. It caused a lot of problems as well because it wasn't the management in Technicolor Hollywood's idea; it got to the point where they refused to believe it could be done. Having been forced to install it, they decided it was worth an Oscar so it was nominated. This is the technical Oscar as opposed to the standard Oscar figures but the management of Technicolor added all their names as the people who had invented this system. So you had me in London with Laurie Atkin who had worked like mad with me electronically on it, but there were also five American names on it who didn't have a damn thing to do with it. Looking back, Technicolor, apart from the last eight months, was a dreamland and Technicolor to me is still home.

[…]

SW: Imbibition is, in a sense, the absorption of dyes by a softened emulsion so that 95 per cent of the dye that is in a matrix is absorbed rather than printed as you would on to

paper. In 1928 the imbibition was adapted for a two-colour process and in 1932–3 the three-strip beam splitter camera was completed. A matrix with a thick emulsion on it goes through a dye bath and is loaded with dye. You have a piece of clear film, which Technicolor call a blank, and prior to meeting the matrix it's been softened because it's been run through a bath of water and it has the property of absorbing dye. In fact, it absorbs 95 per cent of all the dye that is in the matrix. So it's imbibition in the sense of absorption.

In 1935 Technicolor Limited was formed in England. It was owned equally by the American Technicolor Motion Picture Corporation and in London by London Film Productions Limited, Gerrard Industries Ltd and the Prudential Insurance Company. The American parent concern acquired 50 per cent of the stock in return for patent rights, secret processes, etcetera. All of the films for the three-strip Technicolor camera were manufactured by Kodak for Technicolor. The camera lenses were specifically designed for Technicolor cameras and were made by Taylor-Hobson Ltd.

Technicolor negatives at that point in time were processed on drums holding 1,000 ft lengths. These drums were about four feet and six inches in diameter and they were eight feet long and there were three wheels – one at each end and one in the centre – and then there were very smooth slats of wood, which were quadrant half circles, and they were put all the way round. On each of these slats were staples in spherical form from one side across to the left so you fed the film on from the staples and, as the drum gradually turned, it went across and you got 1,000 ft on.

In a long, narrow room there were a series of troughs with the various solutions; developer, wash and fixer, because you were basically developing black-and-white films. Each side of each trough was a bearer and, to carry the drums, you had a long spindle jutting out either side and you put it in the crooks of your arms, and you lifted and you walked along and you put it on these two bearers and revolved it for someone who was also carrying a time clock with a luminous dial on it. You turned it for the length of time in each solution and that's how Technicolor was developed. Quite honestly, if you look at those original three-strip negs, they're as clean as a whistle; no fading, no anything.

Before developing, the blue record was treated in a bleaching bath to destroy the red filter coating on the surface of the emulsion. Once the records were developed, each record became known as its complementary colour; that is, the blue record became yellow; the red record became cyan; and the green record became magenta. You also had to develop the soundtrack itself.

So we come now to matrix printing. The matrix is exposed through the base. I had better explain the reason for that. A matrix ends up as an image in relief similar to a printing plate. It is exposed through the base and, depending on the brightness of the image in any given position, it penetrates the emulsion to a certain depth. The brighter the areas, the further it goes through the emulsion and the more dull parts don't go very far through. So that's the reason for exposing it through the base. In the printer a tungsten filament lamp is used. This is a 1,000 watt lamp. It's quite a large lamp. Blue filters were used in the printer of various thicknesses which made various blue densities from dark blue to light blue and this was to control contrast. There's never been, and still isn't, any colour process other than that one where you were able to control colour contrast. The

matrix stock then was the same for all three records, the YCM, because they were merely black-and-white records and so you could use the same stock, but you were able, by using these filters, to control the contrast.

Now, there was a light board system, because as you know a roll of negative is made up of various scenes; it can be five or six scenes, it can be 200, and so it was necessary to vary the lamp intensity on each scene. The system that was used in those days was that the lamp intensity was split into twenty-one amounts of voltage and there was one and a half volts' difference between each of the points. The change had to be as near simultaneous as possible with the actual join between one scene and another. Obviously the lamp itself took a couple of frames to reach the new level, so it had to be at the join and had to be mechanical in some way. What it was were called light boards. They were a great, tall, narrow arrangement and there were twenty-one bars side by side. They were punched with holes in each of these bars; every half-inch was a hole. When the grading came through from the lighting department as to which voltage, or light point, each needed, we had hundreds of little brass pins and they had to be pushed into these holes because with the juddering of the thing they would fall out if they weren't. So you had to push these pins in, light point ten, twelve, fourteen and so on in the appropriate bar which, as I say, were numbers one to twenty one. If you got a roll with 100 light points or scenes in it, then there were 100 holes from top to bottom. It took a while to set this board up; quarter, twenty minutes, half an hour, which was a devil of a job. One used to put a nick on the side of the negative, seven and a half frames ahead of the splice. In the printer at the appropriate spot you had a lever with a free-running, little wheel on it, which was pressed against the side of the film and, as that nick arrived, it would trigger off the light board.

You had to do register changes [which had to be] read up on a microscope which had register pins on it and they used to sit the films on these one at a time. They would read the green or magenta record which was the one which was shot straight through the lens. This was called 'the norm'. Then they had to bring the yellow and cyan records which had been the bi-pack in register to that green record. So you were talking about vertical and lateral movements in thousandths of an inch and so on this lens mount you had micrometers on the side and on the top. On side one, you could move in tenths of a thousandth of an inch and on the top in tenths of a thousandth of an inch. While the machine was running, 'register control' produced the 'register card' and every scene had its register. So every time you had a nick go through which dropped the light board you had to apply vertical and lateral register corrections.

You also got size variations sometimes because the three pieces of negative, from being used in the camera, should always have been kept together, so that they all always remained at the same temperature, so that when they were put together they were all the same size. If something went wrong and they had to substitute a roll, invariably it would have been kept at a different temperature to the other two and so after development it was a different size [and] didn't register properly. So apart from lateral and vertical changes, there was another micrometer at the base of the lens mount which you turned to increase or decrease size. So you sometimes had to do size changes as well as lateral and vertical changes on scenes. The whole essence of the Technicolor system was in the mechanics, not the photographic part.

The film went through a softening bath to increase receptivity to colour dye. It's in this roll tank that the blank is married with the matrix, the blank being the uppermost. Both blanks are then taken onto a pin belt and held by two rubber rollers. Aerated water is sprayed on as a precaution against air bubbles getting trapped between the layers. This is before they arrive together at the next tank and are spliced together at the appropriate synch mark. There was considerable pressure on the rollers to make the sandwich complete and a jet of water was sprayed on to the position where they met because, if you got air bubbles in the sandwich, then you'd got a piece of film that wasn't any good. Prior to the marriage in the roll tank, the matrix goes into the dye tank where it runs in vertical paths past two cascades. These are supplied with yellow dye pumped up from a vat in the floor below. After leaving the dye tank, the matrix runs into the wash back, a tilted tank about six feet long and six inches by six inches in size, and the front side of it is Perspex so you can see what's happening in there.

The pin belt that the matrix is put onto is 240 feet long and the whole length is soldered into a loop. The temperature is accurately controlled. The greater the temperature, the greater the contrast. So you see, there's another contrast control. It was amazing how tight the matrix and blank were stuck together by the end of 240 feet and there was considerable force required to peel them apart. Both matrix and blank were then taken into their own separate drying cabinets. The blank is taken off and canned and the matrix goes around again if more prints are required. The whole system then happens again with the cyan transfer and again with the yellow. The matrices are run through a 'de-chro bath', that is sodium carbonate 10 per cent, to remove any surplus dye before dyeing again. So that basically is the matrix process and how it works.

And now we come to the production of 16mm prints in Technicolor. This used 35mm matrix film and blank film. This was perforated down the middle with 16mm perforations. This method of producing 16mm was invented over here in London and, by way of using the correct reduction lens and distances, you were able to make 16mm matrices which were just as accurate as the 35mm ones. The blank again we perforated and we had a modified model-D printer, which was able to put the track down the centre of the 35mm strip and then it went to the dye-transfer machine exactly the same way as normal, except of course the matrix and blank were much shorter than it would have been 35mm-wise. And the transfer was done exactly the same way and after that the matrix was dried but the blank went down and we had slitting machines which cut off the sides and left a 16mm film.

ALAN LAWSON: An extremely wasteful process.

SW: But what you have to remember about this is it was the only colour process available. Even when Eastmancolor came in, the cost of Eastmancolor positive stock was so high and we were using just ordinary black-and-white film. The other thing we didn't mention was that, if in transfer something went wrong, we had a reclaim process, so you put the blank through the reclaim machine and it took all of the dye out of it and it was useable again. I mean when the other labs came to use Eastmancolor film at a cost of about four to five times ordinary black-and-white film and if it went wrong it was a write-off. If it went wrong [with us] we still used it again so really we kept this process going for a long, long time.

Now, there was an agreement made when the company was formed that London would service the Eastern hemisphere and Hollywood would service the Western hemisphere. That was [regardless of] wherever the film was made and processed originally and that's how it would be serviced. So every film that they made that was going to be released over here, they would send matrices over here and vice versa. Everything that's made over here goes over there.

The whole of Technicolor was like a hospital, totally clean. We had a staff of eighteen janitors working twenty-four hours a day. Everything was cleaned daily and the temperature was controlled in every room absolutely to 71 degrees Fahrenheit and a wet bulb temperature of 68 degrees and it never varied. We had on the roof a massive air-conditioning system. All the air was inducted. It was totally washed, cooled down and put through another wash before it was ever put into the building. It was a fabulous system.

AL: Was that degree of cleanliness warranted?

SW: Oh yes, because if you went to other labs that didn't have it, well, you've only got to look at stuff on the screen.

AL: The sparkle?

SW: Yes. We thought so anyway. We were very, very proud of our quality. We had a steam engine which ran a great big alternator and from it the negative developers were powered. All of the printer lights throughout the whole place were powered by this steam engine and it was totally voltage-controlled. All aspects of positive printing were on the first floor of the building, the whole lot. On the ground floor was the solutions department, which occupied about two-thirds of the ground floor actually, positive assembly and the shipping department obviously and that's how it was arranged, which was the best way of dealing with everything.

AL: Earlier we were talking about dyes. Now what's the difference between the additive and subtractive processes?

SW: If you think of an additive process, three pictures are taken of the subject through three analogue analysis filters. One will bear various densities representing the red light of the subject, another, the green record and a third the blue record. Ordinary black-and-white positives were made from these negatives and the three positives are then projected simultaneously through a projector so that the images converge on the screen giving a colour picture. Now, if you think about it, you've actually photographed the three colours that you are talking about and you are reproducing those basic three colours. Now in a subtractive process, what you are doing is really photographing everything in the three records, except the colour you're talking about. So, three pictures are taken of everything through filters or on a particular colour-sensitive film. The red record records green and blue, the cyan record records red and blue and the blue record records red and green. In other words, they are minus the colour of the record in the negative so they are negative colour. Now that's the subtractive system, whereas with additive, you're actually photographing the colour you're thinking about.

Now we've come to the structure of Technicolor as it was in 1946. There was a negative-developing department that we've talked about. There was negative assembly. Negative assembly was the cutting room where negs were cut to a cutting copy. There was the rushes department. Neg assembly had a part of it that looked after all the rushes.

After development they made up the rush print. Then, in those days, the rushes were viewed by the sales side. The lighting department was where all the graders were. The graders had to read negatives of each scene on densitometers and that's how they achieved their colour, which one hoped was a neutral colour that produced a black black. When a negative was made up or cut, they produced what we called a printer card with it, which was a continuity card. The beginning and end edge number of every scene went in the two appropriate columns. Then the actual length number in the column next to that, then the scene number was written in the next column and there were three columns, yellow, cyan and magenta, for the lighting department to put their lighting in for each of the three colours for the matrix printers. Then there was a long column at the end of it for a scene description. That was a printer card.

So anyway, matrix control controlled all the printers, lamps, the matrix developer. They tested frequently to make sure everything was going through all right. They'd put another tester through to make sure the test was all right as well. Then there was master and dupe control. They controlled the master and dupe printers and in those days, we had a master and dupe developer which of course was a black-and-white developer. Register control read up the negative on a microscope as a slide which can slide either vertically or laterally with register pins on it. So they'd actually select a frame and put it on to the register pins and, having read the magenta negative, they could then put the cyan and yellow negatives on there and give lateral and vertical corrections to bring them to the same register as the magenta. That was register control.

Then you had solutions control. They had to check all the dyes and all the various solutions. We've got down to lighting departments and they've done their bit. Now the next thing that happens is the negative goes to register control and the register card is made up. You've heard about the printer card, they now make a register card out with all the register corrections that are required on a scene-to-scene basis. So when the matrix printer gets it, he gets that as well. There's a track printer department which printed the tracks and in those days it also printed the greys. Track developing, which again is self explanatory. Matrix and duping, printing and developing. The dye-transfer department and then the rushes. Every inch of film was always viewed by Technicolor.

Because we were always making and designing and coming up with our own ideas, there was what was called the Technical Development Committee. In 1948 they promoted me to foreman and told me that I had to be a permanent member of this committee, which pleased me because where it was technical I was all right.

In 1952 we started to build the Eastmancolor plant. Because Eastmancolor came in in 1952 and we knew that one way or another we were going to have to use it for something or other. Within that [plant] we had first of all just a positive 35mm developer. We later put a 16mm one there as well. In 1953 the last three-strip picture was made. We did the Coronation in 1953 in three-strip and the last picture to be done in three-strip was *Romeo and Juliet* (1954) That made all the Technicolor cameras redundant and we went over to Eastmancolor.

We knew we were going obviously some time before so we'd put in Eastman positive developers. I think because we knew it was coming, it was really 1954 before it was finished. We went over to Eastmancolor and from then on all our rush prints were

Eastmancolor rush prints. We didn't bother to try the dye transfer as it was a bit too lengthy to get there and now with integral tri-pack people wanted rushes very early the following morning, which they never got when it was dye transfer because it took too long to do them. We went over to Eastmancolor rushes but they were, at that particular time, printed on an optical printer – in other words, matrix or similar to matrix printers – as the quick way out. Colour-wise of course we had to use colour filters, correction filters, as the means of correcting colour for Eastmancolor prints. Everyone at that point in time, everyone did that.

I told you that all Technicolor prints were on negative perforations. Well, in 1953, everyone else started to use positive perfs and Kodak only produced Eastmancolor with positive perfs. So that meant altering all of the pins in all of the printers, altering all of the pin belts that had to be remade because they had that positive pin and they'd [Technicolor processing machines] got negative pins and it was very costly. But okay, we went over and started producing matrices with positive perfs. But it came to the point that we had such a vast amount [of] invested interest in matrices that had been made previously because distributors didn't stop wanting prints; they still wanted them. Well, you couldn't afford to remake these highly costly matrices so we had to set up perforators to reperf literally millions of feet of matrices so we were able to carry on making prints for the various customers. It was very, very precision-perforated. The main problem we had, we found that having reperforated you had to do a wonderful cleaning job on them, because having reperforated all the dust got out and tended to stick to them if you weren't careful, but we got over it.

INTERVIEW
DAVE DAVIS

Dave Davis was born in South Wales in 1921. After serving in the artillery in World War II he joined the Technicolor Labs in Denham in 1946 working in the administration side of the labs, taking care of customers' requirements. He worked for Technicolor for thirty years, ultimately becoming production controller and then production supervisor. In this capacity Davis developed a system for organising the enormous volume of print jobs which the labs handled every day.

EXTRACTS PERTAINING TO COLOUR FROM BECTU INTERVIEW NO. 230

DATE OF INTERVIEW: 27 NOVEMBER 1991
INTERVIEWERS: ALAN LAWSON AND SYD WILSON

DAVE DAVIS: We built a nucleus of what was production planning to try to get some order into, well it wasn't chaos but there was certainly some disorder, and by about 1950, I suppose, we had really got it to a state where the laboratory did what we want rather than they did what they want because it was easier for them to print 100 prints of something rather than one, so it was a great battle to get them all trained and oriented, and all the instructions came from a production system log kept on paper.

We developed a record system of everything we wanted to make a Technicolor film, which was a bit different from a black-and-white lab. Things in Technicolor were all different, and you had to have certain things before you could start, and we gradually established a very, very good system of records. So when someone wanted to make a print we knew where everything was and where it could be obtained from.

I had a schedule on my desk, which covered a year's work. At the height of cinema, at its peak in the 1960s, it covered a year from January to January, and on one side of the schedule it had all the distributors. I had I remember British Lion, Columbia, Disney, Eagle Eye, MGM, RKO, Twentieth Century-Fox, Warners and all the others. We knew, for example, that a picture would be on release in May of that year. So, we would pencil in the amount of footage that would be needed to make that number of prints, and in those days the initial order for this country was fifty prints, and they covered generally the north London release and all the Odeons and ABCs. They started off with fifty prints and those went then south of the river for the next week and then they dispersed all over the country. There was always an initial order for fifty prints for export which went everywhere where they spoke English except North America, because we made prints for the world except America, which were made in Technicolor Hollywood. We also knew that that picture would be dubbed in French, German, Italian and Spanish – they were the four – and we would be told that dubbing would be off the tracks. These dub tracks would be available on such a date, so we would then put those things into our schedule.

A good picture could also be dubbed into Norwegian, Swedish, Finnish, Danish, whatever, so all this information was sent to us and was put onto this large schedule, and we could say to anyone, 'We're full up therefore you can have your copies then', or 'You can

have your copies now, but we'll have to move something out', and there was this constant juggling.

The yearly schedule was broken down to a monthly, weekly and daily, almost to a machine schedule, so that the man on that printer was given that work to do. In the old days they used to go and get work, and they used to sort it out; they'd take this, but they didn't do that. They had to do what you gave them and it took a long time to break down this feeling of being told what to do, but eventually we won. In the end we were doing things almost on demand. If a guy rang up and said, 'Look, there's the Bijou in Bolton and the projector's messed it up and reel four is scratched from head to toe. Can you help me?' And I would say, 'Certainly', and I would be able, in hours, to produce a reel four to get back to that cinema, but it took ten or twelve years of battering, before it got to that state.

What do you need to make a Technicolor film? Well, you need a matrix first of all, and this is where it differs from everything else, because you don't need a negative, you need a matrix, which has got three colour records: that's yellow, cyan and magenta, and you need a soundtrack and you need a matt loop. Now the matt loop was a little loop of film which prints the black spaces between the frames. You would give a guy the soundtrack and the matt loop, and he would take some positive film. He would then print the number of reels required and each reel had a document called a route sheet, which had all the information on it which he required technically. This route sheet followed the can of film through the process. Because the blank film went in one end of the machine and the matrices went in the other machine, they had to be separated. Each subject was given a production number. When I left we were up in about 22,000, I think. We had records of all those. To make a print for another country involved making another version of the film, which may have been censored according to the anticipated reception of certain aspects of it, and which would have a different soundtrack. Thus the production of a print for screening in another country involved additional and, or, substitutive procedures: an additional reel of film called a 'main, additional and inserts' would be produced, whereby titles and printed text in the film would be redrawn and rephotographed in a different language to cover all the changes that needed to be made. A positive assembling operator would make a print of the film with all the required and relevant changes.

Over 1,500 features and between 2,000 and 3,000 cartoons were available on demand at any one time. People used to ring me to find out what I had of their material because our system was so good. The record system was amended continually so that it was possible to track each print; to locate who had had what print, at what date, what cuts had been made to comply to the requirements of the censor, what pictures couldn't be sold and where. All this stuff, from 1938 right up until the day I left, was available and, although many people tried to get rid of it, nobody ever did. It was always there and …

ALAN LAWSON: Why would they want to get rid of it?

DD: Well, because people didn't understand you see. They had peculiar people come. The sort of whiz kids who had done business courses and looked at all this paperwork and said 'Christ, we don't need all this' and I would say, 'Yes, you do, because tomorrow someone is going to sell a print to Italian television and we would have to know where it

all is', and they'd say, 'Why do you do all that?' 'Because without doing this, you can't make the print for them.' 'Ahh,' they'd say, 'we'd better keep it.' There's a huge amount of knowledge which people who go to the cinema don't even begin to suspect that goes to make a Technicolor print.

There was a competition between Eastmancolor and Technicolor dye transfer, because the facilities we were getting in the 1960s came sort of half and half. We got half of matrices and half of colour reversals, and the balance of the production schedule moved from being completely dye transfer to probably half Eastmancolor. Although we did all the scheduling, well with Eastmancolor, it wasn't as complicated because you didn't have backgrounds and things like that, and you couldn't use overlays on printers, so all the things that made good films – the Rolls Royces of the industry – you could do. You had to photograph completely new bits of title into the film if you wanted to change it, and gradually with more people on the continent and over the world speaking English, more and more prints were shown in its [sic] English version.

In this era (1970s–), films were sent out to Ideal Film Laboratories to have subtitles added. If a customer didn't want to go to the expense of an overlay, by photographing them, they would send them to Ideal Film Laboratories and they used to use an acid and etch in the titles. From our point of view it wasn't very good because it wasn't terribly efficient in the way that a lot of the titles never used to come out, so when you were running through the reel of film, and you suddenly miss a few titles, we were forever making little bits of film to cut into reels so that they can title it. The worse thing in the Technicolor process was to make thirty feet of film because the effort to make thirty feet of film in the middle of a reel was an absolutely complete timewaster because of the problems of getting it in synch with the picture and the track.

SYD WILSON: What you used to have to do was to print a short piece of matrix to cover the sections required and then make it up with blank leaders to make a complete full reel length and then run that full reel length on the dye-transfer machine.

AL: Wasn't one of the problems though, it always is with the etching of subtitles, that they were being etched onto the wrong type of background anyway?

SW: Sometimes the etch didn't really sink in deep enough to take away all the emulsion and you had these fuzzy-looking things

DD: On *Tales of Hoffmann* we listed the variations in the versions of that film which covered thirty-one pages of thirty-column analysis paper, and to anyone who was into Technicolor from thirty pages of analysis paper with thirty columns, you can make thirty or more different varieties of *Tales of Hoffmann*. Sometimes all of it was dubbed; sometimes bits of it were dubbed, sometimes it was subtitled, sometimes they sang in French, sometimes in English. You name it, you had it. Some bits were deleted, some acts were deleted, but one day it got so complicated that we sat down and we put all the information on this one sheet of thirty-column analysis to know that every part of the world had a different variety of *Tales of Hoffmann*. It was one of our prize possessions.

SW: With the Technicolor process, if you didn't like what you saw on the film, you were able to take the image right off in what we called 'reclaim-it' and then do the dye transfer again and put it back on so, where Dave said people used to

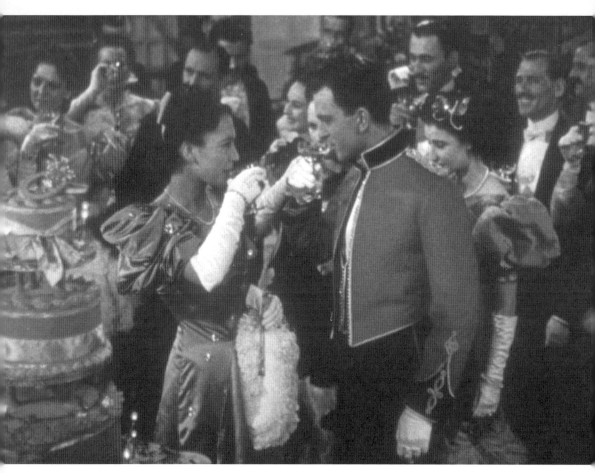

The Four Feathers (1939)

come in and say, 'You've got the wrong title on here', they'd send the track back and then Dave had to schedule it through the reclaim to get it done.

DD: In the early days it came off the machine, it was taken to a projector and it was rewound and projected next to a reference print, which you had to match within certain tolerance. And in addition to that, the viewers could pick up defects like bits of dirt. I have seen people with a roll, 1,800 feet of film, with a little paint brush and a little jar of carbon take every bit of dust, dirt, sludge off that matrix because you couldn't show it to people because it had got little black marks all over it, because the matrix was really alive. It had material in there. Although they were dried before they were put away, because they'd do a print of *Four Feathers* and you'd use your matrix, and you'd rewind it, and you might not use it again for a year if you'd no requirement. It would stay in its can. Now, if that film wasn't dry when it went away, and it was damp with the heat and the compression of the thing, that used to create what are enzymes, which is what your biological washing powder uses to get rid of the dirt.

SW: What happened was that minute spots of water formed on the matrix when it was rolled up. Within the water there was algae and the algae used to gradually eat into the emulsion, so if you got round spots which we used to call mottled, there was actually nothing you could do about it because it had actually eaten the emulsion away.

DD: Right, so you had to make a new matrix, you see, and if you look at television today, I mean, I have this as one of my hobbies, but I know that I can see mottle on an old Technicolor print. If you see something like snow, only little bits coming suddenly and you get your little things and you say, 'Look at that, that's mottle' and you know how old the print is as well.

SW: Quite often it's coloured, of course, because it'll eat into one of the particular matrices.

DD: They had the computer people down for a long, long time and they came up with things which they had done in engineering factories which you could never apply to Technicolor because it was always different. Well, I mean, you could make a screw, and make the computer for it, and that programme would do any screw thing, but they couldn't bring anything to Technicolor because everything was different; the language was different, the technicalities was [sic] different, and there was so much of it. There were so many things in use in one day throughout the plant. There would be 2–3,000 separate bits of film in various stages of being worked at during the day and I spent a lot of time with the computer people telling them what was involved but they could never come up with a programme that worked and it was abandoned for some years. Then suddenly, in about 1983 or 1984, I was probably in Sainsbury's or somewhere, and I saw all these different beans, and cans of butter and pineapple chunks, all going through, and all being put on a computer and registering, and I thought, well, if that can be done there, then we can put all the thousands of bits of film we've got in Technicolor onto a computer using the original production number. So we had a string of figures which would tell you the subject, the name, the title of the film, the version of the track, the version of the picture, how long it was, whether it had any censor cuts and you could then produce it. Say, if you take *Dr No* (1962), which had five large reels and a little reel in a print and you are making

300 copies, so you've got 1,500 big reels and whatever in little ones. Now in Technicolor, each one of those cans has to have an instruction on it to what the man is to do. The first man to get it was the printer, who printed the soundtrack on it, and when he did his little bit, he filled it in and passed it on. Well, originally all those were done by hand; there was a girl there, or two girls, and all they did all day was to write out the route by hand, laboriously, and that route sheet was about 6 by 4, and it was perforated, had three sections and in the old days they were interlevered carbon by hand. Through this system, they were able to track which orders had been printed, which had been shipped, which they were unable to complete because they had sections missing.

The path of the film through a dye-transfer machine, from where we'd put it on at one end and took it off at the other end, and it was regulated by pulleys that went up and down. You had a minimum footage when the pulley was right up the top of about 1,650 ft, and the maximum of when they were down the bottom of about 1,920 ft. Now, most reels of film, double reels of film, fall within that category, and all these things were coming off singly [one reel at a time], and then one day we thought, 'What would happen if we joined it and made a loop out of it?' If you joined the head to the tail together, and make it just go round and round fifty times, if you wanted fifty, and that worked.

However, if you got a reel of film which was 1,584 ft long, you couldn't use that so we said, 'Well, why don't we put a trailer on it, or something, and make it up to the length?' 'Oh well, you can't do that, this is different and the technique's different and you'll have problems with the synch' and we said, 'OK, well, let's try it. Let's take a ten-print order, and waste a bit of film and see if it works.' So, we took a reel of film which was 1,540 ft long, and a trailer which was 220 ft long, joined both matrices together, joined both backs together, made them into the loop and that went round, and we found out we could do ten reels and ten trailers at the same time.

Every West End copy was selected. When I say 'was selected', all the colours went one way. You can say that, if that apple is half a point green that way, and another apple is half a point green that way, then they don't look the same, so what we call premier, and standby copies and trade copies, were always selected, but you couldn't make a premier and standby copy from two prints because that would be impossible, because of the tolerance in the dyes between one and the other. But if you had a ten-print order, you could then from ten-prints select two perfectly good copies. Now those copies didn't have any splices in them, so you didn't see any splices going through this and we used to do the centre titles and then the centre cuts and things, but my career was all to do with making cinema prints. I became a cinema veteran in 1978 after forty years, and I've been to every veterans' dinner since.

INTERVIEW
BERNARD HAPPÉ

Bernard Happé (1912–90) was born in Carlisle. He studied physics and chemistry at the University of Birmingham and then, after a year of postgraduate study, he started work as a geophysicist. In 1936 he responded to an advert for posts at the Technicolor Labs, where he was taken on at £350 pa, eventually becoming senior technician and, in 1953, technical manager. In 1972 he went to China to advise on the setting up of a new Technicolor plant.

EXTRACTS PERTAINING TO COLOUR FROM BECTU INTERVIEW NO. 92

DATE OF INTERVIEW: 13 JUNE 1989
INTERVIEWERS: ALF COOPER, ALAN LAWSON AND FRANK LITTLEJOHN

BERNARD HAPPÉ: I was in positive control under Ian Parsons and our operations were concerned with matrix printing and the register of printers, grey printing, track printing, track developing and basically the dye-transfer process, its three colours. One of my early jobs was to take what were called the 'process answer charts', which were tests which were run at the beginning of each day's operations of the individual colours and to do some densitometry on them to see if we were all right to proceed with production because, unlike the negative side, which was waiting for business to be photographed, we had on the positive side at least some printing work to do from existing matrices which had been sent over from Hollywood. It was a very important part of the Technicolor operation that you should be able to exchange the matrices between the two plants, so that you got the same results from the same matrix whether it was done in London or in Hollywood, and that occupied a great deal of the time in positive control. We had to get the matrix printing characteristics correct and the dye-transfer characteristics correct on the transfer machine, although there was a separate department, a chemistry department who were doing the actual chemical solutions, their mixing and control.

Positive control was also concerned with the pursuit of defects, which was an enormous operation. You transferred the yellow, cyan and magenta images separately and, unless you got them down correctly with the matrix and blank in the right condition, you'd have nasty coloured fringes. So register control was an important part of the operation.

Grey was an essential part of the early dye-transfer system. You should remember that the transfers were made on normal black-and-white stock in those days. It had a silver soundtrack again of perfectly normal characteristics, but it had this light black-and-white image because the dye absorption in the maximum areas wasn't black enough to be satisfactory on the screens. So, you put some grey in there to build it up, which after all was due to the printing process conditions as much as anything else. And that was why it was important to be able to reclaim a defective print so you could save both the stock and the grey image and the track image, which had cost you quite a bit to put back together again. It was in those days a four-colour process and each of them required their own particular control.

ALF COOPER: At one stage we had a defect control department.

BH: Defects was always part of positive control. But chasing defects, whether they were spots of dirt which stopped dye transferring, or bits of gelatine which transferred with colour, troubles where the two films, matrix and blank, weren't sitting together, minus transfer where you didn't get transfer over certain areas. The amount of labour that had to go into ensuring a reasonably consistent degree of quality was really quite considerable. And don't forget that in those days every print was viewed immediately after transfer and checked against a reference print.

In 1937 the practice was to print a grey track and a soundtrack. We conditioned the blank film for a very specific amount of time and under particular conditions with chrome alum solutions to make it suitable to absorb the dye. If the blank film was treated for too long, then the film went hard and the dye wouldn't take properly. If the blank were treated for too little time it was too soft, took too much dye and you got a fuzzy blurred image because the dye diffused. We dropped the grey print as an operation about 1953.

By the time the end of the war came, there was a demand for colour prints but we were feeling the strain of lack of resources; lack of cameras, four of them only; one transfer machine, which I think had got up to about 185 ft a minute by that stage but that was running flat out, six days a week and sometimes on Sunday and we needed more production.

And then it went. That was the boom period until in 1952 or 1953 came the shadow of Eastmancolor and that made a fundamental difference to Technicolor as an organisation. The camera department was no longer the whip hand of the producers and anybody with a camera could buy Eastmancolor negative. But we were badly caught short and this was a severe lack of foresight by the Americans. They could see colour negative coming but they didn't take any positive steps about saying, 'All right, when colour negative comes, what are you going to do?' So the question was whether to give up the equivalent of any other laboratory with colour negative and colour positive or whether we should try and keep the dye-transfer process going, because the dye-transfer process, complex though it was, had some enormous advantages in the days when numbers of copies were used. Once you'd made a set of matrices, you could turn off literally hundreds of copies.

FRANK LITTLEJOHN: And the competition at that time had nothing going for it, of course, because the interpositive, intermediate stock in those days was so terrible, wasn't it?

BH: Well, yes and the interchange between America and England gave a way of maintaining the equivalent quality, and great stress has always been placed on the interchangeability between the Hollywood and London plants. It used what was then comparatively inexpensive raw material in the sense of black-and-white positive stock. It could make large numbers of copies of great consistency and there was a lot to be said for it when release print requirements were sufficient. So the coming of colour negative was first of all met with the very unsatisfactory intermediate stage of making black-and-white separation negatives, extractions we called them, from which we could then use the normal dye-transfer process. The requirement was really that there should be a set of matrix stocks which themselves were colour sensitive – red, green and blue – so that you

could print your matrices direct from the colour negative. The expansion of colour negative didn't lead to the disappearance of the dye-transfer process; quite the contrary really. We had some very good peaks and increasing production of dye-transfer release prints in the late 1950s and early 1960s.

But widescreen was beginning to show up a lot of the limitations of the dye-transfer method as far as the quality of the outline of the image was concerned. Diffusing dye into a piece of gelatine didn't really give you a sharp enough outline; it was lacking in definition in comparison with the competition and this began to be a serious technical criticism, as people started to put their anamorphic pictures on bigger and bigger screens. So again work had to be done, and again, too late I fear. There were two lines which were developed. One had been incipient in Hollywood's research areas for at least ten years previously, because I remember when I visited Hollywood in 1947 and I asked the naïve question about premordanted blank, there was a deathly hush around the luncheon table – the sort of thing you weren't supposed to know about – but it was in fact possible to put chemical components into the blank which would in fact tie the dye down so it didn't go diffusing away through the gelatine areas. This was mordanting.

Also, from the first stages in Hollywood in the 1930s, and applying equally to London from the 1930s onwards, the dyes we used, although they were transferred as yellow, cyan and magenta, were in fact complex mixtures of dyes which were normally available as textiles and they had to be compounded with various proportions of different dyes. The cyan dye had as many as five separate components in it which had to be kept correctly in balance, hence all the work which had to go on in the chemical lab. There had been call for standardisation of pre-mixed dyes in the labs for a number of years on the basis that it would assist with colour consistency but it wasn't taken up until the 1960s. That was the way we finished up with a mordanted blank, no grey, silver soundtrack, and special dyes made specifically by dye manufacturers for Technicolor's formulation.

The other big advance around those later days was the availability of S-Star stock. Cellulose acetate. Well, cellulose nitrate of course in the early days, we were all brought up in the anti-fire regulations with little rooms all over the place. We got through the nitrate period and became entirely safety-based in 1951 and later in the 1950s, the availability of the polyester bases became a possibility. For matrix stock these had enormous advantages. They would stand up to the wear and tear on the transfer machine and multiple usage. They didn't expand and contract and shrink to anything like the same degree, they were much more stable and this made an enormous difference to the consistency and ease of running of the transfer machine. I suppose you could say that it was on that basis from the middle of the 1960s that Technicolor as a process reached its peak in terms of output levels.

Around the 1970s, when we had four transfer machines all going at 300 ft per minute we were doing 310 million ft in the year. In fact we were around the 280–300 ft for a period of about four years then;1968, 1969, 1970, 1971 would be your peak there. **FL: Originally, Eastmancolor was a very soft material and very easily damaged, and we spent a great deal of time, all laboratories did, lacquering and taking the lacquers off and relacquering negatives trying to cover up scratches and minimise them and so on. Liquid printing was developed as an alternative to adding and**

removing lacquer, which involved coating the negative with a film of liquid just prior to printing. This formed the equivalent of lacquer on both sides of the film and evaporated off immediately after.

BH: The very thin uniform layer of liquid not only filled up the scratches and abrasions on both sides, but also it reduced the effective grain seen by the matrix printer. Eastmancolor negative in those days, and possibly still, had a sort of orange-peel surface that was optically reproduced in the matrix printing and appeared as a kind of lightweight grain. The wet printing had the advantage of evening out that surface effect. In the later 1950s, around 1956 onwards, enormously complex demands were being made on the matrix printing process as a result of all these different negative formats. So VistaVision and Technirama, and the squeezes and unsqueezes were making use of colour negative, and all of them on optical printers of varying degrees of complexity. Wet printing was extremely valuable for this.

We were an important contribution to the finance but we weren't supposed to have technical thoughts, these were all supposed to come from the centre. And in fact there used to be a rather cynical phrase, which I don't want to make too much of, that the American reaction to an English invention was threefold, it had three stages. The first reaction is that it won't work. The second reaction was it can be made to work, but it isn't worth doing. The third reaction was: 'We've got a wonderful idea, why don't you do this'?

ALAN LAWSON: I would like to go back a bit if I may? I've come from the camera side of the business and I can remember various old mates of mine talking about the Technicolor experts who come on to the floor.

BH: Oh, the Technicolor consultants. Natalie Kalmus and sometimes another name appeared on practically every Technicolor film from the 1930s to the 1950s. Now the theory behind all that was really a very good one. You see in the two-colour days at the end of the 1920s, colour was beginning to get a little popular but two-colour Technicolor was a tricky one and some colours come out and some don't. The concept was that a colour consultant made available by Technicolor would have a wide knowledge of what had been successful on past productions and what had been unsuccessful and could give advice. You know, 'That deep purple won't come out – it will come out dirty brown and don't expect to get a cobalt blue because the process wont do it', and things like that. They could give some guidance to the set directors or set designers at the time. And the same thing applies with equal strength to the three-strip process. You mustn't use brilliant whites because they burn out, so you have to use what were called Technicolor whites, which were whites dyed in coffee. You mustn't have absolutely dead-black suits for the men's evening wear because it goes an absolutely solid black lump. You must go to a midnight blue, or something like that. So the concept of a colour consultant who provided additional information to the art directors and set designers and costume people was in fact a good one. It was the practice which was so, notorious, to use a careful term.

Joan Bridge was in this country, but the Natalie Kalmus saga has a lot of background to it. It is an interesting thing because it isn't very much on the record. Natalie married Herbert Kalmus in his student days. She had been a model and certainly collaborated with him in a lot of his early experiments. She was an art student in his college days and they married in 1902 actually. Although very few people knew about it, they were divorced in

1921. But they continued their working relationship under the same roof. When I say very few people, even their close acquaintances in the industry hadn't realised there was a divorce. Following that, there was a settlement in 1926 and part of the settlement gave Natalie the rights as colour consultant, which was to become a mandatory clause in every contract for a major feature film that Technicolor signed. So it goes even back to the two-colour Technicolor days. You had to take on Natalie Kalmus as a colour consultant. With the expansion, once three-colour got going from the mid-1930s onward, Natalie built up her team of colour consultants. They were mostly personable young men of artistic leanings although what they actually did, I was never clear. In London we had occasional visits from her and she would allocate one of her colour consultants to a particular production until, soon after the war, Joan Bridge was appointed on a permanent basis as a permanent colour consultant over here. All this would have been quite reasonable if it had gone back to the outline I originally noted, but in fact, the relation between even the camera department, let alone the laboratory and the colour consultants was tenuous in the extreme. As far as contact with the laboratory was concerned, by the time I got there, which was 1937, it was negligible.

AC: They did come over together, Natalie and Herbert, they did come over together on one occasion.

BH: They were frequently over together. Very few people had known they were divorced. They were living in the same place and maintaining their mirage. Where it got unstuck was Natalie was so overwhelmingly attracted by the artistic and creative side of the studio and anything which was just a consultancy and advice didn't fit the bill at all. It was natural enough to hear comments like 'I see the particular mood of a scene being so and so. It should be in such and such a swathe of patterns', which could be completely dissimilar from what the art director had said. So it was easy to see that there were some hellish problems of conflict, but the clause in the contract was there and if necessary that would be brandished about. No colour consultant, no camera. At any rate, as far as colour consultancy was concerned they were in low status as I would regard it by the late 1940s or 1950 or there about and it was about this time that Kalmus actually publicised that they were divorced and, within a year or two of that, colour negative was on the scene and the whole inflated structure had completely collapsed.

It was an immensely satisfying period for a very long time. You felt that you were in a developing industry, that you were making some positive contribution to it, in what was for many years an encouraging context, and I was very happy indeed, despite long hours and troubles and things like that for the whole first period until the 1960s. The 1970s were unsatisfactory because there were management changes. We didn't know where we were going and it wasn't easy to see how things would develop. There was dissension even on the American side about how things should be shaped and the degree of autonomy that should be allowed elsewhere.

AL: One of the things that has come out of all of the interviews we've done with the people from Technicolor is the technical excellence of the machine shop. That is something I find commented on by everybody.

BH: Oh, yes. You see the Technicolor process was a photomechanical process with the greatest emphasis on the mechanics. The photographic side of it was very limited, the

chemical side of it was very limited, I mean in comparison with the emulsion manufacturers, and the colour-stock manufacturers. On the chemists and the photographic side, we had very little. We used what was available. In the early days, it took two minutes for the dye to migrate from one to the other, so a transfer machine had to hold a piece of blank and a piece of matrix with yellow dye together in register for two minutes. Then it had to peel them apart and pass the blank with the yellow image on it to another matrix, which was carrying the cyan image and hold these two in contact for another two minutes and carry them on to a third side, where the same piece of blank would pick up a magenta image. And at every stage those three images had to go on top of each other and go on top of the grain you'd already printed.

AC: Also you had to take into account that the blank was stretching and shrinking on every occasion. In between transfer and imbibing one dye, there was liquid and dryness. Then you'd still got to get that thing back to the right dimensions and you know what it was like. If you overdried it, then it curled up.

INTERVIEW
FRANK LITTLEJOHN

Frank Littlejohn was born in Gillingham, Kent in October 1914. He won a scholarship to Southampton University, graduating with a degree in Physics in 1935. He saw an advertisement in the local paper saying that Technicolor Ltd was looking for young science graduates and joined the company in December 1936 in the negative control department. After serving in World War II he moved into positive control, rising to assistant plant superintendent in 1949 and plant superintendent in 1953. He became managing director in 1968, and was asked to resign in 1971 during a period of instability in the company, after which he went to work for Rank Film Labs.

EXTRACTS PERTAINING TO COLOUR FROM BECTU INTERVIEW NO. 91

DATE OF INTERVIEW: 13 JUNE 1989
INTERVIEWERS: ALAN LAWSON, ALF COOPER AND BERNARD HAPPÉ

FRANK LITTLEJOHN: I joined Technicolor in December 1936, on a very memorable day because I think three young graduates started on the same day. That was myself, Bernard Happé, who was very unique in so far as he eventually became one of the few technicians who became internationally known, and George Newton. His vocation really was teaching but he did two spells with us at Technicolor. He was a great mathematician and he had a very good knowledge of optics, so his contribution to Technicolor was absolutely fantastic. I'm afraid I'm the only one who made no contribution really.
BERNARD HAPPÉ: Nonsense.
FL: I worked in negative control and they were very early days indeed. The builders were still in occupation and it was some time before they got out so I spent my first weeks, months maybe, doing cleaning jobs; cleaning out tanks, cleaning up floors, cleaning walls. I became one of the best cleaners in the business.

The great thing about Technicolor was it was the company that brought science and technology to the film industry, it really was. The film industry really owes Technicolor an awful lot. Not only did it bring science and technology to the industry, but it brought some sort of order out of chaos too, eventually. The paperwork, well, Technicolor was very, very involved in setting the standards for the whole of the industry. It was a great company and, if it got off to a slow start, that was only to be expected. The original licence for Technicolor gave them rights to produce the prints for the United Kingdom and the British Empire plus ships that sail with the British flag. But there wasn't much going by the way of business almost to the time war broke out. We were very, very limited in numbers certainly in negative control so we expected to do everything. Negative control looked after the perforating of the negative, because everything had to be perforated. Sensitising was the job I did, in absolutely pitch dark. We had to learn to wind a 1,000 ft roll of negative on these drums in complete dark and then two people would manhandle this drum by sticking a piece of metal tube into each end. We would manhandle it in pitch dark from open tray to open tray. The

only light in the room was a little green light around the clock where we did the timing for the developing.

BH: It was absolutely necessary to engage your staff of negative developers on the basis of manhandling power. We were in full operation with negatives in 1937 with the Coronation. And that was really an occasion. The first full-length colour newsreel.

ALF COOPER: The first one was the Jubilee celebration down at Dufay[color] because I worked on that.

AL: It was for British Movietone News.

FL: That's right. And every single frame of that negative I ran through my fingers, because when we came out of the dark and we had to wind the negative off the drums and there was a certain technique of holding it, with the edges between your fingers, and quite literally my fingers were cut and bleeding by the time I finished that. But it was a great occasion.

BH: We ran the plant continuously throughout twenty-hours for three and a half days and we slept on the premises. And another thing I found interesting was because of the shortage of people, you did everything. In positive control, I did some matrix printing, I certainly did some matrix developing, I operated on a transfer machine, I did some viewing. I don't remember actually any positive assembly.

FL: There was a tremendous atmosphere which lasted for many, many years. We had lots of problems in the early days but they were all solved in a very cheerful fashion and that lasted to the war years. We only had four cameras which weren't very much in demand at first but as colour began to catch on, [they] were very much in demand and I suppose our best customer at that time was Alexander Korda, who made three big films. Well, I suppose, two-and-a-half. He made *The Drum*, *The Four Feathers* in 1939 and he started *Thief of Bagdad* in late 1939 but that was the film which got completed in America. But it was very interesting because it was a film in which the first colour travelling mattes were played around with, and I can remember experimenting on trying to make a carpet fly through the air.[1]

BH: Chemical fades were done on another machine because you had to have three strips going into the bleach together.

FL: Not true. It was done on the same machine and I did all the experimental work. I decided what time they were going to be so that you got the right number of frames on each of the various stocks. It was done on one original negative taken and put through. If the editor decided he wanted to fade in, that piece of original negative was put in this little machine, through the bleach for the appropriate time, frame by frame. I used to stand by the machine and wind it in, frame by frame, into the bleach and then wash it and hopefully it wasn't ruined. We were able to fade that way. We couldn't make dissolves in those days. We also did in the negative developing room the recovery of the blanks which had been transferred incorrectly, the reclaim process.

BH: It was an important operation, that reclaiming, because it meant that, if you had made an incorrect transfer, you could rub it out and do it again and you could save the positive stock and the soundtrack. In those days, that cost of stock, that

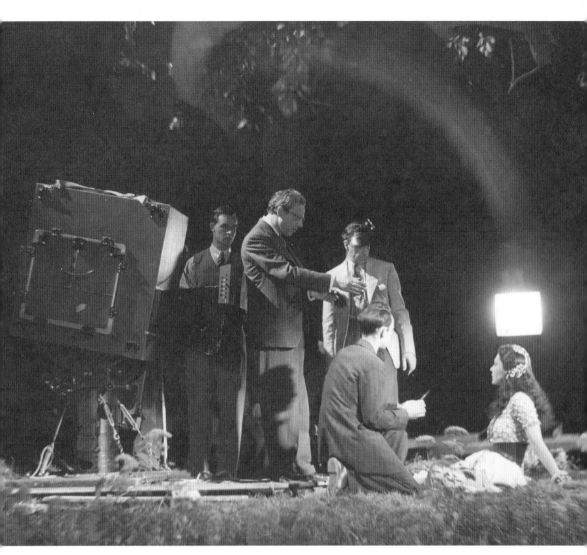

The Thief of Bagdad (1940)

actual photographic material, was high in comparison with everything else. The ability to reclaim a print and retransfer it was an absolutely vital part of keeping the reasonable quality going.

FL: It wasn't long after the war before it had become very popular. Everybody wanted Technicolor. Technicolor Hollywood just couldn't cope. By that time, there was a tremendous backlog of colour films in America. Europe, which had seen no American or British films for all those years, was a ready market for the Americans, so many good friends of mine came over from America working for the big majors. You'd find that studios had made dubbed versions of their films and so there were many versions of existing films to be made and Technicolor Hollywood just couldn't cope. Although it was never official, we were given the okay to make prints for Europe. So our licence, although never officially, extended, became a licence which enabled us to print virtually for anywhere. And of course, from that point on we talked of nothing but getting larger and we had some very interesting times.

BH: It was a period of continuous expansion because during the war, we had been restricted to the four original cameras and one original transfer machine [and] the four original matrix printers, which were becoming more and more overloaded, and although the speed of the transfer machine had been increased over those years, it was pretty clear that one transfer machine could never possibly cope. So from about 1946 onwards we had to think about more machines and the building that went with them.

AC: Frank, what did you come back as when you came out of the services?

FL: I came back as nothing. I was put into positive control [working] on matrix printers trying to change the way we modulated the light, which was very unsatisfactory. It had been done up until that time by resistances which changed the colour of the light so we were looking for different methods. I became plant superintendent and I began to disassociate myself from technical matters and became more and more interested in the commercial side of the business. I became assistant plant superintendent in 1949 and I became plant superintendent in 1953. Then it was the story of more and more work, more and more transfer machines until, I suppose it would be coming up now, to making all those cameras in England.

BH: As part of the expansion scheme on one side, we had to have more transfer machines and the buildings which went with them because a transfer machine requires space about 150 ft long and 25 ft wide, so you had to put those down in the corner and eventually we took three more transfer machines; a total of four. But in parallel with that was the demand for more colour photography and in 1948, it was agreed with enormous reluctance from America that Technicolor cameras should in fact be manufactured in this country. It was unprecedented and it was thought to be quite improper, and in fact in 1948 we had the first of the three-strip London-built or English-built Technicolor cameras. That multiplied the resources enormously. I think about a dozen were made, of which two were high-speed ones, and some of them eventually ended up in other places like the French operation, which was taking shape at that time. Of course, no sooner had we achieved this camera expansion in the early 1950s, than colour negative was

looming on the horizon. And colour negative was making its impact from about 1953 onwards and by 1955 nobody wanted a Technicolor camera. So that made an enormous difference to the camera department, because for a generation they had had the monopoly of supplying the studios, running the cameras, maintaining the cameras, nightly servicing and all the rest of it, and all that suddenly disappeared.

AL: When you talk about the building of cameras in England, were they built at Technicolor?

FL: Oh, no.

AC: I know Ron Hill used to work with all those lens mounts on the camera.

BH: Newalls had the main contract but all the precision work, the movement and so on were in our own shop, but the big castings and complicated machine tools that had to be set up specifically for the purpose were subcontracted to Newalls.

AC: Had we built our Eastman Lab at that time?

BH: No, we hadn't. We had a horrid period when we were caught technically seriously short by the fact that three-strip used black-and-white negatives and therefore could print on a particular matrix stock. When you come to colour negative, you couldn't print matrices directly from it, so we had a horrid period when from each colour negative, production we had to make extractions, which in fact were effectively black-and-white separation negatives and print those on the same stock. It lasted the best part of a year. And Kodak were working on the three-colour sensitive matrix stocks about that time but that took quite a bit of time before that became acceptable. I suppose it wasn't until about 1956.

FL: And once we got that facility and were making beautiful colour prints quite cheaply compared with the competition, the vogue then came for devoted cameramen to mess around with the colour. We had all sorts of strange things happening. I remember *Moby Dick*, where they wanted a sort of black-and-white tinted effect and we got to printing with a black-and-white grey for a while to get the effect John Huston wanted on that. We did a film with Ossie Morris called *Moulin Rouge* [in] which he shot everything through a fog filter and we were swamped with phone calls from all over the country from projectionists who couldn't get their prints in focus.[2] There was a film called *Reflections in a Golden Eye* (1967), a Marlon Brando film, which started off as a colour film and finished up as a black-and-white film with a horrible green tinge to it.

BH: And of course just at that same time, which added to the excitement of everything, was a change of format. Because when Frank and I started, as everyone else had for umpteen years before that, there was only one 35mm size; nice straightforward Academy and you made your cameras and matrix printers and your transfer prints all to that particular characteristic. But when the availability of colour negative came along, then the floodgates were opened. CinemaScope was the one that started it all off. But the run that followed, we had literally, and it was literally, because I counted them on one occasion, forty-seven varieties of actual printing.

FL: These were interesting times actually because we were working on what I consider as the greatest film that's ever been made and it was certainly the film that gave us all the

greatest amount of trouble and that was *Lawrence of Arabia* (1962). It was one of the few that was made on 65mm with an optical squeeze and that was trouble from the very beginning and of course, it was on location a very, very long way away and so we had to wait for the negatives to come in.

I suppose we ought to mention that we used to get up to forty to fifty optical effects in each film and one of the greatest bottlenecks in the Technicolor department was in making the dupe negatives, which had to be cut in amongst the original negatives for all these jolly opticals. This was not only a very tiresome process and of course, the only rush prints we made were dye-transfer rush prints. So we had to make a master of the scene concerned, a negative of the scene concerned, a matrix of the scene concerned, and we had to get transfer of the scene concerned and then discover it wasn't right and do the stuff all over again. Even really when we were doing Eastmancolor as a negative instead of three-strip, it remained a bottleneck and then it was, I suppose, that Syd Wilson came up with auto-opticals.

BH: Yes, that grew out of the A and B printing, which we did for a while on VistaVision. The opticals were done with A and B printing and I think it was Syd Wilson's idea that you could in fact get rid of this A and B printing that was time-consuming and used up a lot of matrix printing time. You could in fact get such an effect if you built up a negative in such a way that your two scenes were there in the one roll and you automatically wound back between them. Now this was possible because matrix printing was always optical. You had to print your matrices optically to get the image in the right place and the right way round, and to make the necessary corrections according to size and shape. So we were brought up with optical printing, which meant that your negative and positive movements could be run independently. And I'm sure it was Syd who initiated the idea that, if you could keep running the negative, but in a period of comparatively short spacing, wind back automatically on the positive and reexpose again, you could get your optical. And that was the auto-optical and I think it was a brilliant idea.

AC: Was that the thing he won the Oscar for?

FL: Yes, he won the Oscar for, but of course, Hollywood shared the Oscar, although it was an English idea. We actually printed films like *Lawrence of Arabia* optically too. We had a 65mm to 70mm optical printer and all those prints of *Lawrence of Arabia* were optically printed, which people in Hollywood said was impossible, and all of them had auto-opticals for sure.

NOTES

1. For more detail on this process, see 'Tom Howard on the Travelling Matte', *Cine-Technician* vol. 7 no. 32, 1941, pp. 78–9, 81.
2. See the interview with Ossie Morris in this volume.

INTERVIEW
LES OSTINELLI, FBKSTS[1]

Les Ostinelli (1918–2008) was born in London. He became interested in film through his childhood hobby of photography, eventually joining the amateur cinematographers' society and making 16mm films. Ostinelli joined Technicolor Labs in 1937, anticipating that he would be able to progress to working behind the camera, but this proved to be difficult. At the outbreak of World War II, he joined the War Office Film Unit. After the war he began work for MGM in the special effects department and became a contact man, liaising between the labs and the production teams. In 1974 he joined Technicolor as director of production services, becoming director of operations in 1978. He finally retired from Technicolor in 1983, remaining a consultant until 1988. Ostinelli was also a consultant at Rank Film Laboratories. In 1981, Ostinelli received the Lenham Award from the Guild of British Camera Technicians and by 1986, he was one of two vice-presidents of the British Society of Cinematographers.

FILMOGRAPHY

1947 *The Silver Darlings* (Clarence Elder, GB: black and white) Special effects

BIBLIOGRAPHY

'BFI Award for Les Ostinelli', *Eyepiece, Journal of the Guild of British Camera Technicians* vol. 7 no. 6, 1986, p. 310.
Ostinelli, Les, 'Optical Fade', *Eyepiece* vol. 2 no. 6, 1980, pp. 44–5.
Ostinelli, Les, 'Giant Strides', *Eyepiece* vol. 2 no. 7, 1980, pp. 46–8.
Ostinelli, Les, 'Colour's First Faint Flush, the Early Days of Three-strip Processing', *Eyepiece* vol. 3 no. 5, 1982, pp. 22–4.

EXTRACTS PERTAINING TO COLOUR FROM BECTU INTERVIEW NO. 266

DATE OF INTERVIEW: 5 NOVEMBER 1992
INTERVIEWERS: ALAN LAWSON AND SYD WILSON

ALAN LAWSON: Can you describe your role as 'contact man;' and liaison between the production companies and the laboratory?
LES OSTINELLI: You visited units and discussed things and whatever, and once the film's completed and the editing's been done, then you'd get involved again. Usually, you don't grade the thing yourself; you sit with it in with the grading because the cameraman's not always available, but at least you have some continuity because you knew what he wanted. They all had their whims and things even in black and white, more so than colour. They all wanted it their certain ways and you were the only one that really knew

what they did want. So then you carried that through into answer printing and grading, showing it to whoever was available: the director, cameraman or whoever. Often it's only the editor, but hopefully you've got the cameraman and director together otherwise they clash afterwards because you've done a print for the cameraman and then you've got to alter it all for the director! So if you can get them together you're on a good wicket and then you can say, 'I'll stand back, you sort it out. Do you want it darker or lighter or greener or browner or what colour do you want?' So that really is what the gist of the job is. The system was always, from the early days, to get into the contact office, you always had to be an experienced grader because then you know what the film can do, you know what the lab can do with the film and you know you can produce what they want or you can't, so that was not a bad idea. The trouble with Technicolor, I found when I went there, was there were no such contact men as I know them. They were all from the camera department, which is not quite the same thing because, although they could be experts on the three-strip camera and everything else, that didn't help much when you talked about processing.

AL: Did you have any cameramen who would go for underexposure?

LO: Well, one of your problems was always trying to keep the underexposed lads up, because there's nothing worse than underexposed film whether it be black and white or colour. It's awfully difficult. You spend days saying, 'Can you come up a bit?' and their response would be: 'I gave it another three-quarters of a stop' and you'd say, 'Well, it don't show much on the screen' because you could never understand whether they did or not you see? And I had that experience with Freddie Young once because, when the second batch of Eastmancolor came in, which was reputedly supposed to be faster emulsion, he was doing a job at the old Danzigers Studio at Elstree and he was telling everybody how wonderful the stock was saying, 'I can do this at' whatever it was, fifty ft candles at f2, and it was wonderful, fast. And, well, I nearly said to him, 'Yeah, but it bloody looks like it on the screen, doesn't it?' because it was underexposed.

It's the people that deliver the goods. There's no better lab than another, they're all the same. There are no secrets to film processing, they all do it the same way, especially in colour. You're governed by what you can do and what you can't, but you've [got] to have people that care and I always cared about the cameramen.

NOTE

1. FBKSTS Fellow of the British Kinematograph Sound and Television Society.

PART III

RESTORATION/PRESERVATION

INTRODUCTION

Film fades and colour balances shift. As the organisations responsible for the preservation and restoration of colour film, archives are caught in discussions that are endlessly driven by concerns over the instability of film stock and the vulnerability of the image to the pressures of machines of production and replay. The retention of materials that were once intended as ephemeral, as multiple prints in circulation, become significant as a singular object that is invested with meaning beyond that of image content. Access to a public collection is caught between the need to protect and fund preservation and storage, and the assertion of access as 'a social right'.[1] Archival policy affects the films held and restored in collections as well as access to them.[2]

This section contains interviews with film archivists supported by documents reprinted from trade papers and journals. It offers an overview of just some of the factors affecting the work of film archives in preserving and restoring numerous different colour processes including tinting and toning, two-strip and three-strip Technicolor, Dufaycolor, Gasparcolor and Eastmancolor chromagenic film stock, especially considering that copies of what is ostensibly the same film can vary due to production, damage and deterioration. The assembled interviews and documents from British and international archives indicate the significance of the provenance of the film for film history and theory, where variations in colour resolution and fading impact on the film text and where each film takes on a specific cultural and ideological form.

The opening interview with Paul de Burgh covers a career which began in 1937 working in optical printing. Later in the 1980s, funded by the National Memorial Heritage Fund (NMHF), he moved on to the restoration of thirty-three three-strip Technicolor films for the National Film Archive (NFA).[3] The restoration process, in keeping with archival policy, produced three black-and-white separations from which a colour image could be reconstructed.[4] Test prints were struck on Eastmancolor film stock and screened at the National Film Theatre as part of the NFA's 'To Preserve Is to Show' programme. These screenings reflected the Fédération International des Archives du Film's (FIAF) advocacy of an archival policy that linked restoration with increased access by transferring the film record to a more viable carrier, thus protecting

source film elements from the damage that would otherwise be caused by repeated projection for screening.[5]

The collection of extracts from interviews and documents that follows, begins by offering a focus on preservation at the National Film Library under Ernest Lindgren's curatorship (1935–73) with Harold Brown as preservation officer (1935–84). The reprinted article 'Preservation of Films' from 1952 signals concerns with the stability of film that marked a gradual shift from cellulose nitrate to safety film.[6] The migration from nitrate to safety film stock undertaken as part of the Nitrate 2000 project was noted by David Francis, a former curator of the NFA, as another step in an unfolding programme of conservation, restoration and access.[7] The interview with João S. de Oliveira, a former employee of the National Film and Television Archive (NFTVA) and current (2012) director of PresTech Film Laboratories, indicates the work of preservation as seeking new modes of deflection, of delaying deterioration while restoration technologies continue to evolve. The impermanence of the image and of preservation lies in predicting the duration of its viability beyond the work that the next generation of archivists might do. For Francis this posits two of the dimensions of archives, that which is analogue and retrospective where the need is to increase availability and that which acquires 'digital-born material'.[8] Thus, interviews with two members of the BFI's NFTVA's staff in the first two decades of the twenty-first century, Kieron Webb, film conservation manager and Sonia Genaitay, curator of fiction, engage with these dilemmas in the project-led work undertaken since 2000.[9]

As cinema as an institution changes, archives find themselves negotiating the relationship between cinema and museum. As film content becomes more accessible through circulation on video, DVD and digital web-based files it is abstracted from its photochemical analogue base. The material substrate of the image bears the marks and scratches of deterioration entwined with the physical characteristics specific to each film stock and colour process. From date codes to variations in the shape and size of perforations along the edge of the film strip, the marks of production, circulation and the aesthetics of different colour processes can be read.[10] Robert Fanstone's appraisal of Dufaycolor signals a visual anomaly 'like wire-netting over the screen' that is a manifest effect of the réseau as part of the material base of this colour process. This effect is negotiated by de Oliveira and Webb in a restoration process that is discussed in their interviews. Similarly, 'Gasparcolor Explained to the R.P.S' is reprinted from *Kinematograph Weekly* and details a subtractive process encountered by de Oliveira and evoked in more detail by Adrian Klein, as chemist, filmmaker and head of the company's London office (circa 1935).[11]

Preservation and restoration are expensive. Francis notes that the NFA's 1974 nitrate holdings stand at 100,000 reels, anticipating £9 million costs and 250, 000 working hours to transfer it to safety stock. In 1991, Jack Houshold, as a former lab technician for Technicolor and the conservation manager for the NFA, cites 160 million feet of 35mm nitrate, while NFA acquisitions continue.[12] By 2004 Heather Stewart estimated that beyond the BFI National Archive's 575,000 high-value items, it would cost $2.3 billion 'to duplicate everything in the film archive'.[13] Thus Clyde Jeavons's comments that 'the Archive's work and its collections are as much international as national' indicate a practice of co-operation that can help to offset some of these costs.[14] Restoration programmes

such as the Lumière Project advocated reciprocal agreements in loaning film elements to support the restoration and reconstruction of films such as *90° South* (1933) in the early 1990s and *The Great White Silence* (1924) in 2010. *Silence* relied on material held at the BFI National Archive, the Filmmuseum in Amsterdam, and La Cinémathèque de Toulouse. A brief account of the theories and practices developed at Haghefilm Conservation B.V. and the Eye Film Institute indicates that negotiation, dialogue and exchange are vital to facilitate the access to and study of archival film as well as to influence the approaches taken in film archives and specialist laboratories.

Paolo Cherchi Usai is the senior curator of the Motion Picture Department at George Eastman House (Rochester, New York) and director of the L. Jeffrey Selznick School of Film Preservation. Cherchi Usai was director of Haghefilm at the time of the interview in 2010 and here he offers a vital perspective on some of the ethical and theoretical issues encountered by archivists in developing an approach to their work. The Haghefilm Foundation, as a subsidiary of the laboratory and sister company of Cineco, seeks to facilitate dialogue between industry professionals, academics and independent researchers.[15] Extracts from interviews with Ulrich Rüdel who was research and development manager for Image and Sound, and Daniela Currò as film preservation specialist at Haghefilm at the time of the interview (2010) add another dimension to the understanding of the issues encountered in the restoration of a variety of colour film techniques, from tinting and toning through to Desmetcolor and digital processing.[16] Following the publication of *From Grain to Pixel*, the interview with Giovanna Fossati, head curator of the Eye Film Institute in Amsterdam, examines issues surrounding the specificity of materials and access to the collection.[17]

NOTES

1. In his interview in London on 12 October 2010, João S. de Oliveira Hon. FBKS, insists that access to public collections is 'a social right'. Paolo Cherchi Usai expresses concern that researchers in viewing the film for study could cause it physical damage, 'Archive of Babel', *Sight and Sound* vol. 59, 1989/1990, pp. 48–50.
2. David Francis, 'What's the Problem?', in Paolo Cherchi Usai, David Francis, Alexander Horwath, Michael Loebenstein (eds), *Film Curatorship: Archives, Museums, and the Digital Marketplace* (Pordenone: SYNEMA – Gesellschaft für Film und Medien, 2008), p. 65; Leon Forde, 'The Ghosts of Cinema Past', *Screen International* no. 1481, 17 December 2004, pp. 15–16.
3. The National Film Library later became the National Film Archive in 1955, the National Film and Television Archive in 1993, and then the BFI National Archive in 2006.
4. Bill O'Connell, 'Fade', *Film Comment* vol. 15 no. 5, September 1979, pp. 11–18.
5. Snowden Becker, 'See and Save, Balancing Access and Preservation for Ephemeral Moving Images', *Spectator* vol. 21 no. 1, 2007, pp. 21–8, 21. FIAF was founded in 1938 and is an association of motion picture archives committed to facilitating preservation and access.
6. 'Preservation of Films', *Kinematograph Weekly*, 13 March 1952, p. 22; Ernest Lindgren, 'The Work of the National Film Library', read to the British Kinematograph Society,

1 November 1944; Harold G. Brown 'Problems of Storing Film for Archive Purposes', *British Kinematography* vol. 20 no. 5, 1952, pp. 1–13.

7. David Francis, 'Preserving the Past', *BFI News*, September 1975, p. 3.

8. David Francis and Michael Loebenstein, 'Archival Control', in Usai et al., *Film Curatorship*, p. 169.

9. Forde, 'The Ghosts of Cinema Past', p. 15–16.

10. Harold Brown, *Physical Characteristics of Early Films as Aids to Identification* (Brussels: FIAF, 1990).

11. 'Gasparcolor Explained to the R.P.S.', *Kinematograph Weekly*, 31 January 1935, p. 47.

12. Francis, 'Preserving the Past', p. 3; Jack Houshold, BECTU History Project Tape no. 199, 1991.

13. Forde, 'The Ghosts of Cinema Past', pp. 15–16.

14. Clyde Jeavons, 'The Archive and around the World', *BFI News* vol. 49, 1981, p. 4.

15. Gabriel Paletz, 'The Finesse of the Film Lab: A Report from a Week at Haghefilm', *Moving Image* vol. 6 no. 1, 2006, pp. 1–32; Paolo Cherchi Usai, Ulrich Rüdel and Daniela Currò, 'The Haghefilm Foundation, Amsterdam: A Learning Laboratory', *Journal of Film Preservation* no. 82, 2010, pp. 87–93.

16. At the end of October 2012 Cineco/Haghefilm Conservation B.V. ceased operations for financial reasons. In December 2012 the company began operating under new ownership as Haghefilm Digitaal. Daniela Currò is preservation officer at George Eastman House in Rochester, New York. Ulrich Rüdel is conservation technology manager at the British Film Institute National Film and Television Archive.

17. Giovanna Fossati, *From Grain to Pixel: The Archival Life of Film in Transition* (Amsterdam: Amsterdam University Press, 2009).

INTERVIEW
PAUL DE BURGH

Paul de Burgh's career spans a range of practices and techniques from lab work in 1937, through to optical printing at Rank and then Anglo-Scottish Pictures, through to work as production manager for *Sympathy for the Devil* (1968) and as a colour consultant for *London Story* (1986). Interviewed here for his work at the National Film Archive (1978–86) focusing on restoration from 1983, he continued this at Rank Film Laboratory from 1986–99. De Burgh undertook the restoration of thirty-three three-strip Technicolor films. Some of these films had been restored previously and again since, marking de Burgh's work as another significant turn in the life cycle of film as restoration technologies continue to evolve.

SELECT FILMOGRAPHY

1986 *London Story* (Sally Potter, GB: Technicolor) Colour consultant

1971 *Danger Point!* (John Davis, GB: Eastmancolor) Production manager

1968 *Sympathy for the Devil* (Jean-Luc Godard, GB: Eastmancolor) Production manager, co-credit with Clive Freedman; filmed as *One Plus One*

1951 *Where No Vultures Fly* (Harry Watt, 1951, GB: Technicolor) Restoration, NHMF, 1988; *The Tales of Hoffmann* (Michael Powell and Emeric Pressburger, GB: Technicolor) Restoration, NHMF, 1988

1950 *Gone to Earth* (Michael Powell and Emeric Pressburger, GB; USA: Technicolor) Restoration, NHMF, 1986

1949 *Christopher Columbus* (David MacDonald, GB: Technicolor) Restoration; *Under Capricorn* (Alfred Hitchcock, GB: Technicolor) Restoration

1948 *The Red Shoes* (Michael Powell and Emeric Pressburger, GB: Technicolor) Restoration; *Scott of the Antarctic* (Charles Frend, GB: Technicolor) Restoration, NMHF, 1988; *Saraband for Dead Lovers* (Basil Dearden, GB: Technicolor) Restoration; *XIV Olympiad: The Glory of Sport* (Castleton Knight, GB: Technicolor) Restoration

1947 *Black Narcissus* (Michael Powell and Emeric Pressburger, GB: Technicolor) Restoration, NHMF, 1988; *Blanche Fury* (Marc Allégret, GB, Technicolor) Restoration, NHMF, 1988; *Jassy* (Bernard Knowles, GB: Technicolor) Restoration

1946 *A Matter of Life and Death* (Michael Powell and Emeric Pressburger, GB: Technicolor) Restoration, NHMF, 1988

1945 *Blithe Spirit* (David Lean, GB: Technicolor) Restoration, NHMF, 1988; *Caesar and Cleopatra* (Gabriel Pascal, GB: Technicolor) Restoration, NHMF, 1988

1944 *Henry V* (Laurence Olivier, GB: Technicolor) Restoration, NHMF, 1988; *This Happy Breed* (David Lean, GB: Technicolor) Restoration, NHMF, 1988

1942 *Jungle Book* (Zoltan Korda, USA: Technicolor) Restoration; *The Great Mr Handel* (Norman Walker, GB: Technicolor) Restoration, NHMF, 1988

1940 *The Thief of Bagdad: An Arabian Fantasy in Technicolor* (Ludwig Berger, Michael Powell, Tom Whelan, GB: Technicolor) Restoration

1939 *The Mikado* (Victor Schertzinger, GB: Technicolor) Restoration, NHMF, 1988; *The Four Feathers* (Zoltan Korda, GB: Technicolor) Restoration

1937 *Wings of the Morning* (Harold Schuster, GB: Technicolor) Restoration, NHMF, 1988

1926 *The Black Pirate* (Albert Parker, USA: two-strip Technicolor) Restoration

BIBLIOGRAPHY

'New Hope of Saving Film Heritage', *Film and TV Technician*, May 1982, p. 19.

Cooper, Alfred, 'Lab Topics', *Cine-Technician* vol. 19 no. 103, 1953, p. 19.

de Burgh, Paul, 'Optical Printing: A Talk Given by Paul de Burgh of Denlabs, on A.C.T's. Own Lecture Course' in A. E. Jenkins (ed.), *Cine-Technician* vol. 18 no. 96, 1952, pp. 66–7, 68.

Pierce, David, 'A History of Colour Part 1', *National Film Theatre Programmes*, January 2003, pp. 16–21.

Eyles, Allen, 'New Life for *Thief of Bagdad*: Allen Eyles meets Paul de Burgh', *London Film Festival Official Programme*, 1989, pp. 26–9.

INTERVIEW TRANSCRIPT

DATE OF INTERVIEW: 18 FEBRUARY 2009
INTERVIEWERS: LIZ WATKINS AND SIMON BROWN

LIZ WATKINS: So, when did you start working in the film labs?

PAUL DE BURGH: 1937.

LW: Did you work with Technicolor at that stage?

PdeB: Oh no, I never worked with Technicolor, but I restored thirty-three films and I just had to find out how to do it mechanically.

SIMON BROWN: What was your first job in the labs?

PdeB: I was the office boy for the guy who oversaw the building of the lab in 1936. He was Gary Schwartz and he gave me a job as the office boy. Then I joined the Territorial Army and I was called up as soon as war broke out because I'd been on training for a month. The unit I joined in south Harrow had mainly Kodak people in it and they were paid throughout the war. Later I got a job with Tommy Howard in special effects, but we were running a small laboratory at the back of what was then the biggest stage in Europe, which was stage four.[1] I used to mix chemicals, do the developing, the spectrometry, do the projection.

LW: You wrote about special effects – optical work – in *Cine-Technician* too?

PdeB: The ACT magazine in 1952! Well yes, that was about black-and-white film only and that was just explaining how one did certain things.

LW: In that article you said that there were some scenes that were more suited to superimposition than others?

PdeB: Well, if you had a night scene and a day scene it would be very difficult, because the day scene would swamp the night scene unless you altered the exposure. You could

give it much less exposure, perhaps just 40–50 per cent to the day scene which is superimposed on to the fully exposed night scene so that you could see the two images clearly.

LW: So the issue would be more to do with exposure than the similarity of image composition?

PdeB: For optical work, such as dissolves, there's a fade out, you rewind in the camera to where you started to fade out and then you fade in over it. So that gives you a dissolve. That was all black-and-white work with blue backing for a travelling matte. Today I doubt whether there's much done that way. I'm assuming that in the studios today they'd be looking at a monitor and the director wouldn't have to rely on his operator any longer. In the old days it was the operator and director working together. The director would say, 'Was that all right?' and the operator would say it was edgy or we'd have to go again, someone didn't hit a mark for focusing and all that sort of thing.

SB: Do you still watch the films?

PdeB: The whole point was that all the archive people would to have to clean the film up, do the joins and so on and then I was left to do the restoration work. So I'd do that all the way through to the first print. The whole idea of restoration was that we were on 35mm film and the restoration itself was in order to make a master positive on safety film that we could file away, having made it from the three original negative separations. The idea was that we could then prove it by making a colour print. So every time we made a colour print, which was once or twice a year, depending on whether it was two films or it might be three or four films, well, not all of them were shown but some were screened at a gala evening at the BFI.[2] So that was very nice. For some years they used to have the Technicolor films of that period on at the BFI, which they seldom do now.[3] I did a lot of the black-and-white Ealing films too.

SB: The classics?

PdeB: Oh yes, *Kind Hearts and Coronets* (1949) and all the Ealing films. I must have done a good dozen or so before I ever left the labs. In fact, when I did the Ealing films and such, Joy, my wife, used to mark up the masters up for me while I was doing all the optical work. For Ealing that was Michael Balcon of course. All the directors were at Ealing.

LW: When you were talking about doing optical work on black-and-white film, were some of those to be printed in colour?

PdeB: No, no we're talking about black and white.

LW: I was just wondering about films like *The Thief of Bagdad* which had special effects and was in colour.

PdeB: Yes, well Tommy Howard, the man I worked for, wasn't even credited, but he put all the work together. This was because, when war broke out, many of the staff disappeared back to America and Tommy Howard was left and so he put the stuff together. So I restored *The Thief of Bagdad* and worked with Tommy Howard. I always thought it was terrible that he didn't get a credit for doing all the work. Larry Butler was the special effects man and he did all the blue backing stuff. Michael Powell got a credit on it although I don't think he was the principal director on it. I did all the Michael Powell pictures actually.

SB: It was while you were in the optical lab that you did those pictures?

PdeB: It was because I could do that type of work. I'd left the labs and I'd worked for ten years with Anglo-Scottish before I went to the National Film Archive. The reason for doing that was that we had £3 million given to us at the end of one financial year by the Arts Minister called Gowrie, who was a liberal peer. Well it was through him that we got the money. I was asked what I wanted to do and I said, 'We'll buy an optical printer among other things' and fortunately that's what we did.[4] I got a Neilson machine. Pete Neilson used to work for Anglo-Scottish when I was there and he was our sort of bodger-up engineer. I also bought an optical printer from Anglo-Scottish, which John Oxbury put it together. Peter and I were working with him because he was our engineer making up things for animation; he could anything you wanted. A year or two later he went to work for Oxbury. Later on and still based in England, Peter started this company called Neilson-Hordell. I never met Hordell who was an engineer and he seems to have been a sleeping partner.[5] So I bought this optical printer for the archive and it cost us £54,000. When Gowrie came round, he saw it and we had a chat and I said, 'Thank you very much – we could do with a bit more money.' Richard Attenborough came down at the same time and he was in the background doing a sort Edward Heath laugh as he did. Later on, I was given a BEM for working on these restorations.[6]

LW: I've read that you were working in the labs and restoration around the time they were making *The Drum* as well?

PdeB: I was at Denham, but I was only a kid in the studios when they were making *The Drum* and *Knight without Armor* (1937).

LW: I just wondered if you'd come across any references to tests on the effects of humidity and temperature on film stock, given the environmental conditions some of those films were made in?[7]

PdeB: I think it's always been an issue, but I didn't know anything about that sort of thing then and I don't think Technicolor did either, but I may be doing them a wrong. I mean they did have their vaults and they'd put their negatives in storage the same as Denham.[8] I mean there wasn't a question of restoration then but, when I went to the archive, Harold Brown was in charge and we knew there were problems because you only had to open a can of film and you could smell what was going on. You could see the film was stuck together and you couldn't save that sort of film. That was impossible. So Harold was the person who was really aware of these sorts of things. I mean as far as I was concerned, I only knew of the problems after I'd gone to the National Film Archive. It makes you wonder what I didn't notice when I was copying the materials. When the lab was under my direction, where the films had been tinted and toned they were in a better shape sometimes than other films because I think the chemicals that were causing the problem were being washed out in doing that process. I might be wrong but I don't think so. Of course later on you've got another problem with [acetate] safety film and so-called vinegar syndrome, which is acetic acid. FIAF had great meetings about it all, but I don't think they've solved the problem. I don't see how it can ever be done. David Francis, in 1976 I think it was, said we have a twenty-four-year plan and by that time the 240 million feet of nitrate will be copied.[9] I'm afraid I don't know how much has been copied, but I guess there must be another 200,000 feet of nitrate still there and it's mouldering away in the bunkers at Gaydon.[10]

SB: I think they tried to get a lot of that nitrate stuff backlogged but you're right, there are still tonnes and tonnes of it there. Some good films as well.

PdeB: I'm sure. I could go on about that for hours!

SB: This is before Berkhamsted was built, so where were the labs that you were based in while you were working for the archive?

PdeB: We had a small lab at the archive. Well, because of my experience at the Rank Labs, whenever they wanted to discard the printing machines or the Debrie machines, the equipment we had came from there. This is except for the one which was at the archive when I arrived. There were also some machines at the other lab that they had up on North Road, so we were able to carry on with the work. The other thing is that we had a marvellous engineer called Phil Read who had never worked in the film business but when I interviewed him with Harold [Brown] and I asked what his vocation was he said, 'I'm working in a glass factory.'[11] I asked, 'What else do you do?' and he said, 'I build motorbikes.' So I said to Harold, 'We've got to have that man, if he can do things like that then he can do what I want.' Phil and I got on very well and he used to make the pins for the shrunken film. In fact after I left, after I was at Denham, Phil was carrying on the work that I did down in the house at Berkhamsted.

SB: That's right it was Ernest Lindgren's house, wasn't it?

PdeB: That's right.

LW: When you're talking about nitrate and acetate film stocks, well, Technicolor has this reputation for not fading whereas Eastmancolor of the 1950s in particular does. Is that something that you've seen evidenced in the labs.

PdeB: Oh, yes. Well, we're talking about something different. What we're talking about is black-and-white separations and Technicolor as a printing process, nothing more. So not the film, but the matrix that they make off of the separations they use for a printing master. A yellow, cyan, magenta master, which is dyed and then a blank film comes together with it and runs along a pin belt which is revolving all the time, so that the film takes each colour from each one of these masters and that is three-strip Technicolor. But with Eastmancolor of course, Martin Scorsese indicated the problem and it's fortunate that he did.[12] The fading affects the print more than the negative. The negatives, well some of them have faded but not as much and, of course, now they can store them in much better conditions. I don't know at all what they're doing in the archive about separations; they probably can't do that and that is probably the problem. Any black-and-white negative will last longer than the colour print, but then Kodak came into it and said that they've got these film stocks that will last for 100 years. Well, I don't know, they may well do. Maybe you'll find they're magenta more than anything as you lose the green layer rather than the whole thing, so that you end up with a horrible-looking print after it's faded. But Martin Scorsese did start that campaign off. I remember Martin coming over and in fact I used to supply the archive prints for Martin. I met him a number of times and of course Thelma Schoonmaker who is his editor. In fact, more than an editor, she's terrific.[13]

LW: I wondered, if you were to view a three-strip Technicolor print and an Eastmancolor print, then visually what sort of characteristics might enable you to tell the difference between them? Does the image resolution and colour range look different to you?

PdeB: Yes, you can tell the difference. The point is that Technicolor is very beautiful in its own right, but it's not quite as sharp because with dye images you get a very slight bleed sometimes. I don't really recall using a Technicolor print to make separations from except I did it on *London Town* and I think that hadn't faded. Technicolor dye-transfer prints don't fade like early Eastmancolor film stock of the 1950s, because now I'm assuming it does what it says on the label or at least I'm hoping it does!

LW: You've said a bit about the role of colour restoration. I'm wondering if you could tell us a little bit more about the processes you used for the National Memorial Heritage Fund programme?

PdeB: Well, the point was that we had the original negatives and if we didn't have them, then I found them. Through my contacts in some cases, I was able to borrow some of the negatives from the library at Borehamwood and send them back afterwards. What I did was to start with was to take the three separations and to make three black-and-white positives. I'd turn the red record, which is the rear record of the bi-pack in a Technicolor camera over, so that it was facing the right way because, when you shoot like that, the red record is like a mirror, you see, it's turned over the wrong way. All separations were made optically. Then I had to put them back together on an optical printer and this is where some of the problems were, because of shrinkage. I used to check every negative and see what pins in the optical printing machine would fit. This is important because there is a big pin and a little pin in the camera. The big pin is the full-register pin and the little pin keeps the film that runs vertically as it comes through the camera steady. So, where were we? Making separations. So having made the three black-and-white positives, you've got to put them together. So the blue record goes through a very dark blue filter, the green goes through another filter and then the red. However, for the problem of shrinkage, even though I'd sorted out the register problem at the beginning of the reel, the only thing I could do was to run it head to foot for, well for example, a 1,000 ft if it was that length. Then you made the colour print and you could see what areas had to be remade to account for problems with registration. So then I'd put it under the microscope and check how much the film was out. What I used to do on the optical printer was to assume that the green record and the blue record were zero and the red record I used to test on a clock gauge on the optical printer. After a certain period, I'd look at the test and see how the layers of the image had finally merged, so I knew that I'd have to use either a plus or a minus reading on the gauges which were tied up with the lens. So when you moved the image, you moved the lens up, down or sideways, rather than backwards or forwards because that would cause a change in the size of the image. Technicolor of course, would do all these changes on every scene when they made their final master for printing, because they had all the information available to them. The negatives run through the optical printer until the technician says, 'Stop.' They'd start at zero, run to 150 plus or minus a figure, then run onto 300, stop again and check the reading again. Those readings would be passed on to the optical department via the people who were doing the registration at Technicolor. The same thing happened with the grading of the film. I couldn't grade three black-and-white separations scene to scene, so I would have to do it in a similar way to the way any Eastmancolor film would have been made.

What we'd do at Denham in the old days was to cut two frames from the end of every negative. So you'd cut the negative, then you'd put that section through a printer to see what grading you needed, but the Technicolor lab had already done that. You couldn't run a machine through a bath of colour and alter the machine and the print. So that's how they'd do it at the film lab. But what I had to do was to sit down and regrade each film from the beginning.

LW: So you'd test a length of film rather than each scene?

PdeB: Oh it would be scene to scene, because we couldn't cut frames out of a negative.

LW: No, no!

PdeB: No. So we'd run the first print and I'd sit in with the grader and then I'd say, oh well, we'll change this or that, until I got a print. We got it right after the first couple of reels, because I used to be a colour grader and so that helped.

LW: So you'd grade scene to scene after you'd produced an initial print of a whole reel?

PdeB: Yes, oh yes, I couldn't chop anything out.

LW: So it was *similar* to the original printing process?

PdeB: Well, we'd run the negative that I'd put together from three separations. At that point I'd have an Eastmancolor negative, but in each grading we'd put that in the machine so that scene to scene it would still be graded. They graded it when I was there by winding each scene through the machine.

LW: Were there 'standard' restoration practices that changed over time or did you have to adapt the process to each film as you went along?

PdeB: Oh no. Well, once I'd made the colour negative, it was a case of grading it to get a print.

[TELEPHONE RINGS – INTERMISSION!]

LW: So you commented earlier on the Michael Powell films?

PdeB: Well, what did you want to say, because you've got a note there about *The Black Pirate* (1926), which was two-colour Technicolor and the print that the archive had was absolutely green. It was just a green colour and Harold Brown at that time used to say things like 'You've got to do it like that.' Well, I used to say, 'No, what you've been given is an old print which has faded.' I'm sorry, but Technicolor does fade and *The Black Pirate* had faded. I actually think that was the first one I did and it's still a bit greenish looking, but you can't make three-colour print out of two-colour Technicolor film elements.[14] The same thing happened when I did the Olympic film, *XIV Olympiad: The Glory of Sport*. It was shot in bi-pack. The whole lot of it was just two films stuck together. So you could only do a green record and a red record and that was the film itself being sensitive to part of the light spectrum. This is mainly because it has to go through two layers of film. I made a false red colour from the other records and in some cases it worked reasonably well, but in others it didn't. In fact with the Olympic film we had a Technicolor print that we were grading to and that was a greenish colour. The only time it was full colour was the sequence that was shot at the opening ceremony when the King and Queen were there. That section was shot with three-strip Technicolor cameras. So to try and turn two-colour

into three-colour would be rather difficult! The same thing happened with *The Black Pirate*. So that's the answer to that problem.

The other thing you were asking about was sharpness and, yes, I noticed the things that I was transferring to Eastmancolor were sharper. They were sharper because Technicolor is a dye-transfer process and therefore, it could not be as sharp because of the dyes bleeding. Another problem was with the dark colours. Well, particularly in *The Life and Death of Colonel Blimp* (1943) when we put the duelling sequence back together, they were wearing blue trousers which in the Technicolor print looked black. So there were times when we definitely got more out of the three-strips put together on to Eastmancolor and even the cameramen who had originally shot the films used to agree with me that these things were better because you couldn't do it with dye transfer.

LW: You mentioned that Technicolor could bleed slightly?

PdeB: You'd get slight bleeding but, for all that, Technicolor was excellent and if you had been brought up not to see anything better, well it's like television now, you look at something from the 1960s and it's awful compared to what we've got today.

SB: Absolutely. Just out of curiosity, did you ever work with any other colour processes apart from Technicolor and Eastmancolor?

PdeB: Only to put the films together. I put together a Dufaycolor film which is the *Sons of the Sea* (1939).[15] Elvey directed it. I knew the cameraman very well and he actually didn't die until he was nearly 100 years old. Yes, he was nice.

SB: What was his name? Do you remember?

PdeB: Not offhand, but I'm told he used to terrify people in Uxbridge going around in his motorised wheelchair. [Laughs] Oh, I know his name, Eric Cross, a lovely man and he was cameraman on *Sons* and it was shot in 1938. Again we had a lot of problems because Dufaycolor is a completely different process and some of the reels were very badly deteriorated. At times all we had were two records that we could use.[16] The records were stuck together and they were very, very badly decomposed. Try as I might, there was nothing more I could get out of them for that picture. But apart from that I've worked with the 16mm lenticular [lenses for filming and printing] but only short pieces for people. I did some for East Anglia for the curator there.

SB: David Cleveland?[17]

PdeB: Yes, he was quite a good friend and I did some work for the girl in Scotland, Janet MacBain and that's about it, I think, for colour processes as such. I did do a restoration of *A Kid for Two Farthings* (1955), which had been shot on Eastman but I had a lot of trouble with that. That wasn't easy to put together and personally, I felt quite ashamed of it all but there was not much more I could do with it.

SB: The restorations you did, the Powell ones, they were the ones that Criterion eventually put out on laserdisc weren't they?

PdeB: Oh, they got lots of screening, *Henry V*, all the Powell films and some of Korda's pictures as well. I didn't do *The Drum* because we couldn't find the negatives. They were in America and we never did it. We were going to do *The Drum*, but we didn't.

SB: That's a shame.

PdeB: The films were chosen for restoration by English Heritage.[18] They gave us the money and said what pictures they wanted to be copied.

LW: You've mentioned a little about comments from the cameramen during the restoration process, so was it possible for you to contact them? Would their input inform your restorations?

PdeB: No, no, not really that was just because, generally speaking, we proved or tested the restoration process with Eastmancolor prints and they were very pleased, people like Billy Williams, Jack Cardiff and Ronnie Neame. Of course, Neame did *Blithe Spirit* (1945) as a cameraman, but he moved on and split from David Lean to become a director and a producer.

SB: So you restored *Blithe Spirit* as well?

PdeB: Oh yes, definitely. It was very funny, Margaret Rutherford!

SB: Always a favourite.

PdeB: Yes.

LW: To step back a bit, if the negative or the print was damaged was it part of the plan to address that?

PdeB: No, at the archive the repairers would go through the negatives and, as I understood it, they were taking every scene apart, so peeling them apart, cleaning them up and putting new cement on. They had nitrate cement at the archive. Then if anything was torn particularly badly, they'd restore that by putting some new perforations on the edge of the strip of film. Once I knew where those sections were, then I could stop the camera and move it through gently frame by frame. Then we'd start again because the master positive and the raw stock were obviously in synch, but generally speaking, the restorations, well, for all the Technicolor ones, the negatives were in excellent order. I did a lot of other bits and pieces you know, early films and colour films and things like that, but a lot of them were just 50 ft in length and so on. I did quite a lot of that kind of restoration and then some of Friese-Greene's early two-colour films, which consisted of alternate frames on a piece of negative with a filter reel in front.

SB: Oh, that'll be either Friese-Greene or Urban-Smith.[19]

PdeB: No, did Urban-Smith do any colour?

SB: Kinemacolor.

PdeB: The same as Friese-Greene, but I've done the restoration of Friese-Greene material.

SB: That was *The Open Road* (1925) and *Kino, the Girl of Colour* (1920) and things like that, beautiful stuff. So is this a list of the films you restored?

PdeB: There's thirty-three there and I used to tick off all the films that I'd done in a copy of Huntley's book, but unfortunately when I came here the book was lost.[20] I didn't do *The Laughing Lady* (1946). I did *London Town*, I didn't do *Western Approaches*, I did do *The Great Mr Handel* (1942), but not *The Drum* or *Sixty Glorious Years* (1938). But most of the films in Huntley's book I'd restored.

LW: I was just wondering when you spoke about *The Thief of Bagdad* and some of the optical effects, if you would mind telling us a little more?

PdeB: Well for *Thief of Bagdad*, the travelling matte system at that time was difficult to make separations from. Unless you know how travelling matte works it's difficult to describe it, but with some of the separations you were trying to make a black matte to run against something so it left a blank or a hole in the image after it was exposed. Then you'd rewind the camera and obviously make a complementary matte to put into the

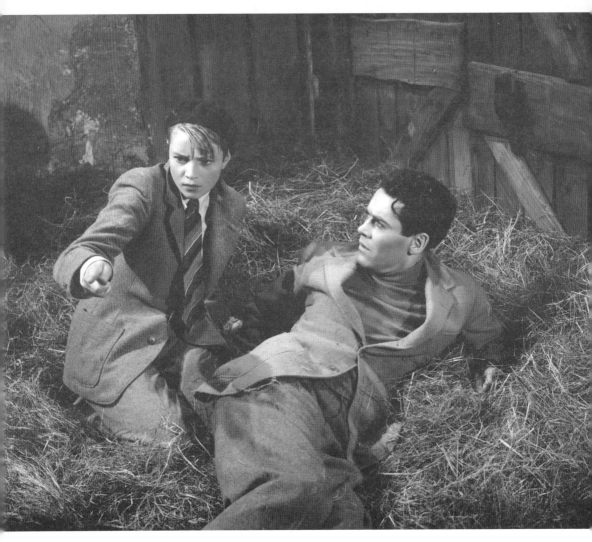

Wings of the Morning (1937)

scene itself. So you've got your background and then your foreground, but there were problems with registration. Some things were difficult when we were trying to put the mattes together for *The Thief of Bagdad* and also for, say, *Gone to Earth*. That had some sequences that were very difficult.

LW: **That's to do with the image quality and shrinkage of the source material you are working with?**

PdeB: Well, when they shoot against the blue backing, then you've got to make the mattes afterwards. There was a density problem in making the mattes and they even had to paint it in frame by frame in some cases just to make a decent matte, but I think today there's no problem with producing mattes.

LW: *Wings of the Morning* **had a very different style for a travelogue sequence. The style of one reel is different and I was wondering if a film is difficult to restore when its appearance changes like that?**

PdeB: I had one problem with *Wings of the Morning* and it was something that was shot almost black and white, looking on a lake. The colour was, but there was some problem or they must have had some camera problems originally because I couldn't get much out of that section. But otherwise *Wings of the Morning* was quite okay. *Wings of the Morning* was about the second film I worked on. The films that I worked on were mainly given to us by National Heritage.[21]

LW: **Well, thank you.**

SB: **Yes! Thank you.**

NOTES

1. 'Tom Howard on the Travelling Matte', *Cine-Technician* vol. 7 no. 32, 1941, pp. 78–9, 81.

2. 'Archive Screens Restored Earth', *Screen International*, 5 July 1986, p. 16; 'Newsreel from the Archive', and *BFI News*, February 1989; and *BFI News*, October 1989 refer to screenings of the NHMF-funded restored prints of *Gone to Earth*, *Tales of Hoffmann* and *The Thief of Bagdad* at the National Film Theatre, London.

3. A History of Colour, Part 1', *National Film Theatre Programme*, January 2003, pp. 16–21; 'The Archive Presents Typically British Glorious! Technicolor Restorations', *National Film Theatre Programme*, October–November 1996, pp. 24–31 and pp. 60–1. This programme of screenings included films restored by de Burgh in the 1980s.

4. Grey Ruthven, Earl of Gowrie was Minister of State for the Arts (1983–5) for the Conservative government under Margaret Thatcher.

5. Neilson-Hordell produced optical printers and projector gates.

6. British Empire Medal for meritorious civil service.

7. See the interview with Christopher Challis in this volume.

8. Cellulose nitrate film stock tended to be used for films made prior to 1951. Further information on the deterioration of nitrate film stock can be found in Paolo Cherchi Usai, 'The Romance of Celluloid', in *Silent Cinema: An Introduction* (London: BFI, [2000] 2009), pp. 12–13 and Anthony Slide, *Nitrate Won't Wait: A History of Film*

Preservation in the United States (Jefferson, NC and London: McFarland Classics [1992] 2000).

9. David Francis, 'Preserving the Past', *BFI News*, September 1975, pp. 12–15.

10. A store for nitrate film was purchased by the BFI at Gaydon in 1978.

11. Harold Brown (1919–2008) was head preservation officer (1935–84) for the BFI National Film Archive.

12. Xu Jianhe and Ge Xiangbei, 'Colour Problem', *Sight and Sound* vol. 50 no. 1, 1980/81, pp. 12–13. Following a campaign led by Martin Scorsese to raise awareness of colour fading, Agfa, Fuji and Eastmancolor began to offer low-fade colour film stock. None of these three companies offered a guarantee against colour fading.

13. Thelma Schoonmaker (b. 1940) has edited all of Scorsese's films since *Raging Bull* (1980) for which she won an Academy Award. She has also won for editing *The Aviator* (2004) and *The Departed* (2006).

14. 'Resurrecting *The Black Pirate*', *BFI News,* January 1973, p. 3 refers to an earlier restoration at the BFI National Film Archive in the 1970s. 'A History of Colour, Part 1', refers to a screening of the restoration undertaken by Paul de Burgh at the BFI National Film and Television Archive in the 1980s.

15. E. S. Tompkins, 'In Defence of "Glorious" Colour', *British Journal of Photography*, 3 March 1944, p. 74 refers to the colour resolution of the Dufaycolor *Sons of the Sea* and the three-strip Technicolor *The Life and Death of Colonel Blimp*, which de Burgh refers to later in the transcript.

16. Eric Cross (1902–2004) is credited for Photography on *Sons of the Sea*. Ted Moore is credited as cameraman.

17. In 1976 David Cleveland became curator of the East Anglian Film Archive.

18. National Heritage Memorial Fund.

19. Claude Friese-Greene (1898–1943) was the son of William Friese-Greene. In 1924–6 he toured Britain filming in an experimental natural colour process. The BFI National Film Archive made digital reconstruction of the screened effect of this process and edited the film footage of *The Open Road* into *The Lost World of Friese-Greene* (BBC, 2006). Charles Urban and G. A. Smith's Kinemacolor (1908–15) was an early experiment with the possibility of natural colour cinematography.

20. John Huntley, *British Technicolor Films* (London: Skelton Robinson, 1949).

21. 'New Hope of Saving Film Heritage', *Film and TV Technician*, May 1982, p. 19.

DOCUMENT
'PRESERVATION OF FILMS',
KINEMATOGRAPH WEEKLY,
13 MARCH 1952

Precautions taken to protect the films in the National Film Library against fire and decomposition were described by Harold G. Brown, film preservative officer of the library, at last week's joint meeting of the BKS and the BFA.

Introducing the speaker, Ernest Lindgren mentioned that the library included films from 1895 to the present day.

Harold Brown said that films must be protected against all hazards for a period measured in centuries. The films in the library were never protected; it is impracticable to make dupes of all and anyone wishing to examine a film runs it through a non-intermittent editing machine.

Practically all the films are on nitrate base and deterioration starts from the time of its manufacture.

For maximum longevity the film should be stored at a temperature just above freezing point, with a relative humidity of 55 per cent. Film reels must not be stored on edge.

He described the library's vaults, which consisted of blocks of 12 vaults built inside another building, the latter provided with ventilation and each vault having provision for the escape of gases.

Tests to reveal the onset of decomposition have also been devised by Kodak, a ¼ in. punching of film being placed in a test-tube with a piece of indicator paper, and heated to 134 deg. C.; the time required for an indication of acidity indicates the condition of the base.

A problem in duplication was excessive shrinkage, buckling might also be a problem. H. D. Waley has constructed an optical printer specially adapted to duplicating these early films, whose perforation standards often differed from those of today. Photographic problems, including those of copying stained and toned prints, had not yet been overcome. It was vital that prints for storage should be free from hypo.

Colour stocks raised another problem, by reason of the fugitive dyes used. The storage of magnetic recordings was under consideration.

INTERVIEW
JOÃO S. DE OLIVEIRA, HON. FBKS

João S. de Oliveira is director of PresTech Film Laboratories Limited, London, which was founded in 2004. De Oliveira was formerly technical manager at the British Film Institute's John Paul Getty Conservation Centre and worked at Cinemateca Brasileira, São Paulo, Brazil, Cinemateca Portuguesa, Portugal, and as professor in the Postgraduate Department of Museology FESP, São Paulo, Brazil. He was also chairman of the Technical Commission of FIAF.

BIBLIOGRAPHY

de Oliveira, João S., 'Black-and-White in Colour', in Roger Smither and Catherine A. Surowiec (eds), *This Film Is Dangerous, A Celebration of Nitrate Film* (Brussels: FIAF, 2002), pp. 117–22.

INTERVIEW TRANSCRIPT

DATE OF INTERVIEW: 12 OCTOBER 2010
INTERVIEWER: LIZ WATKINS

LIZ WATKINS: The work of film laboratories such as Technicolor or Deluxe predominantly involves the repetition of one type of process, whereas it seems that, as a specialist film lab, PresTech adapts machines and tailors each procedure to deal with very specific and often historical colour processes that have their own visual characteristics.

JOÃO S. DE OLIVEIRA: Yes. Today's bulk printing in commercial laboratories is designed to produce an acceptable-quality print based on similar materials very quickly. So they normally have a duplication cycle that goes from the original negative to render an internegative that is already colour balanced. This internegative is adequate for bulk printing at a very high speed and so there is very little light adjustment during printing. At PresTech we get 1920s or 1910s original camera negatives, or sometimes even a nineteenth-century original camera negative. This means that we adjust all our settings to accommodate what is a unique and rare artefact. We produce tests to determine the best way, the settings and levels, to print that film and produce the results we want. It's very time-consuming, laborious work and has to be performed with all the control possible because you are handling a unique, fragile object. It's very expensive.

LW: In an interview with Gabriel Paletz he evokes the idea of an 'archaeology of technology' that seems to go some way to describe your approach to restoration: identifying and adapting machines to be able to restore specific colour processes.[1]

JSdO: For this archaeological approach, I think, Harold Brown for me was the best example. I think I mentioned to Gabriel that this archaeological approach is a necessity because you have to have to identify the date of production for all the materials that you are handling to be able to understand the processes and then to retrieve as much of the technical information as possible.

I am very keen on getting these archival machines. I think they are part of the way you handle the film and so part of the way that you 'look' at it, but they don't 'look' in a way that enables you to detect the information in the film. If you view all the black-and-white nitrate films that we handle, they all have a certain degree of fading because of the composition of nitrate. You form a black-and-white image on nitrate film stock from the silver deposit, but because of the nitrate gases that are available, then very quickly, the first thing that happens to the film is that you tend to lose information where the silver deposits are most finely dispersed in the highlights. So if it's a negative, you lose detail in the shadows, whereas if it's a print, then visible details are lost from the highlights. But these elements – this changed stuff – is still *in* the film and there is a certain band of electro-magnetic radiation that will interact with it even though it appears transparent. So if you have the right sensor, the right way of 'looking' at the film then you can locate, map, and reinstate the invisible details in a digital image. So I think this is a major possibility of digital technology. I have also started to consider the possibilities of this approach for chromogenic fading: whether it is possible that you don't have a displacement of the dye, but just a chemical transformation of the dye that means it does not interact with light any more. That could be why it appears transparent, even though the information is there and in position. These dyes are very complex organic chemicals and deterioration can happen through many different pathways and the image, as product, will be according to the parts. So to get this done with colour, well, I think that it would be possible, but it is very difficult at the moment. With black-and-white film, however, it's not very difficult. It would be a first stage to see what is invisible in a film and then to reinstate the original.

LW: So there's a change in the chemical composition, but the chemicals haven't actually disappeared or moved?

JSdO: Exactly, the information is still there, although less so if the film has been washed.

LW: Otherwise, there's a latent image and although you can't see it, there are other ways that it can be detected and made visible?

JSdO: Exactly, because the film, in a way, has a fingerprint in the electro-magnetic spectrum. So if you have the right frequency, you can detect it. I can remember some projects such as *The Lodger* (1926) that, if it were to be restored now, the work involved and the image produced would be different. Well, *The Lodger* has this problem. You have a vintage print that is the only survivor – or at least there are one and a half prints, if I'm not mistaken – and that print has problems of highlight fading. So we've lost the detail in the highlighted faces of people and the viewer has come to think of that characteristic as normal for a silent film. It is not normal. We worked on *Die Nibelungen* (1924) with negatives and with prints and, because a negative is the reverse of light and shadow, you can see the details in the highlights. However, when you look on the print at the corresponding reverse image then you know more about the missing details.[2]

LW: So the kind of aesthetic that we associate with silent films may actually be a characteristic of an image that has deteriorated?

JSdO: Absolutely.

LW: Can you tell me a little more about your restoration of *The Lodger*?

JSdO: I restored *The Lodger* at the BFI using tinting and toning.

LW: By using the actual dyes?

JSdO: With the actual dyes and toning with the salts, so producing the complexes and compounds that the original process produced. It was quite an adventure.

LW: I can imagine!

JSdO: Initially, we did not get a very good-quality result. *The Lodger* was chosen because it's an important film and we had the print that Harold Brown made using tinting and toning in the 1970s.[3] So without knowing it, we were both doing similar things. But it was not easy to do. This print was unique and was at the end of its viable life, so it was natural to choose this title and very important to do the tests. The tests were not very successful so we then did our own test in the archive. Well, there were lots of health-and-safety enquiries by the union, but in the end we did the film. We did a few films, including *Napoléon* (1927) which is five and a half hours' long. We made two prints. So we proved the system and it works very well, but there were some health-and-safety issues and the BFI decided that we shouldn't continue doing it. When I started here at PresTech, I immediately reinstated the process. Everything is absolutely health-and-safety sound now. It's not an easy process if you have too many different colours.

We also investigated an application process that, instead of dipping the film in solution like with the original procedure, involved applying the solution in a similar way to that used for coating the film base with photographic emulsion. So the colour would be applied with a wheel or a spray so you don't need to have the splices. It's very simple, but it has to be enclosed because you don't want to have fumes from the dye in the air. So we make a judgment based on the number of colours. In the case of *Die Nibelungen*, this is actually a section of the film [a strip of coloured film is placed on the table].

LW: It looks like an amber colour, but the variations under that colour name can be endless.

JSdO: This is what you look for in the print. You have maybe seven, eight different prints in the lab and, if you compare them, then no two are the same. They all have a similar colour, but they are not exactly the same. This restoration was very interesting because they had quite a democratic approach to curatorship. A group from many different institutions met regularly to debate specific tasks. The decision about colour was very mathematical because they decided upon an average of the colours. So we plotted the colour space of the different film elements and determined the centre. Then I introduced a complication that I had also done with *Napoléon* – that is a fantastic reconstruction by Kevin Brownlow, a brilliant man. When the colour materials were found, it threw new light on the film. I then knew that the film had colours, but in the restorations produced up to 1999, there was no colour in the film because all the source materials we had previously hadn't been coloured because they were a second, third or fourth generation away from the film.[4] There are things that are really shocking in terms of quality and decomposition, but it was the only source available so we had to work with it. So we requested the prints and we organised a series of tests.

Obviously the starting point for everybody is to work toward a colour exactly like the print. The problem is that the light source had changed from carbon-arc to xenon and the lenses are all panchromatic because nowadays 99 per cent of the films screened are in colour. There are other secondary issues, but most important was to look for certain tones of tinting but you could hardly see anything on the screen. We had to calculate and

emulate the colours that you would have screened from a carbon-arc lamp at the time: there's a big difference between that and the colours that you see with today's projector lamps.

LW: So the colour screened of a film is going to differ according to the projector lamp?

JSdO: Absolutely right. The logic behind it is that film is experienced on the screen, right? And the technology and conditions of screening change. So you then go into a very complex ethical and philosophical discussion because you probably don't have two screenings that will be similar. There's just a range that is more or less the average of these different projectors, light sources and cinema sizes.

LW: The distance between the projector and the screen would also make a difference to the intensity of colour required on the film strip for certain hues to appear on the screen?

JSdO: Exactly, that's the theatre size, so I spent a long time reading the *JSMPE*.[5] You don't need to have the opacity very high to have a black on the screen, so in a large theatre, all of your renderings change. You have to have a much lighter print than normal. Imagine that you have a translucent material in front of the projector. The print has to be lighter for a long distance between the projector and the screen and the theatre has to be very dark. This is the other thing people don't realise, that there is no black – you can't project black – black is no light. So the blackest bit you have on the film is the white of the screen. It's the difference between the lightest areas and the darkest areas that produces the image. This is a big problem: when you have a large theatre and an orchestra, then where do you have enough darkness for the integrity of the screened image to be maintained?

For every prestigious restoration, you have a big theatre because normally people like to have 1,000 people watching and you put a sixty-person orchestra with light to read music that then reflects on the screen. This is the terror of the restorer because you know, we spend a huge amount of time with this film. For the previous big restoration we did they had the Frankfurt Radio Symphony Orchestra and so sixty musicians were playing. It was screened at the Deutsche Oper, which is not a film theatre, so they had to improvise a place to put a projector and there was a massive amount of light reflecting. Normally, the conductor has to be spot-lit because he has to see well.

Obviously, when you do the print for the premiere, you have to warn the client that you have to take this into consideration. So it's not a print that would look right if you then project it in a theatre just with a pianist with just one little light, which will be the circumstances for 99.9 per cent of the screenings of the same film. So this is the thing for us, the reference or the aim would be to produce on the screen a similar experience that the original process produced at the time the film was made, right? If it were Dufaycolor or Gasparcolor, then you are not going to screen the original elements, but a new print or new digital cinema product, derived from the original. To calibrate your system then, you have to have at least one good-condition print, or, you have to find a way to produce that information.

LW: It's quite an undertaking.

JSdO: It's quite a challenge. So would this be always possible? With Gasparcolor the amount of good-physical-quality surviving materials is limited. Everything is too shrunk.

LW: It's the film support rather than the dyes that have deteriorated?

JSdO: Exactly. If you look to Dufaycolor, then contrary to Gasparcolor, it was always produced on safety film, which means that it's not at as much risk from fire. It was made on an early safety film that normally decomposes in a much more speedy way than cellulose nitrate. So you have the decomposition of Dufaycolor preventing you from screening it. I think we were reasonably lucky because we found some examples, some surplus film stock and we could extract some basic information from it. This is another part of the work that is an interesting area to investigate, that is, the possibility of recreating some control samples or new materials to calibrate and set your processes to.

LW: New reference materials that are similar to the original materials rather than simulating the screened image?[6]

JSdO: It sounds crazy, exactly but it's something that then you could project, checking its limits to see how much the machine really can cope with.

LW: That question of materials reminds me of *The Lodger*. Did you say that you worked with Harold Brown when he was at the NFTVA?

JSdO: Well, I knew Harold Brown, I met him in 1984. He was sixty-five, because he was retiring. So I suspect that was the mid-to-late 1970s when he did this, certainly before 1984. Because of the damage and physical state of it, probably it's more likely to be early 1970s, I would say. I think the restoration that we made of *The Lodger* was in 2000.

LW: That film is part of the BFI National Archive's restoration programme again now, isn't it?

JSdO: Well, now with digital technology, work is coming back to the treasures that people tend to revisit and this is why it's so crucial to preserve the originals, it's because technology evolves. You aim to give the next generation of colleagues the chance to do better what you did in your time.

LW: Do you make a preservation copy of the source materials as you find them and then you begin work on a restored print?

JSdO: The interventions that are normally carried out to stabilise the film have to be very carefully balanced, chosen and researched so that you could use the ones that you know are reversible. If possible, you don't cause a permanent change to the source material. If you have to modify something, it's better to modify the film equipment that you are using to suit the film, than to modify the film to suit the machines.

This, I think, is crucial: to make sure that they will last. *The Lodger* was done totally photochemically and the intertitles were very poor quality. They were damaged but they were the only fragments that we have of some of these.

LW: So, when we were talking about Dufaycolor and the distortion of colour resolution in areas of underexposure, I wondered if that was something that you'd come across in your restorations? Would you colour-correct those anomalies or keep the colour distortions?

JSdO: Dufaycolor is a particular additive mosaic process and a crucial part of Dufaycolor is the manufacturing and printing of the réseau. Unfortunately, the dye that they used to make the réseau was susceptible to acidic degradation. So for Dufaycolor, the trend of deterioration is to become a shade of ultramarine blue. This happens very often. The BFI National Archive has masses of examples in this condition and it's normally because the

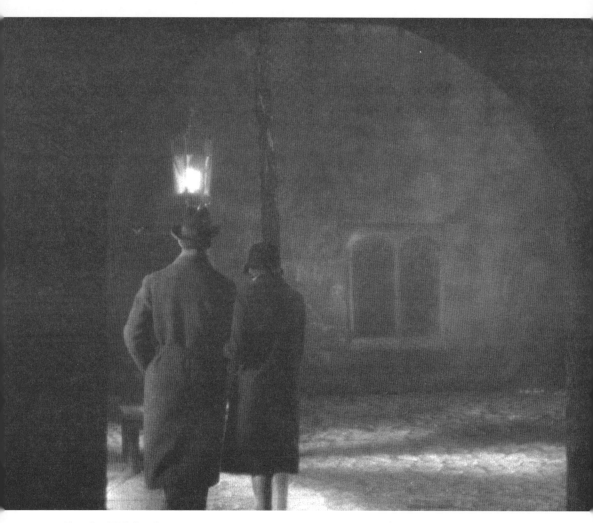

The Lodger (1926), from the
BFI National Archive's 2012
digital restoration

prints decompose. Beyond a certain level of deterioration, the acidity is raised and then its interaction with the dyes has an effect. So we looked at that because it's a photo-mechanical printing process and because the colour image is produced by a moderation of the black-and-white image seen through the réseau. When you film, you do so with the réseau to the lens so that the image is 'analysed' through the colours of the réseau and you have a resultant density formed in the black-and-white film behind it. So if the réseau is destroyed, you can make a calculation on the basis that it consists of parallel lines at 30 degrees of inclination and that there are squares in between these lines; then you know that these particular lines carry information. In screenings of Dufaycolor film this is always visible. I did remove the réseau and looked just at the image, just at the emulsion and gelatine. I just peeled it off and you can see in the black-and-white emulsion the position of the réseau. So it is possible to design a digital process that will construct the image.

I took some Dufaycolor to be scanned so that I could work with it in a digital device and it was very difficult because it's always shrunk and discolours all the time. It was so expensive that we never want to put anything that deteriorates that quickly through it, but I managed to persuade a friend and we did a few frames and we did a trial that did work. It was just handmade because we were more chemists than software designers. But now I know that it's very easily done if you have the resources. So in a way, when I was at the BFI, I was suggesting the preservation of Dufaycolor in black and white, because if you have it black and white you know where the réseau is and you have the information you need to make a restored print. Obviously, some of these deteriorated films did not have the colour, but if you do have colour then of course let's build the colour, or let's do the colour separation of it. Dufaycolor itself is a micro-colour separation. You have single squares and the colour lines that are the separation of them.

These are the particularities that I remember in terms of the preservation of the dete-riorated material. I think it's perfectly good to preserve it in black and white and then later, when technologies and resources are available, to create a tool that will digitally reinstate the colours and restore the film to its original aspect. If you are using an analogue photo-chemical reel, then you are using a film that is designed for printing. It is designed to match film dyes from very standard processes contemporary to the production of that par-ticular film stock and so it is designed to work toward a standardised result. But you get into trouble when you try to copy a film that is not the one that the film stock was designed for. In this scenario, there is an incompatibility between the colours of your new system and those of, let's say, a non-contemporary or obsolete colour process like Dufaycolor or Gasparcolor.

LW: If I understand, then the issue is of applied colour or photomechanical colour processes being imaged by more recent chromogenic film stocks?

JSdO: The 'reproduction' of an image that is not chromogenic or specific to the certain colour range of a film stock.

LW: So, if you did try to use a chromogenic colour film stock to register or produce a colour image from one of these earlier colour processes, what would happen?

JSdO: Then you're in serious trouble. What happens is you will have a certain colour range that you can adjust within, but you will not have the total image. So you have to choose what to reproduce correctly: this end of the spectrum or the other? Whichever you

choose, there will be distortion elsewhere. So you might decide okay, let's get King Kong well reproduced but then the sky may be green. So it is a bit of a disaster zone and it is 90 per cent certain that that green is not an acceptable result; it's something beyond, it's a distortion. To manage this distortion is the issue; that's the key. Managing and so reducing or eliminating it is the problem.

LW: Are there examples of anomalies as we might think of them today that were actually part of the production of the film? How would you discern between anomalies that occurred in the initial production of the film and those that accumulate through deterioration?

JSdO: I'm going to a less complicated scenario. What you're saying is very valid and very important. I'm saying that you have to look to the film without any speculation and your task is to reproduce this colour film exactly as it is with this available film stock. So, let's say you have a print and the contemporary film stock is expecting to register an image from a new camera negative or a new reversal colour print, which has a certain magenta dye and a certain distribution across the colour spectrum. In this case, the film stock is contemporary to the negative and so it is designed to be in that range so together they produce a perfect or a reasonable duplication. But what happens with obsolete film stock, for example, English processes such as Dufaycolor that are different, is that the chromogenic film stocks are not designed for these obsolete films. So the chromatic range of Dufaycolor might be completely invisible to the chromogenic film.

Dufaycolor's mosaic additive colour system produces an additive negative and an additive print. So then you have a problem. If we have red, blue and green on the film and we produce a negative on chromogenic film, then what we are producing is yellow, magenta and cyan. If you have a negative that is red, blue and green from which you produce a positive print then you have the yellow, magenta, cyan. For Dufaycolor, you need to have red, blue and green on the screen to produce the 'natural' colour image. If you make a negative from a Dufaycolor negative by using a chromogenic film stock then you will have yellow, magenta and cyan in the screened image, which is problematic because these colours are visible in the wire-mesh effect of the réseau.

You would have the negative polarity of the colours. Although the sky will look blue, the faces will look right and the green will look green, the image would be produced in a different way. For Dufaycolor, this matters because the réseau is visible in the screened image and the restoration will have distorted the system. To be able to reproduce the right colours in an analogical way is very, very difficult. Always you have to compromise on the finish. There's another film, another example from when we did the restoration of *Alice in Wonderland* (1903). Here and now we are going to do a toned version of that film and it's quite exciting. There are two colours that are not difficult to produce, but to approach it exactly as the original is difficult. So it takes time. Now we find that we have a bit of space, so we are going to do it now.

LW: You'll do the actual toning?

JSdO: Yes, the toning of the film is blue and red/sepia. The blue toning is normally Prussian blue and that's easy to do. It's actually, well, let's say its older name is potassium cyanide and it does have the word cyanide and potassium in the archive.

LW: It's poisonous?

JSdO: There are regulations. The sepia, well, the red is sepia, which is a more challenging colour to achieve. Toning is very particular and it's difficult to try to study the difference directly by the size of the silver filaments and the silver particles or grains. This is something that film restoration doesn't like to acknowledge has changed a lot from 1903 to today. There is a side to colour that is dependent on what materials you use. Metallic silver obviously absorbs all the light, so you will replace that so that little else than blue, so only a bit of red, a bit of green are absorbed and you will produce the colour that you see. But there is another component of the screened colour that is given by the size and distribution of the silver grains, by the way that they are organised on the film.

LW: Like a cloud formation?

JSdO: It has very fine separation and that it's a three-dimensional system is the very thing, but imagine hundreds of thousands of molecules: they are distributed and light scatters in between them. That there is a certain cast to a certain emulsion matters. So in 1903, fine-grain emulsion was not available. After 1947 you only had fine-grain emulsion. So you have to sort of navigate around that. You have to remember that these were industrial processes and not done manually, so you had a machine doing it and controlling it. Sometimes that control is in the lab allowing us to find a way to do something that the machines are not designed for.

LW: So you're looking to modify the machines to do something they weren't designed for? There are lots of manuals just telling you how a colour process should work, but in restoration you need to adapt to accommodate the differences between the film stock and the photographic emulsion to produce a viable image?

JSdO: Yes, it's like music where silence is so important. You're right I think that we don't so much want the things that work as also the things that don't. That's the side that personally interests me. It is to find or learn or do something new in this situation and get new things to think about and to resolve. There is so much to be done in this field. I'm convinced that many silent films are showing something that is not quite right for the presentation of black-and-white film.

LW: It's interesting because in a way that's exactly what is invoked in the marketing of digital viewing as something that allows us to see more. It's happening again with HD, but actually there's so much information in a photochemical film: from the history of that individual print to the changes in physical composition and re-editing over a series of releases. Even when information, as you say, isn't immediately visible, there's still some latent image, there's some residual information that invites analysis.

JSdO: Yes.

LW: So film materials seem to contain a lot of information that a digital facsimile doesn't necessarily allow you to uncover.

JSdO: Yes, I think it's another interesting point, that we believe that all of the photochemical film elements are the same. If I make a print of the film, then the information is limited in comparison to what I can get if I analysed the original negative. So it's the problem of the copy; the copy is never a real clone. The digital has the concept of cloning, because they always think digital to digital, it's a number so here some matrix registers

one-one or one-five, I have a value, zero or one and it's mathematics and it's absolutely right. In copying photochemical film, you imagine you are producing a clone, but if it's a digital copy then you get the compromise of compression. It's a question of what can you lose? What is not considered important? Whereas for restoration and the lab everything is important. If I ask you to decide what information you are going to throw away, well, it might be irrelevant now, but two days later it might be totally relevant and fundamental to somebody else that has a different methodology or that requires a different selection of information. That's why I think the preservation of the original is vital. Everybody knows and everybody says that; that is not new. Everybody agrees today that we have to preserve the original materials and that's for sure.

LW: Okay, maybe that's why I initially questioned the reason that archives would restore the same film again and again, like with *The Red Shoes* or *The Lodger*, but in a way it allows you to see how restoration …

JSdO: Evolves, yes.

LW: If they're such popular films, it also raises the profile of the archive and of restoration work. It's been strange sometimes when I've heard of another restoration of the same film when it seems there's so much other work to be done.

JSdO: I totally agree with you.

LW: So you're preserving it for the next generation, not forever.

JSdO: Yes and these issues are important everywhere but, regarding the economic scale in some cultures, although the very same work needs to be done, they need to use the money to eat and to do other things. In the 1970s and 1980s the transfer of nitrate to safety film was a subject all over the world because you had the concept that the nitrate could ignite and burn all your collection so it would be more responsible to preserve the films by transferring them from nitrate to safety film rather than keeping it.[7] For lots of people, that we had instructions to burn the films was an abomination, so we would work very, very slowly. Then we had a vault in which to put the films that we had made duplicates of. Lots and lots of films that were 'preserved' were burned. Of course, in a transfer an enormous loss of information happens. If you have very, very good contemporary equipment you can do it, but sometimes it was not possible to do that. You have to remember that the idea is to expose the film to the biggest number of people possible, but it is also important that the original artefact survives.

There is a difference that I think you know between the viewer of the films and the viewer of the archive and that lies in the concept of the film as a single object. I think it's necessary to review these things because the conceptual definition of an element in a collection can change due to its perceived cultural importance. More and more, the archive is going with all this effort toward sub-zero storage and so in the direction of very low deterioration. In many ways, this is perfect, but I feel a bit concerned that then we will not be able to see what we want to see. The administration of collections can postpone work that has to be done because of the excuse that no more damage will be caused while the film is in cold storage. But I prefer a generation to have access. The right of public access to a national collection is a social right I think. It is a public collection and access is important because the author of the work planned it to be viewed, that is, the flow of feeling, of the stuff that can come from a painting, from music, from films. But it

is going very well. I now have experience of thirty-five years' work in film archives and preservation and we have come a really long way.

NOTES

1. Gabriel Paletz, 'The Finesse of the Film Lab: A Report from a Week at Haghefilm', *The Moving Image* vol. 6 no. 1, 2006, pp. 1–32; Paolo Cherchi Usai, Ulrich Rüdel and Daniela Currò, 'The Haghefilm Foundation, Amsterdam: A Learning Laboratory', *Journal of Film Preservation* no. 82, 2010, pp. 87–93.
2. Anke Wilkening, 'Fritz Lang's *Die Nibelungen*: A Restoration and Preservation Project by F. W. Murnau Stiftung, Wiesbaden', *Journal of Film Preservation* nos 79–80, 2009, pp. 86–98. See 'Restoration – *Die Nibelungen*', PresTech Film Laboratories, <www.prestech.biz/restoration.html>, accessed March 2012. The restoration was undertaken by PresTech for the F. W. Murnau Stiftung. The source material consisted of prints and some of the camera negatives. The restoration project took four years. The F. W. Murnau Stiftung's editing list informed the reconstruction of the film. The archival gala screening was held at the Deutsche Oper in Berlin in April 2010. A hybrid process was used to restore the film: contact printing as in the production of the 1920s print; liquid gate printing to reduce the visibility of scratches; digital technology to stabilise intertitles from the effects of deterioration and shrinkage.
3. Harold Brown, 'Trying to Save Frames', in Roger Smither and Catherine A. Surowiec (eds), *This Film Is Dangerous: A Celebration of Nitrate Film* (Brussels: FIAF, 2002), pp. 98–102. Previous restorations include Harold Brown's 1984 work on *The Lodger* and that undertaken by de Oliveira. Brown's work is noted in Paul Read, 'Tinting and Toning Techniques and Their Adaptation for the Restoration of Archive Film', in Luciano Berriatua (ed.), *All the Colours of the World: Colours in Early Mass Media 1900–1930* (Reggio Emilia: Edizioni Diabasis, 1998), pp. 157–67. *The Lodger* was also restored and preservation masters produced by the BFI National Film Archive in 2011–12. See the interview with Kieron Webb.
4. Kevin Brownlow, *Napoléon: Abel Gance's Classic Film* (New York: Alfred A Knopf, 1983), details the previous restoration under this title.
5. *JSMPE: Journal of the Society of Motion Picture Engineers.*
6. Robert M. Fanstone, 'Experiences with Dufaycolor Film', *British Journal of Photography*, 7 June 1935, pp. 358–9. Dufaycolor is characterised by a réseau.
7. David Francis, 'Preserving the Past', *BFI News*, September 1975, p. 3.

INTERVIEW
KIERON WEBB

Kieron Webb is film conservation manager at the BFI National Film Archive. He joined the archive in 2000 and later became technical projects officer, working with João S. de Oliveira. Webb has worked on the photochemical and digital preservation and restoration of films that were initially made with colour technologies as diverse as tinting, toning, Friese-Greene's natural colour process, Dufaycolor, three-strip Technicolor and Eastmancolor.

BIBLIOGRAPHY

Webb, Kieron, 'Colour and the Restoration of Motion Picture Film', in Carinna Parraman (ed.), *Colour Coded* (Bradford: Society of Dyers and Colourists, 2010), pp. 55–79.

INTERVIEW TRANSCRIPT

DATE OF INTERVIEW: 23 JULY 2010
INTERVIEWER: LIZ WATKINS

LIZ WATKINS: How would you describe the work of film restoration and preservation undertaken at the BFI National Archive?

KIERON WEBB: Within the last five or six years we've reorganised to have a curatorial unit and programme of work at the archive, so that's where the selection of titles comes from. So if we're going to be working on *Accident* (Joseph Losey, 1967) or if we're going to be working on Humphrey Jennings's films or Hitchcock's silent films, that decision has a curatorial origin.[1]

LW: So it's a project-led programme?

KW: Yes. It's all part of a massive investment into the correct environment for the master film copies so that you have time then to carry out a curated programme of work rather than the perceived need to copy everything as was done when the archive was first established.[2] That was based on the idea that the nitrate film stock had to be transferred *en masse* because it wouldn't last or that you wouldn't be able to use it again. That's now changed because we know we can go back to nitrate copies, whether it's for a photochemical or digital restoration. So the masters are now being held in really good conditions and, as you know, we're going to build a vault that's –5 degrees Celsius and 35 per cent relative humidity [RH].[3]

LW: What conditions are the films kept in at the moment?

KW: Well a lot of the safety masters are here in +5 degrees Celsius and 35 per cent RH, which is a step in the right direction. But some of the nitrate was in a less than ideal environment for storage because it had already been copied. At that time, there was a sense that archiving involved gathering material together, assessing what you had and then copying quantities of that material to protect it. So, once the nitrate had been copied, it wasn't disposed of, but there weren't the resources to keep it in ideal conditions either. I think you can see this happening internationally. We weren't alone. The Image Permanence Institute research led everyone to reassess how they were keeping film and

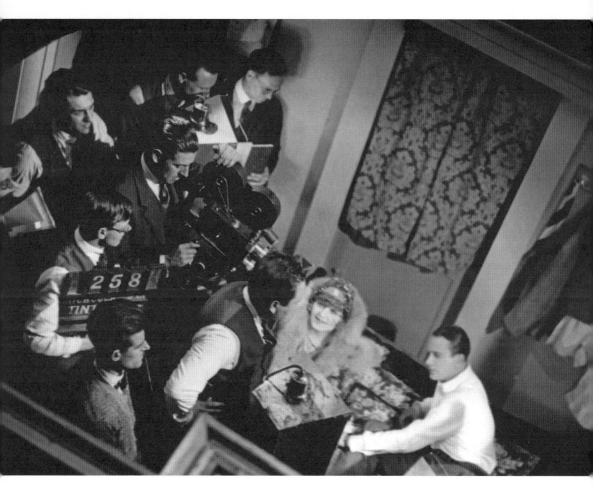

Champagne (1928)

emphasised that, if they kept it in better environmental conditions, then they could carry out a more curatorial-based preservation programme.[4]

LW: If you were to make another restoration in the future would you go back to the new master print that had been made as well as nitrate materials? Do you also research outside of the archive for new film elements that may have been found?

KW: Yes. The silent Hitchcocks are an example of that. It's not as if nothing has been done with them in the past by the archive of course.[5] They've been copied individually.

LW: What films are we talking about?

KW: All nine surviving films which Hitchcock directed between *The Pleasure Garden* (1925) and *Blackmail* (1929).[6] In the past, restoration projects were undertaken as part of the whole programme of preservation that was going on, so as part of the several million feet that was being copied over to safety film every year. That's why in the early assignments some of the early colour systems were copied in black and white. This isn't because the colour was considered unimportant, but they either wanted to reproduce subsequently the original tinting and toning methods or they were prioritising the preservation of the film in the context of managing a huge collection.

LW: It was preserving *an image* of the film.

KW: Yes, having the image and having a record. Now when we approach a restoration like Hitchcock's, it's about doing an international search for other copies that we can compare. We look at copies on small-gauge film too because we know they could be useful for various reasons.

LW: If the silent Hitchcock restorations are part of a project-led programme, what kind of funding does it have?

KW: It's mixed. There have been very generous donations from the Film Foundation and other donors and the BFI's just launched a campaign to raise funds, to ask people to donate. They wanted to give some examples of how different levels of money cover the cost of colour correction and so forth.[7]

LW: It's interesting to put a price on it as some of these films have been the focus of restoration projects before.

KW: But once the whole approach to preservation changes, the costs of doing things and the funding changes. So, for example, the David Lean restorations in 2005–8 were funded by the David Lean Foundation.

LW: The foresight to keep them in circulation!

KW: So that's one way restoration projects are funded, but we also work collaboratively with rights holders as well, like Studio Canal on *Accident*. They share the costs of restoration, because in the end they get a new video master if they want to release it on Blu-ray or broadcast it. That's something that comes out of that programme. If it fits with the cultural programme that we had anyway, then it's nice if we can share the cost.

LW: Do you consult people that have worked with technologies or colour processes that might now be considered 'obsolete'? Do you bring in consultants that perhaps worked on the initial production of the film?

KW: I can't say that that happens a lot, mainly because of the age of the films. In fact I can only think of one colour film that I've been involved in where that happened, which was *Accident*. Gerry Fisher, the Director of Photography [DOP] did attend the digital grading that

Accident (1967)

was carried out and he reviewed it at the end. It sounds like a fool-proof approach – get the person in who shot the film – but that's at a distance of forty years or so …

LW: Maybe remembering the effect you were trying to achieve as much as the prints that were screened?

KW: Yes. Although, in this case it was wonderful because it was Gerry's first film as DOP and he had strong memories of its look. But more generally, in terms of people who worked with those technologies originally, I think that it is a really good point and it probably doesn't happen enough. I often speak with people like Brian Pritchard as they have a link with technicians from that time, even the technicians that are no longer with us.[8] Or in some cases, they've tried to reproduce the actual techniques that were used at the time, which is obviously a slightly different matter, but at least if you're carrying out a digital reproduction of a technique and you know somebody has tried genuine tinting and toning then you'll want it to inform your decisions. *The Great White Silence*, I think, showed that approach to some extent, in the sense that we carried out a lot of research into original tinted and toned samples from the period. This included looking at the Pathé and Kodak catalogues, especially the ones held in Bradford which seemed to be in a great state of repair. Peter Marshall, who's one of our graders here, oversaw the grading of it at Deluxe. He's previously been involved in work on the restoration of *Napoléon*, where genuine black-and-white prints were tinted by João at the BFI National Archive. Pete was involved in that work and so he had a great sense of seeing certain colours being reproduced in those genuine methods. So when it came to *The Great White Silence* and deciding on how a blue tone should look in digital projection, he was able to bring that knowledge to the project.

LW: Do you also research things like reviews or articles that were written at the time of the film's initial release?

KW: Yes, with help from BFI colleagues in the library. I've also begun to ask curators in the Special Collections department here what they hold. So for the Hitchcock project, we could sit and read Ivor Montagu's diaries. They might not mention tinting and toning at all, but we will look into those.[9] We do want to incorporate that kind of research into restorations but you've still got to base so much on the physical examination of the materials you've got now. Even after you've done all that and you feel like you know what went into making, for example Dufaycolor films, you've still got to translate that colour system into another format such as DVD or have a new print to be able to screen it.

LW: If you do comparison work of film elements sourced from various archives, do you keep notes in case another restoration is pursued in the future?

KW: Documentation of your work is crucial. It's no great secret that film archiving has taken a while to do that! It's one of the youngest forms of conservation there is, I suppose. Nowadays, the importance of documentation is really recognised, but how you keep the information will become an issue.

LW: What point are you trying to restore or return the film to? Some archives work toward the point that it was initially screened?

KW: Yes. As on its first release, unless there's a specific reason why you're doing one of the other releases of it. But that's the aim normally, for us anyway, to restore the film to how it was first seen.

LW: But there's the potential to restore it so far that it looks pristine or perhaps to a point that it had not previously occupied?

KW: I think it's pretty important, I mean we're talking in a way now about damage, aren't we? But to be specific to colour, you could obviously try to do that, but we would just want to be faithful to whatever limitations and successes that colour process had at the time. In one of the Jennings Dufaycolor films, *Farewell Topsails* (1937) there are shots of this boat out at sea. In the Dufaycolor print the colour is actually pretty restrained at that point, as a result of the shooting conditions. It's looking a bit grey and monochromatic. British weather probably! So there are two successive shots that look very different. They're both almost monochromatic. One of them has got a blue cast to it and the other is yellowish. It would've been easy to have chosen one or the other and to have brought them both to look the same in the new grade. It would've been easy to manipulate it so that they both looked the same, but we knew the original print was like that and we maintained the relative difference between the two shots in the new copy. There's a narrator on that film and he's saying something like 'as the sunset drains the colours …' as if he's trying to explain away the fact that you've come to see a colour film and there's no colour left. You want to maintain what they did otherwise you lose all sense of history. Even a cursory glance at the history of colour in films shows it's a real zigzag of failed attempts and glorious adventures and broken hearts. To lose any sense of that, I think, would be wrong. Like the example from *Farewell Topsails*: my aim there was to make the new print look like the Dufay print.

LW: To retain an image of diagonal mesh of the réseau?

KW: You're aware of it. It's almost physical with Dufaycolor. For one of the other Jennings films that he made for Dufay – *Making Fashion* (1938) – we had a surplus reel of Dufaycolor print, so it wasn't putting the film at risk to run that reel. So we did. It's incredible to see it. If there are objects in the film that are in one of the primary colours that it used – red, green and blue primaries – they're almost 3D in the way they stand out. There's something about the contrast of the silver image, because of course it's a silver emulsion on top of the réseau.[10] But it's the silver emulsion on top of the réseau that creates something that's really quite physical. I suppose the aim is to recreate the capabilities of the process from any given time, to try and recreate that now so that people have a sense of film history, which we're trying to contribute to. In Giovanna's *From Grain to Pixel*, she says a similar thing, which is that obviously she loves film and if all things were equal you'd want to see a print projected but that if it were possible to simulate a colour system more effectively in a digital projection she would prefer that over a compromised print.[11] I think with Dufay that could be an example. Doing that work we were probably slightly conservative in one way. We knew we were going to go back onto film to make 35mm prints, but perhaps next time we would be bolder in using some of the digital techniques. This, however, would be with the aim of being more faithful to Dufaycolor, rather than with some sort of half-formulated aim of making it look the 'best' it possibly can. I think digital cinema and digital projection may offer – *may* because obviously it's subject to its own industrial norms and formats – the opportunity to better represent the Dufaycolor system than you can do with a modern colour negative and print that uses subtractive primary dyes.

LW: What are the other implications of using digital technology for film restoration?

KW: It's meant that archives now have to regard data as equal to the film master copies. When digital technology was first used in restoration – for example, our work on *The Open Road* – archives saw the restoration through to a new negative and print. Our master for that was the colour digital negative and the black-and-white masters which we printed from Friese-Greene's negatives. The original films and film copies were kept but the digital processes were seen almost as transitory and the data wasn't kept.

LW: You mean you outsource the work, but you don't automatically get the data back?

KW: Well, you have to buy it if you're doing the work outside of your own facilities. They ask you which 'deliverables' do you want from a project. I'm afraid it's one of these very ugly words that digital processes have introduced. It refers to the deliverable outputs from the 2K master – a new negative, an HD master video, a digital cinema master and package. Archives are now actively dealing with all these elements from restoration work. What format do we want that data on to keep it or at least to take it initially into the archive? It's standard now that we get those as part of the project as well. Costs and practices have been changing all the time. *The Open Road* is a job from five or six years ago, and now we're at a stage where we can take in the data on LTO [linear tape-open] data tape, which is a format of magnetic tape. But we'll have to do something with that. We can't just put those on the shelves and hope that they'll work whenever anybody wants to go back to them. That data will need preserving as well.

LW: So we've talked about some of the different processes that you've worked with for restoration projects, but I was also wondering about Eastmancolor. For example, with Losey's *Accident*, I'm curious as to whether colour fading, such as the film going magenta, was an issue?

KW: Only in a limited sense actually. With *Accident* we were fortunate in that the camera negative still seemed very good; the colour was very good in it, although it was damaged and torn. However, the release prints we have from the time are magenta. But it's necessary to 'grade' the scan from the negative to make the colour, contrast and density consistent throughout. So in terms of having a reference point, well, if Gerry hadn't have been able to advise us, then yes, who knows? We would have been exercising our judgment on what colour it should be. We do have a print that was printed from that camera negative more recently but, of course, that's based on a contemporary film grader's decision of how the film would look. However, it's always useful to see how a negative prints up, after all, that's the process it was designed to go through!

LW: What comments did Gerry Fisher offer?

KW: On the first day that Gerry came in, we started at the beginning of the film and got him to give us a direction on the overall colour balance. I know these terms are very general but how 'warm' or how 'cold' the overall colour balance should be. Blue or cyan cools an image and red or yellow gives it a warmer feel. We also set the contrast and density of the image. We spent a good part of that day on that one reel. We went through shot by shot in order, doing scene-to-scene correction. Then, because the time was precious, we asked him to look at some selected shots from throughout the film so that we could work outwards from them and make the reel consistent from a key scene. I had a list of

scenes in mind that I wanted to ask him about. So, for example, the famous really long take where Dirk Bogarde cooks an omelette in absolute disgust at Stanley Baker. It's a good four and a half- or five-minute take, so half a reel almost. We got Gerry to give us the grading for that so we could work from his guidance to get a consistent look. That was the main thing about *Accident*: one of the filmmakers, the key filmmaker in a way, was there, the Director of Photography. We were talking earlier about memory and you know that factor's there, but it was a really important film to him because it was the first film where he was Director of Photography, so he remembers it well and fondly. He says Losey was very keen to work with him to get that look. In fact, that was almost the test question to see whether he'd get the job. Losey sent him the script and said, 'What is it we've got to do with this?' I've heard a Losey interview where he says they could've almost done it in black and white. He wanted it almost monochromatic and especially in those early scenes after the accident and Gerry was saying the same in the grade. There's a sort of monochromatic feel that should be there.

LW: So research in journals and reviews and the filmmaker's insights are important, but what about materials in this instance?

KW: We could use the camera negative and an interpositive printed at the time of release for *Accident*. It was the other Losey film we worked on called *A Man on the Beach* (1955), which is a film he made for Hammer, where colour fading was an issue. It's the film that Losey directed in 1955 so it's pretty soon after he's arrived in the UK. I worked on the restoration of it straight after *Accident*.

LW: So the negative for *Accident* was on Eastmancolor?

KW: Yes, it was Eastmancolor.

LW: But that hadn't faded so much?

KW: No. You have to bear in mind that *A Man on the Beach* is 1955 and so it's only within two or three years of Eastmancolor materials being introduced. So it is known that the colour stability of those Eastmancolor materials – what are known as preprint materials such as negatives, interpositives or internegatives – from that time is unreliable, whereas *Accident* is 1967 and the film stock was dated 1966. By that stage, well the negatives anyway, but not the prints seem much more likely to be stable.

LW: So materials under the same general name continually change in stability. What about three-strip Technicolor? Has the archive revisited those since de Burgh's work in the 1980s?

KW: Well, we've worked on a restoration of *Blithe Spirit* and *This Happy Breed*.

LW: OK.

KW: For *Blithe Spirit*, we haven't got any Technicolor dye-transfer prints in the collection. We couldn't locate a print in other archives either. So we were making our own decisions, if you like, about the grading of that film. So that's a different case altogether. But we do hold a nitrate dye-transfer print of *This Happy Breed* and it can provide a reference for the restoration. When we compare a nitrate print and the new prints, the colour definition in the latter seems more distinct. In the sequence where they're all having Christmas lunch together you can see bunting hanging in the background. The difference between the colours of each individual pennant of bunting might be more distinct than in the dye-transfer print in some way. The three Technicolor negatives have been recombined by

This Happy Breed (1944)

printing them through, respectively, a red, a green and a blue filter. It's not like a digital grade where you can 'key' each piece of bunting and make it the colour you want without affecting the rest. So the difference is related to the materials you're using. But what's interesting to me and what I'd like to try and incorporate more into the thinking around restoration work, is about the projection technologies of the time. I mean the colour temperature of carbon-arcs and things like that, well, how do we actually quantify it? Certainly, the nitrate prints of *This Happy Breed* look like the cyan matrix wasn't applied. The interiors look like the inside of a teapot, just brown and yellow! Here, restoration has to take account of how much difference carbon arcs would have made to the colour of the projected image.

LW: But I thought green was quite …

KW: A prominent colour?

LW: Yes.

KW: Well, but what did the projection bring out, shall we say? That's what I mean. Because it's one thing to compare an original print with a restored print on a light box, and I suppose it's reassuring if you're a restorer. I did that with the Dufay ones and I definitely think they're in the same ballpark. But actually your aim should be to recreate what was projected on the screen. It's not an easy thing to do. That would involve historical and technical research of another kind.

LW: Which would also vary from screening to screening?

KW: Yeah, of course. You know that *This Happy Breed* would've looked different in the better cinemas of the time. Absolutely, yeah, that has to be acknowledged. But I do think it will be important to do that.

LW: What process did you use for restoring those Technicolor films?

KW: They were mostly photochemical, but with digital sections. So certain shots were scanned and cleaned.

LW: What affected the decision to do that on certain shots rather than the others?

KW: It was to do with damage. So, for example, one shot of *This Happy Breed* in the yellow negative had a tear in it. Another example is that the main and end titles only existed as the picture backgrounds in the negatives. The text of the cast and credits existed in the nitrate Technicolor projection print. They scanned that, keyed out the black text and then overlaid it on the background of the scan from the original negatives. Then the combined version was shot back out to film to be cut into the photochemical colour negative.

LW: The restoration process seems to be tailored to each project that you're working on. Would that be a fair comment?

KW: Yes. I suppose it is. I don't know if that's unexpected, but yes, lots of things affect how the project will be done. What the material is, the resources for it, which lab you choose to work with. The latter has an effect because some of them have facilities that others don't have. In the case of the three-strip Technicolor films, Cineric have a really strong photochemical lab background but they also are very strong on the digital side of things. We felt they were very experienced in doing the kind of mix of work we were looking for and so we had faith that the digital sections wouldn't stick out horribly in the finished version. So yes, that's true.

LW: One more thing I'm wondering about is sound – colour and soundtracks. It hasn't really come up in interviews so far and yet there's a physical link to optical soundtracks.

KW: It needs mentioning! In the case of the Dufaycolor films, we had the original optical sound negatives or soundtrack positives for two out of the three. So the sound was treated normally – it was digitised, equalised and new sound negatives were recorded for printing. In that sense they may be more audible than they would've been when printed on Dufaycolor positive material. *English Harvest* (1938) was the one where we just had one projection print as the source element and so the sound had to be digitised directly from the Dufaycolor positive. The facility we used had a scanner, like an image scanner for sound. But when they scanned the Dufaycolor positive on there they found that, as Cornwell-Clyne says, there's this sort of whine at about 9,000 hertz, which is caused by the red lines of the réseau.[12] However, they found that when they transferred it on a normal white light reader that it was fine. The whine wasn't as audible. So the colour system did have an impact on that one to some extent.

LW: It's important to note and thank you for your time!

KW: Thank you!

NOTES

1. *Farewell Topsails* (Dir. Humphrey Jennings, 1937: Producer, Adrian Klein; Dufaycolor), *English Harvest* (Dir. Humphrey Jennings, 1938: Producer, Adrian Klein; Dufaycolor), *Design for Spring* (Dir. Humphrey Jennings, 1938: Producer, Adrian Klein; Dufaycolor).
2. David Francis, 'Preserving the Past', *BFI News*, September 1975, p. 3.
3. The BFI National Archive's new master film store became operational in January 2012.
4. *Image Permanence Institute* (IPI), <https://www.imagepermanenceinstitute.org/>, accessed March 2012. IPI was founded by the Rochester Institute of Technology and the Society for Imaging Science and Technology in 1985 and focuses on the development and dissemination of practices for the preservation of images and artefacts of cultural heritage.
5. 'Rescue the Hitchcock 9', *Long Live Film 1935–2010, BFI National Archive Celebrates 75 Years*, http://www.bfi.org.uk/saveafilm.html, accessed March 2012. Hitchcock's nine silent films are: *The Pleasure Garden* (1925), *The Lodger* (1926), *The Ring* (1927), *Downhill* (1927), *Easy Virtue* (1927), *The Farmer's Wife* (1928), *Champagne* (1928), *The Manxman* (1929), *Blackmail* (1929). Previous restorations include Harold Brown's 1984 work on *The Lodger* and that undertaken by de Oliveira. Brown's work is noted in Paul Read, 'Tinting and Toning Techniques and Their Adaptation for the Restoration of Archive Film', in Luciano Berriatua (ed.), *All the Colours of the World: Colours in Early Mass Media 1900–1930* (Reggio Emilia: Edizioni Diabasis, 1998), pp. 157–67.
6. Read 'Tinting and Toning Techniques and Their Adaptation for the Restoration of Archive Film', p. 160. Prior to the 2011 restoration, Read notes that *The Pleasure Garden* had nine tints, of which two were pretinted film stock (coloured prior to

printing) and six were coloured post-printing. This indicates the material complexities encountered in film restoration.

7. 'Rescue the Hitchcock 9'. A figure of £75 covers costs of scanning 375 frames of film; £15,000 would contribute to reproducing the colour tinting or black-and-white grading of the source nitrate prints using digital colour and image correction.

8. Brian R. Pritchard, 'Motion Picture and Film Archive Consultant', http://www. brianpritchard.com/Tinting.htm, accessed March 2012.

9. Ivor Montagu (1904–84) was editor for *The Lodger*, *Easy Virtue* and *Downhill*.

10. Robert M. Fanstone, 'Experiences with Dufaycolor Film', *British Journal of Photography*, 7 June 1935, pp. 358–9.

11. Giovanna Fossati, *From Grain to Pixel: The Archival Life of Film* (Amsterdam: Amsterdam University Press, 2009).

12. Adrian Cornwell-Clyne, 'Additive Processes', *Colour Cinematography* (London: Chapman and Hall, 1951), pp. 263–324, 306.

INTERVIEW
SONIA GENAITAY

Sonia Genaitay is curator of fiction films at the BFI National Archive. A graduate of the L. Jeffrey Selznick School of Film Preservation in Rochester, New York, she has worked at the BFI since 2002 as a moving-image archivist, digitising material for *Screenonline* and as a curator of children's films.

BIBLIOGRAPHY

Genaitay, Sonia, 'Restoration: *This Happy Breed*', *Sight and Sound* vol. 18 no. 7, July 2008, pp. 41–3.
Genaitay, Sonia and Bryony Dixon, 'Early Colour Film Restoration at the BFI National Archive', *Journal of British Cinema and Television* vol. 7 no. 1, 2010, pp. 131–46.

INTERVIEW TRANSCRIPT

DATE OF INTERVIEW: 29 JULY 2010
INTERVIEWER: LIZ WATKINS

LIZ WATKINS: As a curator at the BFI National Archive, how would you describe the way that the collection is organised?
SONIA GENAITAY: We store all film material according to its status: viewing copies and master materials – the latter being either the best-quality copies or the only copy for each title. Colour and black-and-white films are stored together, so material is not separated by genre or importance. At Gaydon in Warwickshire, we have some safety film as well, but mostly the nitrate. So that's where we keep the nitrate collection.[1] All nitrate material is held at master status, even items which may be used for very rare nitrate screenings. In the new store – it's not built yet, but once it has been built – all master material, both nitrate and safety, will be held at –5 degrees Celsius. We will effectively be freezing the collection. The building will be split into multiple cells, some designed for safety, some for nitrate. We don't organise material by title, but we try to divide different key elements of films across different cells. If there is a risk of a fire or anything, then you want to limit your losses basically. It's barcoded now so you can even have one bit of the film in the one area and the rest of the film in another area. It doesn't matter as you can retrieve it easily. But it's not stored by cultural importance. Everything will be at the same temperature and humidity so it will be democracy for films!
LW: Excellent. Is there still unidentified material in the archive?
SG: There are films that have never been fully examined or looked at before. There is still material like that around. We haven't done everything. So they are still in our database, stored in a temporary location. There are pockets, bits of nitrate films that I have been working on recently that have been in the archive thirty to forty years that have never been properly looked at. I'm sure it was on the to-do list of lots of people and they just never made it.

The Open Road (1925)

LW: So there are fragments and sometimes they're identified?

SG: It's a bit like *The Open Road* to me.[2] What we did with *The Open Road* was an example of creative archiving. Us, the BFI National Archive, being creative with our material as opposed to being faithful to the original. This time we were being creative and we don't have the opportunity to do that very often. I find that very exciting. I think the material was quite – well, we had the right material for it because for *The Open Road* only a few pieces had been exhibited at the time it was released, the rest of it had only existed as rushes in unedited form. So there was this sort of a mass, it was just perfect material for creating, making a montage and creating music to go with it. I really like the work that we've done, but I think it's been wrongly branded as a restoration. If it had been down to me, I wouldn't have called it a restoration.

LW: But even so, it was very useful in that it offered something of the visual characteristics of Friese-Greene's film and the colour process. It's so difficult to get an understanding of that without seeing the moving image.

SG: Well, there's no name for it really. You couldn't really brand it as a recreation, because people wouldn't know what you meant. The word restoration speaks to people. They know what we're talking about. I understand why it was referred to as a restoration because it did the job they wanted it to do. I probably would have used something like the word 'creative' somewhere. It's the first example, as far as I know, of a recreation that the archive has done. I can't think of any other like it because even the Mitchell and Kenyon films, they were still shown as complete reels. They weren't edited by us.[3] They were shown in lots of programmes that went touring. But because the rolls were really short anyway they were compiled, but not a montage cut and put together, whereas with *The Open Road* we cut and pasted it and made a montage really.

LW: Made a new narrative out of it?

SG: We made a narrative out of it, yes. It was not just a compilation. We redid the journey in one hour rather than three. So it's a completely different story. The work that we did recreating the process and the colour – I think we created something that did not exist before. So we continued with the great experiment.

LW: It's an interesting case study and fascinating to see for and despite of that.

SG: It's a great case study. I love that story. I really like it.

LW: From that kind of selection, where the film is difficult to replace, to the question of duplicates, how do you decide what to acquire and what to keep?

SG: For duplicate copies offered you might look at fading, for example. Fading doesn't mean that all of the image goes away. You're losing the colour or usually you're losing one of the three layers of colour. But we can recapture some of it. We can work on this as it's not lost forever. So fading is not a big obstacle unless we were offered a huge collection of ex-distribution prints and they were all at various stages of fading. Then that would be a big problem. I don't think we would be in a position to accept something like this because then it becomes more of a burden than a useful acquisition. Because, given the amount of work that you'd have to do on the films to make them better. That being said, we do sometimes acquire prints that are faded because this is the only print we have. It could have worse problems than fading. It could be incomplete or it could have broken sprocket holes or it could be very, very scratched or anything. Once it's in the vault, the

cold temperature slows it down anyway. It all goes down to storage again. This is why we are investing so much in storage facilities because we know that all the problems about fading, the decomposition and what have you, like vinegar syndrome: all this can be slowed down and arrested whilst it is at low temperature and humidity.

LW: What other effects does deterioration have on film?

SG: Restoration affects sound as much as the image. I think sound is very complex and a really fascinating area, because you have all sorts of background noises and disturbances as well as dialogue and music. If you start cleaning up a soundtrack digitally, you would be amazed the things that you can remove. When we restored the three Jennings Dufaycolor films, we digitally cleaned the soundtracks and it was almost scary when the tracks returned and we listened to them. It was just so, well, it sounded a bit dead actually.[4]

LW: The sound includes the residual noise of material deterioration. Digital cleaning, if it's an optical soundtrack, could potentially efface something of the material trace of that particular print's history? Such physical changes affect the sound we hear?

SG: Yes, it was too clean. They had cleaned way too much. So it was really crisp, but you could probably hear the soundtrack better than in the original film. But you'd lost something that participated in the ambience or the atmosphere of the film.

LW: So if you're restoring a film for an audience today, it needs to be as close to the source material as possible. In addition to this, if you're trying to market it as a restoration and so as new to the public, it also has to look and sound old?

SG: The lab didn't understand why we didn't like them. They thought it was restoration. We said, 'No, there's not enough noise in it, you removed all the noise that we wanted.' We sent it back and they reintroduced some of the noise.

LW: So you develop an approach that is attuned to each film?

SG: Yes, I think it's having a balance, with each case you have to remove the things that are really obviously intruding like big scratches. You have to do your best to tone that down. For me steadiness of the frame is more important than having scratches in there. But for me colour is a big thing as well. You have to be very careful how you grade your film in the end. The grading is critical. For *This Happy Breed*, I think we had something like seven different answer prints before we had the final one. So there were seven different grades of the print before the final grade we were happy with.

LW: What were you encountering in the different prints?

SG: It was a bit complicated for this one because, first of all, the initial grade they did was in America and the print they made was very yellow. Overall, really bright and yellow and it looked [laughs] well, it was completely not what David Lean wanted. Because he wanted something very realistic and this was like, *glorious* Technicolor! So there was nothing wrong about the colour except that it was the wrong palette. So we sent it back saying, 'Well, a bit too yellow.' Then it kind of went back and forth. But we added another layer of difficulty by having sections digitally restored. The whole film was not completely digitally restored – only the sections that were worst affected by mould. So, it was probably 60 or 70 per cent photochemical and the rest was digital. But that meant that, once the digital sections were done, they had to be cut into the negative to make the print. But grading digitally and grading photochemically are two different things. So when we brought the sections together, we could, see a difference in density. So we had

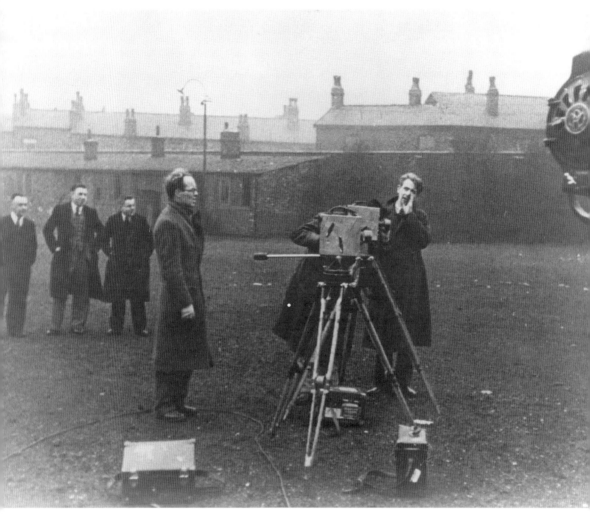

Humphrey Jennings (right)

to, again, go back and forth until everything was an even match. It's still not perfectly even, but somebody with an untrained eye wouldn't notice it. So you do have to be careful about these things.

LW: Thank you.

SG: It's okay. Thank you for interviewing me.

NOTES

1. David Francis, 'Preserving the Past', *BFI News*, September 1975, p. 3. The National Film Library purchased vaults for its film collection at Aston Clinton, Buckinghamshire in 1940. Storage for nitrate film at Gaydon, Warwickshire was secured in 1978. The J. Paul Getty Jr Conservation Centre opened at Berkhamsted in 1987 and predominantly holds safety film stock and those nitrate films that are integral to restoration projects. Since this interview took place, the new master film store at Gaydon has been opened and all safety master materials have been moved there from Berkhamsted.
2. The BFI National Film Archive made digital reconstruction of the screened effect of William Friese-Greene's colour process and edited his son, Claude's, film footage for *The Open Road* into *The Lost World of Friese-Greene* (BBC, 2006). The BBC programme was completed before the digital reconstruction and used different material.
3. *The Lost World of Mitchell & Kenyon* was a restoration project pursued by the BFI and the National Fairground Archive at the University of Sheffield. It was first screened on BBC2 in 2005.
4. The three films by Humphrey Jennings were *Farewell Topsails*, *English Harvest* and *Design for Spring*, which was recut and re-released as *Making Fashion*. See the interview with Kieron Webb.

DOCUMENT

ROBERT M. FANSTONE, ARPS,
'EXPERIENCES WITH DUFAYCOLOR
FILM', *BRITISH JOURNAL OF
PHOTOGRAPHY*, 7 JUNE 1935

It is usual to make startling and revolutionary claims for each new colour process. Probably most photographers are rather sceptical, and reserve judgement until the new method has been tried out. There have been new processes in the past, which work quite well in the hands of their inventors or under laboratory conditions, but which fail when placed in the hands of the photographer who is not aware of limitations, or even if he is, is perhaps not prepared to go the whole way to overcoming them.

The first, and most important, consideration is the accuracy of the colour rendering. In this respect the new process is very satisfactory, and it can deal with subjects including a wide range of colour, and differentiate between different shades of the same colour. The yellows, always a difficult problem for the colour-worker are very faithfully reproduced. The greens are free from the acid tint which has marred the effect of greens rendered by some colour processes, while the reds have full depth. The colours are also reproduced in brilliant but quiet shades, and are free from the blatant notes which are sometimes seen and which have brought colour photography discredit.

A properly exposed Dufaycolor film, processed according to the makers' directions, yields a softly brilliant positive, accurate with regard to colour, and with a character of its own.

THE PROCESS DESCRIBED

Dufaycolor follows other combined methods. That is, the colour-screen is coated with the panchromatic emulsion. The screen differs, being of the 'regular' type. When first introduced in the form of motion-picture film, some photographers complained of an effect resembling wire-netting [réseau] over the projected image on the screen, but this is not noticeable in the colour transparencies that I have made, although I have not yet projected any on the lantern-screen.

DOCUMENT

'GASPARCOLOUR EXPLAINED TO THE R.P.S.', *KINEMATOGRAPH WEEKLY*, 31 JANUARY 1935

Gasparcolour Explained to the R.P.S.

NOVEL METHOD OF PRINTING

Camera in Course of Construction

THE best demonstration of Gaspar-colour films yet seen in this country was given at the Royal Photographic Society on Friday last. Prior to the demonstration, the system was explained by Major Adrian Klein, M.B.E.

Major Klein commenced his talk by pointing out that a feature of the system was that films could be processed by practically normal methods. The stock is coated with three layers of coloured emulsion; on one side is blue-green, on the other side pink on the top and yellow beneath it. The blue-green layer is sensitised to blue light only, and the pink layer to blue light also; the underlying layer of yellow is sensitised to red light. By printing successively, or in some conditions simultaneously, with the

processed. The film is developed in a substantially normal positive developer, rinsed, and fixed. It is then rinsed again, and enters the reversal bath. The function of this bath is to decolourise the layers in the neighbourhood of the developed silver; a re-agent, incapable by itself of destroying the dye, actually functions by means of reflex compounds of the silver. As the action is proportional to the number of developed silver grains, and hence according to the exposure, each colour layer will vary from maximum colour saturation to white.

After remaining for the correct period in this reversal bath, the film is washed, after which all silver is removed by bleaching, followed by a hypo. bath and final washing,

PINK EMULSION	SENSITIVE TO BLUE LIGHT
YELLOW EMULSION	SENSITIVE TO RED LIGHT
CELLULOID BASE	
BLUE EMULSION	SENSITIVE TO BLUE LIGHT

Section of Gasparfilm projection positive

appropriate printing lights, namely, blue and red, one can print these three layers independently of each other.

Owing to the fact that that part of the emulsion exposed to light, namely, the area in which we shall get developed silver, is that part where the dye is going to be decolourised in subsequent processes, there is a reversal of the image, so it becomes necessary to print Gasparcolour from a positive transparency, not from the negative. This presents obvious advantages in three-colour printing; balancing, for instance, can be done before printing.

Processing the Film

Major Klein regretted that he was not permitted at present to discuss the chemistry of the process. The principal operations, however, are as follows: The film having been printed three times with the appropriate intermediate positives, and using the correct printing lights, is now ready to be

and the result is a practically grainless positive transparency in three layers of coloured gelatine. Obviously it is a great advantage to be able to carry out the operations subsequent to the first fixing bath in daylight.

Printing Sound

As regards the sound track, this is printed with white light in an ordinary sound printer on the pink side of the film, which is separately and very rapidly re-developed by a tiny coating wheel, immediately after the bleaching operation. The final sound-track therefore consists of a developed silver-black image against a background of pinkish-red; this colouring is well suited to sound reproduction, because the modern caesium cell is highly sensitive to red light.

At present Gasparcolour film is coated on both sides, but there is no reason why we should not coat all the layers on one side, although the advantages of this would be rather doubtful.

Laboratory Arrangements

It will be gathered that the processing of Gasparcolour films could be carried out by any standard well-equipped laboratory, only minor modifications of the processing machinery being needed. At the present time Gasparcolour have entered into exclusive arrangements with the Standard Kine. Laboratories, of Thames Ditton, for the processing of all material in this country. Already processing of commercial work is proceeding steadily, and time of delivery is only slightly in excess of conditions for black-and-white.

Camera in Production

As to the camera, it is immaterial as to what process is used for obtaining the three-colour negatives. A beam-splitting camera is now in hand, employing two gates at right-angles, and a simple prism beam divider.

(Continued on page 50)

'S PROJECTION-ROOM

GASPARCOLOUR EXPLAINED

(Continued from page 47)

The camera should be available in a few months' time. In the meanwhile, production work is limited to the making of advertising films employing either trick photography or cartoon drawings, and the production of cartoon films for entertainment.

The only requirement of the camera is that it shall be equipped with registering pins. Three consecutive frames of a single film are exposed through a disc filter.

The Gasparcolour process is also ideally suited to the production of lantern slides, while in the case of picture films, a superiority even to black-and-white is claimed, owing to the entire absence of silver in the completed films.

Screen Demonstration

Half a dozen short films in Gasparcolour were then projected, made either from cartoons or models. The first, Major Klein

G.-B.E. IN THE SAAR

To Entertain British Contingent

G.-B. Equipments, Ltd., have supplied two complete "talkie" equipments to the Saar troops (British) for their entertainment during the remainder of their stay at Saarbrucken.

The contract was awarded by the Navy, Army and Air Force Institute for the supply of two double (35 mm.) portable reproducers and accessories, ironclad collapsible booths, and a full complement of spare parts.

A British Acoustic engineer accompanied the equipment on its journey to the Saar on Saturday, January 19, 1935, to give the Tommies the necessary initiation into the mysteries of how to give a kinematograph performance.

Programmes of Gaumont-British films were selected, and included such well-known features as:—" Evergreen," "Chu Chin Chow," and " Jack, Ahoy." Newsreels will be shown, too.

Arrangements have been made for servicing over a period of seven or eight weeks.

mentioned—had had the sound printed on the blue layer, and sound quality was rather inferior. In others, however, the quality of sound gradually improved, until in the later productions it was fully equal to modern standards of recording.

A feature of the colouring was the translucency of the tints; although quite vivid colours were obtained, they seemed to be more like those obtained by additive processes, while the comparison with other subtractive processes was as a comparison between water-colours and oils. There was not a sufficient range of colour in the subjects to pass judgment on the colour rendering, but two noticeable points were the purity of whites, and also a beautiful lustre effect on glassware. In an advertising film showing cigarette tins, the colouring definitely looked like tin, and not cardboard.

In the course of a subsequent discussion, Major Klein stated that many stills of excellent quality had been made from three-colour negatives; no studio work on kinematograph films had yet been done owing to the non existence of a three-film camera.

In reply to G. E. Lansdown, Major Klein stated that the present range of colours had been balanced for projection with an arc running at 80 to 100 amp.; very slight modifications of colour were to be expected if run under other conditions. P. Harris raised the question of the definition in view of the double coating, to which the lecturer replied that the thickness of film was only .0055 in., and at a throw of 120 ft. there would be a separation of only 1½ in. of the two images, which was extraordinarily small. He considered that any loss of definition in other double-coated systems could be attributed rather to faulty registration. He drew attention to the improved definition of the last film shown, which had been taken in a camera embodying a gate of much higher precision.

The Chairman, Dr. Spencer, in proposing the vote of thanks to the lecturer, included G.-B. Equipments for the loan of the British Acoustic portable projector, which had put up a very good show.

INTERVIEW
PAOLO CHERCHI USAI

Dr Paolo Cherchi Usai is senior curator of the Motion Picture Department at George Eastman House in Rochester, New York, and director of the L. Jeffrey Selznick School of Film Preservation, which he established in 1996. He is also curator emeritus of the National Film and Sound Archive of Australia (NFSA) since 2010 and resident curator of the Telluride Film Festival. Cherchi Usai was the founder of the Haghefilm Foundation, which he directed until 2011, and is a founding member (1982) of the Pordenone Silent Film Festival. He previously worked as director of the NFSA (2004–8) and as a curator at George Eastman House (1994–2004).

BIBLIOGRAPHY

Cherchi Usai, Paolo, 'The Demise of Digital (Print #1)', *Film Quarterly* vol. 56 no. 3, 2006, p. 3.

Cherchi Usai, Paolo, 'An Epiphany of Nitrate', in Roger Smither and Catherine A. Surowiec (eds), *This Film Is Dangerous: A Celebration of Nitrate Film* (Brussels: FIAF, 2002) pp. 128–31.

Cherchi Usai, Paolo, 'The Legend of the Earth Vault', in Smither and Surowiec, *This Film Is Dangerous*, pp. 541–4.

Cherchi Usai, Paolo, *The Death of Cinema: History, Cultural Memory and the Digital Dark Age* (London: BFI, 2001).

Cherchi Usai, Paolo, *Silent Cinema: An Introduction* (London: BFI, 2000).

Cherchi Usai, Paolo, 'Film Preservation and Film Scholarship', *Film History* vol. 7 no. 3, 1995, pp. 243–4.

Cherchi Usai, Paolo , 'The Color of Nitrate', *Image Magazine* vol. 34 nos. 1–2, 1991, pp. 29–38.

Cherchi Usai, Paolo, 'Archive of Babel', *Sight and Sound* vol. 59 Winter 1989/1990, pp. 48–50.

Williams, Linda, 'Passio – Review', *Film History* vol. 60 no. 3, 2007, pp. 16–18.

INTERVIEW TRANSCRIPT

DATE OF INTERVIEW: 13 SEPTEMBER 2010
INTERVIEWER: LIZ WATKINS

LIZ WATKINS: There are instances in which technical records, such as those detailing the adjustments made in colour grading, have been kept by the person undertaking the restoration and that have been a point of reference for subsequent restorations of the same film.

PAOLO CHERCHI USAI: There is objective information that can be kept, but then there is also the subjective expertise that resides with the person. When a preservation element is created, the archive will then take good care of it. This opens another can of worms about

the correct fashion of repeating a preservation of a given film a number of times; some-times you lose track of how many times it has been done, but you redo a preservation because you always think you can do better. This is happening with titles like Visconti's *The Leopard* (Luchino Visconti, 1963) and *Metropolis* (1927).[1]

LW: And *The Red Shoes*?

PCU: Yes, but the case of *The Red Shoes* is again different in the sense that there are, to my knowledge, two main sources for this film.[2] I do not recall if and how the two sources were combined in the versions of the film that were available earlier; if they were not, then it is a good idea to do it.

LW: **For restoration projects, some archives work towards the viewing experience of the initial screening of the film; so a point which is subject to interpretation. This resonates with questions surrounding the perception of colour and fading. How would you estimate what colour a film might have been when there are multiple film elements that the restoration could utilise?**

PCU: Most viewers don't have the elements necessary to judge. When a viewer is told that the colour of *The Red Shoes* looks better than it did in the last preservation and they have no way to evaluate this, then as consumers they take it at face value.

LW: **Thinking about different prints of the 'same' film, would it be okay if I asked you about *Passio* (2007)?[3] You've described it as a film version of *The Death of Cinema*.[4] There are seven prints, each of which is hand-coloured to a different design and the negative, as a source element, has been removed or destroyed.[5] Do you consider this practice a way of foregrounding the dilemmas film archives are faced with?**

PCU: It was my way of highlighting certain issues, of presenting a case where you have a film, making seven copies, the negative has been destroyed and even if the negative had not been destroyed no other print will be hand-coloured in the same way. The prints can be duplicated, but if they are, this will probably not be coloured by hand and the experience of these films and of these duplicates will differ. So as each film and its potential duplicate are different, then each viewing experience will be different; each film will mean something slightly different, depending on which print you view.

LW: **I read that you had put them in different archives: if each film is unique, do they immediately get held for preservation and take on the status of master print? Archival practice around master prints would make them inaccessible.[6] Have the films been screened since? Do you keep track of them?**

PCU: The prints can and should indeed be screened! Some archives have received a print of the film; one of them was acquired by Martin Scorsese for his personal collection. As a matter of contractual agreement, the prints are not to be reproduced or duplicated in digital or analogue form.

LW: **Right, but that they can't be duplicated made me wonder about the status that conferred on them?**

PCU: What the archives want to do with the prints is their decision.

LW: **You've set them a dilemma!**

PCU: The prints are all different and under archival rules they would be considered masters. But they are and they are not. They are master copies because they are unique, and

they are not masters because the prints are meant to be screened. That is part of the experiment in a way.

LW: So, it's about the effects of deterioration and what is desirable in a print after 'to preserve, to show'?[7]

PCU: It all boils down to the question, 'Do you want the moving image to bear the traces of history?' If you say 'yes', then you have to accept the consequences, which means accepting the fact that the film will begin showing the effects of time. If you say 'no', then you will be aiming at a perfect image, which is fine, but you will be denying the image the right to have a history. I call it the right to have a history, because I do not see why we should give this right to other forms of human expressions and not to the moving image. I have a feeling that my problem with what we call restoration is that it seems a way to deny the materiality of the work. The challenge of preserving film as the object of an event called 'projection' is not much different from preserving the object where the digital image is stored. I am not satisfied by the answer 'just migrate' [film to another medium]: that's no solution. It is only a way of postponing the problem. It is still duplication and the issue is that it is presumed to give you an identical copy, but the question of materiality has not disappeared. Nothing is new. My book *The Death of Cinema* came out in 2001, but there was a book called *The Death of Film* that came out around 1927. There is a book here in my library that is also around 1927 called *The Crisis of the Film*, now film is in a crisis?[8] Film has always been in a state of 'crisis' since it was born.

NOTES

1. A Brilliant Evening: Restoration of Luchino Visconti's *The Leopard*', Film Foundation, 2010, <http://www.film-foundation.org/common/11004/aboutNewsStory.cfm?QID= 7593&ClientID=11004&TopicID=0&sid=1&ssid=3>, accessed May 2012. Refers to different restorations of *The Leopard* undertaken in Italy, then by Criterion and then by the Film Foundation (US). *Metropolis* was restored by Giorgio Moroder in 1984. Sections of *Metropolis* on 16mm film stock were identified at the Buenos Aires Museo Cine in 2008, leading to a further restoration released in 2010.

2. Robert Gitt, *The Red Shoes* – Preservation Booklet (Film Foundation, 2009), p. 7, <http://www.film-foundation.org/common/news/articles/detail.cfm?Classification= news&QID=6654&ClientID=11004&BrowseFlag=1&Keyword=&StartRow=1&TopicID= 0&Subsection=&ThisPage=0>, accessed April 2012. The Eastmancolor print produced by Paul de Burgh at the Rank Film Labs for the BFI restoration in the 1980s was a point of reference for this restoration. It also referred to three-strip Technicolor transfer prints, nitrate and acetate protection master copies and the original Technicolor negatives.

3. Linda Williams, 'Passio – Review', *Film Quarterly* vol. 60 no. 3, 2007, pp.16–18.

4. Paolo Cherchi Usai, *The Death of Cinema* (London: BFI, 2001).

5. Ruby, violet, indigo, magenta, vermillion, gold.

6. Ernest Lindgren, 'The Work of the National Film Library', read to the British Kinematograph Society, 1 November 1944; Paul Read, 'Film Archive Is on the Threshold

of Digital Era: Technical Issues from the EU FIRST Project', *Journal of Film Preservation*, December 2004, pp. 32–45.

7. Snowden Becker, 'See and Save, Balancing Access and Preservation for Ephemeral Moving Images', *Spectator* vol. 21 no. 1, 2007, pp. 21–8 refers to FIAF's advocacy of 'to preserve, to show'.

8. John Gould, *The Crisis of the Film*, 2nd edn (Seattle: University of Washington Book Store, 1929).

INTERVIEW
ULRICH RÜDEL AND DANIELA CURRÒ

Daniela Currò is preservation officer in the Motion Picture Department at George Eastman House in Rochester, NY. Previously, she was project manager at the Haghefilm Foundation and film preservation specialist and colour grader at Haghefilm Conservation B.V. in Amsterdam, the Netherlands. She has also collaborated in research and restoration projects with Italian film archives such as Museo Nazionale del Cinema in Turin. Ulrich Rüdel holds a doctorate in Analytical Chemistry from the University of Münster and worked on biosensors and intellectual property rights before turning to film preservation. He is conservation technology manager at the British Film Institute, and was formerly R&D manager at Cineco/Haghefilm Conservation B.V. and project manager for the Haghefilm Foundation. Both Currò and Rüdel worked at Cineco/Haghefilm Conservation BV at the time of the interview.

BIBLIOGRAPHY

Currò, Daniela, Claudy Op den Kamp and Ulrich Rüdel, 'Towards a More Accurate Preservation of Color: Heritage, Research and the Film Restoration Laboratory', in Simon Brown, Sarah Street, Liz Watkins (eds), *Color and the Moving Image* (London and New York: Routledge, 2012), pp. 307–19.

Rüdel, Ulrich, 'The Technicolor Notebooks at the George Eastman House', *Film History* vol. 21 no. c1, 2009, pp. 47–60.

Cherchi Usai, Paolo, Daniela Currò and Ulrich Rüdel, 'The Haghefilm Foundation, Amsterdam: A Learning Laboratory', *Journal of Film Preservation* vol. 82, 2010, pp. 87–93.

Paletz, Gabriel M., 'The Finesse of the Film Lab: A Report from a Week at Haghefilm', *The Moving Image* vol. 6 no. 1, 2006, pp. 1–32.

INTERVIEW TRANSCRIPT [EXTRACT]

DATE OF INTERVIEW: 14 SEPTEMBER 2010
INTERVIEWER: LIZ WATKINS

LIZ WATKINS: If a film comes into the lab in a state of deterioration, how do you begin to ascertain what colour it may have been?
DANIELA CURRÒ: That's an interesting question.
ULRICH RÜDEL: I think what it has come to at this point is that any answer requires quite a bit of conjecture. The focus is often on skin tones so those have to be right. Of course it helps to know what the skin tones are like. Obviously this might be different depending on the colour process and variation between prints, but often, if the flesh tones are right, then everything else seems to fall into place. This is, of course, well, I wouldn't say completely unscientific because you have some reference colour that has all the colours in there, but it's only an approximation. The problem with grading faded film is that it's only a calculation. If I remember correctly, there's research that indicates that the dye

fading is what they call first-order reaction chemistry.[1] This means that every molecule of dye has a certain tendency to fade, so the more dye you have the more the film fades proportionally. That approach would be in line with finding one mathematical model to twist things back in shape for the entire film, regardless of whether it's a dark scene, a bright scene, a blue scene or whatever. But of course in conventional grading, you can only compensate for slight colour fading and even then you often get these associated problems that shadows don't appear black any more, and so on.

DC: The problem with analogue grading is that in some cases after correction, the whites and the blacks still don't fall into place and show a colour cast, sometimes looking bluish, greenish or yellowish. So even the best analogue result might not be as good as the result that can be achieved digitally – that is something that cannot be avoided.

UR: It is its nature. I believe there's one shot in *Vertigo* (1958) actually where in the commentary on the DVD, Robert Harris says there's a scene in the bar where it looks all right except that James Stewart's blazer is not supposed to be dark blue, but black.[2] That's because they used some digital restoration, but I think only for a couple of shots for budget reasons, the majority like the shot in question was still a photographic-chemical process.[3]

LW: How do you approach a restoration project if you're trying to maintain some of the characteristics of a certain colour process, like three-strip Technicolor?

UR: Well, that goes back to the question of how much of the colour 'look' is to do with design, how much is really a measurable property of the film, and how much of it happens in the spectator's mind?

LW: Is it addressed through restoration practices where a comparative analysis of different prints in relation to the negatives is made or where there is a series of restorations of the same film such *The Red Shoes*?

UR: For the latest restoration, I have to say I have no reference point as I haven't seen any three-strip Technicolor print of that film or another British film from that era, but something seems to look right as Technicolor.[4] It was a digital restoration, but it was printed on Eastmancolor film stock struck from new negatives that had been produced through a hybrid digital–analogue process. So there seems to be the potential to get the 'look' right and part of that is the advantage of subjective, visual colour restoration: if the film can't render its colour, you can still make believe that it's something close to it. So that's the strange thing about subjective perception and I'm sure it applies to both the saturations or the subtleties in the original dyes even when there's no way we can render them. And in comparing this, we can't test and cut back and forth between two copies of a film printed on different materials. But we can do that, for instance, with hand-coloured films created in our lab specifically for such a comparison project, so that's going to be interesting. We can rarely do full A/B comparison of original and new copies in restorations but, compared to the memory of looking at the nitrate on an inspection table, those hand-coloured copies looked very faithful. But if you were to project them side by side, which would be difficult, it might perhaps be a bit of a different story.

LW: It makes you wonder what you're seeing when you view the film. I remember reading that the National Film and Television Archive's restoration of *The Red Shoes* as a three-strip Technicolor film made black-and-white preservation masters. A new Eastmancolor print was made to test the black-and-white separations.[5] So

that's what you end up seeing. So it's difficult, as you say, to discern between film style and the certain aesthetic that's associated with a process like three-strip Technicolor or a film stock like those produced by Eastmancolor. Is that 'look' to do with the technology or the legacy of Technicolor's advocacy of a certain colour practice?[6]

UR: And dyes, certain dyes and things. But I mean, the example you mention, at least is a positive one: (a) they made black-and-white separations and (b) they quality controlled them. There's a DVD of a film shot in Eastmancolor, *Pollyanna* (1960), which I actually only bought to use for teaching.[7] There's a lovely ten-minute extra on it where Scott MacQueen elaborates on how they found out, when they restored it from the existing black-and-white separations, that someone had forgotten to exchange the colour filters in making them back then. So they had two prints of one colour record, and they were missing another. Fortunately, they found that the one they were missing was one that had faded the least in the colour negative. This meant that they could make a modern separation from it, to fill in for the one that they were missing.[8] There was also a problem with Eastmancolor intermediate film stock, which was about the worst you could get in terms of stability. It's the material that suffered the most from the fading problems in the 1970s or 1980s.[9] If you only have that material as the best master and then you don't have the original film elements, then it's pretty tough.

LW: So film restoration is an adaptive process?

UR: Yes, and as you begin looking more deeply into these issues, trying to understand them, you ask yourself questions that make you more sceptical: I wonder what this will be judged like twenty years from now? Right now, we know analogue and we are aware of some of the disadvantages. We are aware of some of the shortcomings of digital and of some of its advantages. But maybe we'll judge this differently twenty years from now. Or maybe twenty years from now, we'll have another method that will easily fix all the shortcomings of the twenty-year-old analogue restoration. Of course, alternatively, you might have lost other information. For digital work, I don't know. I mean, right now, a mere 2K is standard for positives.

LW: If this is about restoring an image, what do you work toward? I was wondering how you gauge or calculate the information that's been lost?

UR: Well, what is missing? Is it real image information, or is it just random spatial noise or actual distribution of visual information of the image? Because, for instance, the individual place of a grain or shape of silver doesn't really give you as much information as an individual pixel that has a certain grey scale or colour value, or three colour values. So really, you need to decide where the relevant information is that you need to capture.

DC: So when you're digitising an image, capturing the analogue film frame by scanning it, then you can get a different result from the one that you're expecting, but what you want to know is *how different*? Is the difference between the analogue and its digital version so different that it's noticeable to the human brain and eye, or not? If it's not, then is it something that we can accept? So this is the big question.

UR: Then, of course, you have to keep in mind that the same is true for any analogue copy. I mean, the principle of the analogue copy is closer to that of the material that you're copying, but it's still a copy.

LW: Some of the marks and changes you see would be specific to a particular strip of film, and so potentially each print of a film could vary.

UR: It's a little bit like saying, if you want to preserve a book you have to print it on the same type of paper, like the original edition? That's not the information, that's just what the information is carried on. That has to be distinguished from what is the information. Of course, there are certain image characteristics and anomalies that we've embraced as part of the image, like a particular graininess or the unsteadiness of the image. Now more people are saying, 'I don't like this, this looks too stable.' I can understand that. Sometimes I react the same way. It seems kind of irrational when the film industry has been striving to minimise issues like instability, or even photographic grain.

LW: So how do you gauge the colour for a restoration?

UR: Well, for instance, I promised to show you this copy of this Agfacolor tint-and-tone manual because at first for me, it was like a little culture shock. I'm still not 100 per cent sure from when it actually dates, but there's an article that refers to a toning recipe in here that seems to exactly fit a toning recipe that was published elsewhere in 1921 or 1922 which would date it around that time.[10] The copy I have here I think came with a letter from the late 1920s or even 1930, but when we first saw it we were absolutely stunned by how intense these colours were.

LW: It has actual frames of coloured film in it?

UR: Yes and this is also very interesting when we talk about whether or not the so-called 'nitrate effect' exists, because here you see indeed that the film base is as clear as glass. This is something you only see with nitrate, but whether that shows up on screen or not or substantially translates into something on the screen, well that I'm not quite sure about.

LW: They're almost jewel-like colours, aren't they? They are incredibly intense.

DC: They are, yes, but then what we also have to consider is that this is a sample book from Agfa. What about the tints from other companies? Could they have had a different look?

UR: I'm not so sure about that. I don't know what orange they have, for instance, but in other cases I think they might have arrived often at similar dyes, in different places, different geographical locations.

DC: What I mean is that looking at nitrates, I can see patterns coming from a given production company, which usually employed the same colours.

UR: But maybe it's different choices made using the same palette of dyes?

DC: Of course, but how many dyes are there? Were these the only dyes available? And which were the concentrations and mixes used?

UR: Well I guess there are quite a few even just in this book if they have twelve recipes. I mean, this was the conclusion: there's so much we don't know. If you look at the prints, they're usually in a much worse condition. So we can only make observations, but we don't actually know. Maybe the other ones were once as vibrant and have decomposed. Are we looking at a deliberate difference in colours here, between Agfa and Kodak, or Europe and the US, or from 1910–20 or into the 1920s? Or does Agfa just happen to have used better paper to mount these frames, so that they survive better than the Kodak tint-and-tone manuals or say, are the storage conditions in Europe on average better (e.g. cooler) than those on the US West Coast?

DC: So what you normally do you're when looking for a reference point when you get a reel of tinted nitrate on your table, is that you use the colour on the perforation area because you assume it is not as faded as the centre of the frame. Fading in fact could have occurred as a consequence of the heat of the projector's lamp, but sometimes even in a brand new film that has just been tinted, the edges are a little darker than at the centre, regardless of whether the film has ever been projected. So this assumption is not always correct.

UR: Indeed, we confirmed that, on occasion, and it's not really surprising because you know you have to shake your tinting solutions or agitate it at least once in a while to make sure to always get fresh solution to the film. The perforations would create some extra stirring, some agitation which would help the colouring process. So that might be an explanation for that, but it's a subtle difference. Sometimes in films we'll see the effects; we see the films with different colours but without drawing any definite conclusion. For instance, in one project we were looking at the homogeneity of the colour but in some cases we saw variation depending on how we did it. These slight differences in colour intensity perhaps would be not very noticeable with very dark colours. I think we would probably see that well in a colour that is lighter, so that's tricky because you have the combination of chemistry and photography, but also vision and psychology.

DC: Often it is experience that helps you understand what the colour that you see was supposed to be like, because sometimes you are lucky enough to find the same decomposition pattern as you've seen on a film that you've inspected previously. That's why I keep my camera nearby and I always take pictures. For example, in a film I worked on recently, the first shot looked almost to be green-toned and then the shots after it were blue-toned. So then the choice was whether I should select green toning or whether the fact that all the rest of the film is blue-toned should make me think about something else? There was another film that I had inspected previously that had exactly the same kind of green toning, but occurring only in the middle of a shot that apart from this decayed area was toned blue; that particular shot had decomposed further. That made me think that the first shot in the roll I was inspecting had actually for some strange reason a higher level of decomposition. So, it should have been blue-toned like the rest of the film. The subject of the film was a trip to Niagara Falls too, so it made sense that the tone of the film was blue since all the shots were set in a water environment. There are many considerations to take into account. That's why you document the choices you make and keep the originals. Somebody else could judge the same phenomenon differently.

UR: This brings up another issue that might be a bit of a concern, that regardless of which route by which you choose to reproduce a tint and tone, I would say that the standard and usually the preferred one is the Desmet process. You could question how well it preserves colour, because what you're recording are the timing values made in a particular lab, at a particular time, for a particular film stock, and to match the light source of a modern projector.[11] The properties of a segment of film are certainly not comprehensively documented by timing values. You can't predict it very well because every component has a little influence on the actual colour rendition. So it might already be arguable how faithful at all the

image is a match to the original experience, and how good a colour preservation for posterity is achieved by using this method. I mean, if you need new prints twenty years from now, you will have to struggle yet again with similar issues to re-recreate the Desmetcolor from two decades before.

NOTES

1. Rudolf Gschwind, 'Restoration of Movie Films by Digital Image Processing', in Dan Nissen and Lisbeth Richter Larsen (eds), *Preserve Then Show* (Copenhagen: Danish Film Institute, 2002), p. 168.
2. *Vertigo* (1958) Universal Pictures [1996] 2005 DVD Region 2 PAL UK release.
3. Leo Enticknap, 'Some Bald Assertion by an Ignorant and Badly Educated Frenchman: Technology, Film Criticism, and the "Restoration" of *Vertigo* (1996)', *Moving Image* vol. 4 no. 1, 2004, pp. 130–41.
4. Robert Gitt, *The Red Shoes – Preservation Booklet* (Los Angeles, CA: Film Foundation, 2009), p. 7, <http://www.film-foundation.org/common/news/articles/detail.cfm?Classification=news&QID=6654&ClientID=11004&BrowseFlag=1&Keyword=&StartRow=1&TopicID=0&Subsection=&ThisPage=0>, accessed April 2012. Rüdel refers to the 2009 restoration undertaken by UCLA Film and Television Archive in association with the BFI, Film Foundation, ITV Global Entertainment and Janus Films.
5. Penelope Houston, *Keepers of the Frame: The Film Archives* (London: BFI, 1994), pp. 130–1; David Francis, 'Introduction: The Archive Presents: Cinema Our Heritage', in *National Film Theatre Programme*, October 1988, pp. 26–7, refers to the BFI NFTVA's restoration programme undertaken by Paul de Burgh. The restorations were led by Paul de Burgh at Rank Film Laboratories for the BFI in the late 1980s.
6. Robert Surtees, 'Colour Is Different', *American Cinematographer* vol. 29 no. 1, 1948, pp. 10, 11, 31. Natalie Kalmus was head of Technicolor's Color Advisory Service (1933–49), which advocated a colour scheme of muted background tones (browns, greys) and colour highlights (reds, yellows) that would participate in the visual organisation of space and draw spectator's attention to certain areas of the image. For example, the colour scheme would often be built around the female star's wardrobe.
7. *Pollyanna* (Vault Disney Collection), Walt Disney Video, USA 2002.
8. Three-strip Technicolor used a specialist camera and a dye imbibition printing process. In camera it used a prism to produce three colour records (red, green, blue) on black-and-white film stock. These registers were used to make corresponding matrixes (yellow, cyan, magenta), which were aligned and printed on a single strip of film. The phrase 'colour separations' refers to the three component records that are required in combination to form a 'natural' colour image.
9. Richard W. Haines, *Technicolor Movies: The History of Dye Transfer Printing* (Jefferson, NC: McFarland & Company, Inc. [1993] 2003), p. 132; Xu Jianhe and Ge Xiangbei, 'The Color Restoration of Faded Colour Film Prints', *Journal of Film Preservation* nos 58/59,

1999, pp. 40–3; Bill O'Connell, 'Fade', *Film Comment* vol. 15 no. 5, September 1979, pp. 11–18. An intermediate is produced as a stage in the laboratory processing and editing that occurs between the camera negative and the prints that are made and put into circulation in commercial cinemas.

10. Elfriede Ledig and Gerhard Ullmann, 'Rot wie Feuer, Leidenschaft, Genie und Wahnsinn. Zu einigen Aspekten der Farbe im Stummfilm', in Elfriede Ledig (ed.), *Der Stummfilm: Konstruktion und Rekonstruktion* (Munich: Verlegergemeinschaft Schaudig/Bauer/Ledig, 1988), pp. 89–116, 105.

11. Noël Desmet and Paul Read, 'The Desmetcolor Method for Restoring Tinted and Toned Films', in Luciano Berriatua (ed.), *All the Colours of the World: Colours in Early Mass Media 1900–1930* (Reggio Emilia: Edizioni Diabasis, 1998), pp. 147–50.

INTERVIEW
GIOVANNA FOSSATI

Giovanna Fossati is head curator of EYE Film Institute Netherlands (2009–) and lecturer on the MA Presentation and Preservation of the Moving Image at the University of Amsterdam. She holds a PhD in Media and Cultural Studies from the University of Utrecht. Previous posts include curator of the Netherlands Filmmuseum (2004–9).

BIBLIOGRAPHY

Fossati, Giovanna, 'Multiple Originals: The (Digital) Restoration and Exhibition of
 Early Films', in André Gaudreault, Nicolas Dulac and Santiago Hidalgo (eds),
 A Companion to Early Cinema (Malden, MA: Wiley-Blackwell, 2012),
 pp. 550–67.
Fossati, Giovanna, *From Grain to Pixel: The Archival Life of Film in Transition*
 (Amsterdam: Amsterdam University Press, [2009] 2011).
Fossati, Giovanna, 'On the Role of AMIA in Reshaping the Field of the Moving Image',
 Moving Image vol. 11 no. 1, 2011, pp. 155–8.
Fossati, Giovanna, 'YouTube as a Mirror Maze', in Pelle Snickars and Patrick Vonderau
 (eds), *The YouTube Reader* (Stockholm: National Library of Sweden, 2009)
 pp. 458–64.
Fossati, Giovanna, 'When Cinema Was Coloured', in Luciano Berriatua (ed.), *All the
 Colours of the World: Colours in Early Mass Media 1900–1930* (Reggio Emilia:
 Edizioni Diabasis, 1998) pp. 121–32.
Fossati, Giovanna, 'Coloured Images Today: How to Live with Simulated Colours (and Be
 Happy)', in Nico de Klerk and Daan Hertogs (eds), *Disorderly Order: Colours in
 Silent Film* (Amsterdam: Nederlands Filmmuseum, 1996), pp. 83–9.
Fossati, Giovanna, Marente Bloemheuvel and Jaap Guldemond (eds), *Found Footage:
 Cinema Exposed* (Amsterdam: Amsterdam University Press, 2012).
Fossati, Giovanna and Nanna Verhoeff, 'Beyond Distribution: Some Thoughts on the
 Future of Archival Films', in Frank Kessler and Nanna Verhoeff (eds), *Networks of
 Entertainment: Early Film Distribution 1895–1915* (Eastleigh: John Libbey
 Publishing, 2007), pp. 331–9.

INTERVIEW TRANSCRIPT

DATE OF INTERVIEW: 15 SEPTEMBER 2010
INTERVIEWER: LIZ WATKINS

LIZ WATKINS: So how did you first become interested in film restoration?
GIOVANNA FOSSATI: Of course, now I have my own little story! I don't know if it's true any more but it's the film I play in my head when I think about how I ended up here. Well, you know, in Bologna they've been organising for many years the festival Il Cinema Ritrovato and as a student, I was attending screenings, including those by the Nederlands

Filmmuseum, which at the time were presented by Peter Delpeut. He was the deputy director at the Filmmuseum and I was very much impressed by the way he talked about archival film and by his creative approach to it. The work at the Filmmuseum at the time was very much about revisiting the collection, preserving and restoring on the one hand, but also creating new films, and colour was a focus in their work. Peter is also a film director and he made found-footage films such as *Lyrical Nitrate* (1990) and *Forbidden Quest* (1993). The latter film was presented at Il Cinema Ritrovato in 1994, when I was still a student in Bologna.

LW: *Lyrical Nitrate* **of course seems to raise particular questions about the archive and the film image in decay.**

GF: Yes, all the material was coming from the archive. Peter Delpeut spent a lot of time in the archive looking at nitrate films. These films inspired his work, both as a film archivist and as a filmmaker. *Lyrical Nitrate* really inspired me at the time, as well as the work that the Filmmuseum was doing with *Bits & Pieces* [1990–].[1] I don't know if you are familiar with that.

LW: Like film fragments?

GF: It's unidentified film fragments. The whole idea predates Peter Delpeut and was introduced by his predecessor as deputy director, Eric de Kuyper, who started *Bits & Pieces*, a project to collect unidentified nitrate film fragments, without a title.[2] Traditional film history is mainly made of film titles and at the time, there was no place for such undefined fragments. This was a time way before the 'orphan film' concept.[3] *Bits & Pieces* offers a practical solution for all the bits and pieces of nitrate films that we find interesting and beautiful, but we cannot restore as a complete film because we only have two minutes, for example, of a beautiful red-tinted fire or a waterfall, and we really don't know where this footage belongs.

For creating these reels of bits and pieces, there were a few rules, a Dogma manifesto for the film archivists if you will: one reel, twenty minutes of bits and pieces edited together, no longer than a few minutes each. Starting with *Bits & Pieces* number one, we are now at over 500. These reels are restored and projected as such. Now that the *Bits & Pieces* reels have been digitised, we can also re-edit the fragments showing them in a different order.

LW: I understand the importance of asking questions and his stance on film, but the links between digital [digitisation] and access are important. Sometimes public access seems to reach only the tip of the iceberg, because the archives themselves haven't had the time or resources to catalogue the full extent of their holdings.

GF: It's true.

LW: Do you find that some of the shorter films, such as experimental works and those testing technical innovations remain unseen in the archive? I mean those films that were considered less economically significant, but contributed to the development of a new technology? For example, tests for a new colour process?[4]

GF: I don't know if we have any example of that in the *Bits & Pieces*. We do have some colour tests in the collection. For example, we have the film *The Coronation Procession of George VI* (1937) made with a colour system called Francita (Opticolor), which I think is pretty much similar to a three-colour additive system like the Gaumont Chronochrome.[5]

We tested for the restoration of the Francita system and ended up with a restoration with similar problems as they had at the time that the film was originally made: colours that did not perfectly overlap and heavy flickering.

LW: Is it the characteristic of that system you're restoring? Or is image content the focus?

GF: It's an interesting aspect to consider because, if you are respecting the film as an original artefact, then you do want to preserve the original 'problems' of the colour system. They are inherent characteristics of that film and are also some of the reasons why a system like the Francita was never a commercial success – because it had problems! So, from the perspective of 'film as original', the 'problems' are also part of what you want to preserve. Only why focus only on that aspect if, especially with digital technology, we are now in the position of solving those inherent technical problems and see the film without the headache-making flickering of colours? I think that ideally one wants to preserve the film as it was shown because that is inherent to the history of that film.[6] On the other hand, if I can put myself in a position to appreciate also other aspects by looking at it without getting a headache – why not create a second version without the flickering?

LW: Yes, there is that question as to whether you're preserving a record of the process and the technology or facilitating access to more viable image content. There are so many variables. Some archives are working with the caveat of an impossibility of recreating the moment in which the film was first experienced at the cinema. Whilst others are concerned with an estimation of how a particular colour process deteriorates. Both of which are concepts troubled by a hypothesis around an inaccessible source – a screening or prior condition – that can only be estimated and not directly accessed.

GF: That's true. I really think that archivists tend to think that we all work with a shared code of ethics. I find this a very tricky idea, because, first of all, ethics change. I actually don't think we all share a single code of ethics at all. That's not because we disagree that film archives are responsible for preserving our film heritage but because the way we preserve it depends on our framework of reference, and, in the end, on our own perspective and vision of what film is. For instance, at the Nederlands Filmmuseum in the past twenty years, and at EYE now, the focus has always been on showing films. So, if we go back to the seminal argument between Henri Langlois and Ernest Lindgren in the 1950s, the dispute over showing versus preserving, the question that arises is: is archival film the object kept in a can in the archive's vault or is it the film shown to an audience in a theatre?[7] It is a complex matter also on a practical level because preserving sometimes has different or competing interests than presenting. Also from an economical standpoint, the choice can be tricky: if you spend more money for preserving, you might end up with less for presenting.

For some archives it's very different because their only task is to preserve. For us and many institutes like us, it is a kind of compromise. It is less about the film object and more about the presentation set-up, including projection technology and live music. So it has always been much more than only the object of the film as it is kept in the can. Throughout the years we have experimented a lot with showing archival footage to a contemporary audience.

One question I address in my work and that has been central in the discussion with many of my fellow film archivists in the past fifteen years is whether digital brings with it an ontological schism, whether digital is film, or something different? And what is film then?[8] It's a very interesting discussion that, again, leads to polarisation: on the one hand, film as the material artefact, the photographic film; on the other hand, film as a much broader concept that includes digital film. My take is that film has never been a definite concept. It is a transitional idea and, if you look at the film as purely a photographic process on celluloid, then you are looking at just an aspect of it and at a tiny bit of film history.

LW: So a question of whether the film material is actually integral to its textual operations? And what remains to be seen through digital access as offering a kind of hybrid image?

GF: Yes, it's really the idea of pure film and colour. If you look at archival practice until the 1980s, early colour films were duplicated and preserved in black and white. If you look at how we know some of the most popular silent films – think of Chaplin, think of German Expressionism – we used to know them as black-and-white films. Now, when we see *Nosferatu* (1922) in a restored tinted version we might be surprised by the colours because this film has been known for a long stretch of time, and we're talking about decades, as black and white.[9] The auteur approach to film has also influenced the fact that archives have neglected early colour techniques for many years. Early colour techniques were something considered as added post-production, and therefore outside of the control of the filmmaker, rather a later interpretation that the filmmaker wouldn't have wanted. In fact, we don't know for sure as *some* filmmakers wanted control of the colours as well. In fact, auteur cinema is a later concept that did not give form to early (and part of silent) cinema.

LW: What kind of documentation would the EYE Film Institute Netherlands keep of film restorations? If you create a new film object that's a hybrid of different processes, do you document the work that produced it?

GF: This is open to interpretation at this point because we have this big project, *Images for the Future*, where we have six restorers working full time on approximately twenty restorations a month. It is a seven-year project, 2007 to 2014, probably the biggest project ever on preservation/restoration, digitisation and access of the film heritage and television heritage.[10] Partners in the project are EYE, the National Archive and the Institute for Sound and Vision. It is not going to be the restoration or digitisation of our entire collection because we have approximately 37,000 titles in the collection but, by the end of this project, we'll have 5,000 hours of film preserved, restored, digitised and available online. So it's huge.

Paolo Cherchi Usai mentioned *Images for the Future* as an example of how film archival practice is going more and more toward digitisation for access during his speech at the Orphan Symposium 2010. I think that he actually did not realise that preservation is an essential aspect of this project. One great thing about *Images for the Future* is that we won a dispute with the funding entities that you cannot digitise if you have not properly preserved the film. So, every single thing that is digitised is also preserved. In most cases, we are also making film projection copies, because digital projection is not yet

widespread enough to ensure that these films can be shown everywhere. So *Images for the Future* is really unique because it serves at the same time the purposes of preservation, restoration and access.[11]

LW: A question that occurs here is whether you adopt a standardised process if you're preserving and restoring twenty films a month, or whether you adapt it to the condition and characteristics of each film?

GF: That's the huge difference between the work that we are doing as opposed to archives where the image content is considered more important than the visual qualities of the image. We're always looking at the film and deciding based on the material available how to proceed with the restoration. For example, with the experimental films in the collection we have a completely different approach than with more commercial feature films. With experimental films, we do our best to work very closely with the filmmaker, trying to understand how the films were made. We have so many experiments in colour, and the colour technique is not always easy to identify and fully comprehend. Sometimes the filmmaker tried something out in his or her kitchen and we don't know how they did it. We need to talk to them and try to understand and, if possible, recreate what they did as closely as possible.

LW: Do you consult the laboratories that processed the initial releases?

GF: Well, yes. In the Netherlands it's easy, or difficult, depending on how you look at it, because now there is only one film laboratory – that's Cineco, and Haghefilm is the preservation department of Cineco. All other labs are gone so we cannot go back to the original lab, but most people who used to work in different labs in the Netherlands ended up working for this one lab.

LW: Okay, there are implications, but it could also mean that a pool of different approaches is drawn together in one lab? Haghefilm are analysing the chemical composition of film to discern elements that can give an indication of the faded colours of tinting and toning – is that an exceptional practice?

GF: I think that is something Haghefilm does now because of Uli Rüdel working there, who has a very different background from many other laboratory technicians.[12] He holds a PhD in Chemistry and has a more scientific approach to the work than other technicians, who focus more on the everyday processes, rather than researching the chemistry of the original process. In practice we need both, we need to understand the colour as it was, but we also need to recreate something that is presentable today.

LW: I wonder whether the visual characteristics of different film materials can be considered to be part of the film text? It seems sometimes that restoration projects are maybe caught in the dilemma of producing something new, yet which retains some fading or scratches so that it still looks old for the audience of an archival film.

GF: This is very interesting and very tricky at the same time, because audiences are changing. The restorations that we did five years ago are now really under-restored. It's a mixture of what we [the archive] would accept and what the audiences would accept. If I look at a silent film I can accept the signs of time on it. I look through them and I see the film. But if I'm looking at *Casablanca* (1942) or a studio film as a spectator, I get really disturbed by a badly scratched vintage print. There are different expectations – there is something

in my film education and approach to film that will make me much less tolerant for imperfections when I'm looking at Hollywood film.

LW: I guess that in those situations the film was expected to have a shorter life as an ephemeral medium and commodity, but then other films got caught up in the idea of documentation which seems to lie in the image content, but that's just one aspect of history and film. There's technology too.

GF: But there is a process of selection everywhere. In ten years from now the policy will have changed, but there are always films that we are not restoring today which might become very interesting in ten years from now, so let us hope that in ten years they will still be there!

LW: Yes. And thank you!

NOTES

1. *Bits & Pieces* is a project that was initiated by Eric de Kuyper in 1990. The project is ongoing and in 2012 *Bits & Pieces* 610–33 was edited by Mark-Paul Meyer, who is a senior curator at EYE, Amsterdam.

2. Mark-Paul Meyer, 'From the Archive and Other Contexts', in Marente Bloemheuvel, Giovanna Fossati and Jaap Guldemond (eds), *Found Footage: Cinema Exposed* (Amsterdam: Amsterdam University Press), pp. 145–52; Peter Delpeut, 'An Unexpected Reception: *Lyrical Nitrate* between Film History and Art', in Bloemheuvel *et al.*, pp. 217–24.

3. Paolo Cherchi Usai, 'Are All (Analog) Films "Orphans"? A Predigital Appraisal', *Moving Image* vol. 9 no. 1, 2009, pp. 1–18.

4. For example, a film such as the external filming using Gasparcolor in *Colour on the Thames* (1935).

5. Adrian Cornwell-Clyne, 'Additive Processes', *Colour Cinematography* (London: Chapman and Hall, 1951), pp. 280–1.

6. Snowden Becker, 'See and Save, Balancing Access and Preservation for Ephemeral Moving Images', *Spectator* vol. 21 no.1, 2007, pp. 21–8, refers to FIAF's advocacy of to preserve is to show, linking these two dimensions of film archiving together.

7. Henri Langlois (1914–77) was co-founder of the Cinémathèque Française and FIAF; Ernest Lindgren (1910–73) was head curator of the BFI National Film Library (1935–73). See Ruth Beale, 'Lindgren and Langlois: The Archive Paradox', in *The Cubitt Artists' Event Series Public Knowledge*, <www.ruthbeale.net/images/Lindgren_Langlois.pdf>, accessed April 2012). This includes reprints of correspondence between Ernest Lindgren and Henri Langlois.

8. Tom Gunning, 'Moving away from the Index: Cinema and the Impression of Reality', *Differences* vol. 18 no. 1, 2006, pp. 30–52; Mary Ann Doane, 'The Indexical and the Concept of Medium Specificity', *Differences* vol. 18 no.1, 2006, pp. 128–52.

9. Penelope Houston, 'Definitive Versions', in *Keepers of the Frame: The Film Archives* (London: BFI, 1994), pp. 126–41.

10. *Images for the Future*, http://imagesforthefuture.com/en/, accessed March 2012. This is a seven-year project to increase access to Dutch audiovisual heritage. The project began

in 2007 and is funded by FES (Fund for the Reinforcement of Economic Structure). It includes three Dutch archives (EYE in Amsterdam, Sound and Vision in Hilversum, the National Archive in The Hague) and Knowledgeland.

11. In 2011, the Dutch government cut about 30 per cent of the *Images for the Future* budget. As a consequence EYE had to close down the project activities two years ahead of schedule with only 70 per cent of targets realised and the premature loss of valuable project collaborators.

12. Since this interview Rüdel has taken up a post as conservation technology manager at the BFI NFTVA (2012 – current at the time of publication).

PART IV

ASSESSING COLOUR'S IMPACT:
CONTEMPORARY THEORIES

INTRODUCTION

Following the showcasing of three-strip Technicolor in the mid-1930s with the two-reel *La Cucaracha* (1934) and feature film *Becky Sharp* (1935), and as colour films became more commercially viable, there was much commentary about their impact in the trade press, technical journals and in other related publications. After the press screening in Britain of *Becky Sharp*, the film was declared a triumph by *Today's Cinema* under the headline, 'Another Revolution?', observing that Technicolor was the most impressive colour process to date.[1] At the same time as three-strip Technicolor was being introduced, other processes such as Dufaycolor and Gasparcolor were being showcased as viable alternatives. Many key issues, including aesthetic appreciation, taste cultures and economic viability, governed the use of colour. Colour cost more, so when it was appraised, it needed to be distinctive to justify its expense, yet not appear jarring, overly obtrusive or distracting. Outside the avant-garde or the animated film, most commentators preferred colour to be enlisted to underscore narrative features and provide visual interest, particularly for female audiences. Exhibitors were wary of colour representing a film's sole attraction, considering it not worth the extra cost unless deployed in a film that was already an excellent box-office prospect. Producer Alexander Korda, for example, was enthusiastic about colour, arguing that it had the potential to enhance films in which the stars were wearing new fashions, as in *The Divorce of Lady X*. At this point, colour was clearly being assessed as appropriate and desirable for *selective use*, rather than as an option that would infiltrate the industry as quickly as the coming of sound ten years earlier.[2]

In spite of such enthusiasm, the arrival of what appeared to be a significant phase in cinema's technical development occasioned a wider debate on whether colour was desirable for the commercial cinema. In past centuries, colour had attracted the attention of many philosophers, artists and scientists. Multiple modes of discourse about colour resulted, focusing on understanding its complexity and its codification in art; scientific theories of perception; and, post-Goethe, recognition of the impact of culture and subjectivity on colour evaluation.[3] This chapter reproduces three contemporary 'takes' on colour by commentators who, in their different ways, exemplify the range of opinion on colour during a crucial period in its development in the cinema. While many commentators

embraced colour as an exciting technical and aesthetic challenge, others feared that its unregulated application would damage cinema's growing reputation and artistic credentials. Even though the majority of silent films had displayed some form of colour, whether it be tinting, toning, stencilling or the numerous attempts to introduce photographic processes in the first decades of the twentieth century, sound talkies were predominantly shot in black and white. High-brow journals such as *Close-Up* were wary of the adoption of colour, believing it threatened cinema's mastery of the black-and-white representational codes associated with documentary realism.[4]

Much of the debate reflected here engages with the advantages and disadvantages of seeking to control the deployment of colour in the commercial cinema. British artist Paul Nash (1889–1946), known for his landscape painting and as War Artist in World Wars I and II, contributed to a seminal book published in 1938 that vouchsafes a wonderful sense of contemporary responses to key developments in cinema. Nash's background, as a painter who was interested in engraving, the avant-garde and surrealism, makes him particularly qualified to comment on the various approaches to colour prevalent at the time. His criticism of Technicolor, in particular the scenes in *Wings of the Morning* that sought to display the extent to which colour enhanced a film's realism, is striking for its dismissal of what he perceived to be an obsession with naturalism and 'harmony'. The latter did not necessarily mean that he dismissed colour altogether. The second part of the chapter praises how Disney's 'Silly Symphonies' and the experimental animated films of Len Lye embraced colour as capable of creating 'infinite variations of contrast' (p. 254), appealing to the senses rather than to naturalistic effects that were bound to be found lacking when scrutinised by sceptical audiences.

The remaining two documents revolve around the work of Adrian Cornwell-Clyne, a major theorist and practitioner in colour cinematography. He published three editions of a monumental technical book, *Colour Cinematography* (1936, 1939 and 1951; the first two published under his original name Adrian Bernard Klein), which detailed numerous colour processes, their histories and technical specificities.[5] He was involved in the development and exploitation of Gasparcolor and Dufaycolor and is an extremely important figure because the industry became well acquainted with his views, through his articles in the trade and technical press. The article by E. S. Tompkins from the *British Journal of Photography* highlights a debate involving the views of Cornwell-Clyne about Technicolor and its Color Advisory Service led by Natalie Kalmus. Tompkins wrote a regular column in the *British Journal of Photography* that ran from 1942–7. An expert on colour, his articles were intended to inform amateur filmmakers about the latest developments in commercial films from the perspective of 'The Colour Enthusiast at the Cinema' (the title of his articles). As well as seeing most of the colour films released in Britain during World War II, Tompkins engaged with debates about the use and impact of colour. Cornwell-Clyne's views were well publicised, in particular his plea that colour should not be obtrusively 'glorious' in commercial films. Tompkins defends the work of Natalie Kalmus, an unusual position since it was more common, especially in subsequent years, for cinematographers to criticise her work, representing her as obstructive and largely ignorant about colour. While this view has been subsequently challenged, it is interesting here to see Tompkins appreciating her work as well as its

influence on collaborators in Britain, particularly Joan Bridge, who worked as advisor on many British Technicolor films.[6]

In the extract from Cornwell-Clyne's book (1951 edition) he discusses 'The Future of the Colour Film' in the light of developments since the previous edition (1939). In the book he generally advocates a careful, supportive role for colour in commercial cinema:

> The motion picture in colour represents the first opportunity for the creation of colour compositions in which the combinations are subject to continuous change, the emotional significance being built up in sequential form, so exploiting the basic principles of music and the drama.[7]

Like Paul Nash, Cornwell-Clyne appreciated how colour had been deployed in Disney's animated films, and proposes five basic principles that ought to be observed for colour films. The extract finishes with his renowned statement that: 'The first colour film to be received with universal acclamation will be that one in which we shall never have been conscious of the colour as an achievement' (p. 244). This view is controversial but, as we have seen, it is in keeping with dominant views from the period which sought to restrain colour to a non-assertive role of punctuating and underscoring film narratives except when featured in more experimental forms that permitted freer expression.

NOTES

1. *Today's Cinema*, 10 July 1935, p. 13
2. 'They Talk Colour', *Cine-Technician* vol. 3 no. 14, March–April 1937–8, pp. 192–7.
3. See John Gage, *Colour and Culture: Practice and Meaning from Antiquity to Abstraction* (London: Thames and Hudson, 1993) and John Gage, *Colour and Meaning: Art, Science and Symbolism* (London: Thames and Hudson, 1999).
4. See debate referenced in Simon Brown, 'Colouring the Nation: Spectacle, Reality and British Natural Colour in the Silent and Early Sound Era', *Film History* vol. 21 no. 2, 2009, pp. 142–3.
5. Adrian Bernard Klein, *Colour Cinematography* (London: Chapman and Hall, 1936; 2nd enlarged and revised edn, 1939); Adrian Cornwell-Clyne, *Colour Cinematography* (London: Chapman and Hall, 3rd enlarged and revised edn, 1951).
6. For recent reappraisals of Natalie Kalmus, see Scott Higgins, *Harnessing the Technicolor Rainbow: Color Design in the 1930s* (Austin: University of Texas Press, 2007), pp. 39–47 and Sarah Street, 'Negotiating the Archives: The Natalie Kalmus Papers and the 'Branding' of Technicolor in Britain and the United States', *Moving Image* vol. 11 no. 1, 2011, pp. 1–24.
7. Cornwell-Clyne, *Colour Cinematography*, p. 651.

DOCUMENT

ADRIAN CORNWELL-CLYNE, 'THE FUTURE OF THE COLOUR FILM', *COLOUR CINEMATOGRAPHY* (LONDON: CHAPMAN AND HALL, 1951)

On re-reading this section of the last edition of this book (in 1939) the author is impressed with the accuracy of many of the predictions then made. It is a fitting moment to review the former material and to make such comments as may be apposite under the present altered condition of the world.

The question was put: 'Will the colour film altogether supplant the black-and-white film?' Not one word of the reply need be altered. This was the answer:

> It is extremely unlikely that we are about to witness a rapid change-over in picture-making in any way comparable to that which occurred when sound reproduction became available. This statement is made in spite of the daily repeated prophecy that we are in for a revolution in the industry. On the contrary, it is much more likely that the proportion of colour films to black-and-white will gradually, and very gradually, rise during the next five years. It would be very surprising to the writer if in five years from now *one-half of films are made in colour*.

Now the position is that probably not more than one-tenth are made in colour today in 1949, and it will still be surprising to the writer if one-half of all films are made in colour in the year 2000. The reply continues:

> Not the least reason for thinking this, is the cost of negative and positive film stock for colour as compared to black-and-white. Unless remarkable economies can be effected on some other important item of the cost of making a film, it is difficult to see how the extra cost of negative and positive is going to be borne by the producers; especially as it is universally admitted that it is going to be impossible to make more out of a film just because it happens to be in colour, for the very simple reason that the public will not pay more to see it. Naturally, we are justified, in some degree, in hoping that ultimately the cost of negative and positive will perhaps be only a fraction more than black-and-white. There is little evidence that this is likely to be the position for some time to come, however.

The truth is that the prospect of cheaper colour stock is as distant as ever, if indeed it has not retreated beyond the horizon altogether.

After pointing out that the standard of laboratory processing would have to be higher than for black-and-white, it was stated that:

> It is probable that colour printing will remain, for some years to come, the prerogative of laboratories, not only possessing the most up-to-date equipment, but which have the advantage of a specially trained staff who are familiar with the peculiar problems involved in balancing three-colour printing.

This is still true.

Nothing has since occurred to upset the validity of the following:

> To those of us who have had some years' experience of colour films it is a remarkable fact that the introduction of colour into the picture seems to arouse instant criticism from an

audience which will tolerate normally any amount of distortion in black-and-white. It would seem as if the normal power of colour identification is very highly developed. By this is not meant that the average individual in Europe or America – certainly not the average male – has a highly developed colour memory, but that any slight distortion from the condition of neutral balance is very quickly spotted as *unnatural*. And we have to recognize that if the colour process was *perfect* within the illumination limits of projection, the condition of an *illusion* would very nearly have been obtained, the third dimension being the only missing factor. Owing to this developed sensitivity to balance, and probably to range of hue, the audience has hitherto come to regard colour films as being obviously in the experimental stage; and this conviction has built up a considerable antagonism, which it will take a long time to break down. Two-colour films no doubt did an immense deal of harm, and still do so. People learn to expect gross distortions – in fact, all the old history of red trees and sunburnt complexions. It is remarkable how men who have spent a large part of their lives in pioneering colour processes have retained their ability to observe faulty colour reproduction in other processes, but long familiarity with their own process has blinded them to its imperfections; and sometimes to such a degree that they are prepared to swear that brown is green and grey is violet. They are like men in love, who cannot conceive that others may see obvious faults in the supposedly perfect person, or their processes are like old friends of whose defects they have long ceased to be aware.

How true this still is! And how amazing that two-colour processes should have been raised from the dead again! And how sad, too!

Nor need the following be retracted:

It can be argued that a certain lack of realism, an element of limitation, or what artists (painters) call convention, is a desirable artistic quality, but it is unwise to expect the general cinemagoer to appreciate such aesthetic refinements. For them the criterion of excellence in colour will be its approach to absolute fidelity. As the writer has again and again pointed out, the proper approach to the problem for the maker of the colour film should be, at first anyhow, to place the minimum stress upon the accident of colour as such. The quality of the colouring should be such as hardly ever to call attention to itself. The first colour film to be received with universal acclamation will be that one in which we shall never have been conscious of the colour as an achievement. The inclusion of colour will have given us a sensation of well-being, a general feeling of greater completeness. At present, of course, directors are like children who have been given a new toy, and are not quite sure how it is supposed to work, nor quite what it is intended for.

Even the sponsors of Technicolor are prepared to admit that it is a pity that things so turned out that this process gained a virtual monopoly of the field. It would have been a vastly more healthy state of affairs, especially in the early stages of the evolution of the colour film, for there to have been at least three or four alternative types of product. We can predict with almost absolute certainty that this so long held dominance of Technicolor

is coming to an end. We all know that in the public's mind colour films are synonymous with Technicolor. Indeed, Dr. Kalmus and his associates have added adjectives to the language, for do we not frequently read of 'technicolored sunsets'?

The general availability of the multilayer type of negative-positive film should result in the increasing use of colour photography for the newsreel. At any rate, the technical limitations which have hitherto restricted its use for this purpose have been largely eliminated, and now there remains only the economic barrier to be surmounted. The price of positive prints might be so high as to require an impossible increase in the cost to the exhibitor in order to provide an adequate return. Whether any increase in the distributor's charges is practicable is open to question. The trouble is that multilayer film is very costly to manufacture owing to the number of coatings and the high percentage of waste. It is indeed doubtful if this class of film could be made either in the United States or in Britain at a sale price equivalent to that at which the Germans are reported to have sold it during their brief period of production.[1] In any case, Agfa was probably subsidized by the Nazi Government, so that we cannot judge whether the economic conditions of manufacture were in any way normal. The positive stock processed could hardly be sold in Britain at less than sixpence a foot, on the basis of such information as we now possess as to the processes of manufacture and the cost of the raw materials used. At this figure its use would be restricted by the newsreel organizations to films recording events of special interest. That the characteristics of the process lend themselves particularly well to the newsreel has been demonstrated convincingly by films made by the Russians. Obviously the material has latitude approaching that of monochrome, while the speed is adequate to permit very considerable depth of focus. Since over twenty cameras were used for the film of the Sports Parade in Moscow, clearly no more skill was required than it would be reasonable to expect of any newsreel operator.

A study of the attitude today of the British public towards the colour film does not reveal as yet any decided preference for feature colour films. There does seem to be a marked antipathy to excessive use of vivid colour – apparently popular in Hollywood – which may be due to a national liking for the restrained and rather sad tones typical of the British sentiment for colour during the last hundred years. The average cinemagoer is attracted primarily by the individualities of their favourite stars and by the story and treatment, and the question of colour is only a subsidiary factor of final polish. On the other hand, there is not the slightest doubt that the cartoon film is immensely preferred in colour, which is hardly surprising since it is in the animated drawing that colour is discovered to be an expressive factor of major value. Newsreels, documentaries, and educational films, are all preferred in colour.

Had all the sustained efforts of countless men of science, technologists, and financiers to perfect the means of making motion pictures in colour had as their ultimate end the production of ephemeral entertainment for the masses, one might doubt that success was an adequate reward, but luckily the finished tool had work to be put to of more permanent value to man, for the colour film is destined to make a contribution of real value to civilization in education and scientific research. As example we may mention the valuable work which has already been done for medicine and agriculture. Thus the promise of lucrative reward from the exploitation of a technological triumph has not for the first time

resulted in benefits being conferred in cases unforeseen by men moved rather by greed than by desire for mastery of material means for the greater public good.

Man stands at the parting of his way. His technical triumphs offer self-destruction or the enjoyment of a meaningful existence. He must choose. A colour film can be brought to shame by the base misuse of evil propaganda, or a colour film can reveal a secret of nature and so serve the well-being of all men. We who played our part in the fashioning of this tool cannot refuse the challenge. It is for us to choose which way it shall be. Choose then as servants, but not as slaves – for this in truth is the choice before us.

NOTE

1. Nevertheless Kodak and Du Pont have since offered colour positive raw stock at 4½ cents a foot.

REFERENCES

Munsell, A. H., *A Color Notation*, Ellis, Boston, 1907.

Munsell, A. H., *Atlas of the Munsell System*, Wadsworth-Howland, Malden, Mass., 1915.

Newhall, Sidney M., 'Preliminary Report of the O.S.A. Subcommittee on the Spacing of the Munsell Colors,' *Journ. Opt. Soc. Amer.*, **10** (Dec. 1940), p. 617.

Newhall, S. M., Nickerson, D., and Judd, D. B., 'Final Report of the O.S.A. Subcommittee on the Spacing of the Munsell Colors,' *Journ. Opt. Soc. Amer.*, **33**, No. 7 (July 1943), pp. 385–418.

DOCUMENT

E. S. TOMPKINS, 'IN DEFENCE OF "GLORIOUS" COLOUR', *BRITISH JOURNAL OF PHOTOGRAPHY*, 3 MARCH 1944

IN DEFENCE OF "GLORIOUS" COLOUR

By E. S. TOMPKINS, B.Sc., A.R.P.S.

READERS of my series of articles, "The Colour Enthusiast at the Cinema," will appreciate that for the past two years I have been expounding a policy of level judgment and dispassionate appraisal for the colour photographer (past, present or potential), when looking at colour films in the commercial cinema. I have been more than surprised to read, in "The Cinema," for February 9, an article "Colour Films are too 'Glorious,'" written by Major A. Cornwell-Clyne, of the Dufay-Chromex Co., and himself one of the wisest and most experienced of the exponents of colour cinematography.

The salient points made by Major Cornwell-Clyne in his full-page article would seem to be:

(a) The technical details of the most-used colour process are kept secret.

(b) Colour control has to be surrendered by the film director to a colour director from the colour film company.

(c) No one has yet learnt restraint in the use of colour. Major Cornwell-Clyne would like to make a monochromatic colour film.

(d) The prices of colour prints should be reduced; competition from another process would help to do this.

(e) The demands of colour-television will probably result in a call for improved colour-rendering in films to be televised.

I disagree with so much of the content of Major Cornwell-Clyne's article that I feel that I must attempt to reply to it, from my essentially detached viewpoint, right outside the film industry.

The first suggestion, that the development of colour cinematography is being hampered by the fact that Technicolor is a "secret" process, seems very wide of the truth. I have constant recourse to that monumental work "Colour Kinematography," which Major Cornwell-Clyne wrote just before the war, and it is clear to me that he is capable of extracting any information which he might reasonably demand about the Technicolor process from their very considerable patent literature. There is nothing secret about the principles involved, and "Colour Kinematography" includes diagrams of the beam-splitter camera and summary details of numerous patents covering the imbibition system of printing.

Passing on to the second point, it is true to say that the activities of Technicolor's Colour Control Division need to-day to be far less strict than in the two-colour days. Before 1935, only Natalie Kalmus knew what colours the process could cover adequately, and a measure of control was essential. To-day the work of the Division is of a much more supervisory character and likely to be welcomed rather than resented when decisions have to be taken on décor and colour treatment. At any rate, Technicolor's Colour Control Division (Natalie Kalmus and her helpers; Henri Jaffa, Morgan Padelford and Richard Mueller, in America; and Joan Bridge in this country), can congratulate themselves on the artistic successes of recent years in such films as "Heaven Can Wait," "Gone With The Wind," "Blood and Sand," "Hello, 'Frisco, Hello," "Colonel Blimp" and "The Great Mr. Handel," while they cannot feel too depressed about the successful launching of all the lovely low-brow musicals, the swashbuckling dramas and the tender romances, the colour in which has done so much to cheer and brighten the wartime years. Anyone who has followed recent Technicolor developments cannot but have noticed the way in which Technicolor are now prepared to delegate responsibility to producers' cameramen, and

to give directors more freedom in their use of the medium. The result has been the winning of an Academy award by Leon Shamroy, and a series of most striking experiments by such directors of photography as Ernest Palmer in America and Georges Perinal over here. Monopak Technicolor, when it becomes generally available, will give even more freedom.

The need for some kind of colour control was nowhere so well illustrated as in the one brave attempt at a feature film in Dufaycolor made just before the war stopped their work. I have some colour stills before me as I write which serve to remind me of "Sons of the Sea," and of the lack of co-ordination between its variable exterior shots and its studio scenes in which the colour is interjected into the sets and costumes without any deducible underlying plan.

The idea of making a monochrome colour film comes up as a great discovery from time to time. The suggestion is usually made in a spirit of perversity, by someone who either wants to say a "smart" thing, or who is unwilling to confess that he has no better idea as to what to do with colour. Major Cornwell-Clyne is not alone in this crusade. I have already recorded in "Colour Enthusiast" similar ambitions by Major William Wyler (of "Mrs. Miniver" fame), and by the producers of the forthcoming Noel Coward film, "This Happy Breed." The thoughtful cinemagoer laughs at such ideas. Life itself is seldom colourless, although we habitually disregard the subtler manifestations of its hues; but those who have been making colour films for years, and who have been painstaking observers of colour in everyday life, know when to make colour truly expressive by reducing it to the minimum. For example, the whole of the wartime sequence in the middle of "Colonel Blimp" was in this vein. Several people have told me that this section was in sepia monochrome, and have had to be taken to the cinema again to see such subtleties as red lips, blue eyes and red tabs against the carefully contrived general overall khaki drabness of the period. There is a similar brownness over large parts of the opening sequences of "Gone With the Wind," as can be verified from specimens which are before me as I write, showing that even four years ago the use of subdued colour was well understood and practised.

As to the effect of television in colour, it is perfectly true that this post-war development is likely to have a great effect on popular appreciation of colour. Instead of colour entertainment being restricted to a few visits to colour films, probably not more than a dozen on the average each year, colour isolated on the television screen will be a constant feature of our home life. This is more likely, I think, to make the man in the street sensitive to colour, and appreciative of the fine qualities and artistic merit of colour films as they are developing to-day, rather than to lead to any particular demand for a change in the way in which that development is taking place.

Major Cornwell-Clyne hints at the development of a screenless direct-printing negative-positive process, which most people will agree to be desirable, so long as it can compete with imbibition printing. It is probably significant, on the cost consideration, however, that Technicolor in their Monopak system still use imbibition printing as the cheapest method of making release prints. Finally, in the last words of his article, Major Cornwell-Clyne renounces his vow of restraint by looking forward in most low-browed fashion to seeing on the screen in 1944 the record of victory processions in "truly glorious Dufaycolor." To that wish we can only say: "Speed the day!"

ALIAS RATCATCHER—The Scientific Terminology.—We know it has nothing to do with photography, but we just cannot resist re-printing this little gem from the correspondence columns of "The Times."

<div style="text-align:center">To the Editor of "The Times."</div>

Sir,—In a recent circular from the Ministry of Health to local authorities the ingenious author uses the words "rodent operative" to denote what the ordinary Englishman calls a

ratcatcher. Surely, Sir, if words mean anything at all, these two mean either "a workman who is in the habit of gnawing" or "a workman with well-developed incisor and no canine teeth "?

I am, Sir, your obedient servant,

R. B. LUARD-SELBY.

Troutbeck Vicarage, Windermere.
February 8

DOCUMENT

PAUL NASH, 'THE COLOUR FILM', IN CHARLES DAVY (ED.), *FOOTNOTES TO THE FILM* (LONDON: LOVAT DICKSON LTD, READERS' UNION LTD, 1938)

I

By way of preface to this article I think it should be stated that the writer lays no claim to be considered an expert. His experience supplies him only with the most rudimentary knowledge of the technique involved in colour cinematography, and his sympathies are almost entirely with the black-and-white screen. But it has been thought 'interesting' to invite a painter to write on the subject of Colour Films, and that invitation has been accepted and acted upon in good faith. That is to say, the whole undertaking has been, necessarily, limited; the result may well be of no value. But it is a personal record.

In approaching the subject of colour films as a whole, for the purpose of this article it seems best to divide the discussion into three parts – Colour Talkies, Colour Cartoons, and the Colour Films of Len Lye.

Colour talkies refer to the big pictures as opposed to travel and instruction films whose only voice is the commentator's. As a basis for criticism, impressions received in studying two distinctly different pictures seemed most constructive. These films are *Ramona*, made in California last year by Twentieth-Century-Fox, and the recently completed *Wings of the Morning*, made under Fox auspices by New World Pictures at Denham in this country. Both use the latest American Technicolor process.

Major Adrian Klein, who has written the standard work on colour films,[1] remarks towards the end of his excellent book that

> it is certain that in the early stages of colour reproduction painters will be called in to supervise colour direction, who, by the nature of their environment and training are not equipped to understand even the elements of the theory and practice of colour photography.

To this I would add, God forbid; yet I find myself in the position of one passing judgment upon the results of that theory and practice which certainly I am hardly equipped by training or environment to understand. On the other hand, for the first time, I believe, I am in the position of the spectator who confesses with such disarming frankness: 'I don't know anything about Art, but I know what I like.' And for the first time I begin to understand what that means; and to feel something of the comfort of its defiant impertinence. But Major Klein is right when he says that the film colourist of the future will have to possess, as part of his training, a thorough mastery of all the technical aspects involved, in order to collaborate intelligently with the specialist controlling each stage of the colour-recording and reproduction. Even then, he may lack an indispensable quality – that very seldom-considered factor, imagination; or is that taken for granted as the other part of his equipment? I doubt it. At present, so far as I can discover, the use of imagination and the operation of technical processes in colour cinematography have never coincided.

To an artist, the appearance of the average colour photography picture is more or less of an abomination. It lacks everything he prizes – form, definition and subtlety. It emphasises everything he has striven to overcome – realism, banality, false values. He recognises in it potential beauty but is forced to realise that, at present, its whole apparatus is being used for stupid or venal ambitions. This is easily explained. With the arrival of the full-length

colour picture, directors have mentally all gone back to the nursery. I shall never forget the scene in the hayloft during the special showing which Fox Films were kind enough to give me of *Wings of the Morning*. Every nocturnal noise calculated to alarm Annabella (and thereby give away to Fonda, also in the hay, the fact that she was a girl dressed as a boy) was recorded and then painstakingly illustrated. Squeaking; close-up of rat; rattling; full-coloured old-fashioned lantern; banging; part of interior showing door; neighing; picture of horse, twice; and, finally, a rather dim noise I hardly recognised followed at once by a most disconcerting stuffed owl – or just acting stuffed, which persisted for what seemed several minutes; the bird and I, alone in the theatre, glaring at each other. I must say it looked very much like an owl by the time they removed it. That, however, is the clue to the present conception of the colour film. It is regarded as the great opportunity to see life steadily and see it whole – i.e. in full colour. Anything more tedious and, generally speaking, discouraging, it is hard to conceive.

But naturalism and realism are thought to be the productive elements for entertainment value, and since the colour film costs roughly three times as much to produce as the black-and-white and grey, we have what is called *accent on Naturalism*. I regret to find that even so intelligent a person as the author of *Colour Cinematography* supports this ideal as the goal of all his fine technical skill.

> The object is to give pleasure. It is said that by far the majority of the audience in the cinema consists of women. No one in their senses would say that colour does not give pleasure to the average woman, nor would they deny that it plays a very important part in their mental life. This being the case, provided that the colour reproduction is convincingly natural, practically every woman will approve of the addition of colour to the cold grey shadow at present flickering away its story upon the white screen.

And again:

> A travel picture of the loveliest of this world's scenery rendered only in light and shade cannot hold the attention for long. We are impressed only by elements of pictorial composition or by the skill of the photographer; but upon the introduction of colour everything is forgotten save the exquisite sensual pleasure of *recognition*; we are overcome by the magical nature of the thing this evocation of all that is most precious and evanescent in vision.

In this connection I was struck by an odd incident while watching *Ramona*. A naked baby of quite astonishing naturalness was presented in its bath or cot, I forget which. Several women, I presume overcome by the magical nature of the thing, burst into rather hysterical laughter. What surprised me more was that the same effect was produced by some realistic pancakes; even men joining in the laugh. What will happen when Steve Donoghue is seen in full colour – first in mufti at the Dorchester and finally winning the Derby on Wings of the Morning, I cannot imagine.

Yet with all the boasts and strivings of directors, cameramen and laboratory technicians, an absurd but obstinate fact remains. *Colour cinematography cannot produce*

natural effects. It can produce isolated objects with an effect of verisimilitude, provided they are within focus and naturally lighted. But, as its focussing range is distinctly limited – far more so than that of the ordinary screen camera – most of its scenes are travesties, unreal compositions in which things look either too real to be credible or definitely unreal. Figures of unnatural colour force, but not quite sufficiently articulated in *drawing*, move about in landscapes where form, literally, has no definition and, in the near middle distance, gives up the pretence altogether and becomes simply blurred.

At times, ludicrous contrasts are given by shooting the stars by vivid, artificial light – for which they are 'made up' in surroundings lit by the natural sun. Often this is not in the least necessary; even a veiled sunlight, I am told, is sufficient for shooting, but in the case of *Wings of the Morning* weather conditions were so bad that sun arcs had to be used frequently. This brings us up against another discouraging limitation of colour photography. *Apparently*, it can only record one temperature to any extent, and therefore no place appears cool or soft; no delicate shades enter in.

Many scenes in *Wings of the Morning* occur in Ireland where, I believe, the charm of a landscape like Killarney lies in its subtle, indeterminate colour. Also, like any lake country, its form is most interesting under changing skies. Seen at midsummer, or in steady sunlight, it has the rather vulgar 'look' of a picture post-card. The result of the sequence of scenes shot to illustrate John McCormack's singing of 'Killarney' was rather like upsetting the local views kiosk in the village shop; in fact, I have never seen such sunsets anywhere else.

But, again, colour cinematography does not produce even the effect of a good picture post-card. Personally, if it could, I, for one, should be satisfied. Few people realise, perhaps, the charm of certain early colour cards, clear cut and printed in clean bright, cool colours – I have a set of Toulon and one of the Desert which, pictorially, would do credit to any painter. When the great Derby scene is shown in *Wings of the Morning* there is one moment when a couple of gipsy children appear in close-up and in that one shot the camera nearly comes up to Frith, but the general view is very much below his level.

It is all a matter of the definition of form. In both films under review, *Ramona* and *Wings of the Morning*, there is a large proportion of horses. Now, horses in both films look satisfying, more satisfying and convincing than any other objects moving or static. I am still not quite sure why this is. Presumably they are shot in natural light, but still … Humphrey Jennings, the surrealist – who has had considerable experience of practical film colour work – explains it in this way.

> On people the definition seems less good than on machines and dogs. It isn't. But one is satisfied with a sensation of dog: one is not so satisfied with a sensation of a *star*; and colour is sensation.

It may be so. What cannot be disputed, I think, is that colour as used by Technicolor experts does not function as it should for their purpose. It fails to reinforce form. On the contrary it largely obliterates form. This is partly due to the ignorance of directors and cameramen. They use too much colour; they have no understanding of its proper use; they are like the children in the nursery again. They have been given a box of paints and they are having a fine time laying it on thick anywhere they can.

There is another unhappy fallacy existing in the minds of certain directors. This is the *harmony* obsession. A great deal of time seems to be spent in harmonising costumes with interiors, interiors with exteriors, and screen personalities with costumes, interiors, exteriors, and so on. The result, I regret to say, is only to reduce all to the lowest common (or vulgar) multiple in terms of colour and, in the process, to dull definition. What should be studied, of course, is the infinite variations of contrast. But not only is contrast hardly practised, it seems to be unrealised as a constructive factor in producing harmony. The fact is that the Technicolor experts have a certain amount of scientific knowledge not always comfortably digested, and applied generally only along conventional tracks. It is the same in the matter of psychology, a pet field of 'knowledge', especially with women specialists.

Finally, there is the all too important question of how colour affects the *stars*. I have collected a few opinions upon this aspect and they confirm my own impression. Miss Elsie Cohen, organiser of the Academy Cinema, makes this interesting observation:

> Though it does not seem to follow logical laws, I find that I am irritated by seeing a face in colour. For me, instead of lending greater depth to the face it makes it appear empty. I have the feeling that I am watching a fantasy and not a drama of life.

This is a very pertinent comment. Colour photography, for the most part, because it fails to reinforce form, detracts from the structure of the face. It seems to be superimposed in such a way as to obscure the *drawing*. When a painter uses colour he builds with paint all the time, even in water colour which is translucent. The only hope for colour photography to be effective is to understate it instead of piling it on.

The requirements of Technicolor dictate the right policy in this respect where make-up is concerned. Natural beauty, we are told, will be at a premium in future. Beauty that relies on the make-up expert will be under a cloud. But the process is exacting – a close-up shows the pores of the skin. The experts have to admit that heads of hair are going to bother them. Colour does not suit blonde women, and the platinum variety, according to them, is definitely out. Black hair is difficult, browns and half-shades almost impossible. Golden hair and auburn hair seem to photograph best, which is what one might expect, though I fear it is going to add another hot colour element to an already overcharged palette.

But there is more than that to overcome. Unless colour is going to enhance the beauty and interest of the stars, it is not going to be popular with the public and certainly not with the stars. You may think it thrilling to see your pet star *as* in real life, but you may soon wish you had kept your illusion. Even seeing her or him in the flesh, carefully prepared to meet the daylight, might be less disappointing. Do you remember Miriam Hopkins in *Becky Sharp*? And how did the pale lure of Marlene Dietrich stand up to the colour test in *The Garden of Allah* – did it not almost evaporate? How many women fans are almost dreading to meet a coloured Clark Gable? In *Ramona*, Loretta Young is transfigured by a black wig and made up to look like a Red Indian on the wrong side of the blanket, so to speak. But Annabella, that delicate and enchanting heroine of so many of France's best productions, has to look first like the gipsy wife and then like the partly-gipsy daughter of an Irish peer. I could not have believed that any face so physically distinguished might be made almost commonplace, but so it is. There are occasions when her

beauty penetrates the mask, but I could not help feeling that the most significant achievement of Technicolor to date was in making Annabella look *swarthy*. ...

Unfortunately it is too easy to find faults in the production of colour cinematography and too hard to discover important virtues for a discussion of this kind to be made very interesting. Comparing the two films, as a mere spectator I had the impression that *Ramona* came nearer realising Major Klein's ambition.[2] That is to say, the colour was not too overwhelming; one took it for granted quite comfortably most of the time. But in *Wings of the Morning*, the inane pursuit of naturalism, colour for its own, or rather, for Technicolor's sake, and the naïve attempts at colour harmony, do obviously slow up the picture. Imagine travelling in a train where the engine-driver wants to pick the flowers on the railway banks or point out the naturalness of rabbits to the passengers There is no doubt in my mind that the process of colour photography is capable, perhaps even now, of something worth considering from the point of view of the art of cinematography – without developing any sort of 'artistic' affair. I have recently been shown films in Cinecolor and Dufaycolor. The Cinecolor effects are by far the most natural and satisfying I have yet seen. That is because they are, in a sense, an understatement. They have gone far to solve the problem of sharp definition, both for rapidly-moving objects and for objects at varying distances from the camera. But Dufaycolor – which has been taken up by one or two American producing companies and carried further than Cinecolor towards commercial availability for film work – has considerable claims also as a medium. It is an additive process and the latest of a long sequence involving the most inveterate research. Its name derives from Louis Dufay, who manufactured the Dufay Diopticolor and Dioptichrome screen plates in 1908, and has since been working on a film colour matrix fine enough for cinematography. Dufaycolor and Cinecolor are British concerns Spicers Ltd. and Ilford Ltd. having made themselves largely responsible for developing the two processes. But, whatever the process and however highly developed, the directing of the colour machine – like the directing of all machinery to-day employed in producing effects of colour form in two or three dimensions – must, sooner or later, use the artist – the 'real artist' as Major Klein describes him. But not an artist without experience and understanding of film technique. He must be properly equipped and employed intelligently.

To conclude this section of the discussion I am quoting – without comment except italics – extracts from the published statements of four experts engaged in the production of *Wings of the Morning*. They appear to reveal a certain mentality, what I will call the colour-film mentality – at least one species of it. Another, of a very different sort, will be disclosed in the second part of the review.

Mrs. Natalie Kalmus, colour director of *Wings of the Morning*:

In this picture *we are trying to preserve one level of colour throughout*. Over half the picture is being filmed out of doors, so that in these scenes the predominant colour will be the soft and restful green of the English country-side.[3] Even in the gipsy prologue to the picture, where some of the costumes are very vivid, they are offset by the masses of green. When we cut from these exterior sequences to interiors, we try to preserve the same 'light level.' Our sets are brown, grey and green – warm, rich shades of colour for walls, furniture,

tapestries and curtains, but all soft and tending to absorb light rather than reflect it. In this way the colours of the interiors and exteriors are kept at the same level.

Ralph Brinton, art director of *Wings of the Morning*:

> Colour sets the art director many problems. The worst is that characters move from set to set wearing the same costumes. Each set must be a perfect background for these costumes. *Therefore the use of the dominant colour schemes must be avoided.*
>
> Preparation of sets takes a longer time. If you look closely at any surface – from a castle wall to a common-or-garden brick – you will find it has a series of colours in it, blending to one general tone. To reproduce such a brick, or castle wall, we must reproduce all those colours.
>
> To secure the right shade of grey for the interior walls of Clontarf Castle, for example, we had to coat the walls first with white paint, then grey, then yellow. By that time a blue tint had appeared – so we gave a final coat of grey for luck.

Ray Rennahan, cameraman on *Wings of the Morning*:

> Technicolor requires a very light make-up. An actress appearing before a colour camera could walk straight off the set into the street – and if her make-up were commented on it would probably be described as insufficient.

René Hubert, costume designer for *Wings of the Morning,* takes all his range of colours from the shade of the artiste's lips, which, he says, *should be the predominant colour on the screen.* If it were not, it would mean that the colours of a costume or a set were stealing every scene from the human actors and actresses.

II

My conversion to the colour film of any description dated from the moment I beheld Walt Disney's Silly Symphony, *Flowers in Spring* [*Flowers and Trees*]. Disney is one of the few geniuses of the cinema. He stands beside Chaplin as one of the real entertainers. He, too, has made the whole world happy and better for knowing his work. Unlike Chaplin, however, his virtue does not depend upon his visible personality. It is vested in a company of people. This company works very much as the mediaeval guilds worked. It is a kind of school where apprentices are at first set to study drawing and painting as in an art class. There is a good deal to learn, a very special technique to master. The preparation of a cartoon is immensely laborious. Each movement of each figure requires a drawing for itself. The average rate of articulation on the moving screen is twenty-four images per second.

I have always regarded the Walt Disney Productions as one of the marvels of our time. I once visited a cage of comic-strip artists in New York. It was a small room on the forty-fourth floor of one of the more spectacular skyscrapers, and I think it held six or eight

draughtsmen. When they were excited or bored they drew on the walls. The air seemed charged with despair. The mind totters at the very thought of that human machinery which builds up line by line the arabesques of those delirious fantasies of Mickey Mouse. Even more impressive is the thought of the strange master-mind which conceived originally such impossibilities of Nature.

In the early days of the productions there was a very able lieutenant called Ub Iwerks. For some reason he separated himself, and made a sort of rivalry about a frog, but it came to nothing.

The early Disney cartoons, which I believe to be authentic Disney, are truly sensitive drawings charged with a rather pale bright colour, reminiscent of certain drawings by William Blake – the Milton series, for instance. For some time the cartoons continued on what might be called an even keel. No large displacement occurred, variety and invention kept high, and there were some surprising pictorial incidents which seemed nothing short of original. Exciting patterns made by enraged bees or indignant gnats. Lovely little arabesques of clouds and birds. Each 'symphony' brought new gifts from this fertile source; not merely new flights of nonsense, but accompaniments of design which, apart from their descriptive power, were gems of pictorial fancy. From time to time there were lapses: rather obvious absurdities crudely illustrated. I credited these invariably to a different author or authors.

Actually, the development took place in this way. Disney gradually trained a large number of aides to carry out his ideas mechanically. Presently, however, the machine began to show signs of independent life, and these individual manifestations were allowed free expression within the general control. Sometimes this resulted in new and valuable contributions; now and then it tended to produce ideas of poorer quality rather crudely realised, but probably containing some element which made them popular with simple-minded audiences.

So far as colour was concerned, as I have remarked, for some time its quality did not seem to vary to a great extent. As the 'machine' gained in intelligence, however, a considerable change began to take place. Roughly four hundred people work under Disney, and out of such a number new influences must arise. Unfortunately I am unable to specify at this point, so no analysis is possible. But I think it is quite clear that two distinct types of cartoon are now issued regularly from Walt Disney Productions. The first is a lapse in invention and a bore in colour. It usually concerns the interminable antics of kittens or rabbits. Perhaps it might be worth some psychologist's while some day to discover and describe the singular difference which exists, apparently, between the nonsense stimuli of various animals. Why has the mouse suddenly 'stolen the picture' from all the animal kingdom? Why is irritability so inimitably expressed by a duck, of all creatures? Maybe it is merely the Disney genius. In any case the cartoons of rabbits, kittens, and many of the babies, are less exciting than Mouse and Duck, and usually sentimental, particularly in colour.

The second type of cartoon has made immense strides. I am a little hazy about the order of the sequence, but I remember *The Band Concert* as something suddenly exceptional, to my eyes. The incident of the storm, from the moment the whirlwind begins, is a series of colour shocks. This was the first of many successful experiments in sound and

colour pyrotechnics. Several occur during *The Polo Match* [*Mickey's Polo Team*]; more, I believe, during the extraordinary drama of the musical cities. The occasions of expressive colour are more than it is possible to remember. Perhaps the peak is reached in *Mickey's Garden*, a kind of surrealist extravaganza full of imagination, and heightened at every point by rich outrageous colour.

Walt Disney made his first Silly Symphony in 1933, when he adopted the three-colour process. But the problem of producing colour films from pictures where the colours are arbitrarily designed is a very different affair from actual colour photography which attempts to reproduce the natural colour of objects *in Nature*. In all cases where the camera is only required to photograph a designed picture at rest, colour reproduction is no very difficult matter. New improved processes are constantly coming forward. Apparently we are on the eve of a new development, but probably the technical experiments of Gasparcolor, the process originally contributed by Dr Bela Gaspar, the Hungarian chemist, about three years ago, carry us as far as anything yet known. The process, first worked out in Germany, was recently vested in an English company which has made some extremely lively advertising films now fairly widely distributed. Dr Gaspar's achievement was the perfecting of a new material, a film coated with three emulsion layers sensitised to three different spectral regions. By this a full three-colour continuous tone image is possible without the use of dyes or toning. Judging from the results I have seen, the Gasparcolor film is capable of really serious achievement in colour cinematography. Even so, from what I can understand, it is neither the chemist nor the mechanical inventor, but the artist who has said the last word on colour films.

III

It is a good many years ago now since I first saw the work of Len Lye at an exhibition of the Seven and Five Society at the Leicester Galleries. I was at once attracted by its unusual kind of life. It had a totally different life from any other of the exhibits. Most conspicuous of any quality was the sense of rhythm, but it had expressed itself somehow eccentrically – not in the tiresome sense, but in the way of utter independence. Len Lye is a New Zealander who came to England nine years ago. At the Brussels Exhibition in 1935 he exhibited one of his three films made for the G.P.O. film unit – *Colour Box*. It could be accommodated in no category, so one was made to fit it and it was awarded a special prize. That sort of thing is typical of this original artist.

His peculiar contribution consists in painting direct upon the celluloid film with cellulose paint. The process seems to me so simple, so interesting, that I will quote verbatim Lye's technical notes which were recently published in an article by him in *Life and Letters*:

> The colours used ... were the colours in the Gasparcolor film stock it was printed on. These are the blue, yellow and red dyes existing in three layers on the film stock. They are subtracted and blended by printing lights. The camera used for shooting the film was an ordinary black-and-white camera without colour filters.

All pictorial matter was coloured black and white. Thus the colour palette was the actual celluloid itself.

This was possible, as certain colour film systems resolve any selected colour into its blue, yellow and red constituents, which are recorded in black and white. If these black and white records of objects are thought of as densities of the blue, yellow and red dyes intended for that object, and if it is realised that it is possible to control the amount of dye by the amount of black, invested by paint or light on to the subject, then it will be seen that perfect control of colour is possible.

Len Lye conceives the colour film as a direct vehicle for colour sensation. I have studied his three G.P.O. films and I consider *Colour Box* to be a unique achievement, neat and finished. It was made by painting literally to music. The features of the musical form dictated, more or less, the pattern of the colour arabesque. The other films are both more complicated and less successful, but one – *The Rainbow* [*Rainbow Dance*] – is full of possibilities for development in its particular *genre*. Len Lye's aesthetic philosophy of colour and the film I have no space to discuss here. He believes, as I believe, that he holds in his hands a real power for legitimate popular entertainment. A new form of enjoyment quite independent of literary reference; the simple, direct visual-aural contact of sound and colour through ear and eye. Colour sensation.

What might not be done with colour films! If only the best intelligences of direction, photography and mechanics could collaborate with artists of sound and colour, that might make either an incalculable chaos, or a new world.

NOTES

1. *Colour Cinematography.* By Major Adrian Bernard Klein, M.B.E., A.R.P.S. (Chapman and Hall: 1936).
2. 'The first colour film to be received with universal acclamation will be that one in which we shall never have been conscious of colour as an achievement.' – *Colour Cinematography.*
3. None of the greens in the picture, English or Irish, could be described as either soft or restful.

INDEX

Note: Page numbers in **bold** indicate detailed analysis, interviews or extended extracts from works; those in *italic* refer to illustrations; *n* = endnote.

LIST OF ILLUSTRATIONS